ANTAGONISTIC
COOPERATION

LEONARD HASTINGS SCHOFF MEMORIAL LECTURES

UNIVERSITY SEMINARS

Leonard Hastings Schoff Memorial Lectures

The University Seminars at Columbia University sponsor an annual series of lectures, with the support of the Leonard Hastings Schoff and Suzanne Levick Schoff Memorial Fund. A member of the Columbia faculty is invited to deliver before a general audience three lectures on a topic of his or her choosing. Columbia University Press publishes the lectures.

Charles Larmore, *The Romantic Legacy*, 1996

Saskia Sassen, *Losing Control? Sovereignty in the Age of Globalization*, 1996

David Cannadine, *The Rise and Fall of Class in Britain*, 1999

Ira Katznelson, *Desolation and Enlightenment: Political Knowledge After Total War, Totalitarianism, and the Holocaust*, 2003

Lisa Anderson, *Pursuing Truth, Exercising Power: Social Science and Public Policy in the Twenty-First Century*, 2003

Partha Chatterjee, *The Politics of the Governed: Reflections on Popular Politics in Most of the World*, 2004

David Rosand, *The Invention of Painting in America*, 2004

George Rupp, *Globalization Challenged: Conviction, Conflict, Community*, 2006

Lesley A. Sharp, *Bodies, Commodities, and Biotechnologies: Death, Mourning, and Scientific Desire in the Realm of Human Organ Transfer*, 2007

Robert W. Hanning, *Serious Play: Desire and Authority in the Poetry of Ovid, Chaucer, and Ariosto*, 2010

Boris Gasparov, *Beyond Pure Reason: Ferdinand de Saussure's Philosophy of Language and Its Early Romantic Antecedents*, 2012

Douglas A. Chalmers, *Reforming Democracies: Six Facts About Politics That Demand a New Agenda*, 2013

Philip Kitcher, *Deaths in Venice: The Cases of Gustav von Aschenbach*, 2013

Robert L. Belknap, *Plots*, 2016

Paige West, *Dispossession and the Environment: Rhetoric and Inequality in Papua New Guinea*, 2016

Annette Insdorf, *Cinematic Overtures*, 2017

Herbert S. Terrace, *Why Chimpanzees Can't Learn Language and Only Humans Can*, 2019

ANTAGONISTIC COOPERATION

Jazz, Collage, Fiction, and the Shaping of African American Culture

ROBERT G. O'MEALLY

Love Always,
Robert
O'Meally

Columbia University Press
New York

Columbia University Press
Publishers Since 1893
New York Chichester, West Sussex
cup.columbia.edu

Library of Congress Cataloging-in-Publication Data
Names: O'Meally, Robert G., 1948– author.
Title: Antagonistic cooperation : jazz, collage, fiction, and the shaping of African
 American culture / Robert G. O'Meally.
Description: New York : Columbia University Press, 2022. | Series: Leonard
 Hastings Schoff lectures | Includes index.
Identifiers: LCCN 2021022525 (print) | LCCN 2021022526 (ebook) |
 ISBN 9780231189187 (hardback) | ISBN 9780231189194 (trade paperback) |
 ISBN 9780231548212 (ebook)
Subjects: LCSH: Jazz—History and criticism. | African American art. |
 American literature—African American authors—History and criticism. |
 African Americans—Social life and customs. | Music and literature. |
 Art and music. | Collage. | LCGFT: Lectures.
Classification: LCC ML3508 .O48 2022 (print) | LCC ML3508 (ebook) |
 DDC 781.650973—dc23
LC record available at https://lccn.loc.gov/2021022525
LC ebook record available at https://lccn.loc.gov/2021022526

Cover design: Noah Arlow
Cover image: Romare Bearden, *Bessie, Duke, and Louis* (1981). © 2020 Romare Bearden
Foundation / Licensed by VAGA at Artists Rights Society (ARS), NY.

For Douglass, Gabriel, Ines, Rylan

CONTENTS

ACKNOWLEDGMENTS

I n a recent talk at the Virginia Museum of Fine Art, Angela Davis said that scholars and other thinkers needed to footnote not only publicly known scholars and thinkers, but others from whom we've also learned so much—other colleagues, family members, as well as walking partners and shotgun riders (both these latter terms come from the D.C. I knew as a child of the 1950s and 1960s), exes, and those we meet in passing—friends, and I'd include a few enemies. On the loving side of this equation, above all I want to thank my parents, George M. O'Meally and Ethel Browne O'Meally, from whom I learned almost everything of value that I know. I also thank my grandmother Mrs. Anna Serena Carter Browne Pinn, and her sister, my Big Auntee, Mrs. Ethel Carter Billingsley, ladies I quote, in their sometimes perfumed, nineteenth-century Black lingo, almost every day of my life. Thanks to my beloved sisters Constance Mendes, Marilyn Goldsmith, and Sharon O'Meally Miller. Thanks to my son Douglass Malone-O'Meally, who patiently listened to me read these pages, and thus helped me immeasurably. And to my son Gabriel Malone-O'Meally, whose wise words pop up here and there in this book. For their undying support, thanks to close friends Ernest J. Wilson III, Stephen L. Good, and Henry H. Kennedy Jr. I won't name the people I don't like, from whom I also learned a lot—some decades ago while bussing tables in a frat house, o my Lord! I was listening all the while.

On the more official (but no less heartfelt) side of my intellectual debts, I want to thank the Jazz Study Group at Columbia University, intellectual sisters and brothers by whom I have been challenged and changed for over twenty

years: James Bartow, Herman Beavers, Daphne Brooks, Courtney Bryant, J. C. Cloutier, C. Daniel Dawson, Ann Douglas, Gerald Early, Brent Hayes Edwards, Kevin Fellezs, Krin Gabbard, John Gennari, Paula Giddins, Maxine Gordon, Farah Jasmine Griffin, William J. Harris, Diedra Harris-Kelley, Obery Hendricks, Ellie Hisama, Vijay Iyer, Travis Jackson, Margo Jefferson, Aaron Johnson, Margo Jefferson, Laura Johnson, Kellie Jones, Robin D. G. Kelley, Wolfram Knauer, Eric Lewis, George Lewis, Emily J. Lordi, William Lowe, Jacqui Malone, Timothy Mangin, Francesco Martinelli, Ingrid Monson, Jason Moran, Mathew Morrison, Fred Moten, Dawn Norfleet, Carol Oja, Imani Owens, Damon Phillips, Richard J. Powell, Guthrie Ramsey, Helen Shannon, Whitney Slaten, David Lionel Smith, John Szwed, Jeff Taylor, Jessica Teague, Gregory Thomas, Mark Tucker, Sherrie Tucker, Michael Veal, Daniel Jorge Veneciano, Sara Villa, Chris Washburn, and Salim Washington.

I'm also thankful for many other Columbia-Barnard friends and colleagues (past and present), especially Marcellus Blount, Julie Crawford, Eric Foner, Mary Gordon, David Hadju, Saidiya Hartman, Jean Howard, David Kastan, Quandra Prettyman, Samuel Roberts, Edward Said, James Shapiro, Gayatri Spivak, and George Stade.

Special thanks to experts on the music: Leroy Williams, Michael White, Randy Weston, Geri Allen, Herlin Riley, Wolfram Knauer, Kenneth Knuckles, Ellis Marsalis, Wynton Marsalis, Branford Marsalis, and Delfeo Marsalis. I'm also very grateful to comrades Lewis Jones, Lawrence Jackson, John Callahan, Paul Devlin, and Randall Kennedy. Thanks also to D. A. Pennebacker, for granting an important interview. And to William Ferris, Henry Drewell, Patrice Rankine, and Eric Robertson for ongoing conversations about black art and music. Special thanks as well to my mentors Robert Farris Thompson and Sterling A. Brown.

Teaching is a two-way (and sometimes a more-than-twenty-two way) learning process. I'm so pleased to acknowledge learning from these current and former students (aside from those already named): Leo Genjiro Amiro, Nijah Cunningham, Benjamin E. de la Piedra, Lisa Del Sol, Irving Hunt, Jennifer James, Eleeza Kelley, Kaveh Landsverk, Aidan Levy, Jarvis McGuiness, Gail O'Neil, Jessica Teague, Lilith Todd, and Kim Wayans.

Where do projects start? For this book, one place was Reid Hall in Paris, where, in 2009, I met with a roomful of brilliant undergraduates who discovered some of this book's main ideas along with me. Some members of that seminar have literally never stopped meeting—now over daylong brunches, and recently on a long and lovely Zoom. Special thanks go to Devyn Tyler, Gabriella K. Johnson, Claire Ittner, Morgan Fletcher, Anneka Dunbar-Gronke, and Camille Bernier-Greene.

While teaching in Paris, I was also fortunate to be part of a curatorial team at Jazz at Lincoln Center, another birthplace of this project. Thanks to my beloved

teammates C. Daniel Dawson and Diedra Harris Kelley, and to Linda Florio and Emily Lordi. Thanks to Wynton Marsalis, Adrian Ellis, Simone Eccleston, Imani Owens, and Miles Davis (the photographer), and Darryl Sivad.

Much of the work here was first researched and presented as first drafts when I was a Cullman Fellow at the Forty-second Street Library in New York City (2008–2009). Thanks for the leadership at the Cullman of Jean Strouse, and for the many fruitful exchanges with Deborah Baker, Anna Bikont, Akeel Bilgrami, Deborah Cohen, Andrew Sean Greer, Daniel J. Kevles, Hari Kunzru, Julie Orringer, Lauren Redniss, Martha Saxton, Laura Secor, Lore Segal, Ezra Tawil, and Rosanna Warren. That year, I did valuable work at the Schomburg Center for the Study of Black Culture, and at the library of the Museum of Modern Art, particularly in the Papers of Calvin Tomkins. That year, I also benefited greatly from the support, via mail and email, of Kristine Krueger at the Margaret Herrick Library at the Academy of Motion Picture Arts and Sciences in Los Angeles.

I am thankful for the University of Guelph, which hosted me as a lecturer and seminar leader in August 2009. I presented first drafts of some of this material at that time. Thanks for the imaginative leadership of Ajay Heble, and for the comradeship of Eric Lewis and Tracy McMullen. Thanks also to Harvard University's Department of African and African American Studies, which hosted me as an Alain Locke Lecturer in 2015. Some of the material here crystallized as I prepared those Locke Lectures. Special thanks to Henry Louis Gates Jr., Werner Sollors, Glenda Carpio, and Daniel Aaron.

I'm so thankful to my home institution, Columbia University, for its endless support. Thanks to our president, Lee C. Bollinger, for inviting me to give the university lecture in 2008—my first attempt at "This Music Demanded Action." Thanks to my colleagues and students over thirty years in the Department of English and the Department of African and African Diasporic Studies, and especially to my colleagues and students in the Center for Jazz Studies. Particular thanks to Yulanda McKenzie. To the wonderful librarians at Columbia, many thanks—particularly to Jennifer Lee. I'm grateful for the support of my colleagues at Wallach Gallery, especially Deborah Cullen and Jennifer Mock. To the staff of the University Seminars at Columbia, I am endlessly grateful for the opportunity to deliver the Schoff Lectures at Columbia University in 2016, which formed the seedbed for this book. Special thanks to Robert Pollack, director of the University Seminars at Columbia.

I am grateful for my inspiring year (2018–2019) as a fellow at Columbia's Institute for Ideas & Imagination, in Paris. Warmest thanks to my colleagues there: Tash Aw, Susan Boynton, Tina Camp, Amit Chaudhuri, Jenny Davidson, Zosha Di Castri, Elsa Dorlin, Kaiama L. Glover, Xiaolu Guo, Nellie Hermann, Zaid Jabri, Deborah Levy, Mark Mazower, Emeka Ogboh, Hiie Saumaa, and Karen Van Dyck. For administrative leadership—and many acts of

kindness—thanks to Marie d'Origny, Eve Grinstead, and Grant Rosenberg, For their inspired leadership at Reid Hall (Columbia's Global Center/Paris), I am pleased to thank Paul Leclerk and Brunhilde Biebuyck.

Special thanks to other friends and colleagues in Paris, particularly John Betsch, Claire Burrus, Velma Bury, Claude Carriere, Yves Citton, Jean Pierre Criqui, Joel Dreyfuss, Wendy Johnson, Jake Lamar, Anne Legrand, Alexandre Pierrepont, Daniel Richard, Benjamin Sanz, and Daniel Soutif. Thanks in particular to the Cité Internationale des Arts, the loveliest of artists' residencies, and to its generous director general, Benedicte Alliot.

Thanks to major cultural institutions in my hometown of DC—to the Smithsonian, which trusted me to curate "Romare Bearden's Black Odyssey," another starting point for this project. And to the Library of Congress (LOC), where, as a fellow in 2018, I finally had time to examine certain documents (including the papers of Ralph Ellison) that are nowhere else. Thanks to these Washington superprofessionals: S. Marquette Foley, at the Smithsonian Institution Traveling Exhibition Service, and Larry Applebaum and Anne McLean at the Library of Congress. At the LOC, I was so happy looking through the scores of Duke Ellington and Billy Strayhorn, and—thanks to Katherine Blood—perusing rare photographs as well as collage pieces left behind by Romare Bearden.

Thanks for the staff at the Louis Armstrong House Archive for their tireless support. Special thanks for the generosity of Ricky Riccardi and Michael Cogswell. I also learned so much from my colleagues on the board of the Louis Armstrong Educational Foundation—particularly from George Avakian, Stanley Crouch, Dan Morgenstern, George Wein, and Jerome Chazen. For assistance at the Institute for Jazz Studies (Newark), I'm particularly grateful to Tad Hershorn. Endless thanks to the Duke Ellington Society (TDES) for researching the Ellington–Sam Shaw connection; in the TDES circle, Lynne Mueller, Noel Cohen, and Patti Hagan were especially helpful. Thanks to Randall Burkett for his always generous assistance at the African American Collections at Emory University. Thanks also to the librarians at the Hogan Jazz Archive at Tulane University, and particularly for the comradeship of Bruce Raeburn. On the New Orleans front, thanks to dear friends Kenneth Ferdinand, Kalaamu Ya Salaam, Jackie Harris, Keith Medley, Tom Dent, Michael White, Alan K. Colon, Lolis Elie, and Dr. Ken Mask.

I'm most thankful for the assistance, over and over again, of the Sam Shaw Foundation and Archive and the generous Sam Shaw family members, particularly Meta, Edie, and Melissa. Thanks also for the generosity of Shaw biographer Lorie Karnath.

This book would not have been possible without the professionalism and friendship of Romare Bearden's family and foundation. Special thanks for foundation leaders Diedra Harris-Kelley and Joanne Bryant-Reid. Thanks to Bearden documentary filmmaker Nelson Breen, who often shared knowledge

and rare outtakes from his *Bearden Plays Bearden*. Thanks also to Shana Leonard, representing Herman Leonard Photography.

Thanks to the staff of the National Jazz Museum in Harlem, and particularly to founding director Loren Schoenberg, for their assistance in tracking down materials and for many valuable conversations.

This book also had the benefit of editorial assistants: the brilliant Michael Collins and Livia Tenzer. For assistance with researching pictures and permissions, many thanks to Catherine Huff.

Finally, I can't thank enough Sylvie Fortin, my deeply beloved soulmate.

ANTAGONISTIC COOPERATION

INTRODUCTION

Without the presence of Negro American style, our jokes, tall tales, even our sports would be lacking in the sudden turns, shocks and swift changes of pace (all jazz-shaped) that serve to remind us that the world is ever unexplored, and that while a complete mastery of life is mere illusion, the real secret of the game is to make life swing.

—Ralph Ellison, "What America Would Be Like Without Blacks"

N ow's the time to swing to the tune of *antagonistic cooperation*, the uniting theme of this book: to relearn, as American citizens of the planet, to move responsibly in the same direction, even though at times we're at one another's throats. Now's the time, urgently, to learn from time-master altoist Charlie Parker, who could breathe sequences of ten or more notes per second, operating at the tempo of emergency,[1] with and against all comers (and who composed the bebop anthem "Now's the Time").[2] Because Americans are migrants from all over the world, with values and styles so varied we often seem not to be of the same species, our differences are built in, with clashes inevitable.[3] So when our social and political systems are not working—and most emphatically in our current predicament, where our systems are threatened by opportunistic outsiders as well as by cynical bogeymen from within—we must resharpen our readiness not only to improvise

with soul at high speed (again, *at the tempo of emergency*) but also to check and balance those systems while, as citizens, we also check and balance one another and ourselves. According to our formative national documents—and to the amendments and new laws improvised along the way[4]—we must check our checks and balances as, year by year, we also *balance our checks and check our balances*. Never faked out by pipe dreams of perfect accord (well, almost never—Americans love an easy fix), instead we wrangle our way toward sufficiently well tuned creative momentum and coordination—toward jazzlike group interplay and improvisation. Collaborating like varied instruments in ensemble work under pressure, the United States of Jazzocracy is what we are at our best.

Time to evaluate what we are and what we must do, moving forward, together. Let me be clear: I speak of antagonistic cooperation as a form of community building, of competition and coordination with a jazz player's spirit of love.

This book is not about governance and policy, however, but about the strength of the imagination, and specifically of jazz and jazzlike works of art to help all of us to dream of better ways and means of getting ourselves together and moving forward. To move as if we (not only we Americans now but the more-than-human global community) were members of the very same band, which of course we are. As church folk say: "It ain't but the one!"

The epitome of antagonistic cooperation, as we will see, is the jazz jam session, where, historically, Parker and his colleagues in jazz have operated in no-prisoners contests, reaching beyond technical skill or even rehearsed eloquence toward the achievement of something rarer, the sine qua non of jazz: a personal style. (Billie Holiday was not famous for the virtuosic range of her voice, but for its colors, textures, playfulness, and, above all, for her highly personal style of singing the truth as she'd lived it.) While since the 1930s, just-pretend jam sessions have been commercially staged, whether as "battles of the bands" or summit meetings of individual instrumental duelists—"locking horns" (sometimes merely wasting everybody's time, showing off) with another—in fact, the best, truest jam sessions are not public performances at all, but self-regulated after-hours workshops for musicians only: no room for squares. Such sessions, says Ralph Ellison—to whom we shall turn directly in a moment—have constituted the jazz artist's "true academy," wherein participants play *with and against*[5] (an important Ellisonian conjunction of prepositions) one another, as well as the received conventions of their instruments and the forms of the music itself—with and against "the realities of existence."[6] For Ellison, the jam session's rites of teaching through apprenticeship and antagonistic cooperation move beyond what he calls the "thou-shalt-nots" of the academy[7] toward a search for the new and for the self. Ellison's jazz lingo goes churchy as he adds that the jam session is where the jazz player finds not only his/her own "voice" and "sound" but also their very "soul."

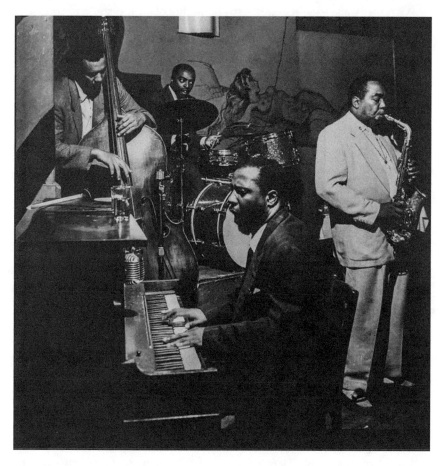

From left: Charles Mingus, Roy Haynes, Thelonious Monk, Charlie Parker.

Photo by Robert Parent (1953). Courtesy of the Robert Parent Estate.

What's just as important to me, and to this book's thesis, is that while the true jam session certainly does require such a body-and-soul wade in the water toward individual self-discovery and direction, it also can provide a dynamic setting where *all* participants' artistic capacities are quickened. Where all become careful listeners to what the others have to say, as each battler pushes self and opponent to higher and higher levels of articulation. These are "thinking by doing" seminars, whose participants, having mastered the material, give themselves to improvisation, in search of the fresh and new. Of course, there's always more "stuff" to master—more study of the history, theory, and structures of art; my point is that in a jam session, you employ every lesson in your artistic lesson book, realizing that rehearsing what's been played before, the "reading"—however perfect sounding—is never enough.

What the jam session requires is the liquid fire of on-the-spot assertion and rejoinder, serious play and interplay toward the achievement of a personal voice with something to say. Such conversations in music differ from the jazz artist's solitary 'shedding sessions—meetings in the woodshed with the self alone and with the ever-present monster whose full name is Practice Practice Practice. At its best, the jam session is a joint 'shedding session where one learns, among other things, to listen and to respond in ways that enhance the conversation for all. Here, one thinks of Socrates's preference for free-flowing improvised talkfests where, instead of even the best book merely staring back at the questioning reader with the same assertions that were there before, new arenas of thought may be pursued through intensely interrogative discussion. Brother Socrates engaged, in other words, in verbal jam sessions and—typically using the wry challenges of the interrogative mood (a form, in African Americanese, of "signifying")—was a master of antagonistic cooperation. Call his meetings at Plato's *Symposium* (from the ancient Greek word for "drinking party" or "feast") examples of old-school head-cut sessions where Parker-paced antagonistic cooperation ruled the day, and where everyone present (including today's readers of Western classics) benefit from the improvised exchange.

Along with the blues and the classic thirty-two-bar song form, the jam session has provided the key model for long- and short-form jazz compositions by Jelly Roll Morton, Duke Ellington, Mary Lou Williams, Miles Davis, Charles Mingus, John Coltrane, Vijay Iyer, and many others—works wherein the brasses shout and side-talk back and forth to the reeds, and where solo slots are prepared to maximize the sound of surprise expected when two tenors or two or more other instrumentalists square off, with and against one another and/or a larger ensemble. Here is the jazz player as representative artist and the jazz band as a model of democracy in action, to hoist a trope that has been in place since at least the 1940s—sometimes as an invidious propaganda flag that ignores the nasty fact that certain fascist leaders have been jazz fans!

Despite such perplexing evidence, I continue to insist on the jazz band as a model of democracy that admits and even welcomes difference. That's what I want to add to the jazz-as-democracy pronouncements, which too often smugly assert a status quo theory asserting a false sense of jazz history as a series of "great man" gestures that salute a society with power relations unchanged. I refer to jazz in the service of creating a world as beautiful as a Duke Ellington composition with its inlaid moments of antagonistic cooperation—tensions and releases swinging so hard that they can make the whole band want to stand up and dance while they play, and which invite their listeners to dance with them. For such antagonism in the service of cooperation is the sound and model of all-inclusive broadband democracy—democracy that is, as Ellison has reminded us, our nation's word for love.[8]

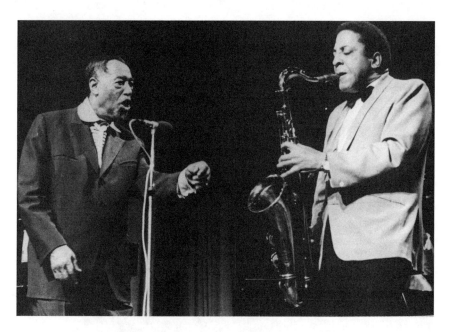

Duke Ellington and Harold Ashby performing "Afro-Eurasian Eclipse," ca. 1971. Duke Ellington (left) shouts encouragements/challenges to the soloing tenor saxophonist, Harold Ashby.

And so this is a book with jazz players at center stage, especially Louis Armstrong and Duke Ellington. But the trick of this book is also to bring writers, particularly Ralph Ellison and Toni Morrison, and visual artists, particularly Romare Bearden and Jean-Michel Basquiat, onto the jam session stage. This book will feature guest appearances by Mark Twain, Zora Neale Hurston, Billie Holiday, and Henry James as well. There's a jazz band for you! Each of these artists is a highly conscious jam-session player (think of Sister Zora on bari sax, Bro Henry on the "godbox"/organ!) who plays not only with those in his or her "section" (his or her own artistic form) but across the art forms. Morrison jams with musicians and visual artists; Ellison with Armstrong; Bearden with Homer and Earl Hines. "The French intellectual can take a theme and improvise on it so brilliantly," Bearden said in a letter to his gallerist. "We are amused, but there is a lack of structure and revelation. They should study some of the great jazz virtuosos like Charlie Parker and Earl Hines and learn how to do this."[9]

For as modern and contemporary artists seem to have been born knowing, the poet learns from the painter, the musician from the filmmaker, the dancer from the sculptor (Romare Bearden said that the best sculpture in the United States was created by dancers in Harlem's Savoy Ballroom). Try to read one of Morrison's novels without thinking of her love of music and painting, of the

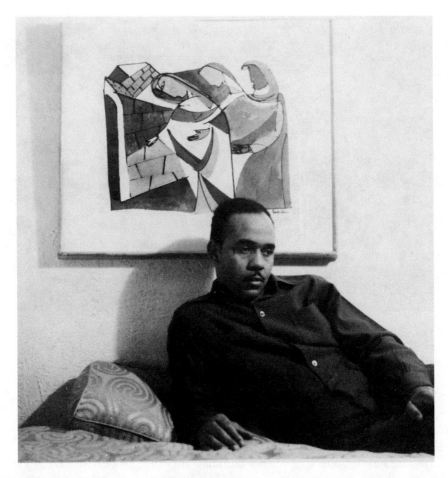

Ralph Ellison, in front of a painting by Romare Bearden, about whose work Ellison composed two important essays. New York (?), ca. 1964.

Library of Congress

collage in particular.[10] Try to say something comprehensive about the painter and collagist Bearden without mentioning his attempts to find visual equivalents of jazz and the blues, or his work throughout most of his career with writers and traditions of writing. Ignore at your peril the impact of photography and film on all these other forms. (For years Ralph Ellison experimented with photography, and, for one important project of the late 1940s, collaborated as a fellow photographer with Gordon Parks.) Forget "high" and "low" divisions, and consider gardeners, radio DJs, quiltmakers, birdwatchers, gamblers, preachers, sports players, pole dancers, cooks, crooks, tailors, street-corner trash talkers—anyone who does anything well[11]—as part of the artist's potential kith-kin-kit.

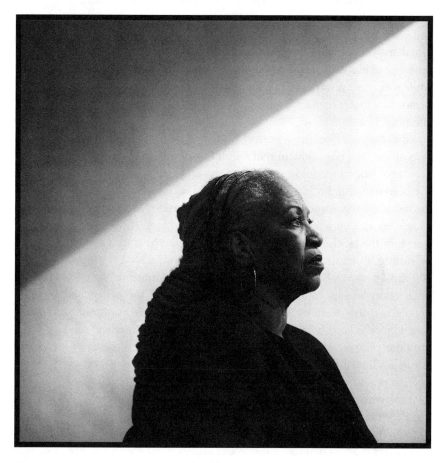

Toni Morrison, who in 2006 gave an important talk at Columbia University on the work of Romare Bearden.

Photo by Damon Winter/The New York Times/Redux

As candidates for emulation and for sometimes hot engagement through antagonistic cooperation. In my chapter on the movie *Paris Blues* (1961), for instance, I make the point that Duke Ellington—who provided the soundtrack but doesn't appear on-screen—found himself substantially at odds with the film's script, the novel it's based on, and its moving images. Out of the turbulent mix comes a score that transcends all these other parts: antagonistic cooperation.

I'm writing about a jam session where all the arts draw together and recover their ancient associations; where the borders between art forms prove porous—Morrison says they actually are "liquid."[12] A polygeneric jam session where insights by James and Twain, whose *Huckleberry Finn* was born as the blues was

crystallizing as a musical form, help us understand blues and jazz music better. And where the artists' readiness for antagonistic cooperation—for the pushes and pulls of artistic influence across the categories of music, literature, and visual art—may extend their work's capacities for meaning. And, finally, where the sense of mutually inspiring community, not without rancor, reminds us that while we cannot always agree, even on basic matters, we can continue to build a democracy that is living, breathing, and, while the music and other arts are still jamming, just might last.

Rereading my book now, sizing up the members of its jazz band, I realize it is significantly a reintroduction of Ralph Ellison and Louis Armstrong, masters of antagonistic cooperation and of the ways and means for community building I've been defining. Both artists fell out of step with the Black Arts Movement of the 1960s and 1970s, and to an extent have remained so: Armstrong for appearing in movies and on television in wide-smiling, handkerchief-waving roles that won him the label of Uncle Tom, a hated moniker that he never could shake off during his lifetime; and Ellison as the man in the Ivy League suit who was still talking about Negro American culture as definitive of American culture while many leading younger writers were speaking of the Africanness of Black people and the death of America as a viable inclusive community. In what might be called our turnstile culture—only one Black writer and one jazz artist at a time, please, and perhaps one painter or opera singer—these two have been left behind, pushed, Ellison might say, out of the groove of history that they once so prominently commanded.

Antagonistic Cooperation aims to welcome them back as profoundly significant cultural guides. Armstrong performs, in fact, in every chapter. My main point is that, in spite of lapses—like his appearance in *Rhapsody in Black and Blue* (1932) in an animal suit, singing an anti-Black song with minstrel pop-eyes shining—he was a musical pathfinder whose legacies, as both instrumentalist and singer ("It was," Stanley Crouch has said, "as if Beethoven had stood up from the piano to sing")[13] have yet to be fully charted. My further contention is that in his extramusical life, even when he wore blackface paint as King of the Zulus for Mardi Gras in New Orleans, he made very deeply affirmative (although almost universally misunderstood outside the Crescent City) political statements. And when the shit really hit the fan (an underused academic term), during the confrontation between Dwight Eisenhower and the high school students attempting to integrate Central High School in Little Rock, Arkansas, Armstrong's public stance helped turn that era around—as we see in chapter 4. If the famously genial Armstrong was mad as hell over Little Rock, it clearly was time for big-time national change.

This book also argues that it's time to reengage with the work of Ralph Ellison (1914–1994), whose novel *Invisible Man* (1952) reigned for more than half a century as the only book by an African American writer that every educated

person, not only in the United States but worldwide, was obligated, typically through school assignment, to read. (In France, where I taught in 1984–1985, the novel was required reading for every graduate student in American literature.) Barack Obama has said that he rereads *Invisible Man* every year, to stay on course.[14] It's fair to call it the single volume with which Toni Morrison wrestled most vigorously and most productively, in her fiction and essays—asserting, again and again, that Black people were *not* invisible to one another, and that the address of her books, unlike *Invisible Man* as she read it, would indicate a "universality" that began with their Black characters and with Black readers. Here's antagonistic cooperation for you: her sometimes pointed engagements with aspects of Ellison's aesthetic enabled her own.

But even in our present era, when undergraduates do not typically read *Invisible Man*, the novel stands. It's been absorbed by our culture, whether we know it or not: "For if there is an American fiction it is this," wrote one early commentator on the novel, "the adventures likely to befall a centerless individual en route through the flow and conflict of illusions toward some still undisclosed center."[15] And, of course, its study of racism in the United States is sadly as pertinent today as in 1952. Some scholars have seen in *Invisible Man* not only a comprehensive summarizing aspect, particularly of the first half of twentieth-century American history, but also an uncannily anticipatory power: its young Black hero's mix of idealism and alienation, his escapes into music, marijuana, and gadgetry; his rise to national leadership; the book's study of police brutality and urban rebellion; its assertions of the power of Black culture to offer direction to the nation; its exploration of the relation of the "Woman Question" to the African American freedom struggle; its monstrous establishmentarians, white and Black, along the hallways of education, business, and politics; and its equally lethal Harlem-based street "saviors" like Ras and Rinehart—all seem to belong to an era *after* the one in which the novel first appeared. Of late, the metaphor of invisibility has been seized by politicians and artists alike to describe being unseen by powerful elites. This problem of invisibility has been especially productive in the visual arts. Yet, few realize that they owe that trope to Ellison who, nearly seventy years ago, dedicated his big first novel to it.

Among the protagonist's many lessons on invisibility is the confounding one that maximizing his place in the world can mean embracing invisibility, operating in the dark. He moves from the easy game of disappearance through disguise to the big-game strategy of "going underground" (going into what Stefano Harney and Fred Moten term the "undercommons,"[16] where potential collaborators in revolution move) to prepare his next steps in the overground world. Unseen, Invisible Man can "make poetry out of being invisible,"[17] as he realizes Louis Armstrong has done; can stand ready, calculating his next actions for when the time comes. What are those next moves? Well, first of all, an artist's job is not to make public policy or to solve social problems as such.

The artist's job is to engage readers in a dynamic conversation that holds our attention—to delight our eye and other senses while they tell the truth about the planet they know best (or about their postage stamp village there). To turn on the lights, to blow back the covers so the rest of us can see, and thus have a better chance of knowing what action is demanded. So we can study and plan whether it's time to cancel a subscription, write to Congress, run for mayor, or take to the streets. To get ready.

But there's another reason I return to this writer again and again: it's Ellison-the-trumpet-player-and-photographer-turned-novelist's emphasis on Black music and visual art as guides to surveying the American scene and getting ready. "Which comes first for you in writing, hearing or seeing?" one interviewer asked Ellison. "I might conceive of a thing aurally," the writer replied, "but to realize it, you have to make it vivid. The two things must operate together. What is the old phrase—'the planned dislocation of the senses?' That is the condition of fiction, I think. Here is where sound becomes sight and sight becomes sound, and where sign becomes symbol and symbol becomes sign."[18] Along with Morrison, Ellison is this book's major theorist on the uses of form and technique among the art forms, as well as on the influence of one art form upon another.

The term "antagonistic cooperation" comes from Ellison, who employed it in his blue-flame exchange of published letters with Irving Howe, which the novelist felt brought out the sharpest intellectual fire from both combatants.[19] Jam-session style, each forced the other to play above his usual game. In the same spirit, Ellison called out Stanley Edgar Hyman, "an old friend and intellectual sparring partner"[20]—one of his terms of highest endearment—with whom he also exchanged a scorching set of public letters on the uses of folklore and myth in *Invisible Man*. In both these battles conducted through public letters, Ellison's charge is racism. Howe's placing him as a direct (and failed) offspring of Richard Wright's "clenched-fist" militant writing, without realizing the range of the younger writer's artistic ancestry, is as appallingly ominous, Ellison says, as segregation in Mississippi! As for Hyman's tracing Ellison's invisible character to the Br'er Rabbit tricksterism of Black folklore, Ellison bristles: "I knew the trickster Ulysses just as early as I knew the wily rabbit of Negro American lore, and I could easily imagine myself a pint-sized Ulysses but hardly a rabbit, no matter how human and resourceful or Negro."[21] Ouch!

A varsity football player at Frederick Douglass High School in his native Oklahoma City, and then a lifelong sports fan, Ellison often saw himself not only as a musician in training but also as an athletic competitor in the tradition of the great Black heavyweight boxers, both contemporary and from the near past. In a letter to his friend and literary sparring partner Albert Murray, Ellison compared his own role as a writer facing critics to that of the cagey civil

rights lawyers of the early 1950s, and also to the boxers they both admired.[22] A character whom Ellison cameos in his later novel *Juneteenth* resembles in some respects his real-life friend Murray, but also serves as a mirror of Ellison's own combination of erudition and Black-style athleticism, a feature of his inner antagonistic cooperation, formal Ellison versus kickass Ralph. "That little Negro Murray" is an itinerant Black preacher

> who had been to a seminary up North and could preach the pure Greek and the original He-brew and could still make all our uneducated folks swing along with him? Yeah, and who used to sit there in his chair bent forward like a boxer waiting for the bell, with his fists doubled up and his arms on his knees. Then when it came his turn to preach, he'd shoot forward like he was going to leap right out there into the congregation and start giving the Devil some upper-cuts.[23]

The two sides of this Murray (and Ellison)—the deep book learning and the ability to deliver dead-on uppercuts—are personified by two characters in Ellison's canon's most famous boxing scene. The protagonist of *Invisible Man*, tripping on marijuana while listening over and over to Louis Armstrong's recording of "(What Did I Do to Be So) Black and Blue," recalls seeing an "amazingly scientific" fighter in the ring with a "yokel." In Ellison, you can place your bets on such self-taught countrymen and women, particularly when an opponent smells of science untested by lived experience.[24] In his short story of 1963, called "It Always Breaks Out," Ellison satirizes his character Vannec's "passion-ate need to define all phenomena—whether social, political or cultural—and codify them and reduce them to formulae—intricate ones—that can be dis-played in the hard sparkling center of a crystal paperweight."[25]

No surprise that *Invisible Man*'s prize-fight yokel watches for his moment and then suddenly, with one blow, knocks "science, speed, and fancy footwork as cold as a well digger's posterior. The smart money hit the canvas, the long-shot got the nod. The yokel had simply stepped inside of his opponent's sense of time."[26] That is what Invisible Man hears in Armstrong's black and blue music: the ability to swing beyond the artificial accuracies of metronomic time. Something that Greek and "He-brew" book learning alone couldn't offer, but that the encyclopedically well read (and well traveled through the art territories beyond the scope of literature) Ellison wanted for himself. My point is that instead of siding with either "science" or "the yokel," Ellison championed both contestants in this battle: a science-buff thinker-tinkerer as much as a proponent of American vernacular culture and its makers, Ellison leaned toward the yokel but cheered, above all, for the battle itself—the rigors of antagonistic cooperation.

Ellison's hard-hitting, jam-session aesthetic sets the stage for my book's examinations of ideas of self and community that come to light through antagonistic cooperation.[27] This is why Édouard Glissant and Fred Moten make multiple appearances in this book. Both poet-theorists use jazz to posit a multiplied sense of self/selves—*with-ing and against-ing* one another, as it were, *checking, balancing.* Both use jazz as Ellison did, to discuss the jazz band as a model democratic community, selves on the road who refuse to settle and who really do hear one another. And with Moten, I often look to Duke Ellington: his heroism in this volume derives from my lifelong love of his music, as well as from Moten's celebration of certain jazz composers—especially Ellington—as always cocomposers, working with and against instrumentalists and singers as much as with audiences that at their best include dancers, all of them part and parcel of a dynamic coproduction of great creative momentum. Self, selves.[28]

"Okay guys," Ellington said to the band in rehearsal. "Don't make that too pretty. Keep some dirt in there! . . . I want that *feel.* . . . 'Shorty' [referring to one his trumpet players, Harold "Shorty" Baker], you sit with the 'bones and get out your tuba. I want you to stick a hat in that bell."[29] He wanted a darker, slightly muffled playing of the notes, not so "pretty" that you lost the beauty of imperfection, the musicality.

As for the term itself, *antagonistic cooperation*, it's important to note that Albert Murray, more than Ellison, used the phrase repeatedly in his essays and interviews. While Ellison used it in print before Murray, the term may have come up during one of their frequent exchanges, in person or in correspondence.[30] Or it may have arisen when each tested new fiction against the other in out-loud reading sessions at each other's Harlem apartments during the late 1940s to 1960s. Murray says he learned the term from Heinrich Zimmer's *The King and the Corpse* (1948), where the dragon of heroic folktales functions to bring out the best in the hero. "This is the manner of the dragon's 'antagonistic cooperation.' . . . Cooperating with the beneficent forces, though antagonistically, those of evil thus assist in the weaving of the tapestry of life; hence the experience of evil, and to some extent this experience alone, produces maturity."[31] It is also possible that both Ellison and Murray (and, for that matter, Zimmer and his editor, Joseph Campbell) first encountered the term in William Graham Sumner's *Folkways: A Study of Mores, Manners, Customs and Morals*, a standard textbook of the early twentieth century that Ellison and Murray may have been assigned at Tuskegee Institute (now University) in the 1930s.[32]

In the context of this book (and of Ellison's and Murray's works as my guides), just as important as Zimmer and Campbell's take on dragon and hero as collaborators is Sumner's extended discussion of "antagonistic cooperation" as one of the most admirable and productive "folkways" across human groups. It was also a practice, Sumner observes, among many other animals of the

planet. "It would be an error," he writes, "to suppose that all nature is a chaos of warfare and competition." He continues,

> Combination and coöperation are so fundamentally necessary that even very low life forms are found in symbiosis for mutual dependence and assistance. . . . *This combination has been well called antagonistic coöperation.* It consists in the combination of two persons or groups to satisfy a great common interest while minor antagonisms of interest which exist between them are suppressed. . . . *Antagonistic coöperation is the most productive form of combination in high civilization.* It is a high action of the reason to overlook lesser antagonisms in order to work together for great interests.[33]

Today, new artists and scientists—particularly when they address issues of global warming and the delicately balanced ecosystems upon which life itself depends—often bring flora and fauna, air, land, and water into this conversation.

And so this book is about artistic kinship and influence, the pushes and shoves that can go with one artist engaging another. Chapter 1, "This Music Demanded Action: Ellison, Armstrong, and the Imperatives of Jazz," makes the case for this mode of antagonistic cooperation, as well as for its flip side, the "ecstasy of influence," young artists' modeling of themselves on the examples of others. The chapter also asserts that while all art is in some sense political, "this music" (jazz) is propelled by a sometimes unseen, but very strongly insistent political imperative. But how is blowing a jazz horn or writing even the most jazz-inflected words on a page *political*? Chapter 2, "We Are All a Collage: Armstrong's Operatic Blues, Bearden's Black Odyssey, and Morrison's *Jazz*," extends the previous chapter's answer to this political question. It takes its title from an essay by the early modern philosopher Michel de Montaigne, who declares that every person is a collection of "lopins" (patches) or a patchwork quilt–like mix of elements and attitudes, some of them contradicting one another, but nonetheless part of the profile of the *Homo erectus*.[34] I roll out Montaigne's metaphor to include our globe as a collage of very different (then again not so different) human parts and pieces, inspired also by Bearden. I also wonder about Toni Morrison, who insists on assembling pieces of memory into parts of an artistic whole as the essence of the creative process,[35] as a collage-making novelist, and one who uses collage (rather than the melting pot, which implies that cultural differences are dissolved away) as a metaphor for mutual cooperation in the United States and beyond.

Chapter 3, titled "The 'Open Corner' of Black Community and Creativity: From Romare Bearden to Duke Ellington and Toni Morrison," defines Bearden's artistic strategy of leaving a portion of a given work "open," blank, unfinished (or seemingly so), as an invitation for the viewer to participate in the process

of making art. Here, I consider such strategies of omission or understatement in literature and in music—"the alchemic unpredictability in that space of the unplayed"[36]—as well as in Bearden's art. I focus on certain public speech-making practices perfected by Mark Twain, whose memorized manuscripts showed open corners where he planned to improvise solos that gave his audience a sense that the whole thing was made up on the spot. Along with this question of artistic appeal through strategic omission, "Open Corner" highlights actual physical spaces through which we move, where a sense of unfinishedness can be refreshing—can offer room to move and grow. The great cities of the world, large and small, have a fresh-air work-in-progress aspect: "open corner" spaces where the refusal or inability to develop a complete plan presents a sense of adventure, free play, open-ended hospitality. What can city planners learn, on this score, from Morrison and Ellington (as well as Billie Holiday and Thelonious Monk)—masters of the open corner?

The final two chapters have taken years to write and could be a book each (later!). Chapter 4, "Hare and Bear: The Racial Profiles of Satchmo's Smile," culminates a long history of thinking about the place of humor in American society, and, more generally, in human lives. Louis Armstrong's controversial humor is closely studied here—particularly his decision to put on a grass skirt and face paint to parade the streets of New Orleans as King of the Zulu Social Aid and Pleasure Club, in 1949. Bearden and Basquiat wrestle with Satchmo's Zulu image in their collages and painting, and they support my thesis that in the end, Armstrong's comic performance as Zulu King, potentially viewed as demeaning, had a profound meaning for the working-class Black community of New Orleans, and, in a sense, for all of us. Do we not need to smile sometimes? Even in the face of oppression, of threatening violence?

Here's a joke that Ellison once told me in private: "If the white man is laughing at us," he said, "at least he's not shooting at us!" It's true that alongside this book's theorizing of jazz-cadenced democratic nation-building, "not shooting at us" (and our not having to load up to shoot back), even framed as a joke, will seem a very low bar to scale. But when we consider the violence of our nation's culture and history, not gunning one another down would be a good place to start: relative peace, as all together, we create a truly United States of America. And is Ellison not correct that in the United States, humor has been a binding force, an "agency" he calls it, helping us to hang together despite our unending differences—even when it hurts?

The check-and-balancing act here is to be sure that the Black butts of race jokes can turn the tables and laugh back at the rhiney butts of their enemies. Then, Ellison says, maybe the actual shooting can stop, and we can all have a laugh together—difficult as this is to imagine during our current foul season of racialized police lawlessness and murder, and those who condone it behind the cover-up banner of "law and order." Is Ellison being too Pollyannaish here? Am I?

Chapter 5, "The White Trombone and the Unruly Black Cosmopolitan Trumpet, or How *Paris Blues* Came to Be Unfinished," the concluding chapter, summarizes the message: Here's antagonistic cooperation in full effect! It is an attempt to capture the drama of the first stirrings of the movie *Paris Blues*, released by United Artists in 1961, which began as the photographer-filmmaker Sam Shaw's dream of a film about the months his friend and studio-mate Romare Bearden spent in Paris. Along the way, the project produced a novel and then numerous scripts before it became all too clear that Hollywood was not prepared to make a movie about a Black artist living freely in the midcentury City of Light. Nor was it prepared for a movie about "mixed" (Black and white) couples, gay couples, adult sexuality of any sort, or, to be sure, about Algerians in France or the Black Freedom Movement in the States—all subjects that the novel included (or at least hinted at). Instead, what we have is a not-uninteresting Black-white "buddy" movie starring Paul Newman and Sidney Poitier, cast not as painters but as jazz musicians who fall in love, not as "mixed couples" (whether by race or gender) but according to the codes of that era: Newman with Joanne Woodward (not, as originally considered, Diahann Carroll); Poitier with Carroll. As I tell that film's little-known history, I focus on the roles played by Louis Armstrong, who appears in significant cameos, and by Duke Ellington, who, with Billy Strayhorn, contributed the best thing about the project: its score.

This chapter's definition of "unruly Black cosmopolitanism," at odds forever with the racist (and otherwise prejudicial) motives that dumbed down Shaw's original intentions almost to nothing, nearly took over this entire book. Meanwhile, here's an "open corner" offer—a preview or vamp, in anticipation: What do you think is needed to counter the petty but persistent powers of American white racism? The movie was so disappointing to Shaw and Bearden that twenty years later, they teamed up with their buddy, the novelist Albert Murray, to do their own *Paris Blues* collaged picture-and-text book—which I survey here in the coda to the book.

My title *Antagonist Cooperation* also applies to my own engagements—often my sword's-point disagreements—with the writers and other artists whose works I treat here, including of course Mr. Ellison. Some of my struggles with him are generational—and involve prevalent habits of mind in our quite different eras that can lead to misreadings on both sides. I came of age in the 1960s, during the Black Arts Movement and the Black Studies Movement, both of which he held suspect. He saw Malcolm X as a dangerous, barbershop-style "exhorter"[37] who protested the Black community's unending problems by "barking at the big gate," with no practical plan for action. He waved away Black Arts Movement writers as frauds and complainers who did not produce work of value.[38] If he were writing today, perhaps Ellison's choices of pronouns would not be so unreflectively male. Perhaps he would have graduated beyond some

of the homophobic shorthand that stains his letters.[39] Maybe he would have listened again to "poor evil lost little Miles,"[40] to Coltrane, and to the post–swing era players like Bird, Mingus, and beyond that stirred the jazz scene of the decades following his years of dancing at the Savoy Ballroom. Ellison tended to dismiss "pretentious" jazz musicians who did not play for dancers, preferring Ray Charles, for example, to Ornette Coleman,[41] underestimating jazz women and men carving out the music's shapes of things to come. And still, with these blind spots duly noted, I nonetheless defend Ellison as the best of his generation on the music (best, along with Amiri Baraka—whom Ellison reviled, saying his sociologically weighted prose on the blues would "give even the blues the blues"—of his century), and also indispensable for those charting the new music scenes he did not care for.

Obviously, the *politics* of art is crucial to my book's project, too. Ellison came of age in the 1930s, the son of an activist, Socialist Party mother and then, in his twenties, a fellow traveler of the Communist Party (CP), with close friends Langston Hughes and Richard Wright.[42] That *Invisible Man* uses a lookalike of the CP as its example of the betrayal of the Black community by organized politics, of a god that failed (as many of his generation, including Wright, said), did not mean that Ellison ever gave up his commitment to art as an instrument of progressive political action. Along with his fiction, his letters and records of his own political affiliations and activities to the end of his life make that clear. Despite his buttoned-down Andover Shop appearance, on certain levels Ellison remained the man who wrote to Wright in praise of his radical history of Black America, *Twelve Million Black Voices* (1941):

It is this which makes us brothers [wrote Ellison]. . . . This past which filters through your book has always been tender and alive and aching within us. We are the ones who had no comforting amnesia of childhood, and for whom the trauma of passing from the country to the city of destruction brought no anesthesia of unconsciousness, but left our nerves peeled and quivering. We are not the numbed, but the seething. God! It makes you want to write and write and write, or murder.[43]

James Baldwin, who loved *Invisible Man* and never published a word of criticism against its author, called Ellison "the angriest man I ever met in my life."[44]

Ellison's political biases mirrored the American national project, decidedly not the Black nationalist one, in any of its mid-to-late-twentieth-century political and aesthetic forms and formats.[45] This, too, is a matter of generational predilection. Arguably, the modern American nation was formed between the world wars of the twentieth century—and Ellison was immersed in that era's debates about what the new nation now stood for, its best and worst features. Ellison was also part of the long twentieth century's Black Freedom movement,

at a point when many Black intellectuals were trumpeting the "gifts of Black Folk" while U.S. educational systems denied that peoples of African descent had any history at all.

"What Would America Be Like Without Blacks?" the title of an Ellison essay asks. Answer: utterly without the most attractive aspects of its culture and without the most potent traditions of what it means to be a responsible, "unillusioned"[46] (in Ellison's lingo) citizen. A nation with no soul. Ellison's formulas about American culture and citizenship still apply—particularly his oft-repeated point that our shared Black-white American culture should lead to higher shared consciousness and then (politics again) *conscientiousness.*[47] Henry Louis Gates Jr. is so right that Ellison's claim for Black people's influence on America "was perhaps the most breathtaking act of cultural chutzpah this land had witnessed since Columbus blithely claimed it all for Isabella."[48] I can dig all this while my biases tend to be toward a sense of *planetary* citizenship, of what I call in chapter 5 "unruly Black cosmopolitanism" stretching beyond national, and other, borders.

And so, this is a book boomeranged in the direction of Donald Trump and his followers, who seem to regard him as the One for Whom You Must Drop Everything—drop values of decency and responsible international intersectionality, drop anything and everything that blocks the way to the foul, nostalgic dream of an all-white American nation of high walls and fast guns turned against all others, particularly the black and brown. God bless white America, and nobody else: here's Trumpism, the hollow patriotism against which Baldwin flung the wonderful term "flatulent,"[49] a nationalism against which this volume is most antagonistic.

But as I hurl this book at Trump, it is also important to me that I embrace his followers, including his like- and lackey-minded right-wing brethren and sisteren (mine too!) worldwide. In the end, for the sake of the planet, we must set aside enough of our differences to run together toward goals that transcend borders of nation and village, as well as of wind and water, soil and fire. No conscientious discussion in these terms can forget that every person left out of true efforts to cooperate in spite of antagonisms—everyone, without exception, left in the water or behind a wall, or double-knotted in red tape waiting to reunite with family held back or imprisoned or pushed aside; everyone shut out by these cruel acts—diminishes everybody else. Radical inclusiveness—seeing the so-called other as oneself, each of us as a patch on the crazy quilt that is our planetary community—that's what this book is all about. Today's evening news is the nightmare that brings responsibility, a call to *antagonistic cooperation.*

The antagonistic cooperation that means most to me has to do with this will to move together, even with strangers, even with trouble in the air. Like the blues that says, "I'm in love with a woman who is not in love with me," or even "I hear my baby call me by another man's name; I know she don't mean me but

I answer just the same," we continue in spite of everything. (At times we get lucky and dance off with better acting partners.) I want to draw a line from this rugged-but-optimistic aspect of the blues aesthetic, and its first cousin the jam session, to the realms of other art forms and of the world of capital-P Politics. For if we cannot learn to jam and dance together, even when our partner strikes us as out of step or awkward, we all suffer, holding up the walls. Put it this Ellisonian way: If we cannot live with the music of the antagonistic cooperation blues, *we die of noise.*

THIS MUSIC DEMANDED ACTION

Ellison, Armstrong, and the Imperatives of Jazz

We write from aspiration and antagonism, as well as from experience.
—Ralph Waldo Emerson

When Ralph can't find the words at the typewriter, he goes upstairs and plays his trumpet.
—Fanny McConnell Ellison

This music demands action, that's good! Or is it: the music enables action.
—George Lewis

For our general sense of the meaning and powers of antagonistic cooperation, in this opening chapter and throughout this book, we turn to Ralph Ellison.[1] He was not only the creator of *Invisible Man* (1952), with its orchestration of the metaphor of invisibility revealing Americans' inability to perceive one another or themselves; in a lifetime of writing essays and fiction, before and after that novel's publication, he also has proved to be one of the two or three most important American cultural theorists of the twentieth century. In our current moment of intense division in the United States—in what may be called our continuing Civil War (with the fundamental issue of Black citizenship still unresolved)—we need Ellison's clear, strong voice, ringing, as he liked to say of favorite characters,

with the power of the blues. We need his sense of the jazz orchestra at its best, where wide variations in individual players' styles and tones are taken for granted as part of musical wholes, presenting a homegrown model for moving forward as a deep-funk, blues-beset nation. "This familiar music," he wrote, "demanded action."[2]

This music's most radical demand—let us cut immediately to the chase of this chapter and of this book—is that we learn to listen to one another (that we hear with what jazz musicians call "great big ears") as well as to ourselves; that we learn, again, to hear even the most razor-edged, dissonant solo improvisations in our national band not only as part of the mix that we must by law tolerate, but as having a John Coltrane–like potential to urge all of us to hear harmonies, melodies, and rhythms where, upon first hearing, we heard only noise. (To hear, for example, "Black Lives Matter" and "No Justice, No Peace" as today's American national anthems.) Let us give up recoiling from failure to reach the impossible (and deadly dull) dream of perfect accord in favor of an American union where we push and pull with and against one another to make music that can sustain us for centuries to come—the music, by the way, that used to make the rest of the world want to get up and dance. (Still does.)

Of all the terms that Ellison drew from his friend and literary sparring partner Kenneth Burke, the idea of "literature as equipment for living" may be the most enduringly profound and useful.[3] Here, the main point is that literature and the arts provide exquisitely precise (and then again, James Brown–raucous) definitions of who we are as human beings, and what we *need*—not just what we want as pastimes or decorations, not just as means of surviving the doldrums of daily living, but what we need as toolkits for becoming our best possible selves and world-responsible citizens. This Burkean maxim serves as a corollary to that other touchstone Burkeism, "literature as symbolic action"—that art not only is, art *does*.[4] Together, these rich terms assert that art spurs readers to take political stances, and, more mysteriously, that the writing and reading of literature are themselves forthright acts in the reeling world of real-time politics. Here, I am testing these cousin ideas—art as equipment for living, art as a staging ground for forthright action—with case studies of jazz and of Ellison himself. Not only was he a writer who started as a musician who aspired to be a composer, but he also wrote, again and again, of jazz as "part of a total culture . . . at least among Afro-Americans,"[5] and as a model for democratic living.

A key entry point into Ellison's theory of art and action is the prologue to his novel *Invisible Man*, one of his most suggestive statements about the meaning of modern cultural expression. It is here that the narrator—invisible because racist whites refuse to see him, but also because he can't figure out who he is or what to do with himself—is prompted by Louis Armstrong's riveting recording of "(What Did I Do to Be So) Black and Blue" to declare *"this familiar music had demanded action."*[6] But what kind of action does the music demand?

What equipment for living is encoded within it? And what might we, as readers, take to be our own jazz-tempered responses, whether to racism or to the demands of living? Might our attention to these aesthetic/political matters help us read the music differently and hear the Afro-drum trumpeting of Ellison's sentences with something of the jazz player's ear? Might such knowledge help us as readers/listeners to know what we must do to get ourselves together and to wage an effective fight against bigotry the world over?

Jazz, perhaps the deepest bedrock in Ellison's writing, both is and demands aesthetic action that is inherently political. Ellison's message is that artistic practices at their best are never merely detached and contemplative but actively political; they're not just metaphysical but *physical*—bodies at the ready, in the way, on the line. Surely that is why Ellison chose an unambiguously political/ philosophical song, not an instruments-only jazz performance, but one with words (what James Baldwin calls language art's "disastrously explicit medium"[7]), to cornerstone his big novel. Armstrong's first studio recording of "Black and Blue" (1929) makes its way "from grief to grievance . . . to slave narrative"[8] as it demands to know what makes every one of us (not only Black Americans) feel so black-and-blue with bruises, so violently beaten up, that is, not just by racial violence but also by the general condition of being human. What action can we take to see and hear one another and ourselves more clearly and generously, and to do what we must do, as we try to draw ourselves together as individuals and as an inevitably blues-tormented but nonetheless deliciously many-hued human family?

We can approach this problem of jazz, art, and action through the experience of the Yale law professor Charles L. Black, Jr., one of the heroic lawyers in the landmark *Brown v. Board of Education* case of 1954. Black, a white Southerner, heard in Louis Armstrong's music a demand for action. Here's Black, writing about hearing the trumpet player for the first time:

> Louis was thirty-one when I first heard him, at the height of his creativity. . . . All through these years, he was letting flow, from that inner space of music, things that had never before existed. He was the first genius I had ever seen. That may be a structural part of the process that led me to the Brown case. The moment of first being, and knowing oneself to be, in the presence of genius, is a solemn moment; it is perhaps the moment of final and indelible perception of . . . utter transcendence. . . . It is impossible to overstate the significance of a sixteen-year-old Southern [white] boy's seeing genius, for the first time, in [the presence of] a black [man]. . . . You don't get over that. You stay young a while longer. . . . But you don't forget.[9]

With this sense of the never-the-same-again transformative power of this music, no wonder Professor Black hosted listening sessions for law students at

Columbia and then at Yale. For over twenty-five years, he organized evenings specifically to listen to Armstrong's music and to offer, as he put it, "ritual[s] of gratitude and blessing for the soul of this man."[10] Put bluntly, these sessions asked, does the man making this much fiercely beautiful music belong to an inferior "race"? Since obviously he does not, in a nation that routinely treats men and women who look like the trumpeter/singer as inferiors, what action must we as women and men of law take to help set things right? What acts of justice and reparation can we help orchestrate? Black heard Armstrong's trumpet say, "I leave it up to you."[11] This music *bore witness*—to use a phrase often adopted by James Baldwin and Toni Morrison to express the function of art and the primary responsibility the human being has to others. The music demanded action.

"A Coupla Scalped Indians"

Ellison suggests another aspect of Black music demanding action in one of his little-known short stories, "A Coupla Scalped Indians," a potent offshoot of *Invisible Man* published four years after that novel, in 1956.[12]

Before exploring this complex story, let's go to the Ellison Archive at the Library of Congress.[13] There one sees, in the typed pages of the work in progress, evidence of the music demanding the mundane but nonnegotiable action of *practice*. How many drafts of "Coupla Scalped" there are! In the story's file folder, one is privy to a writer's version of what jazz musicians call "woodshedding": going to work on fundamentals, usually by oneself (in another twist of vernacular meaning, "woodshedding" implies discipline, usually involving being taken aside forcibly for physical discipline).[14] As "Coupla Scalped" and other manuscripts show, Ellison often started his writing day by typing a favorite passage from Ernest Hemingway, like a musician 'shedding through the cycle of keys, playing sustained long tones or working through an etude before digging into a new piece. As Ellison, who was also experimenting with photography while he was working on *Invisible Man*,[15] would have known, photographers in training often employ a similar practice by looking at a great photograph through their own camera's viewfinder. Ellison, a former musician, once put the requirement of practice in these words: "It takes much more than a broken heart to play the blues."[16] Elsewhere, on the subject of Black writers expressing Black life: "Even homeboys must do homework!"[17] As a Hemingway man (though, as we shall see, not unreservedly so), Ellison was practicing the art of 'shedding inexact and unnecessary words. And like the protagonist of *Invisible Man* (whose trip underground at novel's end may be regarded as a decision to disappear for a while so he can 'shed), he was learning that while 'shedding excess verbal baggage and overcoming

technical difficulties, the writer could also shed the skins and shells of former selves, along with formerly blinding illusions.

On one of the many draft pages of "Coupla Scalped," Ellison handwrote the Burkeism "Passion-Perception-Purpose."[18] With this trinity of words—to which Ellison frequently refers in his essays on fiction—he reminded himself of the resolution to direct himself, as well as his characters and readers, toward a conscious and resolute purpose: toward consciousness and conscience, toward readiness, toward substantive *action*.

Throughout the story, one hears Ellison the former trumpet player at work/play. The boys at the center of "A Coupla Scalped Indians" speak a language full of music. As one of them recalls old Aunt Mackie, one of Ellison's sphinxlike trickster-women of the blues tradition,[19] he chants in a "trombone voice." It's as if he were trying to drum up and then ward off Mackie's ambiguous powers with his jazz-'bone song:

> Old Aunt Mackie, wizen-faced walker-with-a-stick, shrill-voiced ranter in the night, round-eyed malicious one, given to dramatic trances and fiery flights of rage; Aunt Mackie, preacher of wild sermons on the busy streets of the town, hot-voiced chaser of children, snuff-dipper, visionary; wearer of greasy head-rags, wrinkled gingham aprons, and old men's shoes; Aunt Mackie, nobody's sister but still Aunt Mackie to us all.[20]

Think of this chant alongside a praise song delivered by Invisible Man in the novel (inside his head) as he sits in the school chapel remembering his own experiences as a fledgling speaker on that church platform. Like the boy in "Coupla Scalped," Invisible Man delivers his song to a woman, an elder—this time, she is the speaker's perfect congregation member as a call-and-recall collaborator. And again, the song is delivered with music (sometimes the music of the Black preacher's sermon) on the character's mind:

> Ha! to the gray-haired matron in the final row. Ha! Miss Susie, Miss Susie Gresham . . . listen to me, the bungling bugler of words, imitating the trumpet and the trombone's timbre, playing thematic variations like a baritone horn. Hey! Old connoisseur of voice sounds, of voices without messages, of newsless winds, listen to the vowel sounds and the crackling dentals, to the low harsh gutturals of empty anguish, now riding the curve of a preacher's rhythm I heard long ago in a Baptist church, stripped now of its imagery. . . . Hey, Miss Susie! The sound of words that were no words, counterfeit notes singing achievements yet unachieved, riding upon the wings of my voice out to you, old matron, who knew the voice sounds of the Founder and knew the accents and echo of his promise. . . . It was to you on the final row I directed my rush of sound.[21]

Just as Invisible Man's song of praise reflects upon the slave past (among other aspects of Black American history), so, too, does "Coupla Scalped" take on America's ongoing racial violence. In the case of the short story, the presentation of music as equipment for action is in sync with that era's fast-heating Civil Rights Movement. Shortly after the appearance of this story, in 1957, the dramatic efforts to integrate public schools in Little Rock, Arkansas, and Charlotte, North Carolina, claimed the world's attention. It was during the Little Rock showdown that Louis Armstrong—whose gravel voice influenced not just singers and instrumentalists up and down the jazz and pop music traditions, but also the general public—released unexpected verbal shots heard round the world for the Freedom Movement. What, Armstrong asked, did we (the front-line Black high school youngsters in Little Rock and those like Louis himself, supporting them) do to be so black and blue!? And what was the president prepared to do about it? One is reminded of Amiri Baraka's assertion that the bristling tone of Armstrong's music, whether sung or projected through his horn, implied an axe-edged will to reset the world's clocks and order.[22] Text and texture, music and musician demanded action at the speed of light.

The storyline of "Coupla Scalped" is quickly told. An unnamed eleven-year-old boy and his brash buddy, the rightly named Buster, both African American, find a discarded *Boy Scout Handbook*. Without the benefit of a scoutmaster or official Scout status, they give themselves the various tests described in the book. Notably, though unstated in the story, the Boy Scouts started out with a very specific whites-only (and then segregated-only) racial agenda, and yet the paramilitary Scouts were drilled by their scoutmasters in the strategies of woodland self-sufficiency of the Native Americans whom the Europeans had decimated![23] Ellison gives "scalping" a double meaning: yes, the two boys have been marked by historical and current racial violence—scalped in that sense. But true to the story's theme of ritual man-testing, both boys also have just been circumcised ("scalped" is the term they jokingly use), ritually prepared for manhood in their tribe, and are under strict doctor's orders not to overexert themselves while healing. The boys' declaration that they are "just a coupla scalped Indians" reminds the reader (if not the boys themselves—not yet) that as Black males in America, their stretch toward manhood is a quest for continuity and a war campaign into deadly territory where white Americans have brazenly sought their own regeneration through violence against Native Americans, as well as against Blacks and others.[24] Nonetheless, being eleven, and prodded by the double-daring Buster, they overrule all the warning signs and pains as they go right ahead with their homemade regimen. If you're Black in America, Ellison is saying, graduating from tender age to adulthood involves an improvised confrontation with the "scalping" knives of racism.

The boys' circumcision marks the story as one where an important role is played by religion. While the distant carnival music in "Coupla Scalped" most

certainly suggests a time of boisterous, fleshly fun and games (like Mardi Gras in New Orleans), native New Orleanians well know that on the Catholic calendar, carnival is a high season of intense spiritual meditation over Jesus's "loss of the flesh" *(carne-vale)* in anticipation of miraculous rebirth and salvation. Like the ritual surgery of circumcision, the short story's carnival music marks these boys' preparation for spiritual awareness as well as leadership—or tragic martyrdom.[25] This story's heroes in training recall *Invisible Man*'s zoot suit–wearing young Black men on a subway platform in New York—older cousins of the country kids of "Coupla Scalped." "Who knew," Invisible Man ponders, but that these zoot-suiters were "the saviors, the true leaders, the bearers of something precious?"[26]

The tale's religious allusions are at once Afro-spiritualist—think again of Aunt Mackie and her trickbag of conjurations—as well as Christian, Islamic, and Jewish.[27] Whichever traditions inform our reading, this story's main subjects are personal transformation and readiness for visionary leadership. Shakespearean horn-blower "Fools" that they are, the musicians are calling the boys to ritual sacrifice and work: calling them forth as agents of change that is personal, spiritual, and communal.

Here are Huckleberry and Tom as brothers in Black. As in the Twain novel, these daring boys' journey to consciousness and readiness for forthright action come through Blackness and the growing awareness of kinship beyond the "racial" family.[28] Step by step, Buster and the nameless boy (and the reader) increase their knowledge of their collaged identities as "cullud" Americans. But as the story unfolds, the boys and reader realize without contradiction that they also are improvising Boy Scout pioneer/frontiersmen—problematically "white" and "Indian"—as well as Christians, Jews, and Afro-diasporic. Despite the white walls of racism surrounding them, the boys inherit *all* these cultural traditions and the challenges/responsibilities that go with them. Here and everywhere in Ellison's fiction and essays, his Trojan Horse through the walls of U.S. racism and prejudice bears the conviction that all Americans are collaged in their cultural mixes and "mixteries,"[29] and no walls can hold them. (Ellison likes to use the example of the Black man in a Confederate cap or the virulent white racist hating on Blacks while Stevie Wonder's music pumps through his headphones.) And yet—as this story asserts—whatever optimistic readings one may place on such jazz/blues-collaged American identities, the nation's raw, institutionalized power relations remain unchanged. The white scalpers of Indians, Black and red, as well as believers, Christian, Jewish, or Muslim, retain control. At a level of profundity that is spiritual and political, the carnival music demanded awareness and then action: passion-perception-purpose. This Black-songful story demands that in spite of the violent enforcement of white supremacy, the beautifully promising energies of these Black man-children must be recognized through their inalienable members of the

American national family who, as citizens of the world, might be the ones to save us all. Who knew?

At the end of a long day of self-proctored tests in hunting, cooking, and swimming in Indian Lake, Buster and the unnamed protagonist rattle down a hillside toward the bright carnival music they hear in the distance.[30] By now, Nameless (let's call him) has endured all the tests, including the climatic confrontation with old/young Aunt Mackie. Under the pressure of these various rites of passage, our hero becomes separated from Buster and has to loop back to search for him. The day's ups and downs have left Nameless bewildered and hurting, but also transformed: initiated into a higher gear of consciousness. "And for a moment," he declares, "I felt much older, as though I had lived swiftly long years into the future and had been as swiftly pushed back again."[31]

"Coupla Scalped" presents Black music as an art heralding personal metamorphosis. Black music as an assertion of styles and strategies for surviving racist America: a body-and-soul music transcending the usual divides of white and Black, as well as sacred and profane. Just as the carnival music of "Coupla Scalped" contains a church-shout of the sacred ("those fools is starting to shout 'Amazing Grace' on them horns"), it also has more than a touch of the audaciously profane:

> "Listen to that trombone, man," I said.
> "Sounds like he's playing the dozens with the whole wide world."
> "What's he saying, Buster?"
> "He's saying, 'Ya'll's mamas don't wear 'em. Is strictly without 'em. Don't know nothing 'bout 'em . . .' "
> "Don't know about what, man?"
> "Draws, fool; he's talking 'bout draws!"
> "How you know, man?"
> "I hear him talking, don't I?"[32]

The distant music quoting "The Dirty Dozen" blues balances the "Amazing Grace" reference and takes some of the wind out of its sacred sails. In so doing, it introduces a note of Ellisonian paradox and ambiguity, which he calls "ambivisibility."[33]

Before turning to the story's version of "The Dirty Dozen," let us pause over this highly suggestive portmanteau, invented and penciled into the big book manuscript's margin: ambivisibility.[34] It reflects not only the wisdom of such moderns as Virginia Woolf and William Faulkner, but also that of Cubist painters, including Ellison's friend Romare Bearden, who emphasized that we always see the world from multiple angles: one look reveals experience that is "never just one thing." Ellisonian ambivisibility also speaks to W. E. B. Du Bois's canonical imagery of racial "twoness": of Black Americans disciplined

and burdened to regard the world for themselves, and yet also through the eyes of others who may be hostile.[35] Ellison's reshaping of twoness into ambivisibility suggests that a Black person's awareness of being unseen by others (perhaps unseen from many standpoints) actually may *sharpen* his or her own sense of self and world. At the same time, Ellisonian ambivisibility suggests the Black American's ironical awareness of being at once "highly visible" (Greg Tate's "Flyboy in the Buttermilk"[36]) and unnoticed and/or underestimated: doubly unseen. And Ellison points out that being unseen can be a good thing in a variety of ways. Unseen, ambivisible American Blacks can secretly and sometimes clairvoyantly observe those who purport to watch (and control) them. In the world of Ellison, images of me watching you watching me—seeing and not seeing—are pervasive.[37]

Ambivisibility also spells awareness that the world is full of shifting faces, false and true, seen and unseen; a world of love and trouble and of good and bad Aunt Mackies, of sacred and profane. Moreover, ambivisibility could work as a term to describe Ellison's idea of the self as an improvised composite. Indeed, it could suggest his descriptions of the jazz artist's project: multiple players coordinating to compose a work together. Édouard Glissant writes about the self "in relation"; Fred Moten theorizes the self as jazz band, multiple selves in which lead parts and solos may be played by one member of the band/self or, then again, by another.[38] Note, in this context, that from 1939 to 1969, Romare Bearden's day job was as a New York City social worker—by day earning his living on behalf of those at the bottom of the town's social hierarchy (or altogether outside its official ledgers), while by night (and sometimes by day too, drawing while on the phone with clients) working at his art, where a sense of social responsibility was a given.[39] Bearden as a man of action in both his professions: in his artwork and on his beat as social worker. A man of parts that fit together.

In tune with such ideas of ambivisibility, when the boys of "Coupla Scalped" hear "The Dirty Dozen" sounding through "Amazing Grace," they hear a musical version of the aggressively competitive game. Like the dozens or, as Ellison's generation sometimes said, the "twelves"—perhaps related to the twelve-bar blues[40]—the music that the boys hear defines their culture as one mocking all pretensions of privileged bloodlines. Your mama might be the Queen of Chinchilla, as one kid from my Washington, D.C., public high school used to say, "but I'm the alley cat who is whipping your stupid behind right here and right now!"

As Geneva Smitherman, John Szwed, and many other close students of African Americana have observed, the dozens is a democratic game of verbal fire and ice wherein coolness under pressure makes the winner.[41] The dozens-warrior, he or she, wins the day neither by brute force nor, definitely, the entitlement of pedigree, but through improvised eloquence and the ability to think

fast even while one's opponent is laughing up one's mama's clothes. Writ large, in an ever-changing universe of natural mischance as well as violence, one may survive and even flourish through the cultivated gift of on-the-spot readiness or improvisation. Art—including playground art—as equipment for living.

In the midcentury modern world of intense American racial violence, where (as Invisible Man's grandfather says) "our life is a war," it's appropriate that Buster hails the carnival trumpet player as a *soldier:*

> "Why you call him a soldier, man?" I said.
> "'Cause he's slipping 'em in the twelves and choosing 'em, all at the same time. Talking 'bout they mamas and offering to fight 'em. Now he ain't like that ole clarinet; clarinet so sweet-talking he just eases you in the dozens."[42]

Buster teaches his buddy (and the reader) to hear in the music strategies for confronting ever-threatening fates of all shapes and sizes—not just racial—without forgetting that in the racialized American briar patch they inhabit, they must take on the white boys, too. The music posits maneuvers of outright retaliation and aggression at times, but also sweet-talk and studied indirection as more often the wisest ways through hostile territory.

In this context, although Ellison presents the youngsters' roles as improvisers as a sign of their ongoing preparation for adulthood, the idea of shape-shifters also includes Aunt Mackie, whose looming presence warns them that improvisation can take a monstrously self-centered and destructive turn: the improviser as insidiously brilliant Medea or Iago or the Sirens—figures (at least according to the most prevalent interpretation) who share the capacity to improvise as a strategy to kill. As Frederick Douglass discovered, in the world of "the Snake" (as, in his autobiographies, he called the would-be slave breaker Edward Covey, who meets his match in the teenage Douglass), the American game of survival can pit *trickster versus trickster.*[43] To escape the mysterious and menacing improvising conjurer Mackie, the boys must improvise. In this sense, Aunt Mackie is one of Ellison's many agents of "antagonistic cooperation": a tough sparring partner getting the boys ready—not only their sinews but their souls—for a world full of tricksters and troubles.

"'Say, Buster,' I said, seriously now. 'You know, we gotta stop cussing and playing the dozens if we're going to be Boy Scouts. Those white boys don't play that mess.'" Buster's reply brings to a crescendo his song of himself as a Black Indian Frontiersman Mardi Gras Muslim Jew: "You doggone right they don't," he said, the turkey feather vibrating above his ear:

> "Those guys can't take it, man. Besides, who wants to be just like them? Me, I'm gon be a scout and play the twelves too! You have to, with some of these old jokers we know. You don't know what to say when they start teasing you,

you never have no peace. You have to outtalk 'em, outrun 'em, or outfight 'em and I don't aim to be running and fighting all the time. N'mind those white boys.' "[44]

Here is the heart of this story: the Dirty Dozens/Amazing Grace carny music is part of a ritual of self-transformation and celebration. Of realization that, while in the United States, Black people generally have no choice about their status as Blacks (seen and unseen), and they also can *give consent* (as Glissant brilliantly puts it)[45] to Blackness that encompasses multiple identities: the best of Black, red, white; Christian, Jewish, Muslim, Afro-Conjure. Who wants to be a Boy Scout—whether one-track racist "pioneers" or naive Goody Two-shoes— anyhow? As Buster says, "N'mine those white boys."

Deep Reading Is Demanded

"A Coupla Scalped Indians" contains the essential ingredients of Ellison's theory of why art matters: for him, the self is achieved not just through lived experience with other people, but, crucially, *through identification with art's forms and characters*. In life or in art, this is the key imperative: seeing the self in the other.[46] Without good models, whether in life or in art, the commercial world's most available icons—those false coins that have currency for only a moment— can begin to look good enough to settle for. In "Coupla Scalped" and throughout the rest of Ellison's oeuvre, music—especially jazz—offers the best model for the continual movement of the mind and the most magnanimous expansion of the self through art. Listening to jazz, really listening, is by no means a passive entertainment. For Ellison, art demands profound engagements: deep dynamic readings and rereadings and *re*-rereadings. Perhaps this requirement of repeated, careful readings as the self expands is why Ellison's Invisible Man is instructed specifically by a *recording* of a Louis Armstrong performance, not a live concert. Underground at the end, the unseen character wishes that he had not only one but *five* of these Armstrongs, all playing at the same time. The hard business of constructing the self—'shedding old selves and building new, ambivisible ones—requires that he replay the layered music over and over. Such deep listening/reading, in Ellison, *is action*.

Ellisonian self-creation through identification with an heroic role model involves a will to a highly dedicated ecstasy of influence—a term for the way that art can take us outside of ourselves and connect us to others—as well as antagonistic cooperation, the term at the center of this book. As much as Invisible Man admires Armstrong and his music, he offers even Mr. Armstrong a very pointed critique. This antagonism is an essential part of a deep-dive engagement with art; it is never without critique and will to make the world anew.

In Ellison's novel, the Invisible Man's experiences of ecstasy of influence and antagonistic cooperation challenge the listener/reader to follow the narrator's example of not merely entering the music but descending "into its depths, like Dante," down and down some more, to levels where aesthetic-philosophical-religious meanings are tested and revealed.[47] It is instructive to compare these Ellisonian modes of deep engagement to Kenneth Burke's "frames of acceptance" and "frames of rejection": the view that art enables its audiences both to accept experience and to reject it, but above all to confront whatever life has to offer, whether in the form of catastrophic tragedy or the casual cruelties of slapstick humor. Further, both Ellison's and Burke's approaches anticipate Edward Said's heralding of the "heroic reader": the super-subtle one who listens/reads/looks with discerning "receptivity" (ecstasy of influence, frames of acceptance), but who also reserves a diamond-hard will for "resistance" (antagonistic cooperation, frames of rejection).[48] Each of these thinkers makes large claims for *both* these strategies of self-achievement through art, and for the insistence, as Ellison put it, that "this familiar music"—art at its finest—demanded action.

Ellisonian ecstasy of influence is distinctive, however, because of its roots in places like the public jazz dancehalls of America, and quite specifically the Slaughter's Hall of his youth in Oklahoma City. These were the scenes of Black communal celebration: places where, when everything was *copacetic* (as mid-twentieth-century Harlemites used to say), the sheer joy of being alive was ecstatically shared—this in spite of the ineradicability of the blues. When Harlem's Savoy Ballroom, the most famous venue of this kind, was torn down, Ellison told a congressional committee in 1965, "we lost an important institution,"[49] for Harlem's Savoy stood for Black joy-bell ringing, communitywide! Stand close enough to jazz bands in performance even today, and you'll see and hear their overflow of jazz-joyousness. These bandstands often are *rollicking* with laughter: sometimes the music seems to radiate from the music makers' ongoing hilarity. This is the *Black laughter* that Robert Farris Thompson rightly calls "culturally specific."[50] Laughter reflecting a joyous will to affirm the Black group, as if naysayers from outside their circle hardly existed. "What I had considered Pops's grinning in the face of racism," said Dizzy Gillespie, "was his absolute refusal to let anything, even anger . . . erase his fantastic smile."[51] For Ellison, "blues-toned laughter" can be directed at the ways of white folks or "to keep from crying," but also at the joke of the craziness of life itself. Some of it responds to the joy of making music and to the sheer sound of ecstasy bubbling there.[52]

The joyous drama of the Savoy Ballroom may not have constituted a dramatic "farce," as Albert Murray has argued—somehow that is not the right term, but as usual, Murray is on to something.[53] He's right that the bandstand laughter signaled that the entire Savoy scenario had a broadly comic arc. With dancers, singers, and instrumentalists—the public jazz party's triumvirate[54]—all swinging together, no part of this scenario is complete without the rest.

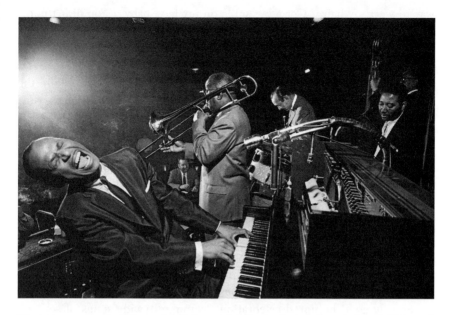

Pianist/composer Earl Hines with (left to right) Jimmy Archey, Francis Joseph "Muggsy" Spanier, and Earl Watkins.

Photo by Dennis Stock (1958) Magnum Photos

The Savoys were places of Black laughter from the dance floor, not just the bandstand. From an Ellisonian standpoint, these dance spaces were vital empowerment zones wherein the Black community fostered its good humor, its unsinkable humanity, as it literally pulled itself together—when the music was slow and bluesy, the dancers pulled *very* closely together. By evening's end, if all went well, the luckiest dancers/lovers left the place arm in arm! This ritualized courtship/fertility aspect of the public dance reverberates to make it a celebration of the continuity of Black selfhood and community. No wonder Zora Neale Hurston called the "jook" (a country cousin of the Savoy) "the most culturally significant place in America."[55]

This Savoy courtship ritual and the jazz dancehall's good humor also pulse throughout the lyrics of the blues, the country cousin of jazz—or, more precisely, its down-home (or Uptown or Southside or Deep Second) grandparent and great-grandparent: jazz's after-midnight sound. The main topic of the blues is love gone wrong. "I know you been cheatin' on me baby," many a blues song announces. "Trouble, trouble, I've had it all my days," says one blues song. "I'm in a world of trouble," announces another. Then again, "I'm in love with a woman but she's not in love with me." On the other hand, "You know I love you baby, But I gotta put you down for a little while." Sometimes blues trouble is delivered by surprise to a replaced lover. Take Denise LaSalle's "I got a new

way to wear my hair, / Got a big smile on my face, baby: / You didn't put it there!"[56] There is a strong note of laughter shimmering all through these songs of love and trouble, seconded by the listeners' complex laughter in response!

But beyond disappointed romance, the implied subject of the blues is a disturbance at other levels: trouble with my lover leading to trouble in the family, and trouble in my mind suggesting trouble that is off the leash, running "in and outta my front door," as Bessie Smith once put it.[57] Whether delivered with a smile of sass or not, whether inducing communitywide laughter as a balm in Gilead (albeit temporary) or not, the subject here is *political* trouble—trouble with being Black in a country that denies not just your citizenship but your humanity, trouble with survival, trouble *big time*. Trouble that's racial—and also black-and-blue trouble beyond matters of race. Trouble fallin' down like rain.

Murray would balk at my making the music so outright political, but his work enlarges the definition of the blues with his argument that the music confronts matters of entropy: random trouble at every turn. Where Murray and I agree is that we both read blues-idiom songs and settings as sites of ecstatically good-humored celebration—communitywide songs of self and group. Murray and I part company where I insist that in the most ecstatic jump-and-shout uptempo blues, and in the tickling and tingling *my-baby-don't-love-me-no-mo'* blues—and then in jazz, which flows over the deep river bed of the blues—are defiant calls to political consciousness and responsibility: *calls to action*.

Let us mine another part of the meaning of *ecstasy of influence* in jazz. We start with dimensions layered within the history of the word "ecstasy" itself. The English word stems from the Greek noun *ekstasis*, from the verb *existanai (ek- + histanai)*, "to cause to stand outside," or by extension, to be beside oneself, beyond the mereness of rapture, in a transformative selfless swoon. As innumerable testimonies make clear, the apprentice jazz player learns, in jam sessions and elsewhere, to stand as if it were outside of themselves, and to yield to the transformative example of the master artist. I compare this with Keats's "negative capability," the artist's dynamic creative identification with the world through which they move.[58] Think of John Coltrane's brilliant album called (and calling for) *Selflessness*. In the case of the jazz apprentice, this Keatsean/Coltranean negative capability/identification is directed not only toward "the world," but crucially toward those master artists whom the apprentice chooses as models, and by whom the apprentice is willing to be molded. Most apprentices will merely copy what they can of the masters' example. But the best will move through the living gate of that example—as Coltrane moved through the mighty saxophone models of Charlie Parker and Dexter Gordon—on the way to the achievement of their own voices. "You can only play so much of another man," Trane said.[59]

Edward Said discusses this process as he champions the aesthetic statement that calls its readers/listeners to what might be termed the "ambivisible" double duty of surrendering themselves to the artist (being *receptive*) without giving up their strong critical faculties (being *resistant*). This Saidian reading/listening is a dynamic critical experience that "requires alertness and making connections that are otherwise hidden or obscured by the text." He speaks of drivingly activistic reading that originates

> in critical receptivity as well as in a conviction that even though great aesthetic work ultimately resists total understanding, there is a possibility of a critical understanding that may never be completed but can certainly be provisionally affirmed. It is a truism that all readings are of course subject to later rereadings, but it is also good to remember that there can be heroic first readings that enable many others after them. Who can forget the rush of enrichment of reading Tolstoy or hearing Wagner or Armstrong, and how can one ever forget the sense of change in oneself as a result?[60]

This is reading with more than a will to dissect or deconstruct, more than a case of "anxiety of influence"—Harold Bloom's term for the fate of artists so obstructed by the examples of fathers/mothers-as-artists that they must kill them. Virginia Woolf's repeated advice to the young woman artist that she must kill her mother is, by the way, a special case, I believe. Woolf means to murder not the terrifyingly talented master (male or female) in the young female artist's path, but the parent in one's head, daring to doubt the young woman artist's talent: the mother or father who monstrously insists on the artist's cowering angel-in-the-house femininity in the face of male power. Woolf urges the young woman writer to find examples to follow, and *not to forget the examples offered by artists and intellectuals from the circle of women.*[61]

Echoing Woolf as well as Longinus's "On the Sublime," and perhaps Keats on "negative capability," Said urges readers (including, it seems to me, fledgling artists) to encounter the past master in a spirit of radical identification (ecstasy of influence)—as if we ourselves were creating the work of art we read:

> It takes a kind of heroism to undertake great artistic efforts, to experience the shattering disorientation of "making" an Anna Karenina, the Missae Luba, the Taj Mahal. . . . It is not only anxiety that drives Melville, for instance, to match Shakespeare and Milton, or anxiety that spurs Robert Lowell to go on from Eliot, or anxiety that drives Stevens to outdo the audacity of the French symbolist, or anxiety in a critic such as the late Ian Watt to go beyond Leavis and Richards. There is competitiveness of course, but also admiration and enthusiasm for the job to be done that won't be satisfied until one's own road is taken after a great predecessor has first carved out a path.[62]

It should be noted how close to a jam-session spirit is Said's emphasis on the artist's carving out his or her own path by employing a will to compete with other artists who have taken that same or similar paths: to play, as Ellison has put it (with reference to Halley Richardson's shoe shine parlor, the musicians' preferred meeting place and jam session setting in the Oklahoma City of Ellison's youth), "with and against" one's peers and predecessors.[63] Note, too, that Said's citing Louis Armstrong as a past master to emulate (and elsewhere in *Humanism and Democratic Criticism*, Duke Ellington)[64] is as outright shocking, given Said's debts to Theodor Adorno, who was dismissive of jazz, as it is exceedingly apt. With this said, I want to underscore Said's observation that heroic readers are changed, directed, and even exalted (not to forget "shattered") by the experience of deep "reading": active engagement with the work in all its "primary drive and informing power."[65]

Sharpening these perspectives on art, influence, and action, both Ellison and Said routinely turn to religious and quasi-religious language—a move that recalls again the religious notes in "A Coupla Scalped Indians." Said speaks of intense critical reading as "a peculiar kind of faith, or as I prefer, an enabling conviction in the enterprise of making human history."[66] In Ellison's novel, the artist in training "descended, like Dante" into depths where humankind's service to God and manifold failures were measured. And like Dante, led toward spiritual/aesthetic wisdom by Virgil (who in turn takes Homer as his model), Invisible Man follows the path mapped by the master artist Armstrong (and others alluded to in the prologue of *Invisible Man*), as the artist in training searches for what Ellison persistently calls his/her "soul." These dedicated jazz artists/soul seekers, Ellison informs us, are the dedicated ones who wore their instruments "as a priest wears the cross."[67]

Here, it is quite important to recall some echoing prose from William Butler Yeats, sentences that Ellison quotes as a kind of mantra through his essays and speeches from the early 1960s on—forecasting the Black novelist's view of antagonistic cooperation and its related concept, ecstasy of influence. Ellison drew from *Amica Silentia Lunae* (1918), Yeats's daybook of ruminations on the artist's work (among other matters). It is here that the Irish poet-dramatist is thinking of actors as artists as he writes specifically of the mystery of finding oneself through the spirited identification with somebody else:

> I think all happiness depends on the energy to assume the mask of some other life, on a re-birth as something not one's self, something created in a moment and perpetually renewed. . . . If we cannot imagine ourselves as different from what we are, and try to assume that second self, we cannot impose a discipline upon ourselves though we may accept one from others. Active virtue, as distinguished from the passive acceptance of a code, is therefore theatrical, consciously dramatic, the wearing of a mask.[68]

Through the "discipline" of mask wearing (it is not a stretch to call it a kind of "discipleship," following the ways of a master), artists seek to find their own faces and values—their *souls*.

All of this is akin to what Roman rhetoricians called *aemulatio*: explicitly invoking a prior model or mentor while seeking out one's own direction. The public speakers most often cited by Quintilian as learning from close study of prior examples are Cicero and Demosthenes, considered the greatest orators of their respective eras. And then there are the many followers of the mile-wide literary path mapped out by Homer. Virgil, in particular, overtly invokes the Homeric model in his *Aeneid* as, through new stylistic as well as plotline turns and twists, he also asserts his own voice and direction. As a composer and pianist, Duke Ellington was influenced by many exemplary musicians, both formally and informally trained ("A-Trained" is one way to describe his lessons from ragtime masters in Harlem!). But like other modern artists, Duke was influenced by everything around him, musical traditions written and unwritten. His description of his listening habits during his midcareer tours of Asia and the Middle East are especially telling: "I think I have to be careful not to be influenced too strongly by the music we heard," he said. "I would rather give a reflection of the adventure itself. . . . I didn't want to get academic about it and copy down this rhythm or that scale. It's more valuable to have absorbed it while there. You let it roll around, undergo a chemical change, and then seep out on paper in a form that will suit the musicians who are going to play it."[69] Ellington did not want to decorate his music with foreign flavors or "effects," however culturally "characteristic" or outright gorgeous; rather, he was seeking to absorb new information to extend a musical language that was all his own. This search for the priceless qualities of one's own voice and self-definition at the spiritual base of the music—something always more than the traps of self-centered individuality, something always striving for more and more of a multiplied sense of self, rippling in rhythm with others—this is what, perhaps most profoundly, the music demanded.

For Ellison, again, such searches are part of a discipline with borderline religious aspects. In an important essay on one of his own key mentors, Richard Wright, Ellison reminds us of the close relation of art and religion by comparing the ecstatic shouting in a Black church—and the hot tears it can induce, along with its dances of spiritual possession—to an audience's epiphanic experience through transcendent art. Ellison criticizes the older writer for distrusting readers' tears (Wright specifically says that he did not want sentimental bankers' daughters' tears to dampen his books). In Ellison's view, such wholesale distrust of readers' responses blinded Wright to the church's vital, cathartic, expressive forms at the root of Black American culture, and

thus to an important aspect of the writer's power to move readers, sometimes by making their tears flow.

> Here [writes Ellison] I must turn critic. For in my terms, Wright failed to grasp the function of artistically induced catharsis, which suggests that he failed also to understand the Afro-American custom of shouting in church (a form of ritual catharsis), or its power to cleanse the mind and redeem and rededicate the individual to forms of ideal action. Perhaps [Wright] failed to understand, or else rejected, those moments of exultation wherein man's vision is quickened by the eloquence of an orchestra, an actor, orator or dancer, or by anyone using the arts of music or speech or symbolic gesture to create within us moments of high consciousness—moments wherein we grasp, in an instant, a knowledge of how transcendent, abysmal and yet affirmative it can be to be human. Yet it is for such moments of inspired communication that the artist lives. The irony here is that Wright could evoke them, but felt, for ideological reasons, that tears were a betrayal of the struggle for freedom. I disagreed with his analysis, for tears can induce as well as deter action.[70]

In *Invisible Man*, Ellison's central character experiences several moments of the "quickened awareness" that I am calling "ecstasy of influence"—none more emphatic, again, than when encountering Armstrong's "(What Did I Do to Be So) Black and Blue" Listening deep inside the recorded music—where tears, moans, shouts, and laughter abound—Invisible Man is shaken by the sound of an old ex-slave woman speaking of freedom. Here again, through intensive listening to the echoes inside the music, the young man encounters a vital lesson (whether he learns it or not remains, in a novel where the end is the beginning, to be seen). Like other lessons in *Invisible Man* and throughout Ellison's oeuvre, the woman's definition of freedom centers on aesthetics with an action agenda attached. Invisible Man asks her: "*What is this freedom that you love so well?*" The woman's answer represents one of the many moments when we hear the author, Ellison, speaking through a character: "First I think it's one thing and then I think it's another," she says. "Now I think it ain't nothin' but knowing how to say what it is that's up in my head."[71]

Freedom of speech, the right to speak one's mind, certainly is what she means and moans (etymologically, the verb "to moan" is very close to "to mean"). But in the context of a novel in which the main character seeks his voice as a public speaker—as some sort of word artist—she also refers to *aesthetic* freedom. Knowing how to project in art "something up in [one's] head"—the image, the rhythm, the sound and color, the feeling—is artistic freedom earned only through painstaking practice and hard thought: through repeated meetings with the monster in the woodshed. John Coltrane's constant practicing was, as one jazz critic put it, "precisely in order to achieve a liberation and more complete expression."[72]

Such is one aspect of the freedoms sought by Invisible Man as he listens to the book's many master speakers, and also to the technically outstanding Armstrong play the blues (or, in the case of "Black and Blue," to Armstrong stirring a strong dose of blueing into a show tune). For Ellison, the hard-won freedoms sought by Invisible Man and by the densely patterned book's best readers are always tightly interstitched: personal, artistic, and political.

Clearly, the art that Ellison celebrates demands much more than the drafts-man's dry technique—as famous as Ellison was for invoking the "very stern discipline" of writing. His criticism of Hemingway, whose aesthetic of spareness is so masterful that Ellison used it as a touchstone and model throughout his lifetime, makes this point, strongly. Hemingway's singular emphasis on sheer writerly know-how, says Ellison—telling precisely what happens and how everything looked, with a minimum of interpretation—freed him to express with consummate clarity everything "that's up in his head." Every fundamental of humanity, Ellison sharply adds, "except that which distinguishes him from the animal."[73]

Such art sans soul can be the merest spinning of wheels; worse than sophomoric showing off, it can be monstrous. At the furthest extreme from Ellison's ideal of the technically fine artist with a soulful freedom agenda is Homer's vivid portrayal of the Sirens, singers and instrumentalists who employ their irresistible art to lure and kill. The Sirens deal not only in music as rhythm and tune—as generally noted—but also in the sung *word*, in language, that disastrously explicit medium. The Sirens claim to know not only the complete history of Odysseus and his people—past and future—but "everything that the Argives and Trojans did and suffered."[74] Often compared to the snake in the Garden of Eden, these tempter artists may be perfect in knowledge and technique; but perfection without the soulful qualities that Ellison calls for can be deadly. For Ellison, artistic discipline involves 'shedding of the highest order: artistic discipleship. And yet, as we have seen, for art to demand positive, self-transformative, community-building action—a true poetics of relation—it must have the other soulful qualities of which Ellison (as well as Yeats and Said) speak so eloquently, and which I'm calling "ecstasy of influence."

Perhaps Ellison's lens of ambivisibility can again clarify our vision here. Homer's experience-hungry Odysseus certainly is desperate to hear the Sirens: he wants the beauty and the knowledge. But he has his men tie him to the mast so that the experience of listening will not kill him. He wants to hear and not hear, to be moved while unmoving. In Ellisonian terms, Odysseus wants the tragic awareness of these songs-to-die-for without having literally to die for them. He wants acceptance and rejection, double vision: he wants to be ambivisible.

Romare Bearden offers another example of artistic acceptance and rejection.[75] In 1959, Bearden attended a rehearsal of the Duke Ellington Orchestra while Ellington was taking the band through his new arrangement of Pyotr Illyich Tchaikovsky's *Nutcracker Suite*. Billy Strayhorn, the adaptation's cocomposer,

walked into the studio with fresh manuscript pages that he had written. "Duke said, 'We've got to change here and here and here.' And Billy Strayhorn said, 'Man, you can't do that—this is Tchaikovsky!' And Duke said, 'Yeah, he's a great composer. But for our band, we've got to change here and here and here.'" And then Bearden added: "That's what I've done with Cubism."[76] Bearden often said that he remained a Cubist throughout his career. But in interviews, he was quick to add that Pablo Picasso and Georges Braque tended to keep their rectangles too predictable and static. "When I did the jazz series," Bearden told an interviewer, "I had to modify this a bit." He continued, "The use of rectangles, dividing the picture by straight lines horizontally and vertically, makes for a formal unity, which I like, and it also gives dignity to the figures. But it doesn't give the moving violent thing. . . . I think my jazz work has the feeling of the classic African sculpture, the Benin or Dan."[77] For Bearden, in search of art in Afro-motion, the Cubists were too square!

Ellison experienced some of this self-discovery through disciplined identification when, as a youngster, he practiced his trumpet until many of his neighbors were beside themselves not with ecstasy but with irritation. "But who knew," he wrote in 1955, "what skinny kid with his chops wrapped around a trumpet mouthpiece and a faraway look in his eyes might become the next Armstrong? Yes, and send you," he continues, sharpening his definition of the function of the jazz artist, "into an ecstasy of rhythm and memory and brassy affirmation of the goodness of being alive and part of the community? Someone had to, for it was part of the group tradition, though that was not how they said it. 'Let that boy blow,' they'd say to the protesting ones. 'He's got to talk baby talk on that thing before he can preach on it.'"[78] Who knew, Ellison writes elsewhere, considering that Armstrong emerged from the penniless depths of the social hierarchy, where the next genius might come from—the next bearer of something precious?[79]

It is not surprising that *Invisible Man*'s meditations on art and ecstasy of influence fix on Armstrong as Ellison's most complexly rendered example. "My strength comes from Louis Armstrong," he once said.[80] In each of Armstrong's several autobiographies—not excluding the countless interviews and many long autobiographical letters—the musician detailed his own complicated and ongoing artistic debts to a cavalcade of exemplary players.[81] Most emphatically, Armstrong honors Joe "King" Oliver, or "Papa Joe," who was the young artist's most significant mentor in New Orleans, and then in Chicago. On one of his collagelike scrapbook pages, Armstrong pasted a small picture of Oliver inside the cutout of his own head—Papa Joe, forever on his mind! Indeed, contrary to those who would trace Armstrong's brilliance no further than to his own unprecedented and untaught "genius"—a corollary of the racist idea of the exceptional Negro, operating against a background of presumed Black mediocrity—Armstrong never stopped celebrating the Crescent City's vigorous

Page from a scrapbook by Louis Armstrong (1952). Note that inside the photo of his own head, Armstrong has pasted a photo of his mentor, Joe "King" Oliver.

Courtesy of the Louis Armstrong House Museum.

systems of apprenticeship. This is the informal but demanding structure, the community's own, whereby new players with an interest would be taken in and taught, often without charge, by adult players deeply committed to passing the tradition along.

Like Armstrong himself, the trumpet king's biographers rightly fix on the abundant New Orleans parades as formative for him. The drummers especially captivated the mind of young Satch (also called "Little Dipper" or just "Dip"), most particularly a trap and bass drum player called Black Benny. Armstrong would name many others who influenced his trumpet playing, from the music instructors at the Waif's Home, where he received his first formal training, to the Karnovsky family, who bought him his first cornet and whose Jewish lullabies became as much a part of his early sense of a complete musical scene as did the songs of the church and of the New Orleans Opera House. Nor does Armstrong fail to credit the excellent readers of music who pushed him to improve his ability to interpret more complex notated charts, from Frank Brown on his first riverboat to Lil Hardin, the brilliant young pianist in King Oliver's Chicago band who, for fourteen years became Lil Hardin *Armstrong*, the Dipper's wife.

Barbershop quartet singers, street singers, brass band players on a variety of instruments, Storyville piano ticklers, and wandering venders singing their wares—Armstrong credited them all. If anyone was a Saidian heroic reader or Yeatsian disciple studying the brilliant second self, the Ellisonian seeker of technical mastery as an aspect of broad freedom of expression, it was Pops.

Neither, in this context of the example Armstrong projected, can we forget that he was a master of masquerade and masking. How could it be otherwise, considering Armstrong's upbringing in the "secret African city" of New Orleans, the nation's premier city of masked balls and parades? It is not news that the faces that Armstrong projected for stage shows and Hollywood could be problematical at best. Without doubt, he could put on the most ridiculous costumes and facial twists—beyond the typical "mugging" that others would do—and broadcast the most absurdly self-deprecating Hollywood lines and lyrics. At times, the roles he took on were part of the dangerous continuum of minstrelsy—a tradition which, despite its legacy of deriding the Black self and image, also introduced great Black performers who could peek through the minstrel mask just enough to exchange a wink with Black audiences. Sometimes Pops was in this tradition of Bert Williams, a performer Armstrong revered. Trickster, Caliban, winker at multiple audiences, Armstrong was, as Ellison argues, everybody's clown but nobody's fool (except perhaps in the Shakespearian sense). One might say that he wore the clown's mask as a shield, behind which he was working on his true identity: that of a deeply delving, deeply committed, deeply challenging artist whose "music demanded action." But Armstrong's clown face was something more than the powder and paint behind which the genius operated, and certainly not an indicator of true self-hating essence: it was one piece of the huge and multilayered, collaged identity of a complex man.

The observation about Armstrong the Fool—with a capital letter—may seem out of place in a discussion of the man as exemplar. But look again. Ellison, in particular, helps us see the funnyman Armstrong as a model to follow. "America is a land of masking jokers,"[82] Ellison writes. And to survive a nation dead set against Black American lives, we have needed the humor and the mask. In several autobiographical essays, Ellison tells how he learned to wear a carefully prepared face in Oklahoma City, where white supremacists could quickly turn violent, and of course in Alabama, where he attended college. But he also wore a mask in New York City, where, as a newcomer in the 1930s, he was not always sure which restaurants or theaters would draw a color line against him. "I had to discipline myself in order to discover just where I was free and where I was not free," he said:

> In the South there were signs which told me where I could go and where I
> could not go. In New York there were no such signs, so I told myself, "Well, you

must go out and discover its freedom for yourself, and the best way of doing it is not to dodge before someone throws a punch at you." As a consequence, I found myself going to, and being accepted in places which might ordinarily have sensed that I was intimidated and turned me away.[83]

The necessity of Black mask and masquerade is recorded throughout African American literature. And in *Invisible Man*, it is Rinehart—the pimp and underground gambler who's also a preacher ("spiritual technologist")—who teaches by example the value of the Black mask as part of a survival strategy and a program of readiness and steadiness; a blueprint for action. Like Br'er Rabbit of African American lore, Rinehart is a trickster whose acts of trickery post cautionary warnings, as well as strategies for negotiating the American briar patch (Northern and Southern), where, as a Ray Charles blues puts it, the danger zone is everywhere.

Armstrong the music maker. A culturally composite American—Black and Jewish-taught lullaby maker, operatic aria singer on the heraldic horn, minstrel man and side-of-the-mouth romantic crooner, hard-driving American Songbook king, and bluesman par excellence—he also became the single most copied artist in the history of American music. For both singers and instrumentalists, in jazz, blues, R&B, pop, or virtually any other American musical endeavor, not excluding the modern classics, his significance is tremendous. This is so much the case that the jazz historian Dan Morgenstern said that if he were forced to deliver a fast disquisition on the definition of jazz while balancing on one foot (another version of the tale of the rabbi putting the Good Book into one phrase), he would relax and say just two words: *Louis Armstrong*.[84]

The Armstrong influence was often direct and unmistakable: singers and instrumentalists alike carried his message throughout the world as jazz arrangers and composers, pushed to alter their work to make room for the Armstrongian sense of what it meant to swing the music.

With his horn or with his voice, Armstrong could float behind the beat, shadowing it, caressing it, playing hide-and-seek with it. He could play directly in the center of the beat, or he could ride through it like a military bandsman, with an urge to syncopate his step into a roll of the hips and shoulders until the march became a dance. If the beat were a steady train, rocking on the rails, Armstrong was an eagle in flight, soaring, dancing in the breeze, now just behind the train below it, now ahead and outracing the train's engines, now landing on one of the cars and riding cool and steady, stirring a makeshift nest before taking flight again.

What does it mean to fly in that way, to swing? It involves what André Hodeir called "a vital drive" or "rhythmic fluidity without which the musical swing is markedly attenuated." This drive, he went on to say, "is a manifestation of personal magnetism."[85] Swing may also be seen as a forward-tilted, dynamic

process of coordinating with fellow workers/players and listeners/dancers alike, pulsing together. Albert Murray associates this vital drive with the sound of a train: rocking in rhythm as it bears down on the agents of trouble called the blues. In this sense, what it means to swing is to give the boot to the blues, as Murray says—to jump and jive them out of sight. All of this, again, is connected to the will to dance, to groove in time while holding tight onto somebody special.

Armstrong did not single-handedly invent swing, but he did help to perfect it. He swung his solos, the brass sections, and indeed entire bands in which he played. Gunther Schuller makes the point that, with his urgency of sound and top-spinning sense of vibrato, Armstrong could make a single note swing.[86]

To gauge Armstrong's influence as a vital driver of the swing engines of this music, compare the cadences of Fletcher Henderson's band before and after Armstrong's membership in it from September 1924 through November 1925. Even considering the dance-beat strong presence of Charlie "Big" Green (trombone) and Coleman Hawkins (tenor sax and other reeds), it was Armstrong's sense of swing that tipped the whole band forward. Armstrong's sense of momentum, the physicality of his playing made even Big Green and Hawk sound stiff by comparison (think again of Bearden's critique of the "square" Cubists). That said, is it at all surprising to learn that Armstrong was an exceedingly good dancer?![87]

Dipper-style playful rhythmical propulsion eventually affected everybody who played jazz; to that degree, it is not inaccurate to declare Armstrong the prime mover and shaker of the Swing Era. Ellington reportedly told his trumpeters in the 1930s to think of themselves as a whole team of Armstrongs: "Just do Louis," he told them. "Brass, reeds, rhythm—all. Do Louis. And I'll be Louis on the piano!"[88] And when, in the 1960s and 1970s, Ellington announced to the audience that his band would now perform the future of jazz, he had a trumpet player come out and do a dead-on Armstrong imitation! Duke wanted his own bands, present and future, to have the flexibility and sound-of-surprise coordination associated with Dipper's playing. He wanted them to *swing*.

In a study of the science of time, the materials scientist Ainissa Ramirez puts Armstrong alongside Albert Einstein in offering new definitions of time that shattered the world we thought we knew, of rigid timekeeping, and remade it as a world of Armstrongian swing:

> Marching bands focused on having musicians execute like clockwork. John Philip Sousa, like Sir Isaac Newton, loved precision. Armstrong, like Einstein, found beauty in the lack of it. An eighth note wasn't played exactly as written but swung, and how the note was executed was decided "in the spur of the moment". . . . Armstrong made every note do something, allowing him to stretch the present time with his music.[89]

Ramirez gives a useful (and playful) reading of an Armstrong recording of 1928 called "Two Deuces," in which the time-master trumpet genius

> is continuously behind the beat, shadowing it. The notes are delayed and compressed, which creates a gap between Armstrong and his band. To meet up with them again, Armstrong revs up and then hits the gas. Armstrong stretches not just the notes, but also the listener's sense of time. While the songs on a 78-rpm disc are three short minutes, they are so rich with information it causes our brains to believe the recording is longer than it takes to cook ramen noodles.[90]

As Armstrong's new style of playing invited musicians to rethink time, it challenged them to listen again to all music, to reconceive their very lives as moderns. Indeed, as with other masters through whom the ecstatic listener assumed a second self based on that master and found not only the secret of the master's creation (or part of it), but *himself or herself*, Armstrong was the living gate through whom legions of players discovered their own voices, selves, and souls as artists. Take just the trumpeters: Roy Eldridge, Henry "Red" Allen, Oran "Hot Lips" Page, Charles "Cootie" Williams, and many others took Armstrong's rowdy lyricism, the painting of the melody across the sky in blistering blues and reds. Dizzy Gillespie and Jon Faddis took the skywriting Armstrong and built their styles in the streaking stratosphere. Miles Davis, Clifford Brown, and Ruby Braff took the rich, dark middle and river-bottom of Armstrong's melodic horn and discovered themselves by diving through that deep range. (Late career Miles could also launch starburst musical flares from the trumpet's upper register.)[91] Clark Terry took aspects of all these styles and added a lightning-fast bebop impulse that also owed a lot to Louis.

Much the same could be said of Armstrong's children among the singers:[92] Ethel Waters, Billie Holiday, Rudy Vallee, Bing Crosby, Sarah Vaughan, Frank Sinatra, and Marvin Gaye. Each took a part of the master's message as the piece upon which to build his or her own style. Each became free through the discipline of ecstatic listening and assuming the second self. These are the dynamic actions defined by Ellison's use of Armstrong's art as model— a model of self-creation through social interaction and hard-won, studied identification.

The crucial homework, the hardest assignment, is to lose oneself in the music—to surrender to the music itself and to its makers, and then to the world through which one moves. Through it all, the action required is the counterintuitive act of finding oneself by losing oneself: through it all, to discover and nurture a self in readiness for positive action in the world.

Embedded in this idea of self-discovery through the ecstatic influence of art is another vital dimension identified by both Ellison and Said, each in his

own terms. *resistant reading*, says Said, is crucial to the activist reader's task. He refers to reading with suspicion, caution, and an unending stream of questions about sources and motives, historical places and moments, gender and race, and national as well as global signification. For Said, resistant reading is synonymous with spyglass critical reading, reading with an "armed vision."[93] Such reading not only recognizes the inherent contentiousness, paradox, and intimacy of the written word; it is reading with purpose, reading in search of information that readers can use, as well as for things against which they will push back. This is hard, close, action reading: aggressively critical.

Said's words on the experience of exile are pertinent here. You can feel his anger as he objects to the easy praise of exile in the feather-light terms typically used, for example, to romanticize Hemingway's and F. Scott Fitzgerald's airy, dusk-lit Paris. Instead, Said's "Reflections on Exile" calls exile a devastating and irreparable system of loss and pain that may not necessarily be borne or fixed. But Said also detects in exile an inducement to a healthily resistant attitude toward one's place in the world. To make the point that these concerns are not only modern and postmodern, Said frequently cites this passage from the twelfth-century monk Hugh of St. Victor: "The person who finds his homeland sweet is a tender beginner; he to whom every soil is as his native one is already strong; but he is perfect to whom the entire world is as a foreign place. The tender soul has fixed his love on one spot in the world; the strong person has extended his love to all places; the perfect man has extinguished his."[94]

This extinguishment does not mean being willfully miserable or outcast wherever one goes in the world—preferring a world to bark at—but recognizing the discordant note, both in oneself and in one's surroundings, old and new, *always*. To wrestle with angels at every crossroad, far and near, perhaps especially in one's native land. To live with a certain uninterrupted defiance or, as Ellison put it, antagonistic cooperation.

One sees this process in Ellison's artistic relationship with Twain, James, Hemingway, Faulkner, and Wright—writers with whose work he felt most at home, and thus writers of whom he was relentlessly critical. Likewise, just as most jazz players—apprentices and masters—typically face their artistic peers with a will to welcome and celebrate as they learn from one another, many (most? of the best?) also are willing to tangle—to question, to elaborate and extend, to edit, to upend. Antagonistic cooperation: also a process that, when the spirits are moving, presses artists to enhanced self-awareness while lifting them into the fresh air of new discovery and greater expressional eloquence.

Thus does Ellison call the scorching exchange of letters with Irving Howe over his own debt to Richard Wright an instance of "antagonistic cooperation."

Likewise, at least five of his other published exchanges of letters trace artistic/intellectual conflicts—two, from Ellison's side, to Irving Howe and Stanley Edgar Hyman; one more high-heat note to Norman Podhoretz[95] (wherein, incidentally, we meet Mr. Ellison rather out of control—much more blustering with antagonism than in any sense cooperative). And how interesting that while most of their letters are very friendly and generous, Murray chose to call his book of letters with Ellison *Trading Twelves*, as if the two then-young lions were playing the dozens together, or trading choruses in a hot-contest twelve-bar blues, with the writers as musicians whose typewriters were hard-hitting horns.[96] And yet, of course, they were running together, so many of their insights about art and ritual seem to emerge from their conversations over many years—cooperative antagonists through it all.

Let us consider one of Ellison's *Trading Twelves* letters, in which he compares his project as a writer to that of Jack Johnson, the first Black boxer to win the heavyweight championship of the world. He names other great Black fighters as he invokes the Black "studs" battling segregation in the Supreme Court:

> Just as with writing I learned from Joe [Louis] and Sugar Ray [Robinson] (though that old dancing master, wit, and bull-balled stud Jack Johnson is really my mentor, because he knew that if you operated with skill and style you could rise above all that being-a-credit-to-your-race crap because he was a credit to the human race and because if he could make that much body and bone move with such precision to his command all other men had a chance to beat the laws of probability and anything else that stuck up its head. . . .) [H]ere I'll also learn from your latest master strategists, the N.A.A.C.P. legal boys, because if those studs can dry-run the Supreme Court of the U.S. and (leave it to some moses to pull that one) I dam sure can run skull practice [a football coach's direct-hit teaching session] on the critics.[97]

It should be added here that Ellison's most significant mentor, as a writer, was Richard Wright, of whom the writer in training declared, "In him we had for the first time a Negro American writer as randy, as courageous and as irrepressible as Jack Johnson."[98]

But what is antagonistic cooperation as an artistic practice? *Invisible Man* offers important hints. The novel's prologue presents several scenes of conflict: the yokel and prizefighter, the slave woman who has poisoned her master (and whose sons by that man wanted to kill him, too), and even the sermon on how Blackness will make and unmake you, which ends with "a voice of trombone timbre" screaming at Invisible Man to *"Git out of here, you fool! Is you ready to commit treason?"* Next, the old singer of spirituals speaks ancient Hebraic lines, Job's *"Go curse your God, boy, and die."*

One after another, the novel's speakers confront contentious situations and hostile audiences: Trueblood, Ras, Tod, and Invisible Man himself are fighters with words. Several of Invisible Man's speeches are delivered in boxing rings or former boxing rings. Recall, too, that the novel's first pages involve a near-murder by our hero, who relents only because the white man who bumped him did not see his invisible self: "Out of resentment, you began to bump people back. And, let me confess, you feel that way most of the time. You ache with the need to convince yourself that you do exist in the real world, that you're a part of all the sound and anguish, and you strike out with your fists, you curse and you swear to make them recognize you. And, alas, it's seldom successful."[99] One of the ironies of being Black in America, Ellison says, is that at night, one may be "too dark to see"; and at other times, one is a fly in the buttermilk—"too dark not to see," with no place to hide.[100] He also meditates on the anger and violent impulses of Invisible Man, who, at times more like Wright's Bigger Thomas than readers may remember, swings hard at whiteness itself—relenting only as he realizes that for his specific white target, as for others, he does not exist.

Descending into Armstrong's "Black and Blue," Invisible Man hears a restatement of his grandfather's deathbed words: "Son, after I'm gone I want you to keep up the good fight. I never told you, but *our life is a war*," he says (echoing Buster's statement, "You have to outtalk 'em, outrun 'em, or outfight 'em"). Like Buster, the old man recommends strategies other than outright warfare. "I want you to overcome 'em with yeses," Grandfather tells Invisible Man, "undermine 'em with grins, agree 'em to death and destruction, let 'em swoller you till they vomit or bust wide open. . . . Learn it to the younguns," he whispers fiercely before he dies.[101]

Later, having left college and arrived in Harlem, Invisible Man confronts a man calling himself Peter Wheatstraw, whose blues singing suggests a world of enigmatic trouble to confront. Walking along in Harlem, he sings out: *"She's got feet like a monkey / legs like a frog—Lawd, Lawd! / But when she start to lovin' me / I holler Whooo, God-dog!"*[102] Here, obviously, the message is no more direct than the riddle of the Sphinx faced by Oedipus or the mysteries confounding other mythic heroes. Indeed, the words require the kind of wrestling for meaning—including the horrifying news that you yourself may be the problem you are trying to solve (something Invisible Man, like Sophocles's Oedipus, discovers)—that is an especially high-stakes form of antagonistic cooperation.

A similar lesson in parsing tricks and trouble is offered when the narrator discovers the practical joke of the letters played on him by his college's "bloodletting" president, Dr. Bledsoe. After traipsing around with letters of recommendation that advise prospective employers not to hire him, Invisible Man learns, finally, that he's been taken in by a cruel "fool's errand." Stunned by the news that he's the butt of this trick, Invisible Man is riding a city bus

when he hears a man whistling an old jazz-band melody that now carries a wry soundtrack to the sad but comically instructional trick-letter scene:

> Suddenly the bus jerked to a stop and I heard myself humming the same tune that the man ahead was whistling, and the words came back:
>> O well they picked poor Robin clean
>> O well they picked poor Robin clean
>> Well they tied poor Robin to a stump
>> Lawd, they picked all the feathers round from Robin's rump
>> Well they picked poor Robin clean.

The old song had been played for a laugh, Invisible recalled. "All the kids had laughed and laughed, and the droll tuba player of the old Elk's band had rendered it solo on his helical horn; with comical flourishes and doleful phrasing. 'Boo boo boo boooo, Poor Robin clean'—a mock funeral dirge. . . . But who was Robin and for what had he been hurt and humiliated?"[103]

In his 1962 essay on Charlie Parker, where this same melody, "Cock Robin," comes up again, Ellison himself gives the best gloss of the "lugubrious little tune":

> It was a jazz-community joke, musically an extended "signifying riff" or melodic naming of a recurring human situation, and was played to satirize some betrayal of faith or loss of love observed from the bandstand. . . . Parker, who studied with Buster Smith and jammed with other members of the disbanded Devils in Kansas City, might well have known the verse which Walter Page supplied to the tune. . . . Poor robin was picked again and again, and his pluckers were ever unnamed and mysterious. Yet the tune was inevitably productive of laughter even when we ourselves were its object. For each of us recognized that his fate was somehow our own.[104]

Typical of Ellison for these stripped-bare moments of revelation, in both the novel and the essays, to ring with laughter. Also typical of Ellison to remind us by the feather-plucking laughter that as humans, we are all in the same tragicomic predicament: all subject to be hooted at by the blues. Here, the "cooperative antagonist" must face the bluesy fact of free-floating trouble in the world. And the challenge is to anticipate and sidestep the trouble if you can, braced by the cautionary tale that is the blues. Or, since of course *all* trouble can't be avoided, face it with the equilibrium of the blues, and with the good humor (the blues-toned laughter) that includes a willingness to laugh at oneself.

Ellison's supreme model for antagonistic cooperation is the jazz jam session—rarer and rarer these days, I'm told, but still present on the contemporary jazz scene. Called by jazz players "cutting sessions," these are sometimes

fiercely competitive encounters where the unready are subject to get their "heads cut," as the musicians say. In such dynamic sessions, the fledgling player is taken to school as he/she discovers his or her voice, self, and soul through the ecstatic identification with mastery, as we have seen, but also through antagonistic cooperation. Fresh growth and discovery can also arrive unsweetly, through encounters where instead of ecstasy, one feels the sting of humiliation as one's brightest feathers are picked clean.

In his famously apt conjunction of prepositions, Ellison observes that in these cutting sessions, artists play "with and against" one another. Here, the contest is not merely about dry technical mastery in the sense of simple speed or complication of musical design; rather, it is passionate individuality in sound that is the sine qua non of jazz—playing the complexly layered self with purpose. In true with-and-against jam sessions, even tested old pros can find themselves in the thick of competitive angst: "And even the greatest can never rest on past accomplishments," says Ellison, "for, as with the fast guns of the Old West, there is always someone waiting in a jam session to blow him literally, not only down, but into shame and discouragement."[105] The bartender at Minton's told Ellison that whenever they were in that now-famous Harlem club, "Lester Young and Ben Webster used to tie up in battle like dogs in the road. They'd fight on those saxophones until they were tired out; then they'd put in long-distance calls to their mothers, both of whom lived in Kansas City, and tell them about it." And for those new to the cutting-room floor, the testing was harsh and public, but the prize was the invaluable badge of courage reserved for the truly initiated. Eddie "Lockjaw" Davis, for instance, "underwent an ordeal of jeering rejection until finally he came through as an admired tenor man."[106] Even Charlie Parker suffered such a trial by fire, and rejection, when he first came to the Big Apple from Kansas. "To finally come through," by the way, returns us to the discourse of spirituality, for to come through, in ecstatic Black church terms, is to cross over with a changed name into a bright new realm as one of the saved.

In jam sessions, Armstrong could be the most welcoming of teachers, volleying improvised choruses as if just for fun, each chorus containing a lesson. With peers, he could be the perfect host—not unlike a preacher making way for a guest preacher to enter the pulpit.[107] For those who preferred it the other way, Armstrong could take you directly to the woodshed for a beatdown. Through Satchmo's example, both Invisible Man and the readers gain instruction. In the case of the novel's narrator, instruction comes through hard lessons taught by master players: the grandfather, Bledsoe, Norton, Trueblood, Tarp, the old vet, Mary, Tod, Ras, Rinehart, and Brother Jack. The prologue's presentation of Armstrong has set us up to see this caravan of heroes, villains, and madmen as antagonists with and against whom Invisible Man must jam: through friendly instruction (Mary, Tarp), and then again through jam-session head cutting (Bledsoe, Jack). Even these last two, who in a sense try to destroy the young

man, serve as fierce initiators at last. He needs to know that such antagonists are out there and—like Buster and Unnamed in "Coupla Scalped"—how to work around or *through* them. It is in this odd sense that even Invisible Man's worst enemies "cooperate" with his project of gaining self-knowledge that can lead to purposeful *action*.

Both forms of jam-session learning—ecstatic identification and antagonistic cooperation—involve not only the required solitary, reclusive study ("'shedding") but also learning through interaction with a group. Further, two or more working in concert (and here, one cannot escape the New Testament's promise of spiritual intervention whenever two or more "gather in my name") produce something more than either working alone could have predicted or produced.[108] The jam session is not just a place of studying what's been invented already, but of creating pathways that are avant-garde in the military sense of finding new directions for advancement.

Jamming not only with and against other players, but with and against art forms themselves—editing the forms of blues and jazz, editing the forms of the novel—can also uncover new directions to action in that aesthetic sense, as well as in the hard-facts world of here-and-now political change.

The jam-session lesson is the greatest one to be learned from listening to Armstrong with an Ellisonian sound system. It teaches that in the dynamic spirit of the jam session—through ecstatic identification and antagonistic cooperation—one seeks one's voice and one's duty as an activist in the world: one seeks one's calling. These requirements of reception and rejection explain why Invisible Man cannot simply follow to the letter the grandfather's example or good advice—or Trueblood's or Ras's or the vet's mixed examples, not even generous Brother Tarp's or soulful Mary's.

In *Invisible Man*, even Armstrong comes in for severe scrutiny. "Perhaps I like Louis Armstrong," muses the invisible narrator, "because he's made poetry out of being invisible. I think it must be because he's unaware that he is invisible."[109] If the narrator means that Armstrong was not conscious enough, as an artist, of the significance of his music or his performative presence, I think he is wrong. Armstrong wore the mask of the carefree artist, but few worked harder on making art. As his archives in Queens, in New York City, show, even from an early age, he knew that he was *Louis Armstrong*! I think Ellison—or to be fair, just his narrator—may have been faked out by Armstrong's stage-show nonchalance (how hard it is to make any real skill look easy!). I also think Ellison wanted his character, Invisible Man, to resist the wisdom even of the novel's wisest man and greatest exemplar, in the jazz mode of thinking for oneself and in the mode of dynamic collaboration to produce the new.

Invisible Man must measure and weigh the advice of *all* these father-mother figures. True to a long literary tradition, some of the best advice in the novel comes from the insane asylum inmate, who tells him that he must "be your

own father."[110] Put another way, he must engage in the jazzlike interaction that requires more than call/response or other forms of simple linear dialogue or consecutive reasoning. It requires an ongoing process of deeply engaged inter-action in search of the new, the wearing of the skin of the second self, whether in ecstasy or in the turmoil of antagonistic cooperation, until one "comes through" with the ability to swing one note, as Armstrong could do—or, in the Monk, Miles, and Lady Day tradition of jazz, to make silence swing.

CHAPTER 2

WE ARE ALL A COLLAGE

Armstrong's Operatic Blues, Bearden's Black Odyssey,
and Morrison's *Jazz*

*I learnt how to quilt from my grandmother Virginia. . . . I was on one end
and she was on the other end. I liked to be with her. . . . How I start to
make a quilt, all I do is start sewing, and it just come to me. My daughter
ask me the other day what I was making and I said, "I don't know yet; I'm
just sewing pieces together," and the quilt looked pretty good. No pattern.
I usually don't use a pattern, only my mind.*
—Lorraine Pettway

Someone is stitching up a hem, darning /
a hole in a uniform, patching a tire, /
repairing the things in need of repair.
—Elizabeth Alexander

Reparation . . . is such an essential part of the ability to love.
—Melanie Klein

Performing Collage: Armstrong and Pagliaccio

I start with the great Louis Armstrong: a man of parts and pieces if ever
there was one. He will help us approach my thesis that *We are all a collage*, as
individuals and as a planetary community. How in the world can we all find ties
that bind?

With his horn and his voice, Armstrong created extraordinary musical
collages: virtuoso stitchings in sound. In his music and his acting, he created

wondrously complex versions of himself, including self-inventions that were deeply troubling to certain audiences—portraits that make even as generous a cultural historian as Gerald Early label him "Uncle Tom."[1] The most casual observer knows that Armstrong played stereotyped movie roles, as in the often-cited short *Rhapsody in Black and Blue* (1932), where he appears in a ludicrous leopard suit to deliver a not-funny race song titled with the racist epithet "Shine." Billie Holiday's defense, that he "Toms from the heart," gives us Louis lovers small consolation. Neither does the footwork of Krin Gabbard and others help much when they declare that in the leopard-suit scene, as the trumpet genius lifts his golden horn with an arm of steel and plays the solo of life—Mister *Arm-Strong* indeed—all else is forgotten. I much prefer the sober reading of Brent Hayes Edwards, that in the case of Armstrong's offensive images and lyrics, there's no easy consolation to be had—we are stuck with the great man himself in a stupid suit, awash in soap bubbles and racial stereotypes. We accept these offensive trifles, Edwards says, alongside the great man's notes of genius, one image never canceling the other but only hanging there, as the pieces of a collage hang side by side—some of them miscellaneous pieces that we cannot fathom.[2]

On April 17, 1955, *The Ed Sullivan Show* featured Armstrong in a skit where he sang "Vesti la giubba" ("Put on the costume"), the famous tenor aria from Ruggero Leoncavallo's 1892 opera *Pagliacci* ("Clowns").[3] Here is Armstrong the funnyman musical genius, adding notes of tragic Italian opera to his collage of a performance. The joke of intentionally miscasting Armstrong in opera was matched by opera star Robert Merrill's misfit casting: in answer to Armstrong's rendition of his new hit record "Vesti la giubba," he would (over)sing Armstrong's hit "Honeysuckle Rose." "We're going to open the show tonight," said Sullivan, "with Basin Street versus the Metropolitan Opera House!" At the risk of seeing collages everywhere, all the time, note that along with the Black-white cross-casting comes the juxtaposition of nineteenth-century "high" Euro-art and modern "pop" American hit-song-singing—hanging together in defiance of ready-made taxonomies.

By the mid-twentieth century, "Vesti la giubba" was best known in U.S. pop culture as a prime example of opera art gone to seed in cartoon comedy and rock-and-roll songs—some of which, at least, retained something of the aria's original pathos and sting. "Just like Pagliacci did," sang songwriter Smokey Robinson in 1967 (a year of racial rebellion in his home city of Motown), "I try to keep my sadness hid."[4] In the opera, the actor Canio, circus clown by trade, discovers his wife's infidelity but finds that he must nonetheless "put on the costume" because "the show must go on."

Armstrong would have known "Vesti la giubba" as a standard performance piece from his formative years in 1910s and 1920s New Orleans, America's

Louis Armstrong and Robert Merrill, appearing together on the *Ed Sullivan Show*, 1955.

SOFA Entertainment.

premier city for live grand opera at the time.[5] The theaters along the St. Philip Street and St. Charles Avenue of Armstrong's youth offered gallery seats to Blacks, and, in one case, a balcony with a barrier dividing the races, "which would prevent any kind of communication."[6] Although the young Armstrong was too poor to have theater ticket money, he certainly heard performances while standing on these streets, which were near his Third Ward home turf nicknamed "Back O'Town" or "The Battlefield." "I had Caruso records too," recalls Armstrong, who bought his first Victrola when he was seventeen,[7] "and Henry Burr, Galli-Curci, Tetrazzini—they were all my favorites. Then there was the Irish tenor, McCormack—beautiful phrasing."[8] Black performers sang and played opera "sets" (often including other musical forms too) at Black functions, formal and informal. If any city in America could be called Collage City, this city of four or five European and U.S. flags—many more once its African, Caribbean, Native American, and Asian residents' colors are unfurled—it would be La Nouvelle Orléans! Home of the Black Indians and, as we shall see, of Armstrong as the Zulu King.

One of the Library of Congress interviews with Jelly Roll Morton, jazz music's first theorist, features Mister Jelly on the piano, casually streaming excerpts from Charles Gounod's *Faust* and Giuseppe Verdi's *Il Trovatore* as he reminisces about the standout party pianists of the 1890s on Royal Street in New Orleans. To illustrate the scene of his boyhood, Morton plays a wistful piano version of *Trovatore*'s "Miserere"—an aria also quoted by Sidney Bechet on his 1939 version of "Summertime" (the first recorded jazz treatment of that aria from George Gershwin's *Porgy and Bess*).[9] As Ricky Riccardi observed,[10] in his trumpet improvisations, Armstrong often quoted arias he favored, including *Pagliacci*. The high notes concluding many Armstrong performances from the mid-1930s onward may well have been influenced, as Riccardi said, by the trumpeter's love of the recording of the *Rigoletto* quartet "Gualtier Maldè" that features the voice of coloratura soprano Amelita Galli-Curci.

Confronted by an interviewer's general question about opera in 1962, Armstrong began to sing (in his alluringly scratchy tenor voice) the dramatic lines of Maddalena, *Rigoletto*'s contralto.[11] The point is that popular arias like "Vesti la giubba" were part of the air one breathed in that city, regardless of race or class. One early-twentieth-century white visitor from Alabama "was struck by hearing Negroes in the streets of New Orleans humming operatic melodies."[12] Along the Nola streets of Armstrong's youth, musical collages that included snatches of opera filled the air.

Of course, 1910s New Orleans was not just the nation's greatest opera city; it was also one of the nation's smokin'est hotbeds of gospel (Mahalia Jackson was born in New Orleans in 1911) and blues, with several varieties of blues idiom, including infant forms of jazz, on the city's burners. Any of these Afro-musics, most explicitly the blues, could confirm the comic aspect of the proclaimed will of "Vesti la giubba" to go on with the show in the face of tragedy. (Unlike pop versions of the blues, Sterling Brown said, "where the sadness is feigned," in the genuine blues "it is the happiness that is feigned."[13]) Here is one bluesman's answer to the discovery that his wife is two-timing him: "I heard my woman call me by another man's name / I knew she didn't mean me / but I answer just the same." Oh, my brother! In another blues, Johnny Shines consoles himself by boasting, "I'm'a build me a mansion, out on some ole lonesome hill / To every one woman who won't like it, / There'll be a hundred-and-five that will!"[14]

Can there be any doubt that as a Black man in twentieth-century America, Armstrong knew the experience of *laughing on the outside*, as the expression goes, while *crying on the inside*? He understood the Black artist's experience of being taken lightly or outright ignored—or called an Uncle Tom—while, in fact, being deadly serious about their art and routinely taking political action. Of course, Satchmo did not have the conventional, outsized, operatic voice; but knowing the song and many like it across the categories, he projected it with deep virtuosic passion on the *Sullivan* show. Through the mask of light comedy,

Armstrong *sings out*, as they say in certain Black churches, doubtless delivering much more complexity of meaning than Sullivan's Sunday after-suppertime viewers expected to receive: the layered performance as collage.

Armstrong's "Vesti la giubba" brims with other comedy, too. After tapping his chest as if to clear his system and performing a few mock test sounds—"Mi-mi-mi-mi-mi-mi," now oddly suggesting that, in spite of all appearances, he is about the business of projecting *himself* as usual: "Me-me-me-me-me-me!"—Armstrong assumes the classic operatic pose: hands clasped across his chest. With a secret smile, he looks through the camera's eye at his millions of viewers and lifts the melody in a mix of Italian and English:

Vesti la giubba [Put on the costume],
Smear your face with powder.
The people pay you, and they must have fun!
Ridi, Pagliacci! [Laugh, Clown!]
Come and dig little Satchmo,
Playing the clown,
Laughing it up and DOWN!

By the time he reaches the line "Ridi, Pagliaccio!" Armstrong is in full effect! The superficial joke is set aside as he reaches for blueslike comedy at the edge of tragedy, singing to the rafters with head thrown back in a *very* large tenor voice, one unmistakably his own (as the jazz tradition insists). With the line "Come and dig little Satchmo," he mugs for the camera and studio crowd, as if acknowledging the joke in his nickname: "Satchel-Mouth" (and the fun of the whole exercise). But as he interrupts the phrase "Laughing it up" by bursting into a strong mock laughing fit, a kind of roar, he mimes the removal of makeup or a mask from his face. He glances at Merrill and then finishes with "and DOWN!"—followed by more laughter edged with aggression. Merrill evidently is so affected by the unexpected mix of ingredients in Armstrong's performance that he misses his cue to slap five with "Little Satchmo," who has stolen the show. "We wear the mask," writes the novelist Ralph Ellison (and Armstrong seems to know), "for purposes of aggression as well as for defense."[15]

Is it an exaggeration to declare that Armstrong had masked political agendas here? Perhaps the answer lay in the fact that his appearance on *The Ed Sullivan Show* that night occurred just a few months after Marian Anderson's debut at New York's Metropolitan Opera House on January 7, 1955, finally breaking that theater's color line. Was it to commemorate that event, covered in the worldwide press, that the set of the *Sullivan* show that night included matching signs in all caps: "METROPOLITAN OPERA HOUSE" and "BASIN STREET CLUB"? I think so. Armstrong's appearance beneath that sign, shoulder to shoulder with Robert Merrill, celebrated the breakthrough achievement of Anderson,

Black America, and opera. The backstory of placing this Armstrong-Merrill routine on the *Sullivan* show remains a mystery.[16] Who pitched the skit to Sullivan? Did the idea of doing it that particular night come from Sullivan, a man not known for his activism on the picket line but well loved in Black America for routinely showcasing Blacks on prime-time television? Or was the secretly smiling Armstrong—who "put on the costume"—behind it all?

Meanwhile, who knew, then or now, that Armstrong was literally a collagist—a maker of visual artwork in the form of collage? In 1953, the jazz artist wrote to a friend that one of his favorite pastimes was "using a lot of scotch tape . . . to pick out different things when I read and piecing them together to make a little story of my own."[17] A thinker-tinker (as Ellison's character Invisible Man says of himself), Satchmo enjoyed decorating the boxes that came with the tape recordings of music and informal talk that he had made in his den at home (in Queens, New York City) and in dressing rooms and hotel rooms on the road. Onto all the surfaces of these seven-inch-square cardboard boxes, Armstrong taped photographs (or hand-cut fragments), greeting cards, and miscellaneous materials culled from the tidal wave of media covering his career. Some of these tape boxes feature scissor cuttings as delicately done as Valentine's Day greeting cards of another era. More often, the tape boxes are thick with clippings of printed words, along with Armstrong's own typed and/or hand-drawn words—often playlists of recorded materials or brief commentaries on the pictures. A survey of the archive at the Louis Armstrong House Museum in Queens, where the boxes are kept, shows that Louis enjoyed using liberal amounts of tape—not always just clear tape, sometimes masking tape and/or heavy hospital tape—to "laminate" the collage boxes and/or to create borders, frames, textures, and layers that turned up their volume (so to speak). Some of his visual compositions are quite beautiful. Few are without touches of humor, sly subtleties along with strong doses of self-mockery. All feature high energy from the man who loved to create new versions of himself, in whatever medium was available.

Of course, Armstrong's box-collages invite comparison with his other forms of expression. His many typed and rugged handwritten letters and autobiographical works—with their invented systems of spelling, capitalization, and punctuation and overlay of amendments and insertions—suggest a kind of word-collage. More important, might his trumpet and vocal solos—with their boldly stitched (and then invisibly backstitched) quotations from the church house to the house of blues, from opera, Hollywood, Broadway, and Tin Pan Alley, and from Crescent City parade routes and the singsong dirty dozen narratives from Back O'Town Nola—be called collages in music? And might Armstrong's collage aesthetic give us a new way to think of his complicated stage and screen performances, with their mixes of concert elegance, starburst solos, and sideshow high jinks that are sometimes a half-step from minstrelsy? Here, do we not see the musical genius, autoarchivist, minstrel jokester, and Caliban—all

Audiotape box collaged by Louis Armstrong in 1956 or 1957; "420" is a code number for marijuana, his recreational drug of choice, and "Swiss Kriss" was his favorite laxative.

Courtesy of the Louis Armstrong House Museum.

on the same page? Maybe Armstrong's collage aesthetic helps us see the slapstick humorous optimism, as well as the dead-serious politics, folded into his surprising version of "Vesti la giubba."

It would be an absurd exaggeration to declare Louis Armstrong either a ballot-or-bullet activist in the tradition of Malcolm X or a visual artist in the tradition of Pablo Picasso and Romare Bearden.[18] But to jump-start our discussion of constructing art and the self, who could be better than Satch, with his layered art forms and persona? Bearden said that the art of visual collage is "putting something over something else,"[19] layer on layer. Sidney Bechet wrote that his music consisted of "pieces of melodies"—a soundscape of the Crescent City and Côte d'Azur (and many other places) he knew well. Jazz is a layered

music where a blues-based melody is put over blues changes, Gershwin's "I Got Rhythm," or another pop song, and where quotations from all over the globe may abound. And jazz is a musical narrative displayed "in pieces," as novelist Gayl Jones says, with one fragmented storyline leading to another "instead of telling one long thing."[20] In the case of Satchmo's "Vesti la giubba," the "jazz" (an early expression for the improvised part of a performance) is placed on top of an opera played to Sunday night's most populous audience: Sunday-night collaged music by a Sunday collage maker, if you please!

Collage and the Layered Self

On November 13, 2006, Toni Morrison spoke at a Columbia University conference celebrating the artist Romare Bearden, and, true to form, she gave the audience everything they came for, plus a good deal extra.[21] That afternoon, she recounted a chance meeting with Bearden on an airplane and his promise of a gift, soon delivered, of a collage representing a character from one of her books. It was an "extraordinary, completely stunning portrait," Morrison told her audience. Bearden's collage *Pilate* (1979), based on Morrison's novel *Song of Solomon* (1977), showed her aspects of the fictional character that she

> hadn't seen or known or even suspected when I invented her. What he made of her earring, her hat and her bag of bones was far beyond my word-bound description. Heavy, heavy with the life that both energized and muted her, [Bearden's *Pilate* was] daring anyone to deprive her of her symbols, her history, or her purpose. I had seen her determination, her wisdom, and her rather seductive eccentricity, but I had not seen the ferocity that he saw and rendered.[22]

Could Bearden the collagist do things that Morrison could not do in language? "Well," she said, "I can do a lot in language, I can make it sing; but by the time Romare gets through slashing at paper with that knife of his, yes, he can do things I cannot do."[23]

As much as the backstage-and-front-stage collage work of Louis Armstrong, Morrison's reflections on Bearden and her own work as a novelist have enabled my case for collage as a model for self and community.[24] As Morrison's talk raised questions about the mysterious rhythms of artistic influence across and through the genres—and about things that one art form could do that another could not—it also made me wonder about the creative process in general: "the quiet at the center,"[25] from which art that is sometimes as fierce as Bearden's Sister Pilate emerges. What interests me just as much is the modernist idea, posited in collage but also present in literature and music, that we are *all* a collage: a mix and mixtery of elements, as individuals and as a community, not

just as nationals but as citizens of the planet we share with plants and animals, water and soil, fire and firmament.[26] What, to quote an old church song, are the "blest" ties that bind? What are the possibilities for healing, for repair? What draws us together?

A historical predecessor to modernist ideas of identity as collage is Michel de Montaigne, the Renaissance Man (in the double definition of that term) who saw in a flash the thesis that I'm arguing all these centuries later. Montaigne wrote: "We are all patchwork and so shapeless and diverse in composition that each bit, each moment, plays its own game. And there is as much difference between us and ourselves as between us and others." He warned (reminding us of Walt Whitman on this subject),[27] "Human actions commonly contradict each other so strangely that it seems impossible that they have come from the same shop. One moment young Marius is a son of Mars, another moment a son of Venus. Pope Boniface VII, they say, entered office like a fox, behaved in it like a lion, and died like a dog."[28]

"We are all patchwork" is a translation of Montaigne's phrase "Nous sommes tous de lopins." "Lopins" referred to pieces of cloth, or swatches, and later expanded in meaning to include cuts of meat and plots of land or crops ("lopins de terre"): strips divided from an original whole. Picture the view from an airplane of rectangles and rows of farmland—or of neighborhoods, urban and suburban. That Montaigne specifies *"de* lopins" suggests not only that each person is a patchwork of pieces and parts, but also that each individual is cut from a single, huge roll of original material.[29]

Montaigne's patchwork thesis guides this chapter and this entire book. Its resonance with formulations of the collaged character of the Black American self and community (in the expansive contexts I've been describing) is expressed with eloquence by Elizabeth Alexander, who observes, "Collage lets us think about identity as a spoked wheel or gyroscope on which its aspects spin and recombine. Collage also allows us to see African-American creative production as cohesive rather than schizophrenic. In other words, the disparate aspects of personalities and of influence that might seem contradictory can actually coexist in a single personality, or a single identity."[30] There's a vital feminist aspect here—one associated with the Black woman's circle of quilters. "Any discussion of the African-American collage," says Alexander, "must include a discussion of the quilt. Quilts embody the simultaneous continuity and chaos that characterize African-American history in all spheres. If African-American creativity is always in some way grappling with African-American history by trying to knit together the fragmentation that forms its core and the paradox of fragmentation as a center, quilting is a motif for a creative response to that history."[31] All but exclusive to women, African American quilting is an art of collaborative improvisation—a practical art of using patches and pieces to make composite wholes, to "make do,"

which exemplifies what Zora Neale Hurston specified as "characteristics of Negro expression": angularity, dynamic insinuation, asymmetry, and the never-too-much-beauty rule that she called the "will to adorn."[32]

Bearden's friend the poet Derek Walcott has observed that every time Bearden took out his scissors to make a collage, he honored Black women—even when he was not explicitly depicting quilts and quilters, as he often did. The quilt-collage connection is explicit in Bearden's collage *Miss Mabel's Quilts*, from his semiautobiographical *Profiles* series of 1979, which includes quilt-like patternings throughout—wallpaper, pictures around the room, furniture, textures of skin. Reminiscing about scenes that informed *Miss Mabel's Quilts*, Bearden said that when his childhood neighbor Miss Mabel washed and hung her quilts on the line to dry, his whole community was treated to a fantastic show of imaginative play with color, shape, and texture—all granting young Bearden a sense of direction in art.[33] In the *Profile* series, quilts and quiltlike patterns are so pervasive, they suggests that the quilters' circles may rival Bearden's ubiquitous trains as forms inspiring his artistic creativity.

Romare Bearden, *Profile/Part I, The Twenties: Miss Mamie Singleton's Quilt*, 1978. She was famous for her quilts. Collage on board, 28 × 41 inches. The title and accompanying sentence were composed by the artist in collaboration with the novelist Albert Murray.

On this question of art and Black identity, Morrison also finds it immeasurably important to see Bearden's collaged images of Black Americans not as indications of *fractured* Black selves but as complexly *layered* selves: selves as collages and the Black community as a highly variegated set of collages. Of course, all parts and members of the U.S. Black community are not the same: within the group—there's a wondrous variety of languages, accents, and ways of living. I define Black selfhood and community as collagelike in their tears, frayed edges, and sometimes uneasy fits and textures—the patches of bold color that work, although we can't say precisely how—that are part of the fabric of personal and group culture. Here's where I locate a wondrous African diasporic set of identities: a multicolored Black collage,[34] supported by shared stitchings, common enemies, and an enduringly soulful will to work (and play) together.

The idea of selves and communities as collages resonates in the work of the contemporary philosopher-poet Fred Moten, who, with special reference to African American life, has written about the self as a traveler or "touring machine."[35] For him, this self at its best is "communitarian": a "touch-activated," fast-moving set of "generative forces," deploying a "social interactive rebellious play of improvised selves." In a further virtuosic tumble of poetic terms, Moten praises the traveling Black self as a kind of "unregulated," "interconversational" jazz-band player: a section player and soloist, as well as a composer, arranger, and bandleader making music on the fly. We are all, at our best, *de lopins*—not only are we collages, as individuals we are pieces from *(de)* collages: all part

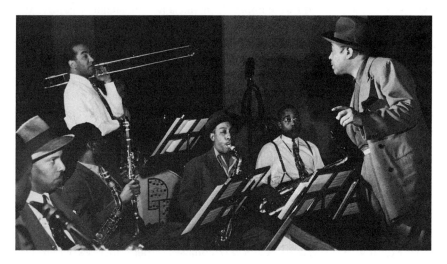

Duke Ellington (right), with (from left) Harry Carney, Otto Hardwick, Jimmy Hamilton, Lawrence Brown (trombone), Johnny Hodges, Al Sears. Ca. 1945. Rehearsals were part of the process of composition.

of a jazzwork or collage-in-music kind of music in motion. What excites me as much as Moten's idea of the self in motion is his presentation not only of jazz-band players, but also *jazz-bandleaders* as special cases of self and selves in motion. The case of Duke Ellington, the composer-bandleader who was also one of his band's greatest soloists, is particularly pertinent here. Ellington cocomposed his music with and for (and yes, against) the fifteen or more band-mates who completed his/their work in improvised performances that changed a bit (or a lot) every night.

Moten's thinking springs, as he often acknowledges, from the Martinican philosopher Édouard Glissant, who speaks of the modern Black self as born in the "moment when one consents not to be a single being and attempts to be many beings at the same time." For the Black woman or man, the transition to modernity is the moment of "passage from unity to multiplicity . . . the moment when all the components of humanity—not just the African ones—consent to the idea that it is possible to be one and multiple at the same time; that you can be yourself and the Other; that you can be the Same and the Different." Glissant adds, "When that battle is won, a great many accidents in human history will be abolished."[36] His marvelous use here of the word "consent" (whose Latin roots mean "to feel together") makes explicit the idea that we can give *consent* to our collaged selves and communities, and in so doing, we express our will to harmonize ourselves: to draw ourselves together.

In their art, Bearden and Morrison are working through some of these same ideas and ideals—improvising selves in relation. "The more I played around with visual notions as if I were improvising like a jazz musician," Bearden told an interviewer, "the more I realized what I wanted to do as a painter, and how I wanted to do it." He continues:

> You have to begin somewhere, so you put something down. Then you put something else with it, and then you see how that works, and maybe you try something else and so on, and the picture grows in that way. One thing leads to another, and you take the options as they come, or as you are able to perceive them as you proceed. . . . Once you get going, all sorts of things begin to open up. Sometimes something just falls into place, like piano keys that every now and then just seem to be right where your fingers happen to come down.[37]

Beyond depictions of improvisation to improvisation as a way of painting, how exciting to discern Bearden's jazz/collage aesthetic in work where jazz seems very far from the artist's mind. Two examples that are also relevant for questions of Black identity are his *Odyssey* series of the late 1970s, based on Homer but set in African or Caribbean landscapes;[38] and again his contemporaneous *Profiles* series, tracking the emergence of the artist's personal aesthetic

through sources ranging from the quilts and gardens of Mecklenburg County, North Carolina, where he was born, to an array of other American, Asian, African, and European influences. In both of these beautiful series of collages—refusing, as collages, any rigid narrative lines and fixed rhythms—traces of jazz show up in unexpected, yet very highly significant ways.

Bearden's *Profiles* and Pan-Atlantic *Odyssey*

Both in his two-part *Profiles* series, drawing on personal reminiscences from the 1920s and 1930s, and his *Odyssey* series, drawing on decades of reading Homer, Romare Bearden undertakes journeys home, each trip shedding light on the other, and each revealing aspects of Bearden's collage aesthetic beyond the realm of his artworks as such. Best known for depicting the rural Black South and the Black urban North, contexts he knew intimately and revisited in the *Profiles* works, Bearden created the *Odyssey* series in 1977, and in so doing staked claim to Homer as an ancestor whose ancient, epic poem he would amend. Bearden made *The Odyssey* more relevant to his time and place—and to questions of modern Black identity. As I will discuss, we can also see the emergence of his collage aesthetic in the *Profiles* series.

Amend Homer's text Bearden did: he did not *illustrate* the ancient tale; instead, in the spirit of the improvising collaborator, he transformed[39] the epic, moving it from one form of art to another, adding and subtracting as he saw fit, translating printed words on pages into lines, colors, and rhythmically patterned images arranged on the multisized boards, canvases, and papers that make up his takes on Homer. The wondrously complex layering and unlayering (including the tearing away) of Bearden's *Odyssey* collages reflect the artist's will to shift emphasis, multiply entry points, and explode perspectives.

In remaking *The Odyssey*, Bearden declares himself free of any narrow portals of artistic lineage based on race, nation, era—or even of artistic form—for he translates poetry into the cuts and colors of collage. It is significant that Homer inherited the epic of Odysseus from long traditions of story and song (and visual renderings from ancient Greek pottery and sculpture) that shaped and shifted tales and characters from teller to teller. Bearden inherits all: the oral and written, painted, carved in marble, sculpted in stone. And he adds to them his own inheritance of modern retellings of Homer by James Joyce, for example, and by his literary friends Claude McKay, Derek Walcott, and Ralph Ellison.

Bearden's most radical innovation is the Africanness of his *Odyssey* series, and especially his reimaginings of Poseidon and Circe as African deities. In an important interview, Bearden spoke, in particular, of Poseidon's African roots—something strongly suggested in Homer—and of the decision to underscore

Romare Bearden transformed Homer's Poseidon (a) and Circe (b) into black gods. *Poseidon, The Sea God—Enemy of Odysseus*, 1977; collage of various papers with foil, paint, ink, and graphite on fiberboard, 44 × 32 inches. The Thompson Collection, Indianapolis, Indiana. *Circe*, 1977; collage of various papers with foil, paint, and graphite on fiberboard, 15 × 9 3/8 inches.

(not contradict) the celebrated universality of *The Odyssey* by choosing jet-black paper cutouts to depict the epic's characters:

> I had an exhibit of all the Odysseus Series at a college. And a Japanese student asked me why were all the people in the series black, because it's Homer's *Odyssey*. I said, well, everyone says that this is a universal statement. It has to do with a search for a father. It has to do with adventure . . . [It] involves Poseidon who always has to come up from Africa, where he wants to be with his friends there. And it is universal. So if a child in Benin or in Louisiana . . . sees my paintings of Odysseus, he can understand the myth better.[40]

Surrounded by a watery blue field and wearing a Benin mask of Cape Crest, Bearden's Poseidon carries symbols of war and death to Odysseus and his fellow marauders, who have blinded Poseidon's son Polyphemus, the Cyclops.

Not only does Poseidon bear a shield and spear, he also holds a sad-looking skull, as if to make his deadly powers of vengeance more vivid. Here is Bearden the modernist, committed to the Black American Freedom Movement, asking us to see the world from the point of view of an African sea god who's furious because his family members have been killed in his waters: many millions gone. Here we witness Bearden's search for new artistic angles, new audiences, new forms of life.

With this in mind, it is not surprising that in one little-known precursor of the *Odyssey* series called *The Cyclops*,[41] Bearden suits up this version of Homer's one-eyed "monster" as an Afro-Caribbean spirit-figure set to use force, if necessary, to maintain good order.[42] A ghastly, Klansmanlike specter (a modern Odysseus, without the heroic trimmings) threatens this Cyclops and his lush

Romare Bearden's one-eyed son of Poseidon is a Black Power figure. *The Cyclops*, ca. 1968; collage with various papers on fiberboard, 12 × 18 inches. Collection of Robert G. O'Meally.

green home, again. But this time, the collaged Afro-figure—who represents many Black power traditions, east and west—stands ready. His single-eyed face is a thumb piano or mbira: from an ancient African family of instruments often associated with marshaling the ancestors. What does this Black God's son (or grandson) want? *JUSTICE!* When does he want it? *NOW!*

But Bearden's *Odyssey* of the 1970s chooses as its main character neither Poseidon nor his son, the Cyclops. Nor is the protagonist of this epic-as-collage either Odysseus or his son Telemachus, whose coming-of-age narrative occupies the first third of Homer's *Odyssey*. Instead, Bearden's Black Odyssey is all about the women, particularly about Sister Circe: five of the twenty-one collages in the series depict her and her enchanted realm. In Homer, she's the beautiful lover-witch, guiding and tempting the hero. Rhyming nicely with prior imagery in his oeuvre, Bearden's Black Circe should be seen as part of his long series of conjure women: American Black women—Southern, Northern, and Caribbean—who, according to tradition, could mix a potion to send a wayward man back home to his wife. Or, alas, things could go the other way—the conjure woman could drop a man dead in his traveling shoes. In Bearden's *Red*, Sister Circe is a glittering, gold-jeweled, Afro-Eurasian goddess, set against a royal red background, who keeps a snake, a lion, and a cock-eyed bird (other men who have crossed her path?) around her as pets, and who nonchalantly looks death directly in his hollow-eyed skull. Set on a pedestal next to Circe, this death's-head is evidently ready to end the days of anyone she names. Her profile suggests traditions of Indonesian puppetry, while the uncoiling snake on her arm[43] marks her as a cousin of the African Mami Wata figures charted by Henry Drewal as women of superior spiritual as well as physical (and sexual) potencies who vigorously swim the seas.[44] True to Bearden's project of global collaging (not without its own will to ironical juxtaposition), Red Circe's snake connects her with the Hebrew Bible's Eve.[45] Coming and going, Sister Circe is a change agent of extraordinary powers and representative of Bearden's collage medium as message.[46] And part of whose message is that to get home, don't follow the men this time—*follow the women!*

In Bearden's *Odysseus Leaves Circe*, the goddess adopts a shape that makes her a close cousin to this artist's many other powerful women, including Billie Holiday. Among Bearden's several portraits of Holiday was the collage he made in 1973 to fulfill an album cover-art commission for the compilation *Billie Holiday: The Original Recordings*. Bearden depicted Lady Day, whom he'd known since their first days in Harlem when they were both young adults, as a triumphal goddess—not, according to the cliché, as the broken Lady of Sorrows. Holiday's triumph, Bearden knew, was that in her music, she confronted the blues-fact that life is a "botheration on the mind" and a "low-down dirty shame," but that life did not defeat her, or us, anyhow. The lesson of blues music, Bearden affirms again and again in interviews and in his paintings—and now in this blues collage—is that art celebrates victory. Farah Jasmine Griffin has observed that in

Holiday's most famous blues song, "Fine and Mellow," Lady makes clear that her love is not to be taken for granted: "Treat me right baby," she announces, or "you know you gonna drive me away." The brilliant note of surprise in this Holiday collage is that it is one of Bearden's very few self-portraits: emerging from the wings, at the top center of this Lady Day album cover, is a small, hatted figure wearing Bearden's signature overalls—a cutout of the artist himself! And voila! It's Lady Day (actually *two* Lady Days in this collage) opening the curtain to make way for Bearden to do his thing. *Follow the Lady!*

Like Lady Day, Lady Circe is part of a long line of powerful women lighting up Bearden's canvases: wondrously beautiful goddesses, as well as conjurers and obeah women who reveal as well as reorder the worlds through which they move. With such improvising change agents in mind, Bearden's sense

Romare Bearden created this collage for a Billie Holiday album cover. The artist said that his favorite Holiday song was "When the Moon Turns Green." Note what appears to be a self-portrait, in the top center. *Billie Holiday*, 1973; collage of various papers, acrylic, and fabric on fiberboard, 27 × 31 inches. Private Collection.

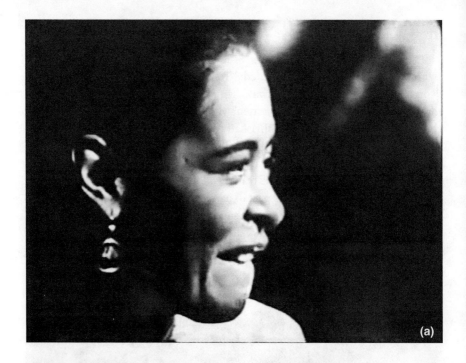

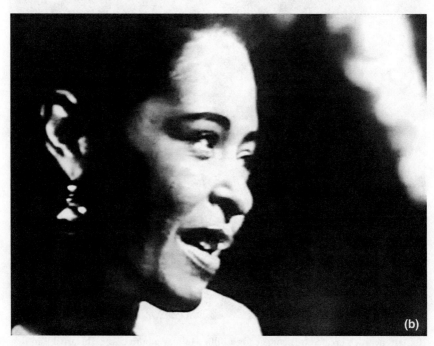

Billie Holiday (a, b) and Lester Young (c). In these stills from their TV performance of "Fine and Mellow," you can feel the mutually felt ecstasy of influence. "The Sound of Jazz," 1957, CBS.

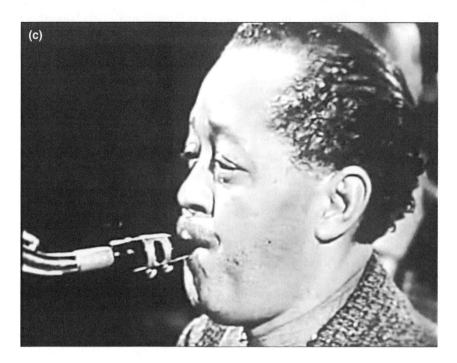

(*continued*).

of mission as an artist steeped in jazz culture as part of planetary culture is confirmed.[47]

The writer Albert Murray referred to the *Odyssey* series work called *Odysseus Leaves Circe* as *Circe's Empty Bed Blues!*[48] As with *Red Circe*, there is no passage in Homer to which this collage refers directly: no reclining nude Circe in Homer, no attendant offering solace, no sparse room, no ship at a distance, sailing away. This is strictly Bearden's take on the departure of Odysseus from the point of view of the all-too-human (though divine) lover left, as it were, to sing *Circe's Empty Bed Blues*. As in his other *Odyssey* series works, the surface is flattened and dramatically colored—the Cubist's play of tilted boxes, including the boat-shaped parallelogram that is Circe's bed of sorrow, on which she swims out of her clothing, tightly clutching a pink pillow/surfboard. And there is the contrasting play of clipped circles—a bowl, a vase, the ends of the pillow/surfboard's curves retracing Circe's voluptuousness in lines contrasting the rigid poles of her beloved's departing ship. Her curviness contradicts any impression that this woman of the blues has been fatally wounded: like the saucy personae of many a Bessie Smith blues, this "well-girdled woman" (to quote a phrase often used by Homer), a goddess after all, will rise again.

In this context of powerful blues women as influencers of Bearden's art, let us turn to Bearden's only acknowledged self-portrait, *Artist with Painting and Model* (1981),[49] in which he depicts himself standing before a nude Black female model, having painted/collaged two women in the work-within-a-work shown here. It's significant that *Artist with Painting and Model* also shows sketches of women on the studio floor—female muses everywhere! The two Black women in the collage (who recur in many works across decades) are sometimes identified as Mary and Elizabeth, the mothers of Jesus and John the Baptist, at the moment of the Annunciation—the acknowledgment that both women are pregnant with transcendent spiritual figures. It's fair to say that Bearden reflects here, in 1981, on his own version of this scene from 1934, and he translates its earlier forms into his now-preferred language of collage—with its aesthetic of layering, improvisation, and transformation. One of the three female figures in the sketches on the floor is the Benin Queen Mother, the African image most often collaged into Bearden's works—and an important source for his explicitly Africanized revision of the painting of the 1930s. A primary subject of *Artist* is Bearden's evolving creative process, emphasized by his inclusion in the work of these work-pad sketches as well as other tools—pencil, paintbrushes, and journal, along with the gray sheet of paper from which the artist has cut out the form of his own hand. Other "models" for *Artist* are suggested by the inclusion of a reproduction of a painting by the thirteenth-century Italian Duccio de Buoninsegna, masking-taped to the wall behind the easel.

The nude model shown in *Artist* is identified in the work's accompanying text (these appear with each entry in the *Profiles* series): "Every Friday Licia used to come to my studio to model for me upstairs above the Apollo Theater." Her name alone, Licia (meaning "light" in Spanish and Italian), a popular name choice around the globe, makes Bearden's model a kind of universal female figure: the eternal feminine, with her lovely cloth waist-wrap. But above all, the presence of this African American model in his studio (her sketch resting beside the Benin head) and the reference in the work's accompanying text to his days in Harlem "above the Apollo Theater" recall one of the self-fashioning stories most often told by Bearden. This is the tale of "Ida," a "homely" street-walker who offered to model for the young Bearden at a time when he was suffering from artist's block. Recalling his telling her that as a prostitute, she was in the wrong profession, Ida told him: "When you can see the beauty in me, you'll be able to put something on that paper of yours!" "That," Bearden often told interviewers, "was the most important lesson I ever received in art." He added that if Rembrandt and Michelangelo could turn "ordinary" models into queens and kings of everlasting allure (and could also appreciate everyday people wearing royal robes and crowns), so could he.

With this signature painting in mind, consider the *Profile* series' many other women as artistic guides to the young artist: quilters, gardeners, schoolteachers,

women of the church (and, in the case of *Susannah in Harlem*, out of the Bible), women of the bordello, conjure women. These avatars of knowledge, magic, sensuality, and the divine play important parts in Bearden's collage aesthetic of layering and recombination as modes of creation and identity.

Perhaps the most complexly layered work in the entire *Odyssey* series, *Sirens' Song* is another important woman-centric collage by Bearden. Homer tells us that to keep Odysseus's sailors from leaping into the sea to follow the Sirens' voices in song to their doom, Circe instructed Odysseus to plug his "oarsmen's ears with beeswax kneaded soft." Ever eager for new experiences, Odysseus decides he will "joy in hearing the song of the Sirens" only after his men have lashed him to the ship's mast and promised to hold him fast no matter how desperately he may beg for release.[50] At first take, Bearden's is a song not just of Homer but also manifestly of Henri Matisse: one where the Sirens explicitly reflect Matisse's late cutout swimmers and dancers: otherworldly beauties (based on this-worldly favorite models) vividly collaged.

But as usual, Bearden offers repetition with difference: a changing same. For starters, his black and brown Sirens are female in most cases, androgynous in others, along with yet others who may be male. The world's temptations, he seems to say, come in many shapes and sexual orientations—as opposed to the classical notion (East and West) that temptation is *female*. In this collage, and then in some watercolor versions that follow, Bearden turns the ship's mast into a Holy Cross, to which the hero is affixed. This New Testament reference leads to yet more considerations of the Hebrew Bible's opening verses: this time to the Sirens as multiple Eves, offering treasures and temptations—beauty, knowledge, and the great human achievement of choice—that may be worth dying for. To all these layers, Bearden adds a hanging Black Odysseus on the mast/cross, one who looks less like a conventional crucified Christ than like a Black man *lynched*. His arms and legs dangle like a dead or dying man's. Gwendolyn Brooks was on this same page when she wrote: "The loveliest lynchee was our Lord."[51]

Bearden's woman-centric Blackening of Homer leads us to look at his *Sea Nymph*. In this work, he creates what is perhaps the *Odyssey* series' most arresting image. The collage is true to Homer: Odysseus is saved from Poseidon's raging storms by the sea nymph Ino (elsewhere called "The White Goddess"), who instructs him to take off his clothes, abandon his raft, and swim to safety. He must use the magical veil she has given him. This advice, along with Athena's protection, guides him to safety. But here again, the fact that Bearden's goddess and Odysseus are both Black makes us look at the work with new eyes—and "understand the myth better."[52]

How often have women been the ones doing whatever was necessary to keep Black kith and kin together—mates, grown children, and other relatives, including extended family who may not be blood relatives. Consider Ralph Ellison's note about Mary in a chapter cut from his novel *Invisible Man*, in

which he reflects on such Black women saviors. "For those who . . . hunger and thirst for 'meaning,' " writes Ellison, "let them imagine what this country would be without its Marys. Let them imagine, indeed, what the American Negro would be with the Marys of our ever-expanding Harlems."[53] Elsewhere, Ellison declares that Bearden's paintings express "the 'harlemness' of the national human predicament."[54]

That Bearden has such Harlem savior-women in mind, now on an Afro-diasporic scale, is indicated by his making Ino's shawl a strip of Kente cloth: silk and cotton fabric woven for royalty since at least the sixteenth century by the Akan people of West Africa. Derek Walcott, born in St. Lucia, saw the water into which Bearden's Sea Nymph dives as Caribbean "coral water." This "Black diving figure and the green water," he said, "immediately strike me not as Aegean but as completely Caribbean. And as it is for Romare, it is perfectly valid for me to think of an archipelago in which there are boats and pigs and men . . . and

Romare Bearden recasts Homer's killer goddess Scylla as a mother bird, guarding her babies. As in Bearden's *Cyclops*, here Odysseus is the potential menace. *Scylla and Charybdis*, 1977; collage of various papers with paint and graphite on fiberboard, 14 3/4 × 15 3/4 inches.

a succession of islands—home to me—to think of the *Odyssey* in terms of the Caribbean."[55]Classicist Emily Greenwood adds a question: What if Sister Ino were not just saving a shipwrecked Black man, but wrapping a figure from the Middle Passage in a royal shroud? Mourning, celebrating the lost ancestors that James Baldwin called the "Many Thousands Gone"?[56] Now Bearden's watery tale has a deeply tragic (heroic) wave. Now the White Goddess is, in the language of the 1970s when Bearden created his Homeric series, very *Black*.

Look at Bearden's *Scylla and Charybdis*. Like the Sirens, these killers are almost invariably presented by painters and sculptors as monstrosities to the *n*th degree. Homer specifies that they work not with sly potions and beauty but with raw ferocity. Scylla, "whose howling is terror"[57] and whose twelve feet and six hungry heads on long necks make her a grisly dealer in "black death";[58] and Charybdis, an ugly, living pit that swells with water and pulls "terribly down; may you not be there when she sucks down water," Circe warns Odysseus, "for not even the Earthshaker could rescue you out of that evil."[59] The only way to pass these rock-and-hard-place killers with any hope of survival is to steer clear of Charybdis altogether. While sailing on the safer side, nearer Scylla's shore, means sacrificing the six men that Scylla's heads will inevitably gobble down, "it is far better to mourn six friends lost of your ship than the whole company."[60]

This particular intervention by Bearden into the open corner of Homer's *Odyssey* may be as potent as his portrait of the Cyclops as an African warrior. And yet it is true to a Beardenian tradition, for while his eyeless, duck-head/scorpion-tailed Scylla definitely does have an animal-world Frankenstein aspect, she also fits into this artist's long series of tireless mother-protectors: Harlem Marys guarding with their lives the homes and communities where they live. In this way, she fits into Bearden's aesthetic of radically shifted perspectives: of requiring his viewers to see the world not from the standpoint of "heroic" Odysseus but from that of his antagonists. Here, the most profound lessons have to do with women and with family (Poseidon not as killer-god but as righteous father, Scylla as mom), but also with the spiritual discipline of seeing oneself in the other. As a modern, Bearden reorchestrates the ancient wisdom as a planetary jazz symphony that places women and families at center stage. And that gives consent, in the language of Édouard Glissant, to seeing oneself in the other—to recognizing the person on the other side of the planet not only as kin, but potentially as the one capable of saving us all.

Morrison's *Jazz*: The Novel as Improv and Collage

Let us return now to Toni Morrison, fiction maker/collagist supreme. "The pieces (and only the pieces)," she wrote in 1984, "are what begin the creative process for me. And the process by which the recollections of these pieces coalesce into a part (and knowing the difference between a piece and a part) is

creation."[61] Concerning her construction of the character named Hannah Peace in the novel *Sula* (1973), Morrison writes:

> I have a memory of her and it's like this: the color of her skin—the mat quality of it. Something purple around her. Also eyes not completely open. There emanated from her an aloofness that seemed to me kindly disposed. . . . That's not much, I know: half-closed eyes, an absence of hostility, skin powdered in lilac dust. But it was more than enough to evoke a character—in fact, any more detail would have prevented (for me) the emergence of a fictional character at all. What is useful—definitive—is the galaxy of emotion that accompanied the woman as I pursued my memory of her, not the woman herself.[62]

Writers drawing characters not from such spare memory fragments but from real lived experience and whole people startle Morrison, she says. "There is no yeast for me in a real-life person, or else there is so much it is not useful—it is done-bread, already baked."[63] Here, the key to creativity is to edit memory: to forget and to remember selectively, creatively.[64]

Collage may not be the nonnovelistic medium most readers associate with Morrison.[65] Many have observed the abundance of musical ingredients in her work. The music of her language alone is so powerful that her libretto of *Beloved* (the operatized version of her 1987 novel)[66] outsang the opera's score! And so often her storylines depend on music and musicians—on the subtleties of meaning conveyed by an invisible (and often wordless) art form about which, in essays and interviews, she has written with inspiration.[67] But the influence on Morrison of visual artists like Romare Bearden is surprisingly deep. "I have to say I've been very generous to myself in getting ideas from painters," Morrison told a 2006 gathering at Columbia University. From visual artists, she imported "scenes or figurative arrangements on a canvas." She told a *New York Times* writer, "In paintings I can see scenes that connect with words for me, and I think it helps me get the visual, visceral response I want."[68] From Bearden, in particular, she was "struck by . . . the tactile sensuality, of his work, and the purity of the gesture . . . [the] aggressive, large-as-life humanity in his subject matter." She admired his lack of condescension and sentimentality—an aspect hard won in a culture so dedicated to the creation of Black stereotypes. The fierce knife work in Bearden's collages defeats these stereotypes. "The edge of the razor that I see embedded in Bearden's work prevents—or ought to prevent—easy, self-satisfying evaluations of his subject matter," she said.[69]

There was a razor at the nib of Morrison's pen, too. And along with something fierce in her approach to line and character, she drew on Bearden's ideas about composition and structure:

> The attraction to me in [the collagist's] technique is how abrupt stops and an unexpected liquidity enhance the narrative in ways that a linear

"beginning, middle, and end" cannot. Thus I recognize that my own abandonment of traditional time sequence—and then and then and then—is an effort to capitalize on modernist trends. And to say something about the layered life—not the fractured or fragmented life of black society—but the layered life of the mind, the imagination, and the way reality is actually perceived and experienced.[70]

Morrison's statement here is quite important. With these words (as in her fiction), she challenges not only conventional once-upon-a-time narrative schemes, associated with classic nineteenth-century fiction, but also takes on those branches of twentieth-century social science (one novelist calls it "social science fiction")[71] that adopt a narrow linear approach to Black individuals and their communities as hopelessly broken to bits—fractured and fragmented only. Complexly layered characters and communities: that's what Morrison sees in Bearden's collages of Black America. Pieces and parts that can be torn and broken, as humans are; but that also overlap and *hold together*.

Like practitioners of collage and jazz, Morrison challenges her readers to follow circling, sewn, and zigzag lines into the quiet places (and places not at all quiet) where new creative thinking and activist planning thrive. Her fiction invites the reader to look at and listen to her writing as if looking at a Bearden or listening to a Dexter Gordon elaboration of the blues—*to collage and jazz with her as they read*. Here is a model for deep reading: to read with the intensity of dedication and inspiration involved in the writer's own act of writing!

In Morrison's novel *Jazz* (1992), certain characters—quite notably the narrator—model this impulse to deep reading and to the dynamic contemplation and readiness for action that it implies. Such characters are "settin' in the house," like Bessie Smith, "with everything on my mind."[72] Alone or in groups of two or three, they contemplate a world strained and cracked to pieces. *Jazz*'s Violet is herself described as "cracked" and is one of that book's characters most urgently in need of repair.[73] Despite—because of?—these "cracks," Violet and her associates are among those characters most deeply pondering ways of holding the pieces of themselves and their communities together: *strategies of repair*. Seen in this light, *Jazz* is a contemplation piece where, in the face of shattering unpredictability and violent rupture, creative thought and action are still possible.[74] This is a book where *repair*—collagelike stitching, binding, collaborative improvisation—is a name for romantic as well as communitywide love. Here, love is defined by the will to fix things that have fallen apart: to re-pair the broken selves and separated couples. "Reparation," Melanie Klein asserts, "is such an essential part of the ability to love."[75]

Jazz is a novel where love, frayed and fractured as it is, somehow *holds*. This may be the deepest message in the musical form of jazz. "I had written novels in which structure was designed to enhance meaning," wrote Morrison, but in the novel *Jazz* "*the structure would equal meaning*. I didn't want simply a musical

background, or decorative references to it. I wanted the work to be a manifestation of the music's intellect, sensuality, anarchy; its history, its range, and its modernity."[76] This goal of "writing jazz" was suggested by the book's first words, a prefatory inscription quoting gnostic scripture: "I am the name of the sound / and the sound of the name. / I am the sign of the letter / and the designation of the division."[77]

Led by an improvising narrator, we follow the never-in-a-straight-line novel *Jazz* as a work swinging in crisscross recollections and crooked doublings back, pieces and parts. Sparking her work on *Jazz*, Morrison says, was "seeing a photograph of a pretty girl in a coffin, and reading the photographer James Van Der Zee's recollection of how she got there":[78]

> She was the one I think was shot by her sweetheart at a party with a noiseless gun. She complained of being sick at the party and friends said, "Well, why don't you lay down?" and they taken her in the room and laid her down. After they undressed her and loosened her clothes, they saw the blood on her dress. They asked her about it and she said, "I'll tell you tomorrow, yes, I'll tell you tomorrow." She was just trying to give him a chance to get away. For the picture, I place the flowers on her chest.[79]

This "piece" was just enough, Morrison said, to inspire her work without closing it down by seeming too fixed or finished.

Once one detects the collage as a blueprint for Morrison's construction of sentences and paragraphs, one sees her using it everywhere—nowhere more than in *Jazz*, a galaxy of a novel of shining pieces and parts, intricately articulated: Joe's invented last name; his mismatched eyes, each a different color ("double eyes," one character calls them: "A sad one that lets you look inside him, and a clear one that looks inside you"). Violet (out of her hearing, she is called "Violent") is named for a blend of blue and red and for a color between *hyacinth* and *dahlia*. (Is this Violet in search of qualities that Alice Walker has associated with the color purple?) She forces down power drinks to try to make her rear end, which the years have flattened, round out again. Candy-chewing teenage Dorcas (the murdered girl named for the generous woman in the Bible who is raised from the dead by the apostle Peter), whose acne-flushed cheeks (fixable, Joe feels sure, if she'd drink two quarts of pure water twice a day) look like they've been trampled by small horses' hooves—cherry cheeks that Joe, who at fifty is three times his part-time lover's age, *adores*. When they make love, Joe tries to remember to bite down on a corner of their blanket, to muffle his shouting. "I could tell by her [Dorcas's] walk," says *Jazz*'s scrutinizing narrator, "her underclothes were beyond her years, even if her dress wasn't."[80] The pieces of Dorcas, the narrator also informs us, are alluring but do not quite match: she is literally a layered child.

Reflecting one of the most significant impulses of the New Negro Movement, and also exemplifying collage aesthetics, Joe "Trace" has reinvented himself over and over again, renaming and refashioning himself into a newly hopeful and sophisticated city person. Deadly sinner that he is (he is a statutory rapist and murderer), he is the novel's modern man "set flowin' "—in Farah Jasmine Griffin's term for the sea change migration of 1910s and 1920s Black America— toward life in fast new America.[81] Joe Trace is a New Negro for a New Century.[82] That's part of why he goes after a lover who is so very young, so new, still form- ing. The love of this young girl brings out new dimensions of his own life. "I told her things I hadn't told myself," he says. "With her I was fresh, new again."[83]

Joe's newborn freshness with Dorcas is part of a complex continuum of changes in New Negro Joe Trace. "Before I met her," he says, "I'd changed into new seven times."[84] The first change, paralleling the lives of Frederick Douglass and Booker T. Washington, was to give himself a new name: "When I named my own self," as Joe puts it, "since nobody did it for me, since nobody knew what it could or should have been." Having no known family name, when Joe overheard his adoptive parents say that his real folks had left "without a trace," he figured that must be him: "Joe Trace." The self-made man's eighth change, into Dorcas's secret night lover, was when "I changed once too often," he says. "Made myself new one time too many."[85] Still, with the larger Harlem Renaissance frame in mind (and with the idea that there are "traces" of former selves in the ongoing process of Joe's becoming himself), surely he is right when he observes, "You could say I've been a new Negro all my life."[86] Will this new Negro have the courage to invent himself yet again—beyond self-pity, toward the complex and robust processes of repair upon which, in this novel, love depends?

Violet, who danced alongside Joe on the train barreling from the South, is also a variety of New Negro, "set flowin'" in Harlem. At the time of the story's main action, it is significant that Violet is in the "change of life" and is acting so peculiar that the community considers her outright crazy. There are two Violets here, in need of re-pairing: the eccentric but generally quiet hairdresser- without-license, the savvy independent businesswoman who "cuts heads" in her kitchen and makes house calls when money is tight; she who talks to her pet parrot, whose trick is to say, "I love you."

But then there's "the other Violet,"[87] who butcher-knifes Dorcas's dead body with such unforgiving force that it takes several strapping men to hold her back. This is the Violet that the community comes to call "Violent." Like many of the fox-crazy characters in Morrison's oeuvre, Violet has "cracks"—the sections of broken speech that fall out of her mouth; her untoward acts that represent breaches in the community's social decorum—which are not only telling, but sometimes represent flashes of sixth- or seventh-sense clairvoyance. Violet, too, is a collage then, and when her words break out, the reader learns, it's best to listen.

Considering double-personality Violet, the eight (and, ultimately, catlike nine) changes of Joe Trace, with his mismatched eyes, and poor layered Dorcas, one recalls Bearden's many flat figures whose cutout pieces do not match. Their painted faces may confront viewers directly, while their other faces also are seen in profile, Picasso-style: multiple sets of body parts and facial features. Here, as Montaigne and Whitman have reminded us, contradiction offers insight and perspective by incongruity: the truth and the whole (fragmented) truth.

These layers and changes, in collage and in Morrison's collage-novel, are related to jazz music. Think of an Armstrong solo, full of allusions and layers: turning a received melody around and around and inside out as it offers, in multiple meters, multiple perspectives. By the late 1930s, jazz musicians "composed entirely new melodies on the chord structure of older pop tunes without ever fully revealing their sources," writes jazz historian John Szwed. " 'Sweet Georgia Brown' could be turned into Coleman Hawkins's 'Hollywood Stampede', or Thelonious Monk's 'Bright Mississippi', with the old subliminal melody peeking through the new one."[88] Famously, Charlie Parker used the jazz standard "Cherokee (Indian Love Song)" as the launchpad for his classic, "Koko." Such layering in jazz music itself, which musicologists call "contrafact," leaves room for homage as well as parody, and for what Cheryl Wall has brilliantly termed "worrying the line"—rethinking original meanings. Morrison's subtle layerings of prior literary works—most often the Bible and other ancient texts, Eastern and Western, but also modern classics by Virginia Woolf, William Faulkner, Ralph Ellison, and Gabriel García Márquez—are part of what marks *Jazz* not only as a modernist novel of "tradition and the individual talent" but as a jazz novel and a novel of collage.

In her characterizations and elsewhere, Morrison pieces and stitches collages into *Jazz*. Portmanteaus—word collages with and without sound—are everywhere, frequently more than one per page. One particularly telling instance comes when Dorcas walks through Harlem, pulled by teenage desire and tantalized by the big city's sights, smells, and sounds:

And the City, in its own way, gets down for you, cooperates, smoothing its sidewalks, correcting its curbstones, offering you melons and green apples on the corner. Racks of yellow head scarves; strings of Egyptian beads. Kansas fried chicken and something with raisins call attention to an open window where the aroma seems to lurk. And if that's not enough, doors to speakeasies stand ajar and in that cool dark place a clarinet coughs and clears its throat waiting for the woman to decide on the key. She makes up her mind and as you pass by informs your back that she is daddy's little angel child. The City is smart at this smelling good and looking raunchy: sending secret messages disguised as public signs.[89]

How jazz solo–like is this fresh, intense rush of images! How jazzlike, too, is the quotation of the blues line sung to Dorcas's back—lyrics that salute (and warn) her, "daddy's little angel child." The words that sail the Harlem streets echo an eloquent Bessie Smith song of herself (trumpet interjections by Louis Armstrong) called "Reckless Blues" (1925), whose lyrics declare: "My mama says I'm reckless, my daddy says I'm wild / I ain't good looking but I'm somebody's angel child." The fleeting allusion to Smith's blues invokes the great singer's art and her tragically short life at the same time as it warns Dorcas against her deadly sugar daddy, Joe Trace. The reference also underscores Dorcas's identity as a highly vulnerable orphan whose father and mother were killed in the East St. Louis race riots of 1917. Part of what fells poor Dorcas is her very identity as a Black girl of her time and place in the United States, where ordinary teenage "recklessness" (quite aside from sleeping with a man several times her age) can spell doom. Are these encouragements and warnings issued, too, by Armstrong's Amen-ing trumpet?[90]

Elsewhere in *Jazz*, Morrison seems to take pages out of the playbook of Bearden, who spoke of adding layers to his paintings as a way to increase their "volume." A painting is never really finished, he says: meaning is added, piece by piece, and sharpened through subtraction, with piece by piece removed. Eventually, the "unfinished" work (ever, Bearden suggests, in the process of creation) is "relinquished" or (he says elsewhere) "released."[91]

Likewise, in editing her own work, Morrison adds and subtracts, sometimes increasing the "volume" of a paragraph with a virtuosic collage of word-images. In the following example, the narrator directs her reader's eyes to New York's street signs, "messages disguised as public signs": "this way, open here, danger to let colored only single men on sale woman wanted private room stop dog on premises absolutely no money down fresh chicken free delivery fast. And good at opening looks, dimmer stairways. Covering your moans with its own."[92]

With these words, phrases, and lines ("pieces" and "parts"), Morrison creates a collage mix that initially offers punctuation to indicate where one public sign ends and another begins: "this way," comma splice, "open here." But then the commas (which, one is reminded, Gertrude Stein, one of Morrison's models, hated for "standing around holding a sentence's coat") disappear, letting ambiguities run free. Along with the routine street-sign messages of invitation and warning comes a blur of words that could be read in several ways: "danger to let colored" or "danger to let colored only"; "colored only single," or is it some variation on "only single men on sale"? Does "men on sale" connect with "woman wanted," or is it "sale women wanted, private room"? In this novel where red birds are heralds and where young men scouting for women are called "roosters," does the sign say: "fresh chicken free"? In one of the memorial services for Morrison, who died in 2019, Oprah Winfrey said that she once complained to her friend that her novels required so much

returning to earlier passages so she could understand more fully how the work as a whole accrued (and changed) meaning. "That's what I call reading," was Morrison's rejoinder.

In another example of Morrison's verbal collage-making, Aunt Alice, "idle and withdrawn in her grief and shame" in the weeks after her niece Dorcas's death, reads newspapers (having their own brutally straightforward logic) with new eyes.[93] The mid-1920s city spirit has spelled violence for women. "Every week," she found, "a paper laid bare the bones of some broken woman": "Man kills wife. Eight accused of rape dismissed. Woman and girl victims of. Woman commits suicide. White attackers indicted. Five women caught. Woman says man beat. In jealous rage man."[94] Here again, the telling juxtaposition of phrases—newspaper headlines strewn across a table—yields its share of amplified meanings, questions, and ambiguities—never to be read in a straight line. The short scraps of headline type, every week, seem violent in themselves.

And amid the violence, aside from the churchwomen who relied on the Lord as their sword and shield, "who else," asks *Jazz*'s narrator, "were the unarmed ones?" The answers step forward in another hyperbolically virtuosic collage of images:

> The ones who thought they did not need folded blades, packets of lye, shards of glass taped to their hands. Those who bought houses and hoarded money as protection and the means to purchase it. Those attached to armed men. Those who did not carry pistols because they became pistols; did not carry switch-blades because they were switchblades cutting through gatherings, shooting down statues and pointing out the blood and abused flesh. Those who swelled their little unarmed strength into the reckoning one of leagues, clubs, societies, sisterhoods designed to hold or withhold, move or stay put, make a way, solicit, comfort and ease. Bail out, dress the dead, pay the rent, find new rooms, start a school, storm an office, take up collections, rout the block and keep their eyes on all the children. Any other kind of unarmed black woman in 1926 was silent or crazy or dead.[95]

Morrison's word collages swarm with characters, images, and situations that her novel's main characters—Violet, Joe, Alice, and the narrator (about whom more shortly)—are turning over in their minds. One of the functions of the music (as well as of the collage and of this novel) is to sit and think things over à la Bessie Smith: to witness and weigh evidence and advice, however perplexing or contradictory, before taking action. Alice's niece Dorcas has been shot dead by Joe Trace, whose wife, Violet, charged into the funeral to slice up the dead body with a knife. What, the novel wants to know, led to these acts of violence? And can anything be done to make things right again, to repair them? Under

such strain, what makes these communities whole? What could fix and make them *hold*? Can the broken marriage—and then, writ large, can the fragmented community of Harlem and of the Harlems of America—be put back together again? And what about the break between white and Black Americans, also at war in this novel? (We must not forget that Dorcas's parents were killed during the St. Louis race riots.) Can the disunited States be drawn together? The nations? What might the variously divided groups learn from the experiences of Joe, Violet, and the sacrificial Dorcas? From the form of the novel as jazz collage?

Repair and Reparation

Not merely a novel of blues-idiom music as Black excitement and extroverted display, *Jazz* is a novel of repair and reparations—of a tailor sewing seams and linings,[96] of hairdressers marcelling (pressing decorative waves into) hair and clipping the ends just so.[97] It is a novel of sitting and thinking in the eye of the storm, where it is (sometimes) quiet, poised for action. Repair, perhaps this novel's main theme, is its name for love. Repair is also the main theme of the blues—not despair but repair. What Morrison adds to Albert Murray's classic definition of the blues, as a ritual dance music that inspires courtship and fun as it puts trouble in its place (temporarily), is that the blues is a highly intellectual and political music: in tune with the aspirations of the New Negro Movement and in time with drumbeats of that era's protest marchers in Harlem.

What Morrison and Murray share most profoundly is the conviction that this music, the blues, holds the parts and pieces of a cracked modern life together. Murray could have cosigned *Jazz*'s emphasis on the blues as a body-and-soul music that is also a thinking music, rhythmically puzzling through the fissures and fractures of life with a will to fix things. Soundtrack: "Sitting in the house, with everything on my mind." Put another way, this blues-based traveling music seeks a way home. "The way home we seek," writes Ralph Ellison, "is that condition of man's being at home in the world, which is called love, and which we term democracy."[98] To "repair," let us remind ourselves, means not only to fix but to "return" (as to "repair home")—in the case of this novel, to repair to the home base of first human principles of decency and care.

As Dorcas's teenage friend Felice[99] sits with Violet, she finds that those who call Violet crazy may be right after all: Violet *does* talk in a strange, cracked way. "But I understood what she meant," Felice says. "How many trees can you look at?" says the younger woman, who can't imagine living outside concrete New York. "And for how long and so what?"[100] "Go to 143rd Street and look at the big one on the corner," Violet tells her, "and see if it was a man or a woman or a

child." Felice laughs as she considers again Violet's sanity. It is then that Violet asks what may be described as the question of the novel:

> "What's the world for if you can't make it up the way you want it?"
> "The way I want it?" [Felice says.]
> "Yeah. The way you want it. Don't you want it to be something more than what it is?"
> "What's the point? I can't change it."
> "That's the point. If you don't, it will change you and it'll be your fault cause you let it. I let it. And messed up my life."
> "Messed it up how?"
> "Forgot it."
> "Forgot?"
> "Forgot it was mine."[101]

In this and in other vividly expressive dialogues, Morrison's *Jazz* models the kind of work involved in remembering that one's life is one's own, and thus open to improvised invention and repair. Just as for the novelist—or the jazz musician or the collage artist—the stitching and layering of "the pieces and only the pieces" into "parts" is, as Morrison says, "*creation*" —such is the work, too, when it comes to the creation of the self.

It is significant that, again and again, the novel presents this self-creative work as emerging from the dynamism of serious conversation—as dynamically collaborative, in the jazz mode. Just as jazz may be defined as an improvised conversation in music, Morrison's *Jazz* is a *spoken* novel: a book full of talk where, like the other characters, the narrator engages her reader in something closer to dialogue than one-way discourse. To engage in silent dialogue with her reader, the writer relies on what jazz players call "comping" (short for "accompanying"): providing cues and cosignatory encouragements for the other players, particularly for a soloist—something we see in Armstrong's trumpet interjections and Amens for Bessie Smith. We might call this highly charged intimate conversation capital-letter "Speech," in the sense that W. H. Auden has defined that term[102]— on-page spoken language in its most highly expressive aspect: conversation as self-wide and communitywide creative work: *conversation as revelation*.

Consider, in this light, the jazz solo–like exchange between Dorcas's Aunt Alice, still deep in mourning over the death of the teenager in her charge, and Violet Trace, the woman who desecrated the body at the funeral and who visits Alice to seek her advice. These are middle-aged sisters in complex grief, guilt, and grievance. Alice, running low on patience, speaks first:

> "Forgiveness is what you're asking and I can't give you that. It's not in my power."
> "No, not that. That's not it, forgiveness."

"What, then? Don't get pitiful. I won't stand you getting pitiful, hear me?"

"We born around the same time, me and you," said Violet. "We women, me and you. Tell me something real. Don't just say I'm grown and ought to know. I don't. I'm fifty and I don't know nothing. What about it? Do I stay with him? I want to, I think. I want . . . well, I didn't always . . . now I want. I want some fat in this life."

"Wake up. Fat or lean, you got just one. This is it."

"You don't know either, do you?"

"I know enough to behave."

"Is that it? Is that all it is?"

"Is that all what is?"

"Oh, shoot! Where the grown people? Is it us?"

"Oh, Mama." Alice Manfred blurted it out and then covered her mouth. . . . "You want a real thing?" asked Alice. "I'll tell you a real one. You got anything left to you to love, anything at all, do it. . . . Mind what's left to you."

"You saying take it? Don't fight?"

Alice put down her iron, hard. "Fight what, who? Some mishandled child who saw her parents burn up? Who knew better than you or me or anybody just how small and quick this little bitty life is? . . . Nobody's asking you to take it. I'm sayin make it, make it!"[103]

Eventually, Violet imparts Alice's advice to Felice, and to us as readers: *Make it!* Create your own lives out of whatever material is available, and don't forget the power of love. For the reader, too, the questions hang in the air: *Is this all there is? You saying take it? Don't fight?* The novel offers answers but leaves them so open-ended—*You got anything left to love, do it!* and *Don't take it, make it!*—that the reader's job of reading is also a job of actively creating answers, creating meaning. Like Woolf, Faulkner, Ellison, Márquez, and her other favorite literary modernists, Morrison insists that her readers work with her—that they sit through the delays in understanding that her novels often require. That her readers engage, as Glissant says, in "piecing together the implied vertigo. . . . the scattered and hidden knowledge. Yet we all know that, in the end, we will have to add things up."[104]

That is what *she* calls reading.

Given the book's title, it's important that the intimate conversations in *Jazz*, building toward one of the novel's several moments of epiphany, mark the author's expectations from (and her promise to) her readers as jazzlike. Morrison angles not for readers' acquiescence but their engaged exchange—something close to what Violet remembered as the "voices of the women in houses nearby singing 'Go down, go down, way down in Egypt land . . .' Answering each other from yard to yard with a verse or its variation."[105] "Variation" is one of the several operative words here, for Morrison's goal is to prompt

the reader to "run the changes," as jazz musicians say, to improvise one's own variations on a given text—just as, famously, Thelonious Monk does with the standard ballad "I Should Care," which through his art the piano player makes his own. Or think of Billie Holiday, reinventing (sometimes turning the tables on) every song she did.

Novels are not reducible to themes: they make and are their own meanings. Nonetheless, it is fruitful to think of *Jazz's* central theme as *improvisatory repair*. Through its pages, Violet and other hairdressers are marcelling hair, but also clipping the ends—to promote good hair health and new growth—just so. Alice, who is a seamstress, sews back the lining of Violet's tattered coat. Most significant, Violet and Joe Trace surprise us (and the narrator) by refusing to give up on one another, by working to fix their marriage that seems shattered beyond repair.

One large message seems to be that mistakes and serious breaches that do not seem fixable are an inevitable part of human interaction; and if we are to survive as a family, whether sitting in the house or at the international conference table, we must nurture the impulse to fix these breaches, to fix things. This theme of repair, as both a spiritual matter and a necessity for survival, is a cousin of improvisation, which also requires close cooperative interplay and hard work: pasting the torn places until they fit. Again, I refer to layering to create a new picture of possibility. In this way, the novel, like Bearden at his best, is about jazz and the blues, where troubles are real and where love is never easy—and where improvisation and repair offer love's best hope to last.

One final note: Toni Morrison's talk on Bearden at Columbia University rang with a declaration that informs this chapter and offers a kind of manifesto for twenty-first-century commentary on the arts. Critics have become sophisticated in their analysis of individual artworks within the context of particular art forms. And, Morrison says, compartmentalizing art forms "is convenient and useful for study, instruction in institutions." The problem is that such divisions do not represent "how artists actually work. . . . The borders established for the convenience of study are, I believe, *not just porous, they are liquid*. Locating instances of this liquidity is vital if African American art is to be understood for the complex work that it is and for the deep meaning it contains."[106]

To understand Morrison's project in *Jazz*, we must sound the work's marvelous liquidity. The work's dialogue with writers is palpable: Woolf, Faulkner, Ellison, Márquez. But the novel's conversation across the usual borders includes James Van Der Zee and Romare Bearden, Duke Ellington and Bessie Smith. Further, it involves Morrison's consideration of Bearden's renderings of Ellington and Smith—and of music and collages and quilts as models and guides. And, of course, of the peculiar potency of the word—spoken, sung, and written in the liquid spaces where all the arts flow together—to stitch

(or should we say to stir) us back together. Last word to Morrison, spoken by *Jazz*'s jazzlike narrator, on the writer's job of recording painful breaks and blues and proposing fixes:

> Pain. I seem to have an affection, a kind of sweettooth for it. Bolts of lightning, little rivulets of thunder. And I the eye of the storm. Mourning the split trees, hens starving on rooftops. Figuring out what can be done to save them since they cannot save themselves without me because—well, it's my storm, isn't it? I break lives to prove I can mend them back again. And although the pain is theirs, I share it, don't I? Of course. Of course. I wouldn't have it any other way. But it is another way. I am uneasy now. Feeling a bit false. What, I wonder, what would I be without a few brilliant spots of blood to ponder? Without aching words that set, then miss, the mark?[107]

CHAPTER 3

THE "OPEN CORNER" OF BLACK COMMUNITY AND CREATIVITY

From Romare Bearden to Duke Ellington and Toni Morrison

Romare Bearden frequently used a work by the Tang dynasty Chinese poet, musician, painter, and statesman Wang Wei as his prime example of the "open corner" in art. Wang's most famous waterfall painting makes "a complete and wonderful statement of a waterfall," Bearden told an interviewer, "but it demands something of your looking at it. It is like all great distillations. . . . there's always one corner that seems to be open—nothing's there."[1] Elsewhere, he said that he first learned of the open corner as a painterly device from a specialist in the history of Chinese calligraphy and landscape painting—a man Bearden remembered only as "Mister Wu." "The Chinese open corner meant a lot to me," he said. There's "one corner that's left open for the eye to enter the picture. And certain parts left unfinished, for the onlooker to complete with his eye."[2]

The open corner is a striking feature in Bearden's own work. *Mountain Top*, a 1968 collage/silkscreen in honor of the recently martyred Martin Luther King, is a luminous example of his activation of the device. Counterpointing the image of King—placed at the bottom center of the piece, with his back to the viewer and his congregation on either side of him, its members' hands reaching toward his—are flowing bands of mountain, sea, and sky that command more than half the space. Atop the vista lies a slender, triangular slice of orange, lit by a small orange sun, hinting at another world—a stacked-skyline arrangement perhaps inspired by Chinese landscape works. Flat expanses of purple, green, and sky blue open a vast corner, an invitation for viewers to complete the composition with their own eyes. Does this wall

Romare Bearden's tribute to Martin Luther King. *Mountain Top*, 1968; screenprint, 30 × 19 5/8 inches. National Portrait Gallery, Smithsonian Institution, Institution. NPG.2007.170.

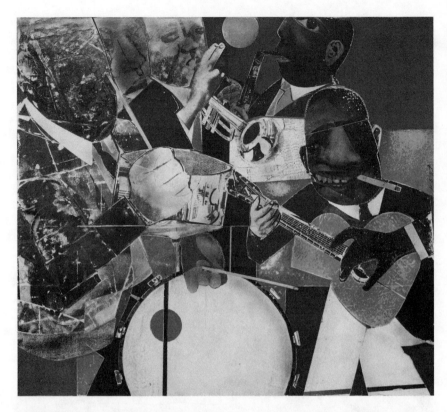

Romare Bearden, *Of the Blues: Kansas City 4/4*, 1974; mixed media collage of various papers on board, 44 × 50 in. Private collection.

of color, mainly blues, reflect the loss of the man whose outstretched arms and pierced garment suggest godlike exaltation and sacrifice? Does it offer visions of the infinite, of heavenly perfection? "We've got some difficult days ahead," said King in his most famous speech. "But it doesn't matter with me now. Because I've been to the mountaintop. . . . And I've looked over. And I've *seen* the Promised Land."

A companion piece to *Mountain Top* is Bearden's collage *Of the Blues: Kansas City 4/4* (1974), another example of the artist's evocative open corner.[3] Here are jazz musicians at work, arrayed in a circle of heads and hands holding horns and a guitar. A drum and drummer hold the whirling wheel's high-energy center, while at the upper edge, as in *Mountain Top*, a small light shines next to a figure who blows an alto sax and looks out with a cool, steady eye—this work's visionary. To his immediate right, a deep blue, unmarked area extends

an open-corner invitation. The collage records Kansas City, in the form of one of its early-to-mid-century Eighteenth Street and Vine jazz clubs, as a dynamic workplace where every member, including the viewer, is invited to the bandstand, with the rhythm section (sometimes called "the engine room" by jazz musicians) at the center, to be part of the churning, improvised whole. The composition has an aerial photographic aspect, evoking the map of a big city's ever-shifting spaces—an urban labyrinth that requires a watchful eye to navigate.

Both of these works are reminders of the impetus for Bearden's turn to collage, following an early meeting of Spiral, a New York Black artists' collective that came together in 1963 in response to the increasing momentum of the Civil Rights Movement, and in particular to the March on Washington of that year.[4] How might Black artists play a useful role in the movement? If every Spiral member brought in cuttings from books and media and other miscellaneous objects they'd collected for use and inspiration, Bearden suggested, they could build collages together—communally constructed statements about being Black in America and the need for concerted collective action. Spiral's members elected not to take up his challenge to create art together in this way. But for Bearden, the collage medium's message rang true. To him, collage encompassed jazzlike improvisation and the unillusioned contemplation (and joy) that defines the blues. And the form involved the practice/politics of making art that invited community collaboration in the creation of meaning and the promise of concerted action.

This chapter tracks dynamic open corners not only in visual art but also in music and literature—and in the everyday world of politics and policy. I construe the open corner as an aesthetic device that reflects a robust will to create loopholes of retreat[5] and open-ended, inclusive communities—more than "neutral zones" (a New Orleans term for the strips of shared land dividing city streets), but spaces of freedom. The open corner is an invitation, a will to draw us together with a shining sense of possibility and responsibility. It echoes the view that art celebrates its capacity to beautify, contemplate, and critique the world, to tear it down and rebuild it: in the words of Langston Hughes, "to make the world anew."[6]

The Open Corner in Jazz and Dance

Bearden's strategic use of the open corner owes something to the work of jazz musicians. The painter Stuart Davis first urged him to pay particular attention to the virtuoso pianist Earl Hines's use of spaces between notes in chords and note sequences—his deployment of sonic intervals.[7] Indeed, "interval" became one of Bearden's key terms to define jazz's influence on his art—a sonic counterpart to the open corner. Studying Hines's dynamically musical

spacings spurred Bearden to reconsider color, line, and shape in relation to the in-between spaces in his own paintings—rhythmically arranged intervals of "blank" spaces and visual silences that conveyed a jazzlike sense of expectancy and surprise. When Davis himself turned to abstraction, he found that "jazz drumming and abstract painting seemed different to me only as craft—in both, rhythm was decisive."[8]

Bearden's friend, the percussionist/composer Max Roach, also saw the parallel between jazz rhythms and Bearden's art. He equated Bearden's open corner to drummers' use of pregnant silence, when they "lay out" on drums while the other members of the band create beats of their own:

> It's not that there's necessarily *nothing* going on. There's always a pulse there. There are times when there's nothing but the pulse. . . . Some of the horns, like Lester [Young] and Bird [Charlie Parker], had a built-in rhythm section. They didn't need a drum or a bass player. When they played, you felt the pulse. So that allowed the drummer to do colors. It freed us. With these people, it was always there: the silence, the meter. The pulse was there, in the silence. Bearden's paintings are like that.

And, pointing to the patterns and spacings of a Bearden painting, Roach said, "There's the rhythm I see here."[9]

Ella Fitzgerald and Count Basie, 1979. Their contrasting styles—her shimmering streams of improvised notes, his spare punctuation remarks—created musical drama.

Photo by Tad Hershorn.

Bearden also learned from family friend Duke Ellington as well as Count Basie and Thelonious Monk—all quick-fingered "ticklers" who carved radically understated personal styles from the glittering ragtime piano work of James P. Johnson, Fats Waller, and Willie "The Lion" Smith. Stanley Crouch called Monk "the Picasso of jazz. Just as Picasso demanded that the viewer *do* something other than peruse. . . . Monk demanded that the listener play the song along with him, fill in the holes he left. His use of silence made the pause between musical statements a statement in itself."[10] These pianists showed Bearden that complex patterns of expression gain power by being pared down. Miles Davis, another master of space in music, was a model for the artist as well. So was John Coltrane, genius of revisions of melody, harmony, and time. As Amiri Baraka put it, Coltrane "would play sometimes chorus after chorus, taking the music apart before our ears, splintering the chords and sounding each note, resounding it, playing it backwards and upside down trying to get to something else."[11] With his process of "constructions and destructions," Bearden told an interviewer, he was "like Coltrane, destroying, building, seeing what else happens with a theme."[12]

Like Trane's, Bearden's work reflected a disavowal of finish, an unending will to "claw at the limits" of what had gone before.[13] "I don't ever really finish my paintings," Bearden told an interviewer. "At a certain point I *release* them." Elsewhere, he said that he "relinquishes" a painting: "You, the observer, have to put the period on it."[14] Perhaps Bearden's observation of these jazz masters "taking the music apart" led Bearden toward collage, inviting him to take a step (to extrapolate) beyond the painting's homogenous layering to the layering of heterogenous things—"some*thing* over some*thing* else"—and the role of restraint, including intervals, silences, and the trembling of dynamically articulated "incompletions": art that includes the full suggestive power of open corners.[15]

Jazz was a special model for Bearden because of its insistently collaborative, communal nature. Ellington, Monk, and Basie were brilliant piano accompanists for solo players—they knew how to " 'comp" (to accompany), to give just the right prompts and leave blank areas in the musical canvas, inviting a soloist's next improvised assertions. Monk told the saxophonist Steve Lacy, "You've got to know the importance of discrimination, also the value of what you don't play. . . . A note can be as big as a mountain, or small as a pin. It only depends on a musician's imagination."[16] These three pianists also were composers/arrangers/bandleaders (in jazz, these terms overlap) who mastered the art of creating transitions and openings in their arrangements for soloists. Ellington, Monk, and Basie knew when to lay out on piano and have all the horns lay out as well, to let just the drum, the bass, or the rhythm guitar—or to let the whole band take five—to remind us of the musicality of intervals of anticipation and contrast. These dynamic lulls could be timed and spaced to create excitement for dancers—opportunities to hold the floor with little or no musical accompaniment. "At times," drummer Leroy Williams has said, "it's not so much the

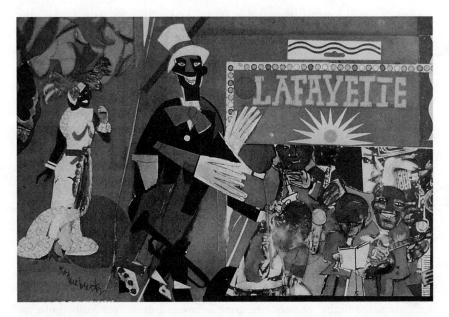

Along with the dancer/comedian at the center of *Johnny Hudgins Comes On (Profile Part II: The Thirties*, 1981; collage on board, 14 × 22 inches; collection of Rick and Monica Segal), this Romare Bearden work seems to feature Chick Webb's band and a singer who could be any of several glittering divas of the 1920s–1930s: Gertrude "Ma" Rainey, Florence Mills, Josephine Baker, Bessie Smith, Ethel Waters, or Billie Holiday. Original caption, by Bearden and Albert Murray: "He was my favorite of all the comedians. What Johnny Hudgins could do through mime on an empty stage helped show me how worlds were created on an empty canvas."

© Romare Bearden Foundation; licensed by VAGA at Artist Rights Society (ARS), New York; Courtesy of the High Museum of Art, Atlanta.

rhythm section or the horn players who are swinging the music, or the singer; sometimes the ball is passed to the dancers in front of the bandstand. *They* are carrying the band!"[17]

Dance, and performative movement more generally, is the focus of Bearden's polychrome collage *Johnny Hudgins Comes On* (1981), from the series *Profile/ Part II*, depicting the once-famous Black comic dancer. This work's open corners are profoundly suggestive of rhythm as a promise and the *power of space*— including power in real-world spaces where culture happens. By locating the titular comic dancer's performance at the Lafayette Theater, a landmark Harlem neighborhood performance venue of the 1920s and early 1930s, Bearden declares the subject of this work to be the open corner of this relatively surveillance-free Black space, and of other such spaces, here and there, all over in Black America. And at the Lafayette, Hudgins needed no props or words for his act to resound. With the eerie stage silences broken only by the occasional "Wah-wahs" of an

offstage trumpet player, which became Hudgins's performance signature, the dynamism of his gestures and body in space filled the stage with a sense of possibility. "What Johnny Hudgins could do through mime on an empty stage," announced the caption that Bearden wrote for the collage's exhibition,[18] "helped show me how worlds were created on an empty canvas."[19] The work's title, caption, and boxed-within-box imagery celebrate Hudgins's charisma and creative mobilization of the open corner on a sonically and visually empty stage.[20]

The Open Corner, a Physical Space of Black Creativity

Paralleling the paintings, music, and dance that used the open corner as a creative device or strategy lay physical, worldly spaces left open for creative work and play—Black spaces like the Lafayette Theater just mentioned. These were open corners of rest and zest, of labor and collaboration, of invitation and shared leisure, of ritual play, of self as *selves*. Places where, for Black Americans, freedom, long deferred, and dreams persistently bloom.[21]

This galaxy of issues, where art and politics are in orbit, might be approached through the word "jurisdiction," whose root meanings refer to *rights* and *places for certain modes of diction or discourse*. Places that serve as open corners are spaces where ideas of equity and justice can be expressed: they are spaces of civil interchange, spaces of civic cosmopolitanism. New York City offers many examples: in addition to Manhattan's Harlem, think of Queens's Flushing and Brooklyn's Flatbush. But these places often face a multitude of threats, including gentrification and urban renewal achieved by the violent removal of residents and communities and the obliteration of neighborhoods. How can we safeguard these vital but endangered jurisdictions? How can the welcoming of the open corner thrive as these cities-within-cities morph and grow?

In a discussion of U.S. Black communities as free Black spaces, the public positions of Bearden's close friends Ralph Ellison and Albert Murray are worth revisiting. The two writers were famously fierce critics of certain constraining conceptions of American Black spaces that were widespread at midcentury— Blackness as *starkly limited by definition*. These conceptions often leaned on social science methodologies, which Murray derided as "social science fiction." Ellison and Murray took on Kenneth Clarke and the "Dark Ghetto" social scientists of the 1960s and 1970s, as well as policy makers like New York senator Daniel Patrick Moynihan, whose 1965 report *The Negro Family: The Case for National Action* cast the Harlems of America as dysfunctional and ascribed this dysfunctionality to the family unit.[22] Murray and Ellison also directly challenged the fiction writers Richard Wright and James Baldwin as representative of their era's aesthetic of Black literary realism/naturalism, which, briefly put, tends to emphasize humankind's losing battle against the bleakness of life.[23] For Baldwin, Harlem was a tight, low cage, a trap-world "as hungry as a tiger and

where trouble was longer than the sky."[24] To escape the place, one of his characters muses, you have to do what animals sometimes do—leave part of your limb in the trap. In times of trouble, he adds, "the missing member aches."[25]

This is not to say that either Ellison or Murray sanitized Harlem. Instead they celebrated a lively community: a place with a rich indoor/outdoor culture of personality and potentiality, a Black global village. "We seek not perfection," said one Ellison character, Senator Sunraider, "but coordination."[26] He and Murray celebrated Harlem as a cosmopolitan jurisdiction where sociality itself offered checks, balances, and open spaces through which to move.

This is a vision of Harlem—where much living unfolds outdoors—at its wide-lens best, offering the wonder of the chance encounter that so many American writers, from Toni Morrison back to Henry James, have posited as the characteristic of a great city.[27] Great cities are great *walking* cities—cities made for walking. "If you can walk you can dance," said the tap dancer Honi Coles, giving a master class that started with the veteran hoofer leading students in a walk around the studio that quickly became a playfully polyrhythmical vernacular dip and strut.[28] His walk recalled Ellison's glosses on the Black American dances "Walking the Dog" and "Strutting with Some Barbecue." These, he said, were examples of "symbolic communication through bodily movement [that] is not only traditional but [represents] modes of unspoken social commentary, satire, caricature, disavowal, intimidation, and one-upmanship."[29] If you can walk, you can dance, and once you're dancing Honi-style, you can say so much!

Walking the gridded and high-low streets of Harlem, one is invited into a kind of communitywide dance, to paraphrase Jane Jacobs,[30] with elbow room for more than merely staying out of everybody else's way: these are welcoming, inclusive places, with "plenty good room" (as the Negro spiritual says of Heaven) for creative exploration. "Where did you learn to improvise?" an audience member asked pianist-composer Vijay Iyer. "I learned it as a small child walking with my family on the street," he said. "I learned to stay on course while making room for those around me. I learned it from my mother."[31] Describing the creativity and playfulness of New York City children of the 1960s, Ellison adds: "So you see little Negro Batmen flying around Harlem, just as you see little white Batmen flying around Sutton Place."[32] Girls and boys alike cast themselves as fast-moving dancers in the street, swooping through to save the day and the world. Harlem street youth's savior power comes up in *Invisible Man*, too. Looking at young Black zoot-suited (1930s) Harlemites moving "like dancers . . . swaying, going forward, their black faces secret, moving slowly down the subway platform, the heavy heel-plated shoes making a rhythmical tapping as they moved," Invisible Man suddenly asks himself, "Who knew (and now I began to tremble so violently I had to lean against a refuse can)—who knew but that they were the saviors, the true leaders, the bearers of something precious?"[33]

Writing about Harlem streets of this era, Claude McKay also recalled young-sters literally dancing:

> Children swarm in the streets, although the new playgrounds are full of them. Groups of children persistently practice the Lindy Hop all over Harlem, as if they were all training to be expert dancers. . . . With its pattern, Harlem's children make fantasy on the pavement. When a new piece is put in the nickel-odeon of a bar and it lilts to the Lindy Hop, the kids come together on the pave-ment to dance. Since they are not permitted to enter, they sometimes ask adults to put coins in the machine to give them music. Utterly oblivious of oldsters passing or watching, they dance with an eagerness and freshness that is even rustic. They put a magic in the Lindy Hop. . . . They make a folk dance of it.[34]

Named after the airplane pilot Charles Lindbergh's 1927 transatlantic flight, the Lindy Hop, with its soaring lifts and jumps, was Harlem's way of dancing while flying, or flying while dancing.

In contrast to the "dark ghetto" and "Black deficit model" of Clark and Moynihan, Ellison recalled his first visit to Harlem as a trip to "one of the great cities prominent in the Negro American myth of freedom, a myth which goes back very far into Negro American experience. In our spirituals it was the North Star and places in the North which symbolized Freedom, and to that extent I expected certain things from New York."[35] This promise depended on Harlem. For Ellison, early- to mid-century Harlem was "an outpost of American opti-mism, a gathering place for the avant-garde in music, dance, and democratic interracial relationships; and as the site and symbol of America's freewheeling sense of possibility . . . our own homegrown version of Paris."[36] Although the Harlem of Ellington, Langston Hughes, and Florence Mills is no more, "anyone who wishes to grasp what this nation has lost in Harlem's decline" should con-sider "how this single section of a great metropolis was able to endow New York City (and thus the entire nation) with so much of its hope, its style, its dash."[37]

Toni Morrison later defined another dimension of New York's openness through her character Jadine in the novel *Tar Baby* (1981), who eloquently declares not only Harlem but all of New York City, occasional bad smells and all, "a black woman's town." Returning from the Caribbean, Jadine discovered the city anew:

> New York made her feel like giggling, she was so happy to be back in the arms of that barfly with the busted teeth and armpit breath. New York oiled her joints and she moved as though they were oiled. Her legs were longer here, her neck really connected her body to her head . . . The smart thin trees on Fifty-third Street refreshed her. They were to scale, human-sized, and the buildings did not threaten her. . . . [I]f ever there was a black woman's town, New York was it.[38]

New York, the open corner, enjoys many inner-corners, all claimable by free-spirited Black women.

The claiming of the city as Black space is one of the most significant aspects of Bearden's aesthetic, particularly when we think of free spaces of broad hospitality as aspects of an artwork's welcome and appeal. I speak here of that unconditionality of hospitality which, as Jacques Derrida reminds us, is nestled in the word's root meanings: an explicit welcome to the potentially hostile, even to outright enemies (*hospes* in Latin means "foreigner" or "stranger," and also refers to a guest who is presumed to be friendly).[39] True hospitality[40] opens the door to any and all, without asking for their identity or documents. Welcome always involves risk. *The Block* (1971), Bearden's best-known work, set in Harlem, presents another kind of open corner work. As many observers have noted, its open windows and doors reveal shared lives as well as private inner lives. It also offers open corners for viewers to collaborate with the artist in the creation of meaning. Consider, in this light, Louis Armstrong's dressing room, with its door wide open, as a site of extraordinary hospitality. In a roll call of saints and sinners welcome in Satchmo's backstage open corner, guitarist Danny Barker remembered:

> In the room, you see maybe two nuns. You see a streetwalker dressed all up in flaming clothes. You see a guy come out of a penitentiary. You see a blind man sitting there. You see a rabbi. You see a priest. Liable to see maybe two policemen or detectives. You see a judge. All of them different levels of society in the dressing room and he's talking to all of 'em. "Sister So-and-so, do you know Slick Sam over there? This is Slick Sam, an old friend of mine. . . ." "Slick Sam, meet Rabbi Goldstein over there, he's a friend of mine, rabbi good man, religious man. Sister Margaret, do you know Rabbi Goldstein? Amelia, this is Rosie, good time Rosie, girl used to work in a show with me years ago."[41]

Black Spaces of Freedom and Imagination

The Black jurisdictions exemplified in Bearden's *The Block* are also beautifully charted by a range of literary theorists—Robert B. Stepto, Melvin Dixon, Farah Jasmine Griffin, Saidiya Hartman, and Brent Hayes Edwards, among others— who often map these open corners as spaces not only of assertion but *refusal*. These critics have taught us that Black havens—at times temporary and precarious—figure throughout the Black literary tradition. One finds images and instances of Black "running space" and "elbow room"—and refusals of confinement and of outsider's definitions—from the earliest slave narratives through the long Harlem Renaissance to the twentieth-century fiction of Ellison and Morrison and beyond. In Morrison's novels, for example, Africans in America

could sometimes pray without interference in woodland clearings, and Black women could speak among themselves along Southern roads or front rooms at home, off the white (and sometimes also the Black male) radar.

To explore these spaces of refusal, it's helpful to look to a region and city far from New York, in the heart of what was once plantation land: New Orleans. A text that helps us explore its open corners is *Treat It Gentle* (1960), by the city's great reedman/composer/bandleader Sidney Bechet, both a record of his training and travels in music and a key work in the literary tradition of Black autobiography. It is one of several Black imaginative self-histories to present scenes in and near Old New Orleans's Congo Square, which, in antebellum New Orleans, famously served as a relatively free Black space where Africans could celebrate their cultures with a minimum of white interference. On the Blacks' "free day" in New Orleans, Omar, Bechet's grandfather, would hear drums from Congo Square:

> First one drum, then another one answering it. Then a lot of drums. Then a voice, one voice. And then a refrain, a lot of voices joining and coming into each other. And all of it having to be heard. The music being born right inside itself, not knowing how it was getting to be music, one thing being responsible for another. Improvisation . . . that's what it was. . . . Down at the bottom of it—inside it, where it starts and gets into itself—down down there it had the same thing there is at the bottom of ragtime. It was already born and making in the music they played at Congo Square.[42]

This free music stirred Africans in America to remember Africa, but Congo Square itself was an imperfect getaway: "Another thing about this Congo Square," said Bechet, "sometimes it was used for a selling-block. The masters would come there to buy and sell their slaves."[43] Such are the open corners of freedom in Black America, always somewhat tenuous and marginal.

Treat It Gentle also draws vivid images of Black outposts of relative freedom just beyond the Crescent City: the mysterious swamp called the bayou, teeming with life and reeking of death, where Omar meets comrades who helped him escape the white mob out for his blood. "If you've never been down in those bayous that's something to see," writes Bechet. According to one guide to Louisiana's bayous, "It is a place that seems often unable to make up its mind whether it will be earth or water, and so it compromises."[44] In this fecund region of wet black soil, "the quality of the water is curious. . . . The liquid is thick, dark, stained. Earth-steeped, the color is frequently a heavy brown or purple, almost a black. Drop your hand a few inches below the surface, and it cannot be seen."[45] "It's so even and calm there," says Bechet. "There's big dark trees dripping in the water, funny lilies, things rotting, strange birds flying and swooping, bats, snakes—lots of snakes—and when the night come it's just like some burglar

coming to steal what little light there is." Waiting in the bayou to meet his lover, Omar sings to himself—a happy melody of anticipation: "It wasn't much of a song, not what we'd call a song. There wasn't much rhythm to it, but just pieces of melodies. It was moods he was making up out of himself. . . . That's the way his song was; it was quiet and far off, but it was everywhere inside him."[46] In the heart of the bayou, Blacks could speak to one another through music: "It like they were in Africa again, like they was calling to one another, to another tribe. . . . Back there in the bayou, those runaway slaves took that glad song my grandfather had made and they sent it away into the night, sending it back to my grandfather, trying to give him the gladness and the power of it again."[47]

Bechet's bayou should be read as one of Black literature's many vital *maroon* spaces—open-corner territories where former captive Africans refused slavery and formed their own communities, and where the Black drum pulses and night calls that will later crystallize as "jazz"—the shared "pieces of melodies"— already ran free. Here, the music itself appears as a character whose powers of protection and redemption are such that those who follow Bechet's example learn to "treat it gentle."

Fred Moten and C. Daniel Dawson both speak of maroons and their jurisdictions, but also of *maroonage* as a state of mind: the African fugitives' will to escape slavery and to set up spaces of Black self-sufficiency and governance.[48] Thus, maroonage is a refusal, bound up in the decision to "make your getaway" (as the blues say), and also to relax and find "plenty good room" (as the spirituals say) to live and breathe. It's a means of rejecting stricture and dwelling in an open corner instead: a back space and a Black space, *where freedom dreams.*[49]

And this fugitive spirit is also in the music of Sun Ra. Composer, keyboardist, and bandleader, Ra insisted that *"space* is the place"—that he and his music were meant not for this world but for the outer space of interplanetary travel and dwelling: a juridical elsewhere. "Next Stop Is Jupiter, Next Stop Is Jupiter," declared one of the chant-songs of Ra's "arkestra," the band so named to suggest holy flight.[50] His vision of journeys beyond America, and indeed beyond the gravity of Earth itself, involved imaginative travels and dreams of physical escape. According to Sun Ra biographer John Szwed, when the vocalist Art Jenkins was seeking a gig with Ra, Jenkins sang an R&B tune to the composer/bandleader: "Sonny" [as intimates called Sun Ra, whose family name was Herman "Sonny" Blount]

> told him that he had a nice voice, but what he was looking for was a singer who could do the impossible ("The possible has been tried and failed; now I want to try the impossible"). Art came back one day when they were recording at the Choreographer's Workshop, and dead set on getting on a record somehow, rummaged through a bag of miscellaneous instruments looking for something he could play. But every time he picked up something, someone in the band

would tell him to leave it alone. When no one objected when he pulled a ram's horn from the bottom of the bag he began to sing into it, but backwards, with his mouth to the large opening, so that it gave out a weird sound which he made weirder by moving his hand over the small opening to alter the tone. Sonny broke out laughing, "Now that's impossible!" and asked him to improvise wordlessly on the record.[51]

Growing up Black in the 1920s and 1930s in Birmingham, Alabama—later called "Bombingham" because of its relentless racial violence—Sun Ra understood the need to build a life on a plane beyond the one assigned to you. An open corner could be a mental space where, in spite of one's surroundings, freedom reigns.

Louis Armstrong was another musician who sometimes dwelled apart from the world we know. Asked how he managed to play so well when surrounded by second- or third-rate musicians, he explained, "When you play there are always two bands—the one you hire, and yourself. When the hired one is good, you turn them up mentally and dig them. But when they're not, you turn them off and *you* become the band. If you spend your life depending on other musicians. . . . it's too bad for you."[52] Particularly when wearing his heavy, horn-rimmed spectacles, Louis seemed all set to take off for someplace else, where he became the band. Both Ra and Armstrong could leave the planet when it tried to hold them down and take off for *otherwhere*, a new territory where the music provided a space beautiful enough for their sound.

Jook Houses, Music Clubs, and Other Safe Spaces

In a post-Katrina world, New Orleans had to be reimagined, freshly dreamed. Lionel McIntyre, a New Orleans architect and city planner, has reminisced about the neighborhood where he grew up and adjoining neighborhoods—open corners of that great city—in terms of their unforgettable sounds.[53] McIntyre's recollections of casual walks through the Ninth Ward are striking: meanderings along streets where you could hear small bands playing for sports games and the bass-drum sound of basketballs bounced on playground asphalt; where you heard master percussionist James Black giving lessons to students; where Fats Domino ran through the cycle of keys. You could hear the church choir getting ready for Sunday, and you heard jazz royalty—the Jordans and the Marsalises, the Toussaints and the Battistes—woodshedding (practicing). "The art," Ellison has written, "was what we had in the place of freedom."[54] Where will the art now be made? What will that city's hallowed Black neighborhoods—worlds apart from the Disney-like parts of Bourbon Street—look like in the years to come? How will they sound?

To rebuild New Orleans as a jazz city—a place whose landmarks include robust sonic imagery—is not a matter of nostalgia. The challenge is to comprehend that sonic images cannot be bought and sold; they are built into neighborhoods as part of a way of life, of routines and rituals. In turn, they buttress neighborhoods. There have to be open corners for new James Blacks to create the world anew.

Zora Neale Hurston is a pioneer theorist of Black creative space. What made New Orleans *New Orleans*, Harlem *Harlem?* Hurston brilliantly said that "musically speaking, the jook house is the most important place in America."[55] For all the loud and wrong bawdiness of such places, they are sites of carefree celebration of "drylongso" (to use a Southern Black vernacular term meaning

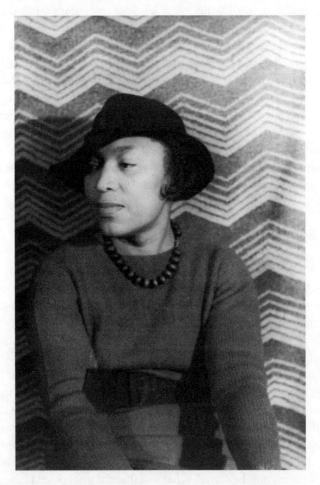

Portrait of Zora Neale Hurston by Carl Van Vechten, photographer; 1935.

Courtesy of the Library of Congress.

"ordinary" or "everyday") Black life, and even of spiritual renewal,[56] reminding us that many of humankind's most inspired moments occur in down-the-side-road and across the way open-corner spaces. And these moments have a physicality: as bodies come close to each other, they are reminded that the secret of life is to make life swing. The basic unit of life, says Albert Murray, is the party of the first part together with the party of the second part, "or vice versa"—two people together![57] Murray and Hurston also make the key point that there's all the difference on Earth between "Negro entertainment" and the art created when Blacks are playing for themselves in ritual settings where courtship dances[58] roll and tumble—and where a prime purpose is to "stomp the blues," to park troubles at the door while the music plays.

The jook houses and so-called good-time houses of dockside East Baltimore were, we should recall, the setting that fostered Billie Holiday: a wide-open part of town where, in the midst of danger and violence as undeniable as in Louis Armstrong's New Orleans, artistic creativity ran relatively free. The pioneering musicologist Willis James, Holiday's contemporary, stressed the relaxed, in-group nature of these places where Black art could thrive:

> Where Negroes are brought together in a situation that requires them to rely mainly on each other for interest and recreation, the production of songs of a secular as well as a religious type is likely to be greater than in situations where they work individually and live very different types of lives. This is largely due to the fact that group action aids the imagination in subject matter and at the same time serves as a kind of insurrectionary force in the developmental stages of a song pattern or subject.[59]

New language, new music, and new dances—insurrectionary forces in Black art—flowed in and through the roadside and portside juke joints of America.

Bearden, too, drew artistic inspiration from spaces where Black music thrived, as we have seen in *Of the Blues: Kansas City 4/4*. Several of the collages in his semiautobiographical *Profile* series (exhibited in two parts, in 1979 and 1981) refer to spaces from his childhood and young adulthood.[60] The first installment of the series, which looks at Bearden's boyhood in the 1920s, features Deep South churches and roadside country bands. The later corpus focused on Black Pittsburgh and especially Harlem, and includes *Uptown Sunday Night Session* (1981). Its caption, cocomposed by the artist with Albert Murray, specifies that "the legendary Sunday nights at Leroy's, on the corner of 135th Street and Lenox Avenue, included a floor show. Unlike Connie's Inn and the Cotton Club, Leroy's was mostly off-limits to tourists." The pieces called *Rehearsal Hall* and *Sitting in at Barron's* (both 1981) also refer to places less concerned with entertainment than with musicians creating music for one another and for local homefolk: open corners of Black creative collaboration.

Some open corners were places of education in the hard-knocks school of antagonistic cooperation, where musicians themselves upheld the musical standards. *Sitting in at Barron's* is captioned, "When you sat down at Barron's you knew very well you would play only so long as you kept Willie the Lion Smith, J. P. Johnson, Lucky Roberts, and Fats Waller interested in what you were doing." The four named musicians were among the most famously demanding house pianists at Barron's, whom the young Duke Ellington regularly came to play with and against (to use Ellison's telling phrase), jam-session style.[61] Such clubs were safe spaces of a very particular sort—safe for high-speed, risk-ready artists forever in training who came to play and *work*—safe for the young learners to "sit in," but only until their elders decided they were done.[62] Such a jam-session setting is the jazz artist's "true academy," writes Ellison.[63] Unlike the music conservatory, "here it is more meaningful to speak not of courses of study, of grades and degrees, but of apprenticeship, ordeals, initiation ceremonies, of rebirth. For after the jazzman has learned the fundamentals of his instrument and the traditional techniques of jazz—the intonations, the mute work, manipulation of timbre, the body of traditional styles—he must then 'find himself', must be reborn, must find, as it were, his soul."[64] These intense jam sessions provided open corners for musical self-creation, and—considering Ellison's thesis that jazz players were model artists and the jazz band as a model for democratic coordination—they also presented models for self-determination, richly construed.

With such language reminding us of the deeper purposes of jazz in its communal settings, consider that two of the *Profile* collages—which all somehow trace the artistic education of the young Bearden—are set in bordellos. In *Mamie Cole's Living Room* (1978), which is captioned, "Her place was not for the working man," the piano at the edge indicates that the depicted nude beauties and the music created in such places both served as Bearden's muses. Bearden reminds us that down-the-block or down-the-road open-corner spaces were frequent settings for musical experimentation and creativity, particularly during the first third of the twentieth century. The windows of *Mamie Cole's Living Room* open onto expansive vistas (one seems to show other planets), with the portraits on the wall also reflecting dimensions of living beyond the one depicted. "I'd like to call your attention to the pictures on the wall," said Bearden. "I used this to show the people who were there and that there was a definitive continuity in their lives."[65] This collage also offers a variety of depicted textures—wallpaper, upholstery, fruits, rugs, the ladies' skin—suggesting rhythmical interplay, the sense of interval that Bearden spoke about so often.

Railroad Shack Sporting House (1978), the other bordello collage in the *Profile* series, is especially poignant in the wording of its title and caption. The reference to the railroad connects the place and artwork to the history and mythology of the train, the main symbol of the *Profile* series and a defining

motif in twentieth-century Black music—a technology of displacement, but also an engine of self-reinvention. Referencing a girl whom Bearden sometimes identified as his first girlfriend, Liza, *Railroad Shack Sporting House*'s caption reads, "When I was old enough, I found out what Liza's mother did for a living." Again the artist places portraits on the painting's back walls. Is one of them Liza as a high school graduate? Does the other depict Liza's grandmother (whom Bearden mentions twice in statements about this series), one of the artist's many loving guardian-mothers? Do these background figures keep Liza's mother safe as she offers transactional hospitality (and sexual play) to a stranger? Is this in any sense a scene of Liza's mother's own pleasure and/or journey toward new horizons in life? Perhaps these bordello scenes gave Bearden a way to offer his own presentations of beauty to an art market whose appetite for exploitation could be ravenous. If so, they also provided an unexpected instance of the open corner as inspiration for the artist-in-training.

Modes of "Open-Corner" Creativity: Ambiguity, Suggestion, and Understatement

Ralph Ellison wrote alone, but he used the language of collaboration when describing the genesis of *Invisible Man*. The novelist confided to a friend that he told his editor, Albert Erskine, that he (Ellison himself) was "having a time deciding what kind of novel it is, and I can't help him. For me it's just a big fat ole Negro lie, meant to be told during cotton picking time over a water bucket full of corn [whiskey], with a dipper passing back and forth at a good fast clip so that no one, not even the narrator himself, will realize how utterly preposterous the lie actually is."[66]

 In such Black storytellers' circles, Ellison told an interviewer in 1967, we tell "Negro lies"; the lies, or in-group tall tales, were packed with life lessons and information that the jazz drummer Eddie Locke called "true facts." Here, said Ellison, "we tell what Negro experience really is. We back away from the chaos of experience and from ourselves, and we depict the humor as well as the horror of our living. We project Negro life in a metaphysical perspective, and we have seen it with a complexity of vision that seldom gets into our writing."[67]

 Ellison's subtle distinction between lived experience and the humor or horror it evokes, the twinness of truth revealed in a lie, reflects certain hidden or invisible aspects of Black experience. When Ellison's protagonist, Invisible Man, is challenged on his knowledge of Harlem by a white political colleague who has a Black wife, he suggests that the man have his wife show him the inside (the open corners) of that part of town: ask her to "take you around to the gin mills and the barber shops and the juke joints and the churches,

Brother. Yes, and the beauty parlors on Saturdays when they're frying hair. A whole unrecorded history is spoken then."[68]

Harlem's Savoy Ballroom of the 1930s and 1940s was "one of our great cultural institutions," said Ellison: it was one of these open-corner spaces, Harlemites' wooden Heaven of a dance floor, with plenty good room for everyone:

> In the effort to build much-needed public housing [Ellison continued] it has been destroyed. But then it was thriving and people were coming to Harlem from all over the world. The great European and American composers were coming there to listen to jazz—Stravinsky, Poulenc. The great jazz bands were coming there. Great dancers were being created there. People from Downtown were always there, because the Savoy was one of the great centers of culture in the United States, even though it was then thought of as simply a place of entertainment.[69]

In the context of defining a Black cultural open corner, how fascinating that along with space for social dancers, wallflowers, observers, or those who came mainly to listen to the music (some while dancing, of course), the Savoy featured "the Corner." This was a space at the northeast section of the dance floor that was off-limits to all but virtuoso footwork artists, many of them professionals: dancers only.[70]

Facing labyrinthine walls of U.S. unfreedom, Black Americans managed to carve out spaces of freedom where they created much of what distinguishes American culture. The invisibility of such richly productive cultural incubators as jook joints, good-time houses, churches, and beauty parlors—spaces typically left out of American cultural history—left Black Americans ironically freer from the "thou shalt nots" of official culture to create modern Black selves, art forms, and communities. Freer to take the chances necessary to create, in art and in life, the new, the definitively modern. Freer to "make poetry out of being invisible."[71]

Doubtless some of the freedom of these spaces, sacred and secular, is derived from their association with Black professionals on the move—musicians, athletes, itinerant preachers, itinerant workers—and the pleasures of finding oneself at home on the road, the pulls of relatively unhindered kinesis. Then there are the joys of skirting border spaces where the sacred and the secular meet and blur. In one of his most evocative remembrances of his lay days, Ellison's character the Reverend A. Z. Hickman describes a scene in a hard-rocking public roadhouse or jook house. Hickman's language in this passage, for all its bravura as frontier-style brag—recalling Ellison's own description of the free Black space of the imagination where *Invisible Man* was composed—also springs directly from the "communion and fellowship" of the Black church. As a jook house blues

trombonist, he'd learned to eat, drink, and raise his voice with the others. Part of a ceremonial circle, he

> used to put a number-two washtub full of corn on the table and drink your fill for a dime a dipperful. . . . And there was Ferguson's barbecued ribs with that good hot sauce, yes; and Pulhams. "Gimme a breast of that Guinea hen," I'd say, "and make the hot sauce sizzling." All that foolishness. Ha! Me a strapping young horn-blowing fool with an appetite like a bear and trying to blow all life through the bell of a brass trombone. Belly-rubbing, dancing and a-stomping off the numbers and everybody trying to give the music a drive like those express trains. Shaking the bandstand with my big feet, and the boys romping by midnight and jelly-jelly-jelly in the crowd until the whole house rocked . . . Surely the Lord makes an allowance for all that, when you're in the heat of youth. . . . You have to scream once maybe so you can know what it means to forbear screaming. That Chock beer, how I exulted in that; rich and fruity mellow. A communion there, back there in that life. Its own communion and fellowship.[72]

Such scenes made room for what, in notes to *Invisible Man*, Ellison calls "ambivisibility": they articulate an unillusioned acceptance of ambiguity and the perspectives that double-vision/invisibility alone can offer.[73]

In today's Harlem, one can count on the fingers of one hand such open corners of communion and creative ambivisibility—dwindling, under the pressures of newfangled gentrification. Gone, as we have seen, is the Savoy; gone the Hey-Man and the Nest; gone the Renaissance Ballroom.

Zora Neale Hurston spoke of another aspect of the open corner. In shimmering Zoraese, she defines Black dancers as masters of "dynamic suggestion":

> Every posture gives the impression that the dancer will do much more . . . It is *compelling insinuation*. That is the very reason the spectator is held so rapt. He is participating in the performance himself—carrying out the suggestions of the performer. The difference in the two arts is: the white dancer attempts to express fully; the Negro is restrained, but succeeds in gripping the beholder by forcing him to finish the action the performer suggests. . . . No art can ever express all the variations conceivable . . . The Negro's dancing is *realistic suggestion*, and that is about all a great artist can do.[74]

An exemplar of this aesthetic of understatement is the master tap dancer Chuck Green, who laughed as he declared, "Jazz tap dancing is happy, and satiric."[75] On stage, Green, who was a large man, seemed to float as he worked the edges of audience expectation—always implying much more than he was delivering. Smiling to himself, Green invited his viewers to fly with him, filling in the blanks.

Ellison's strategy as a writer was similar: "you simply cannot put it all there on the page, you can only evoke it—or evoke what is already there implicitly in the reader's head, his sense of life."[76] Again, the artist lures the reader with what is left out, "to involve himself [sic], to attach himself [sic], and then begin to collaborate in the creation of the fictional spell."

Black understatement has a long history. "A still tongue makes a wise head," says Frederick Douglass to his fellow conspirators (who've been betrayed by one of their number). "Own nothing," he advises them.[77] And many a blues song makes clear: "You can read my letter baby. But you sure can't read my mind." And "You don't know, you don't know my mind." (Frequently, the following line is "You see me laughing, I'm just laughing to keep from crying.")[78] Near the end of Morrison's novel *Beloved* (1987), the reader encounters these words three times: "This is not a story to pass on." This is not a story to ignore or pass by, much less to die for (to "pass away" on); neither is this a story to pass along to others (the advice of many oppressed people, to avoid discouraging the next generation). Neither is this a story to "pass"—in the variety of senses in which Blacks have "passed for white"—on. Here is a fictional version of the twoness and threeness of the yes-no-maybe blues: Do not fail to comprehend and confront Black history's most painful aspects, but also, do not be a party to continuing the causes of those painful aspects. Own the tale; own nothing! Ambivisibility.

One hears instances of this dynamically insinuative doubleness throughout the blues, which, as Ellison writes, can "make us constantly aware of the meanings which shimmer just beyond the limits of the lyrics." He says, "The blues is an art of ambiguity, an assertion of the irrepressibly human over all circumstance, whether created by others or by one's own human failings. They are the only consistent art in the United States which constantly remind us of our limitations while encouraging us to see how far we can actually go."[79] Here, Ellison implies a politics of the blues: a will to move beyond all confinement and limitation. "How long," asks one of the greatest of all blues songs, "must I keep my clothes in pawn? . . . I can see the green grass growin' up on yonder hill / But I ain't seen a greenback dollar bill, in so long."

"So long," is that song's answer. "So long, sooo long." These blues queries echo Job's angry challenges to God and the Psalms' distressed inquiries: "How long wilt thou forget me, O Lord? *For ever?* How long wilt thou hide thy face from me?" Bringing the "How Long?" question directly into the political realm is Martin Luther King Jr., whose speech on the steps of the Alabama State Capitol building following the March from Selma to Montgomery of March 7, 1965,[80] develops a drumbeat "How Long?" rhythm. His repeated response riffs on the Bible and the blues with an important corrective: "Not long," King proclaims, again and again. "Not long!"

The contemporary visionary theologian James A. Forbes Jr. once explained that, as a fledgling divinity school graduate, he could not buy or beg an Amen in his hometown church, a shouting Baptist congregation in Black rural North Carolina, until he learned a lesson from his father, a seasoned country preacher. "You must leave space for an Amen," Rev. Daddy Forbes taught him. "You must let your sermon breathe."[81] This leaves space for the congregation to enter, as Bearden said about the open corner in art: not only to confirm the truth of what the preacher/artist is saying with Amens, but also to get involved in the sermonic process with either a dubious "Well" or "Hmm" or an editorially redirective "Say that." It is in and through the sermon's open corners—the intervals left for potential Amens—that the Spirit, stirred by communal creativity, can guide a message larger than either the preacher or the congregants. This open corner is a space for communitywide creation, an invitation to the Holy Spirit, or what Rev. Forbes has called "space for grace."[82]

The Open Corner and Improvisation: Literary Origins

Ambiguity and understatement, as features of the open corner in Black creativity, involve a third mode: improvisation. To trace its workings in African American art, it's helpful to recognize two literary predecessors, William Shakespeare and Mark Twain, who may be unexpected key figures in the Black cultural tradition.

Both Shakespeare and Twain wrote brilliantly about blackness and whiteness, love and power, struggles to be free. The Bard is cited by virtually every Black American writer since Frederick Douglass, who quotes him twice in his first slave narrative, in 1845, and was known to give outstanding private performances of soliloquies from *Hamlet* and *Richard III*. Shakespeare scholar Kim Hall has pointed out that even in the nineteenth century, Black performers of scenes from Shakespeare typically were met by choruses of Black audience members repeating lines back to the actors. In the twentieth century, there were recorded jazz versions of Shakespearean poetry, as well as a full-length concert of musical portraits of Shakespearean scenes and characters by Duke Ellington and Billy Strayhorn.

So let us consider literary scholar Stephen Greenblatt's observation that as Shakespeare developed as a playwright, he learned to leave something like an open corner in his plays—something unfinished. According to Greenblatt, Shakespeare worked by deliberate subtraction. He built considerable play, so to speak, into the steering wheel of his plays—room to move, invitations in—especially in his late, more experimental works, where tragedy met comedy and conventional form and formula dissolved.[83] When from his plotlines or character descriptions Shakespeare "took out a key explanatory element,"

writes Greenblatt, "thereby occluding the rationale, motivation or ethical principle that accounted for the action that was to unfold," the playwright invited "a peculiarly passionate intensity of response. . . . The principle was not the making of a riddle to be solved, but the creation of a *strategic opacity.* This opacity, Shakespeare found, released an enormous energy that had been at least partially blocked or contained by familiar reassuring explanations."[84] In its refusal of predictable solutions to the calculus of problems raised in his dramas, Shakespeare's opacity asked his audience to participate in the artist's process of invention: to connect the narrative dots, to elaborate on the questions he'd left strategically open. Like Bearden's open corner, Shakespeare's opacity was, among other things, an invitation to the audience to collaborate.

Just as Shakespeare was essential to Black American writers, no one could miss Twain's monumental achievement of capturing the note and trick of everyday American speech, or fail to apprehend his presentations of Black characters as his novels' most eloquent carriers of messages of freedom (including Huck Finn, who is decidedly Black in his culture and values). It is, of course, true that like Shakespeare,[85] Twain took false steps on the road to Black portraiture; his Jim of *Huckleberry Finn* crosses the line into minstrel stereotype. But as a positive counterweight (though not an excuse), Twain was master of a particular open-corner aesthetic strategy that would serve Black artists well. By 1900, when he was one of the most sought-out after-dinner speakers in the Anglophone world, Twain liked to declare his talks strictly "impromptu." Then he would peek through his bushy eyebrows and add the deadpan line, "It usually takes me more than three weeks to prepare a good impromptu speech."[86]

By "impromptu," Twain seems to have invoked the word's Latin roots, *in promptu,* meaning "in readiness," or "all ready and set to go." The related Latin adjective *promptus* means "ready." Contrary to the current implication of "impromptu" as fumbling and makeshift (definitions also often pinned to the word "improvised"), Twain's "impromptu" meant "painstakingly prepared to appear made up on the spot."

"A person who is to make a speech at any time or anywhere, upon any topic whatever," confided Twain to his journal, "owes it to himself to write the speech out and memorize it." One motive for this strategy was that it allowed Twain to hand out copies of his talks to reporters before or right after the gig, so they could quote him in their papers (or run the talk complete, as written) without mistakes. But memorization also served the cause of effective delivery. "A speech that is well memorized," said Twain, "can, by trick and art, be made to deceive the hearer completely and make him reverently marvel at the talent that can enable a man to stand up unprepared and pour out perfectly phrased felicities as easily and as comfortably and as confidently as less gifted people."[87]

The surprise here, and the useful method for other artists, is not Twain's credo that for a speaker to seem natural, he or she must get the lines down in

advance and practice the delivery. Part of the trick of impromptu speaking, Twain explained, is to salt down a speech with what appear to be the mistakes of the offhand talker, as well as to leave in some intentional gaps:

> A touch of indifferent grammar flung in here and there, apparently at random has a good effect—[and] often restores the confidence of a suspicious audience. [The veteran speaker] arranges these errors in private; for a really random error wouldn't do any good; it would be sure to fall in the wrong place. He also leaves blanks here and there—leaves them where genuine impromptu remarks can be dropped in, of a sort that will add to the natural aspect of the speech without breaking its line of march.[88]

Here, Twain acknowledges the genuinely improvised moments in his performances, the spontaneously generated riffs that fill in the blanks.

As Twain explains, he adjusted each performance in response to other players: he listened with special care to the speakers preceding him, and especially to the person presenting what Twain suffered as "the compliments," the remarks advanced by his introducer. "You sit and wonder and wonder what the gentleman is going to say who is going to introduce you. You know that if he says something severe, that if he will deride you, or traduce you, or do anything of that kind, he will furnish you with a text, because anybody can get up and talk against that."[89] Meanwhile, of course, our impromptu speechmaster was ready with his memorized material, "before you know it he has slidden smoothly along on his compliment to the general, and out of it and into his set speech, and you can't tell, to save you, where it was nor when it was that he made the connection."[90]

As a closer to the speech at the Whitefriar's Club in 1906 where he revealed all of this, Twain pretended to admit that alas, he was caught at the finish line with no takeaway message. And so he confesses to closing with a "little maxim"—one that in fact touches on the virtuoso nature of his performance: "I always use it in an emergency, and you can take it home as a legacy from me, and it is: 'When in doubt, tell the truth.' "[91] This was a rule whose Black cousin was Ellison's dictum on "lies"—tell the truth propelled by the force of improvised narrative know-how: tell a truth truer than the hard-boiled facts.

The Open Corner and Improv: Jazz

On this question of the open corner, where the truth unobtrusively tips through, the jazz musician exemplifies Black American culture's use of improvisational techniques. For understatement and innuendo with a cool charge in the air, Miles Davis and Thelonious Monk remain the obvious

masters—both disciples of the Queen of Dynamic Suggestion, Billie Holiday. Don't forget the Lady!

Not only did Ms. Holiday leave dramatic openings for her own reinventions of melody and time signature, like Twain's gaps in his scripts, she also propped what one of her favorite accompanists, Buck Clayton, called an "open window," which invited him to dialogue with her in the fullness of the magic moment when she was working "impromptu." "I would just watch Lady's mouth," Clayton told an interviewer, "and after she had made one of those real pretty phrases, I would come in with something to go with it. Sometimes I'd say *Amen*, sometimes I'd just say *Yes Baby O Yes I know just what you mean*."[92] He had no intention of getting in her way, of course; he just wanted to join her in the creative process at its impromptu best: in the rich, thick moment of improvised give-and-go. Lester Young was another favorite accomplice of Lady Day: a master of compressed conversational pick-and-roll, in and out of the moment where she worked.

According to Harry "Sweets" Edison, another eloquently understated Holiday accompanist,[93] it was Count Basie who taught them both, and the whole band, when to come in and when to "lay out." "I learned very well from Count Basie," he told an interviewer, "because he was the greatest economical piano player who ever lived. Billie Holiday was a great disciple of this too: to put the right note in at the right time, you know. And your timing is very important. It's not how many notes that you sing or how many words that you sing that makes it great. It's how many notes you leave out. That made her a greater singer, too."[94]

Holiday's greatness, not unlike Twain's, had to do with the ability to engage in spontaneous give-and-take with interlocutors. But Billie was never an improviser in the mode of Ella Fitzgerald or Betty Carter. Lady rarely scatted, and when she did, it usually was for eight or fewer bars of well-planned *Ooo-ooo-oo* playfulness. According to her early accompanist, Teddy Wilson, Holiday preferred to take her time learning a new song, going over its structure and melody as written until she owned them enough to shape them to her own purposes— much like Twain memorizing his speeches or Forbes leaving space for grace. Once she had refreshed a new piece—once she had improvised new melodic lines and harmonies—she would stick with them for a while, repeating them on records and in public performances with slight changes based on the moment and the company she was keeping—both the musicians and the audience being part of the dialogue in art. "One night it might be a little bit slower," she said, "the next night a little bit brighter, according to how I feel."[95]

She was a composer of very good songs; but it's more significant that she was a cocomposer of everything she sang, working impromptu in the songs' open corners, and inviting colleagues to come inside. As a composer in the moment, she was always doing what Ellington called "listening ahead,"[96] planning her

next musical statements in response to what she was hearing around her—comments in music that also were invitations to colleagues for further cocreation. Such invitations extended to listeners, too. Could we call this a Shakespearian opaqueness?

Consider Holiday's signature song, "Strange Fruit." Composed by Abel Meeropol and not, as Holiday often claimed, written especially for her, "Strange Fruit" was a song that Holiday nonetheless came to own, and she was not shy about expressing her displeasure when others presumed to sing it. Comparisons of the original sheet music with Holiday's various recordings make clear that she painstakingly disassembled and then rebuilt the song in her own style—just as she routinely undid and redid songs from Broadway or Tin Pan Alley. For the first recording of "Strange Fruit" (1939), Holiday compressed the melody and slowed the pace to increase the song's searing power. According to jazz historian John Szwed, "Throughout the record there are downward arcs of notes and slight bendings of pitch characteristic of the blues, especially on the words 'Southern,' 'South,' 'sweet and fresh,' 'of burning flesh.' . . . She seems to be bearing witness to what she is describing, her vocal a near recitative, flattening the melody, approximating speech."[97]

Recordings from the 1940s and 1950s show that, increasingly, she intensified the drama of the weighted language by extending the silences between phrases—creating spaces for the audience to take in the meaning, to reflect. A television clip of Holiday's performance of the song in the mid-1950s shows, too, how she twists and extends the vowel sounds of certain words ("drop," "crop") until they become a mournful, accusatory wail. She cuts short the final, full-throated cry of "crop"; she does so with a suddenness that leaves her audience no room for sentimentality or self-pity, but instead confronts it with a void of silence—before the nervous applause appears—which is almost unbearably charged.

Duke Ellington offers still more examples of open corners in music. For night after night over six decades, the maestro wrote new pieces of music—more than two thousand works in all—detailing parts for fifteen or more musicians (but not for the drummer, who was expected to "create something," and not, of course, for "our piano player"). Typically, he would leave blank spaces where the soloist's job was to create something to fit the overall composition. On rare occasions, Ellington would use a practice evidently first perfected by Jelly Roll Morton:[98] he would write out the solo statements he wanted from his players, note for note. These Ellington practices recall Twain's strict memorizations with blanks left for his solo improvisations, or Holiday's rehearsals in search of running space for new treatments. Ellington never specified in written scores the desired dynamics for his written solos, but it was understood that he wanted them played with the intense freshness of on-the-spot discovery. "Take a Boston," Ellington would sometimes write on

a score, said Clark Terry. Or he'd say, "Put the pots and pans on!" or "Ooze into it!" Or "whatever comes to his mind that he would think would make an emphatic impression on the one who was playing the solo," said Terry.[99] Whether Ellington's intentions for a soloist were spelled out or not, it is significant that the maestro left open corners for his players to cosign his work with statements in their own voices and styles.

Ellington understood that, in the improvised African American jazz idiom in which he worked, "it is the musicians—not the instruments, not gestures from the leader, not dots on paper—that make the music."[100] This is one secret to his success as a composer. Those who make the point that Ellington was a musical Shakespeare—writing parts, as the playwright did, for actors capable of portraying a wide variety of characters and tailor-made for these particular

Album cover depicting Johnny Hodges, alto saxophonist in the Duke Ellington Orchestra, on stage with a music score attached to the microphone—all part of the performance of deadpan improvisation in the "open corner" of a written score.

players—speak truth.[101] Like the theatrical company that Shakespeare knew very well, and in which he himself sometimes appeared with his favorite actors, Ellingtonians had a long-term, intimate knowledge of the maestro's art, and he of theirs. His baritone saxophonist, Harry Carney, was with the band for forty-seven years, until Duke died; alto sax player Johnny Hodges stayed for thirty-eight years; and the brass and reed men Lawrence Brown, Ray Nance, Paul Gonsalves, Russell Procope, and Jimmy Hamilton all were in the band for over twenty years. No wonder when Johnny or any of the other regulars left the band for a while, certain parts and pieces written specifically for them were not played until they returned—or, if they did not come back, were never played again!

The rich trove of scores at the Smithsonian shows that at the top of every Ellington part is not "First Trumpet" or "Second Alto Sax," but "Nance" (if Ray Nance were playing lead trumpet for that particular piece), "Rab" (the abbreviated nickname of Johnny "Rabbit" Hodges), and so on. Ellington composed each part for the specific range, timbre, mood, and talents of each player. For instance, he would play on trombonist Tricky Sam Nanton's unique ability to "make a sound so sheer that someone once likened it to tearing paper."[102] Sometimes Ellington's demands on his players could be mysterious. "How do you like your part?" he asked trumpeter Clark Terry after the first run-through. Came the reply:

> "It's fine Maestro, I dig it. But at letter E it says I'm Buddy Bolden. Nobody knows how he sounded, Maestro; he didn't record. What do you want me to do at E?" "But Clark, you ARE Buddy Bolden," Duke told me. "You break glasses across the Mississippi River from where you play those New Orleans dances!" And damn if I wasn't psyched into playing louder and clearer. Duke was right. I was Buddy Bolden after all![103]

In these scores, Duke was not only creating balances and blends of his music's melody, harmony, and rhythm; he was orchestrating conversations and showcases for the strong musical personalities in the band: for blues-shouting Rab in contrast with smooth, "legit" Juan Tizol on trombone, for instance. Or Rab, now in another disposition, as the star-crossed teenager Juliet (in the Shakespearian suite called *Such Sweet Thunder*), whispering tender poetry to her Romeo (Paul Gonsalves on tenor sax).

For a record of this collaborative improvisation in action, we have the wonderful film of the Ellington orchestra's studio session on July 11, 1967, as they recorded his new composition "Rondolet," a revision of a 1957 piece called "Slamar in D Flat."[104] This is an up-tempo blues, with tricky phrasing for the trombones and with solo space for Rab. As the band plays, Ellington serves block chords, gives hand signals, stands up to dance—all to manifest what he

wants from everyone, written and unwritten. Clearly, the composer is continuing to create and cocreate the piece as it is being recorded. "Take it from the top," his hand signal says. Then (another hand signal) to Rab, "Frame your last solo remarks within this last part," "Make it funky, man!" and then "Cool it down, wrap it up!" Throughout, everyone (except, as usual, the drummer Chris Columbus, who plays his signature dance-beat shuffle rhythm; the piano player; and this time, the bassist Jimmy Woode, whose blues lines are traditional) is reading sheet music, perhaps recomposed (from the 1957 original) the night before. But there's play in every line. And in the open corner, Rab adds his own intense dramatic statement to give a sense of completeness without closing the composition down. All set to record the piece, Ellington still was not hearing what he wanted from the 'bones. "Fuck it," he muttered. "Rolling!" and maybe next time they'll get it right. For now, time to relinquish!

Out of this ferment came a kind of truth—truer than the score—that Ellington had learned to draw out of himself and the players. He learned both from the formally trained "conservatory boys" and from the "ear cats," many of whom did not read music at all. His favorite conservatory-educated musician was perhaps the Black violinist/composer Will Marion Cook. "Now Dad," Ellington recalled asking him about a new composition, "what is the logical way to develop this theme? What direction should I take?" "You know you should go to the conservatory," Cook told him, "but since you won't, I'll tell you. First you find the logical way, and when you find it, avoid it, and let your inner self break through and guide you. Don't try to be anybody but yourself." "That time with Cook," Duke said, "was one of the best semesters I ever had in music."[105]

Some ear cats, like Sidney Bechet, refused to learn notation for fear that it would confine or compromise their musical gifts. Duke often quoted with ironic satisfaction the answer of a jazz musician who was asked about his reading ability when he applied for a job. " 'Yeah,' said the man, 'I can read, but I don't let it interfere with my blowing.' "[106] Perhaps it was from the ear cats that Ellington learned not to make a piece too fine or finished. In an interview, the Ellington Band drummer Louis Bellson recalled the maestro in rehearsal telling the trombone section, " 'Okay guys, don't make that too pretty. Keep some dirt in there.' It means to keep that swing in there, that wonderful looseness. 'I want that feel,' he'd say. 'I want you to not just read the notes, but I want you to *play* the notes.' "[107]

The Open Corner and Improv: Morrison and Ellison

Open-corner modes of creativity are also deployed in modern Black literature. Interestingly, writers' awareness of their use in music has been critical. In discussing modes of writing, Toni Morrison told an interviewer, "There has to be

a mode to do what the music did for blacks, we used to be able to do with each other in private and in that civilization that existed underneath the white civilization. I think this accounts for the address of my books. I am not explaining anything to anybody. My work bears witness." She told the truth as she knew it, without compromising for white readers or anybody else. She added, "If my work is faithfully to reflect the aesthetic tradition of Afro-American culture, the text, if it is to take improvisation and audience participation into account, cannot be the authority—it should be the map. It should make a way for the reader (audience) to participate in the tale . . . If my work is to be functional to the group (to the village, as it were) then it must bear witness and identify that which is useful from the past and that which ought to be discarded."[108] Hers is "Say Amen Somebody" literary music: writing with awareness of all the creative modes afforded by an open corner.

The title page of Morrison's novel *Jazz*, and then its eloquent preface, spell out its subject and modus operandi. "I had written novels in which structure was designed to enhance meaning. Here the structure would *equal* meaning."[109] One of *Jazz*'s open-corner strategies was to leave out the omniscient and/or first-person narrator, as conventionally conceived. Instead, she invents a jazz narrator who improvises the weaving of the tale and her reactions to it "in the moment"—as jazz players say—of action. Here was a call-recall narrator, an important character in her own right, inviting readers to collaborate in improvising the tale.

We follow the novel as a work swinging in crisscross recollections and doublings back through pieces and parts of the story: "never," as Morrison says of human perception and experience, "a straight line."[110] Where does the novel start? Not with a once-upon-a-time narration, but with sound-words from an open-corner narrator: "Sth, I knew that woman." She'll tell you what she tells you when she gets ready. And she'll leave out enough, in the jazz tradition, to do what Bearden, Holiday, Twain, and Ellington (among others) did in open corners: invite audiences in for a little call and response, or as Bearden liked to say, a little call and recall. And where does the novel *Jazz* end? Morrison's narrator says, "Shoot, I don't know. You're holding the book, you tell me!" She could be channeling Shakespeare, too.

This refusal, this buildup of expectation that gets pushed on to the reader, is a case of Black understatement or, dare we say, "cool." For Ellison, this was something to wrestle with because of the vividness of the example of Ernest Hemingway, whom Ellison called "the true father-as-artist of so many of us who came to writing during the late thirties."[111] Ellison loved Hemingway's understatement and his heroes' silent coolness under pressure. But by the 1950s, he was saying, too, that as a Black American writer, he could not unequivocally trust Hemingway-style understatement. Ellison's point was that the racial divide was so wide that neither Black nor white readers or writers

could take for granted the meaning of things not spelled out. Too little mutual understanding held these groups together, he said, for the writer or reader to be sure that they were on the same page.[112] This doubt may explain why *Invisible Man*'s narrator sometimes will make a statement and then make it again, and then make it yet again!

And yet, *Invisible Man* remains a novel full of asides, jokes, and understatements that signify. Like Morrison, Ellington, and Twain, Ellison wants it both ways: he tells what he wants spelled out in poetic diction that could not be more explicit. And yet he also wants a corner left open, a dissonant note, the undertone, the invitation for an Amen. "Who knows but on the lower frequencies," says the narrator at the big novel's end. "Who knows but that . . . I speak for you?"[113]

The part that Ellison says Hemingway left out is the very part that Ellison wants most emphatically expressed: the humanity. One of Ellison's characters calls it the "shit grit and mother wit" of robust lived human experience—grounded by a diamond-hard sense of responsibility.[114] Here, through explicit statement and highly evocative understatement in the open corner, Ellison issues art as a call to action, a call for community.

So do the other artists explored in this chapter. All of them work the open corner as an open invitation and a space for freedom; as a place for in-the-moment creativity and collaboration. As a wide space with a long welcome table for ones we don't know or understand. In the open corner, as on a Harlem corner, we have to take the risks involved in seeing uninvited strangers not only as welcome guests but as sisters and brothers; we have to act as hosts and see to it that all feel safe, *all*. That they feel at home in a cosmopolitan neighborhood whose lower frequencies are ambivisible, with open corners and justice for all.

CHAPTER 4

HARE AND BEAR

The Racial Politics of Satchmo's Smile

Right behind my chair an enormous avalanche of laughter broke loose. It was the Negro servant. . . . How I loved that African brother! America as a nation can laugh, and that means a lot.
—C. J. Jung

The brother in black puts a laugh in every vacant place in his mind. His laugh has a hundred meanings. It may mean amusement, anger, grief, bewilderment, chagrin, curiosity, simple pleasure, or any other of the known or undefined emotions.
—Zora Neale Hurston

When seen laughing with their heads stuck in a barrel and standing, as it were, upside down upon the turbulent air, Negroes appeared to be taken over by a form of schizophrenia which left them even more psychically frazzled than whites regarded them as being by nature.
—Ralph Ellison

You only have to look at the Medusa straight on to see her. And she's not deadly. She's beautiful and she's laughing.
—Hélène Cixous

I n this chapter, I survey a series of comic performances by Louis Armstrong—in his music, films, and lesser-known collages—for their masterful deployment of humor to defuse, and refuse, racial tension. I also discuss Armstrongian humor, which had nothing to do, directly, with American race relations but was something larger, a joyousness just for himself, whether the white (or Black) folks liked it. Along the way, I explore American humor itself, first as a central part of what Henry James called the national character (if we can still use such an expression), and second as theorized in relation to race by Ralph Ellison. I ultimately examine Armstrong's role as King Zulu of the New Orleans Mardi Gras of 1949, as well as responses to that performance in collages and paintings by Romare Bearden and Jean-Michel Basquiat.[1] Finally, we will follow Armstrong to Africa for another comic masquerade with strong political implications. My most urgent message is that in this season of political aggression by the racist hard right, we need to remember to smile as we step aside from these grim-faced bullies—and to smile again as we push them back! Let us not allow their resistance to profound political change to take our good humor away. We don't want to win the next round's political battles, only to lose our deeply felt joy in the lives we choose.

At its base, my subject here is humor and power. I refer to a contemporary America where, as everybody knows, virtually all official power—financial power and the power to decide who governs—is concentrated in the hands of the very few at the pinhead of our national pyramid. Ours is a nation, too, where those same few, whom James Baldwin calls "the splendid," have much to say about how they (as well as the rest of us) are seen and not seen. The need to include humor in this discussion of power is intensified by the recent presence of a veritable joker in the White House, a crackpot reality-show smart-mouth! How telling to contrast Donald Trump's daily dribble of foul jokes—and his calculations of who thinks they are funny—with American humor at its very best: with Armstrongian smiles and laughter serving the robustly positive civic mission of drawing us together as a national family.

Certainly we are, as one of Ralph Ellison's characters brilliantly declared, "the United States of Jokeocracy."[2] We laugh to keep from crying, as many a blues song declares (Smokey Robinson wrote a few Motown songs along these lines, too; see chapter 2). We laugh at our own moves through the world, at our foibles as individuals and as members of groups with peculiar ways of doing. We laugh at the fields of paradox that confront us in the United States, in our patchwork "man-and-mammy-made society," still unfolding like a gigantic origami puzzle or Buster Keaton newspaper.[3] We laugh at the absurdity of our human circumstances—laugh, yet again, to keep from breaking down in tears. Vaudevillians Bert Williams and George Walker "achieved something beyond mere fun," said James Weldon Johnson. "They often achieved the truest comedy

through the ability to keep the tears close up under the loudest laughter."[4] Such laughter is a mighty healthy thing. At the very least, laughing at ourselves keeps us humble as we step outside the castles of our skins and see, in flashes, ourselves (and others, too) somewhat more clearly.

It's Americans' laughter at other people, however, that gives this chapter its argumentative edge. Laughing at others can also be a mighty healthy thing: how strange we Americans look to one another in our made-up faces surrounded or topped with hair bobs or baldies, our skirts and leggings skin tight or flapping, with our carnival of shoes and bling, the real stones and the fakes. I agree with Ellison's assertion that a still-young nation of so many creeds, colors, and classes urgently needs the agency of humor to help us work together in coordination. Go ahead and laugh, while our neighbors around the corner laugh back! The secret seems to be that such laughter compels the human identification with others—as we see our own risible weaknesses in them—and thus is finally a force that connects us. The rub here is that it's also true that laughter can express or incite suspicion, misunderstanding, and hatred. And I certainly do not mean to suggest that joining a stampede of bullies to make fun of an outsider is healthy. When one group hogs (or owns) the mike and uses that advantage to stream derisive laughter at other groups, trouble is brewing. "When Americans can no longer laugh at one another," Ellison also rightly says, "they have to fight one another."[5] And I would add, laugh *with* one another.

Armstrong's Humor and Anger

Can there be any doubt that the man called Satchel-Mouth or Satchmo, his mouth reputedly big as a pocketbook or satchel, was funny? Often, Louis Armstrong's comedy was a mix of just-for-fun larks and the highly serious— a mix not unlike that of Mark Twain, or for that matter of the ancient Greek comic playwrights, who worked fart jokes and phallic-display parades into their plays because comedy was the only theatrical form that permitted discourse on current politics. Armstrong certainly was, as he liked to say, "out here in the cause of happiness."[6] But Satchmo watchers know that the musical genius could be more than genial—he was in command of the full range of human reactions to life and, through his art, a full range of ways to make his audiences feel—and that his humor was often more pointedly political than meets the eye. How to read the serious side of Armstrong's humor? How to read his deep humor, with "tears close up under the loudest laughter"?

The most direct example of Armstrong's will to political action, often rightly cited, is his response to the 1957 Little Rock confrontation over school integration.[7] What's almost never acknowledged is that this incident offers

a telling example of Armstrong's humor, serious and deep, in the jagged African American grain. In an unusual foray into the political arena, the man called "Satch" and "Dipper" publicly called out President Dwight D. Eisenhower, who had remained silent while Arkansas governor Orval Faubus brought in the National Guard to prevent Black students from entering Little Rock's all-white Central High School. In his hotel room in Grand Forks, Armstrong was watching TV news reports of the explosive standoff when Larry Lubenow, a student at the University of North Dakota, showed up to do a puff piece for the local newspaper. Lubenow was surprised to find himself in the room with a boiling mad Armstrong. "The way they are treating my people in the South," Armstrong told him, "the government can go to hell. It's getting so bad, a colored man hasn't got any country." As for President Eisenhower, the man had "two faces and no heart" and was "gutless" for allowing "an ignorant plowboy" (Faubus) to run the situation.[8]

These remarks are salty enough, in the Black barbershop tradition of trading insults: while Armstrong did not talk about Ike's mama, he did comment, as the Dirty Dozens love to do, on his face(s) and on Faubus's intelligence, age, and social rank. But wait—maybe mamas came in for some ranking, too! Twenty-five years after the incident, Lubenow, interviewed by journalist David Margolick, gave new details of the Armstrong/Little Rock story. Armstrong had actually called Faubus "a no-good motherfucker."[9] He punctuated this deep-dozens slap at political authority by singing a loud "Star-Spangled Banner" that asked, "Oh say, can you motherfuckers see, by the motherfucking dawn's early light?" until he was hushed by Velma Middleton, his Armstrong All Stars bandmate, who was also in the room. Can there be any doubt that Armstrong helped Lubenow translate these too-real expletive outbursts into the still-Black vernacular language of "two-faces and no heart" and "ignorant plowboy?? Lubenow's editor at the Associated Press, finding even this sanitized "translation" out of character for the famously easygoing Armstrong, insisted on proof. The next day, Lubenow visited Armstrong again to show him his article with the toned-down language. "That's just fine," Armstrong told him. "Don't take nothing out of that story. That's just what I said and still say." As a signature at the bottom of the reporter's manuscript page, Armstrong used big block letters to print the word "SOLID."

Armstrong knew all too well that he would pay a price for this statement, watered down or straight-up, in gigs at home and abroad. And pay he did; despite the efforts of his manager and others in his camp to deny his words, he was denounced and in some cases dropped from shows. It is also true that Eisenhower ultimately did intervene on behalf of the Black students. Armstrong's anger, channeled as humor, barb-wired as it was, had given the trumpet man–singer a stage upon which to make an effective political statement.

When Eisenhower finally sent troops to Arkansas a few days later, Armstrong telegrammed the president with apparently conciliatory words:

MR PRESIDENT. DADDY IF AND WHEN YOU DECIDE TO TAKE THOSE LITTLE NEGRO CHILDREN PERSONALLY INTO CENTRAL HIGH SCHOOL ALONG WITH YOUR MARVELOUS TROOPS PLEASE TAKE ME ALONG "O GOD IT WOULD BE SUCH A GREAT PLEASURE . . . AM SWISS KRISSLY YOURS LOUIS SATCHMO ARMSTRONG.[10]

If the acidic barbershop humor has turned into something more sugary, Armstrong also stirs in other ingredients with the sign-off, "Swiss Krissly Yours," a reference to his favorite brand of laxatives. No doubt Eisenhower, the small town Midwesterner, born in the Deep South, whom biographers have revealed to be decidedly anti-Black,[11] was not very amused to find his hand forced by a Black man known for his smiles.[12]

With this incident in mind, I now turn to several other Armstrong serious-comical community acts. While these may not have been as momentous as Little Rock, they nonetheless exemplified the kind of laughter that this chapter heralds. Each example speaks its piece about comic form and Americans learning to face difficult truths without forgetting to smile occasionally. My contention is that these Armstrongian acts suggest the need for his particular brand of humor: for a broadly good-humored vision of the world that nonetheless will take no stuff from the likes of Ike. This is a humor indispensable in our nation today and in our ever-shrinking planetary village, for somehow Armstrongian humor permits us to say what has to be said and to take follow-up action without shattering our sense of belonging to a national family that's been violently shaken but nevertheless remains "SOLID."

One such community-building performance featured Satchmo sharing the television-studio stage in 1958 with the white trombonist-singer Jack Teagarden to deliver, for the umpteenth time, their version of the Hoagy Carmichael song "Rockin' Chair."[13] In this particular skit, the two old friends laugh with and at Carmichael's lyrics, at one another, and at life and death.[14] Using their horns, voices, and fantastically expressive faces, they inflate and deflate the meanings of the lyrics. With word changes here and there, the two men undercut its inherently sentimental central image, an elderly father confined to his chair and dreaming of the "chariot" finally coming to take him away. At the same time, they invoke and then deride the American habit of viewing everything through the narrow viewfinder of racial prejudice. In sum, their "Rockin' Chair" opens new sightlines and confirms, through humor, a communal contract.

It's important to note that Armstrong and Teagarden's undoing of the song's sentimental subject matter had been anticipated by Carmichael himself. Both

his original printed lyrics for "Rockin' Chair" and its 1930 recording include quick notes of humor: as the song's old man rocks in his lonely chair, the consolation drink that he calls for his son to fetch him is gin. In this recording, Carmichael shares the humorous talk-sung vocal lines with Irving Brodsky. Featuring the "son's" stage-show falsetto ("Ole rockin' chair get you, pappy?") and the pappy's mock-serious replies, the patter is underscored by the rhythm section's prancing foxtrot—all of this at odds with the idea of sad tears for the chair-bound elder. Add now to the recipe the mock-sorrowful side-talk by the record's virtuoso soloists—Bix Beiderbecke on cornet, James "Bubber" Miley on trumpet, and Joe Venuti on violin—and the song's irreverent house-party spirit is complete.[15]

Complete, that is, until the 1958 version by Pops and Tea pokes holes in the song's lyrics and goes on to make fun of romance and of death itself, to say nothing of their inlaid jokes on race. With Teagarden playing the father and Armstrong the son, they appear to reenact the conventional American hierarchy. "I'm gonna tan your hide," sings smiling straight man Teagarden, following the original lyrics; Armstrong responds in his own words, "My hide's already tanned!" In response, they both crack up. "Nobody knows the trouble that both of us have seen," interjects Armstrong, now quoting the Negro spiritual. As Jack concurs, Louis adds, "You're telling me," with a you-know-just-what-I'm-sayin' look. "Fetch me some water, son," croons Tea. "You know you don't drink water Father!" improvises Louis, mugging for the camera. "You 'member ole A'nt Harriet?" sings Tea. "How long in Heaven she be?" "Oh, about a year-and-a-half" says Dipper, improvising. Later, as they switch roles, suggesting a flexible sense of identity that has nothing to do with race, Armstrong asks if Tea "remembers ole A'nt Harriet." "Oh, I knew her well!" he says. Armstrong jumps back, wearing a mock-scandalized mug, and then scat-sings a teasing song in Jack's direction. "Not THAT well," says Teagarden. Throughout this performance, Teagarden and especially Armstrong enact what Cheryl Wall has aptly termed "worrying the line," extending, undermining, outright contradicting the received lyrics' meanings through humorous, improvised commentary/repetition, now with vital differences.

This version of the song is memorable because the humor cuts in all directions—each man laughs back at the other. When humor is balanced in this way, so is power, and a space is cleared for political assertion. One persistent (half-fair) critique of today's "political correctness" is that it prevents certain jokes from being told. For instance, the Chevy Chase–Richard Pryor n-word bit, a *Saturday Night Live* skit from 1975 that mocked Black/white relations, couldn't be done today. Nor could the tale be repeated in polite company that when Teagarden and Pops first met, Tea said, "You're a spade. I'm an ofay. We got the same soul. Let's blow."[16] I am an unapologetic proponent of political correctness—whose other names are "politeness" and "civility," cognates

denoting the respect we extend to family and friends, and then to everybody. But this civil care does not cancel the fact that we really do need to laugh at ourselves and at one another—again, "when Americans stop laughing at one another, they start to shoot at one another."[17]

Henry James's and Ralph Ellison's Case Notes on the Pathology of American Humor

Before turning to more Armstrongian examples of comedy and politics, let me take a step back and consider this question of American humor from a broad perspective, moving from local politics toward capital "P" Politics. Henry James and Ralph Ellison are our main guides.

In a paragraph well known to scholars of American literature, James enumerates the sources of inspiration for the writer: "the items of high civilization, as it exists in other countries," which are not to be found in the United States. Indeed, James's inventory of such items missing from the American scene is so damning that he has to admit that it makes one "wonder to know what was left":

> No State, in the European sense of the word, and indeed barely a specific national name. No sovereign, no court, no personal loyalty, no aristocracy, no church, no clergy, no army, no diplomatic service, no country gentlemen, no palaces, no castles, nor manors, nor old country-houses, nor parsonages, nor thatched cottages nor ivied ruins; no cathedrals, nor abbeys, nor little Norman churches; no great Universities nor public schools—no Oxford, nor Eton, nor Harrow; no literature, no novels, no museums, no pictures, no political society, no sporting class—no Epsom nor Ascot![18]

But wait! Before presuming that such sustained cultural "denudation" could only mean that "if these things are left out, everything is left out," James specifies that "the American knows that a good deal remains." What's left—"his secret, his joke," James says—is "his national gift: that 'American humor' of which of late years we have heard so much."[19] This gift of humor, ironically exercised in James's virtuoso list of lacks, is most fully employed in his one truly funny novel, simply and aptly titled *The American*.

In that novel from 1877 (revised by the novelist in 1907), the titular character, Christopher Newman, takes a break from growing his fortune in Gotham stocks to tramp abroad on "the European tour." (Do consider Newman's travels alongside the mid-twentieth-century tours of Paris described in chapter 5.) Newman is so much the caricatural American, head to toe, that a sharp observer of the man penciling check marks in his red guidebook while at the Louvre "might

have felt a certain humorous relish of the almost ideal completeness with which he filled out the national mould."[20]

While in Paris, dull Mr. Newman tells his local ex-pat American friends of his resolve to take a wife—"to possess, in a word, the best article in the market."[21] The reader cannot miss the crassness of such language, or of the enterprise. In the novel's opening pages, we've already seen how easily Newman's been dazzled by the coquettish young copyist he meets in the museum, whose commonplace renderings of masterpieces Newman values above the originals. Through a full round of comic romantic stumbles, Newman reveals his gift not only for "good nature" (a phrase often applied to him, not without Jamesian derision) but for good humor—now in the ancient sense of "humors" coursing through his body.

True to the conventional romance, the class-assertive family of the French "article" he's boldly selected, Claire de Bellegarde ("Fair" "Well guarded" Lady C), is secretly out of money. So her family, these "persons pretending to represent the highest possible civilization and to be of an order in every way superior to his own," conspires to play him, to marry into his money. In French that Newman does not comprehend, and with cruel side-looks that he does not notice, the Bellegardes debate whether the deal is worth the strain and stain of condescending to this vulgar "Duke of California."

The tale turns when Newman stumbles upon incontrovertible evidence that the Bellegardes are guilty of murder. The reader must ponder Newman's decision, once he's learned what they have done and that they've made a fool of him, not to use his evidence against them—to toss it into the fire. In the end, while surely the novel's comic dupe and dunce proves to be none other than Newman, he is both the butt and the ironical bearer of "the American humor of which we've heard so much." Choosing high ground above tit-for-tat revenge, and "justice" in the narrow sense of the Black vernacular "just us," Newman decides not to play the snooty French folk's cop, judge, jury, and executioner.

True to his name, Newman exemplifies the New World New Man, in the sense that he exudes the fresh air of American good humor with an unfailing sense of responsibility. This humor is a form of largesse that refuses to exploit weakness or stoop to conquer. Newman never pretends to be anything but rough-hewn, but he is sufficiently self-aware to laugh at himself. He laughs off the whole Bellegarde episode, too, in a tossing away of the evidence that spells forgiveness and a belief in redemption that applies even to glittery fakes and rogues—and murderers. Of course, along with Newman's good humor comes shallow class prejudice and Eurocentrism; the man's hollow capitalist acquisitiveness in the form of exotic trophy wife–ism speaks very poorly of The American. We are not told, in the novel, how he made his fortune, just that he was "a born experimentalist" who exerted himself in a

"western" manner and scene. What were his investments? What, if any, sense of responsibility or irresponsibility went with his deals, the novel does not say—and Newman's failure to consider such matters (which is also James's failure) again speaks poorly of our protagonist. His manners are laughably vulgar. He is boorish, a bore. But all these deep dents in our Newman's armor do not eclipse his strengths. Christopher Newman certainly is not one of the ironical "supersubtle fry" of James's later works—those upon whom nothing is lost.[22] That role is played by the ironic narrator/writer and by the attentive reader—not only of words but of situations and 'cross-the-parlor "looks." Perhaps the central irony of this novel is that Newman, who certainly exemplifies many of the characteristics that James detests in Americans, also is a kind of genius of democratic spirit with a Johnny Appleseed wink—or, one might say, a Bert Williams or Richard Pryor smile.[23] Armstrongian anger turned to eyes that smile.

Ralph Ellison is another writer whose humor does not automatically rise to the surface—at least, not upon the first reading.[24] Still he was a brilliant theorist of comedy, American-style. Ellison often quoted James on the joke as our trademark American gift and cited James's fiction to show that behind the scrolling rococo sentences stood a "sly rib-tickler."[25] "I imagine that he wanted to write tragedy, like most of us," said Ellison. "But comedy seems to be the basic American mode in literature." Be that as it may, Ellison does not let James off the hook for certain deficits in his humor. Perhaps, he says, the nineteenth-century novelist's quick aside about the joke was "nothing more than condescension" toward American culture, more evidence of the tide of national "thinness." Furthermore, while James may not have been aware of it (or did not choose to admit it), says Ellison, "this joke was in many ways centered in our [African American] condition. So we welcomed any play on words or nuance of gesture which gave expression to our secret sense of the way things really were."[26] James's *The American* makes no mention of the question of race in America (or in France). It is doubtless with this elision of race from American jocularity in mind that Ellison also takes on the critic Lionel Trilling for close reading James's catalogue of things missing from American culture without even mentioning James on the joke. "One wonders what the state of novel criticism would be today," writes Ellison, "if Mr. Trilling had turned his critical talent to an examination of the American joke."[27] Such an investigation would have led directly to Mark Twain's *Huckleberry Finn* and *Pudd'nhead Wilson* and the works of other American writers in which African American culture, including Black political questions wrapped in jocular form, was central.

One of Ellison's most important insights on American comedy comes in an essay involving jazz music—not, this time, focusing on Armstrong (who, as we shall see, figures prominently elsewhere in the Ellison canon on humor), but

rather on another paragon of modern music also known for his luminescent smiles. Ellison's "Homage to Duke Ellington on His Birthday" celebrates the composer/bandleader and highlights Duke's slyly humorous habits of spoken and musical expression in a way that brings Satchel-Mouth's mugging to mind. Asked about being overlooked for the Pulitzer Prize in 1965, a slight that made several members of the nominating committee resign, Ellington, who had turned seventy that year, remarked that the committee was doing him a favor by not spoiling him with too much success while he was *still so young*. Ellington's tongue-in-cheek retort, Ellison notes, was part of a long Black American tradition of side-talk that was as full of mockery

> as the dancing of those slaves who, looking through the windows of a planta-
> tion manor house from the yard, imitated the steps so gravely performed by the
> masters within and then added to them their own special flair, burlesquing the
> white folks and then going on to force the steps into a choreography uniquely
> their own. The whites, looking out at the activity in the yard, thought they were
> being flattered by imitation, and were amused by the incongruity of tattered
> blacks dancing courtly steps, while missing completely the fact that before their
> eyes a European cultural form was becoming Americanized, undergoing a
> metamorphosis through the mocking activity of a people partially sprung from
> Africa. So, blissfully unaware, the whites laughed while the blacks danced out
> their mocking reply.[28]

Here, Ellison characterizes such barbed systems of satirical exchange—which Henry Louis Gates Jr. refers to as "signifying" and Robert Farris Thompson terms "dances of derision"—as generating new perspectives on recurring human situations, and thus new forms of art.[29] "Oh, we used to mock 'em every step," one former slave woman recounting such scenes remembered.[30] In spite of the obvious power differential between the big house and the slave yard that she describes, laughter was exchanged on both sides, fueling "a rich creative vein."[31] "Before their eyes," Ellison says, "American choreography was being born."

Ellison's dynamic figure of speech reminds us that as Ellington listened closely to Antonin Dvořák's transformations of certain American church and secular songs into European classical compositions—in his *American Symphony* in particular—Ellington was getting set to "dance back" his fan-tastically rich and slightly mocking musical replies.[32] With this image of cir-cling influences, Ellison also implies the development of new ways to conceive self and community. He sensed the prospect of sufficiently overcoming rac-ism and other prejudices, including the impulse to devalue art forms that become popular, to recognize Ellington and Armstrong as much more than

Pulitzer-worthy forces in our midst: as gods walking the Earth in our time! Need it be added that Armstrong also remained, through his lifetime, too young to win a Pulitzer.

Ellison was right that there's a big smile in Ellington's good-time music, just as in Armstrong's. In fact, one of the ritual functions of blues-idiom music is inspiring laughing-happy good times not only to roll but, as one blues song puts it, *to roll and to tumble*, or to exult in dances of courtship as well as sexual delight.[33] But Ellison was also right that certain Dukeish "slightly mocking" smiles could mask defenses and aggressions, too, flashing shields and swords against the violently dismissive (and outright violent) world through which the maestro traveled. "Part of the genius of black music," writes Nathaniel Mackey, "is the room it allows for a telling 'inarticulacy', a feature consistent with its critique of the cannibalistic 'plan of living' and the articulacy which upholds it."[34] "Hear that chord?" Ellington asked Barry Ulanov, whose biography of Duke appeared in 1946. "That's *us*. Dissonance is our way of life in America. We are something apart, yet an integral part."[35] "Do you play the music of your people?" Ellington was asked a few years later by a French interviewer who had a camera crew on hand. "My people? Ohhh, my people!" says Ellington, starting to play bluesy, discordant "Negro chords" while seeming to prepare his standard "apart yet integral" answer. Maybe it was the lateness of the hour; anyhow, the Maestro's patience ran thin, and then—as the slightly mocking humor became a dance of derision—it snapped. As if musing, he began to sharply toss off a few groups of people to which he belonged: piano players, "those who aspire to be dilettantes," "those who appreciate Beaujolais," those influenced by the music of the people. "THE people," he repeated, "that's the better word; the people rather than my people. Because the people are my people."[36]

Of course, Ellington, who probably created more music explicitly in celebration of Black Americans and their culture than any composer, wanted *both/ and*: Blackness as a category hosting the complex composite world citizen that I call the unruly Black cosmopolitan (see chapter 5). In short, he was not one to be backed into a racial corner. The music of my people, he seemed to be saying, is a music that has had quite enough of white walls and categories. As Ellison says, Duke's was "a creative mockery in that it rises above itself to offer us something better, more creative and hopeful, than we've attained while seeking other standards."[37] Likewise, Armstrong—looking at his audiences in the big-house theaters of the world—gave people everything they came for, without forgetting the extra something they also wanted but for which they'd forgotten to ask: a powerful new art and democratic perspective, always (well, *almost* always) wrapped in a rainbow of smiles. Sometimes the big-time smiles had razor edges.

Alongside the keystone Ellisonism that, in the United States, comedy has been a vital engine of new art and new thinking about our national democratic experiment, we unexpectedly find Ellison's insistence—late in his career—that even comedy relying on brutal racial stereotypes can be productively community building. Before tackling this hydra-headed problem directly, let us take a step back to visit again with Henry James and to reconsider certain James-Ellison-Armstrong connections—certain aspects, one might say, of James's American joke. Irony may be "the deadest horse in the critical water," as the literary historian Joseph W. Reed once told me. But in considering the ironical Armstrongian wink, James and Ellison have done much to revive an old beast. In a preface to one of his collections of short fiction, James offers a salty rejoinder to the critics who find his "unmistakably intelligent" characters unlikely on the American scene:

> What does your contention of non-existent conscious exposures, in the midst of all the stupidity and vulgarity and hypocrisy, imply but that we have been, nationally, so to speak, graced with no instance of recorded sensibility fine enough to react against these things?—an admission too distressing. . . . How can one consent to make a picture of the preponderant futilities and vulgarities and miseries of life without the impulse to exhibit as well from time to time, in its place, some fine example of the reaction, the opposition or the escape? One does, thank heaven, encounter here and there symptoms of immunity from the general infection; one recognizes with rapture, on occasion, signs of a protest against the rule of the cheap and easy; and one sees thus that the tradition of a high aesthetic temper needn't, after all, helplessly and ignobly perish.[38]

Let one recognize with rapture that James's diction here is twisting with ironies that include strong dashes of self-irony. This much also is clear: that James's "supersubtle fry" and "animating presences" were all gifted with wit that spelled acuity of insight into American culture as well as into Americans themselves, ironical views with glints and flashes of clairvoyance. In both his fiction and nonfiction, James invites readers to regard the world through a kaleidoscope of ironies and jokes shared by brilliant characters (and their author), in anticipation of readers likewise armed with eyes for the tellingly humorous. James calls his creation of such gifted characters, and the structures of "operative irony" that surround them, a perfect example of the "high and helpful . . . civic use of the imagination?"[39]

Civic use, or uses, of the imagination: that's the essence of my subject here!

For his part, Ellison, who repeatedly cites James as a nineteenth-century American writer practicing civic uses of imagination (which he generally finds

wanting in writers of his own era), revises James on irony (not only, as we've seen, on "the joke" in general) in ways that relate significantly to our study of Armstrong's humor. In 1974, Ellison told those gathered to hear his Class Day Address at Harvard that American racial brutality was part of a web of crimes associated with the worst kind of pride: *hubris*. Indeed, in an ironically Jamesian catalogue of examples, Ellison named racism as our most fatal flaw, our national Achilles' heel. And, as he told those graduating seniors and their families, racism is not our only form of tragic failure:

> The same goes for our pride in production, in the size of our gross national product, in sheer bigness, in our inventiveness, in our ability to create and fulfill needs both false and real, and in our ingenuity in exploiting the natural resources of this great land. . . . Our most seriously considered enterprises have taken on the character of maliciously motivated practical jokes. Even our ability to govern ourselves appears to have gotten out of hand. So if I speak here at length of nemesis, it is because I suspect that whatever else the times in which we live turn out to be, they are our days of nemesis.[40]

The most original turn in that speech comes in Ellison's announcement that the "antidote to hubris"—our national vanity and blind me-first-ism—is irony. Here, Ellison refers to the African American humor that induces what elsewhere he calls "blues-toned laughter" at situations falling in the gap between the way things are and the way they're supposed to be. (That's the space, he says in the essay "What America Would Be Like Without Blacks," filled with images, storylines, and especially sounds that Black Americans call "soul.")[41] But he also calls irony "that capacity to discover and systemize clear ideas"[42]—to see, in the sudden burst of light produced by the joke, and particularly, by a joke full of soul, parts of the American scene usually hidden in shadow; to really see, to understand in ways that move the seer from shadow to action. This view of irony stands perhaps as a corollary to George Bernard Shaw's doubtless tongue-in-cheek assertion that "all genuinely intellectual labor is inherently humorous."[43]

In Ellison's letters, we meet a more freewheeling (and often outright hilarious, as well as ferociously angry) teller of tales and observer of scenes than usually appears in his published writings. (See his letter to Richard Wright in praise of *Twelve Million Black Voices*, for example, and then his narrative about trying, as a boy, not to laugh at the "blast" of mule farts he had heard while riding a mule-drawn cart with an adult family friend. Also check out his letter from Rome about his failure to locate the proper ingredients for the ceremonial dish of pickled pigs' feet.)[44] In a 1957 letter to Albert Murray, as Ellison refers to a review by another literary sparring partner, Stanley Edgar Hyman,

he comments on Armstrong in a way that guides the rest of this essay. "Here, way late," he tells Murray,

> I've discovered Louis singing Mack the Knife. Shakespeare invented Caliban, or changed himself into him—Who the hell dreamed up Louie? Some of the bop boys consider him Caliban but if he is he's a mask for a lyric poet who is much greater than most now writing. That's a mask for Hyman to study, me too. . . . Hare and bear [are] the ticket; man and mask, sophistication and taste hiding behind clowning and crude manners—the American joke, man.[45]

Those misreading Armstrong as primitive Caliban can be blind to Armstrong the lyric poet whose *mask* is Caliban, he who learns the language of the powerful and whose "profit on't," he says, "is, I know how to curse." Note the passing reference to Armstrong's 1956 recording of "Mack the Knife," the 1928 Kurt Weill/Bertolt Brecht ballad from their play *The Threepenny Opera.* Armstrong's version of the song follows the lyrics as written, saluting the gloved-hand killer Macheath and his comrades. And the jaunty scoring of the melody by Weill, who loved jazz, opens the door for Armstrong to transform the show tune's traveling music for "Ole Mackie" into a rocking "line-forms-on-the-right-dears" dance party that features, as part of the fun, "Sweet Lucy Brown."

Armstrong's "Mack the Knife" is a prime example of his ironic humor. Here is Satchmo beckoning listeners to enjoy "Ole Mackie," the strutting dance floor special, while meticulously (even joyously) pronouncing the song's casually violent words. One might say that Armstrong puts bluing into the wash of the stage-show song—that is, a dose of the blues, essentially good-time music that is typically full of love-on-the-rocks and "botheration."[46] Louis A: master of doubleness, "mask and man, the American joke, man!"

All of this speaks to Ellison's argument about American humor as a national "agency"—to which we presently turn. Influenced by the scholar of American culture Constance Rourke (on whom more later in this chapter), Ellison saw the United States as a nation of immigrants desperately in need of humor as a form of agency for adjusting to one another, for finding common ground. Even before there was a United States, Ellison said, colonists of European descent who were born here (James's New Men) began to find their newcomer British and other European cousins strange—to say nothing of the Native Americans and the Africans. Similarly, Africans born in the Americas must have regarded the successive waves of newcomers from the African motherland as kith and kin, but also as somewhat strange foreigners. "The northerner found the southerner strange," Ellison said. "The southerner found the northerner despicable. The blacks found the whites peculiar. The whites found the blacks ridiculous. Some agency had to be adopted which would allow us to live with one another without destroying one another, and the agency was laughter, was humor."[47]

The key to having this formula work as a democratizing force, he said, was that the oppressed must have the agency to laugh back at those laughing at them. Otherwise, the laughter is simply smug and cruel. "If you can laugh at me," said Ellison, "you don't have to kill me. If I can laugh at you, I may not have to kill you." If you can laugh *with* me, I would add.

Even brutally stereotypical jokes can be healthy, Ellison said. Here is where many would say that he took his comedy theory one step too far. He claimed that through the process of laughing at the comic dupe, from either side of the racial line, the human identification is made. Recall the comically thwarted effort of Invisible Man—eponymous hero of Ellison's great novel—to discard a metal bank grotesquely shaped like a smiling Negro head;[48] this young Black man can't dispose of the heavy shards after it's been broken into pieces because, evidently offensive as they are, they're part of his American cultural toolkit: equipment for living.[49] Invisible needs to laugh at himself, to gain critical distance from the shattering experience of living Black in America. He also needs to know how white jokesters see him—including the evil-eyed smilers controlling the power ritual called a "battle royal," for which Black boys, including him, batter one another as a form of white male entertainment. (For a detailed discussion of the novel's "Battle Royal" scene, see chapter 5.) A vital part of this young man's education consists of his learning to manipulate enough facets of his own image to fake such enemies out of their shoes so he can step around them, and/or, when necessary, return fire.

Ellison's little-known short story "It Always Breaks Out" (1963) proves the writer's rule of irony as clear thinking, sometimes as epiphany. This story's torrent of vulgar racial jokes is released by McGowan, a white reporter from the deep South who makes the case that "everything the Nigra does is political": from reading dangerous writers like "Bill Faulkner" to repainting his or her home and buying a fancy Frigidaire, or worse, riding around in one of those bug-eyed foreign cars instead of the traditional local autos (even Cadillacs are comparatively safe). "Look out for your quiet Nigra," he says. "He's plotting something!" The man's Northern white colleagues are struck dumb with embarrassment by the Southerner's virtuoso miscellany of political subtleties in Black activities. But then our Northern white narrator has a moment of ironical insight as he realizes that there's something very tellingly correct in the flagrant incorrectness of the white Southerner's off-color jokes:

> I envied [the Southerner] and admitted to myself with a twinge of embarrassment that some of the things he said were not only amusing but true. And perhaps the truth lay precisely in their being seen humorously. For McGowan said things about Negroes with absolute conviction which I dared not even think. Could it be that he was more honest than I, that his free expression of his feelings, his prejudices, made him freer than I? Could it be that his freedom

to say what he felt about all that Sam the waiter symbolized actually made him freer than I?[50]

These pointed queries make the white narrator think again about Sam, the Black man who through it all has unobtrusively waited on the white men's tables:

> Were there Negroes like McGowan, I wondered. And what would they say about me? How completely did I, a liberal, ex-radical, northerner, dominate Sam's sense of life, his idea of politics? Absolutely, or not at all? Was he, Sam, prevented by some piety from confronting me in a humorous manner, as my habit of mind, formed during the radical Thirties, prevented me from confronting him; or did he, as some of my friends suspected, regard all whites through the streaming eyes and aching muscles of one continuous, though imperceptible and inaudible, belly laugh? *What the hell*, I thought, *is Sam's last name?*[51]

Ellison has been considered a modernist loner, an artist working in isolation. But as his recently published letters have made quite clear, that loner reputation is less than half true, for he remained in close touch with certain literary friends through long stretches of his life, including Albert Murray, Saul Bellow, and Stanley Edgar Hyman. None was more significant for him than Kenneth Burke, who defined literature's "comic frame" as the most encompassing of all literary perspectives. More falls within the jurisdiction of the comic, wrote Burke, than of tragedy or the epic. Along with slipped-on-banana-peel silliness and never-neverland happy endings, including quick-fix marriage plots, comedy can encompass both tragic and epic action—its wider lens can encompass aspects of these other forms—and more. In particular, comedy can offer what Burke called "perspective by incongruity"—reminders, through unlikely but telling juxtaposition, of the absurd mismatches of human experience.[52] This rhetorical strategy explains a good deal of the explosive hilarity in Ellison's writing—not just "laughter to keep from crying," or strategic defensive comedy, but "blues-toned laughter" that signals sudden, new focus and resolve.[53] The "It" of "It Always Breaks Out" refers to white racism, as well as to the painful, hysterical laugher evoked by that story's extended anecdote, an embarrassingly too-true joke. It's worth comparing the laughter in that story (later embedded in the posthumous novel *Two Days Before the Shooting*) with that in the early story "Flying Home" and with Ellison's essay "An Extravagance of Laughter," where eruptions of laughter signal hard-bought clarity of vision, suddenly gained.[54] Such laughter sounds all through *Invisible Man*.

One of Ellison's most frequently cited sources on American cultural practices is Constance Rourke, the anthropologist and cultural critic whose *American*

Humor: A Study of the National Character (1931) outdoes even James in counting humor as the foremost American trait. She "saw American humor as having the function of defining and consolidating the diverse elements—racial, cultural and otherwise—which go into the American character; a business to which James made a profound contribution, even when irritated by what he considered the thinness of American experience."[55] Rourke declared every American a composite of three comic types from American vernacular theater—including the country's front porches, beauty parlors and barbershops, and juke joints. One of these types was Black, while "frontiersman" and "Indian" completed the collaged American character. Her contention that Black identity was internalized by all Americans and appears in their art forms and daily lives becomes a principal Ellisonism and the foundation of his view of cultural appropriation.

"There is always integration of artistic styles," Ellison told an audience in 1972, "whether it is done out of admiration, out of need, or out of a motive of economic exploitation. It finds its way to the larger American public, and as such, everyone who is touched by it becomes a little bit Afro-American. Sometimes they become Afro-American Episcopal Zion; sometimes they become Black Baptist (as most rock singers are now); sometimes they become a little bit Southern in their talk and a little colored in their walk."[56] Ellison could also use the concept of blended identity to deflate notions of white purity: If John C. Calhoun's Yalie accent featured a Southern wail, Ellison said, he "probably got it from his mammy."[57] Here, the novelist slipped John C.—the notorious pro-slavery statesman from South Carolina, and surely one of the forebears of Trump's racist presidential administration—into the dirty dozens.

We all delight in the cadences of Black culture, wrote Rourke and Ellison. And all Americans sometimes wear a minstrel mask—for Blacking up, or enacting Blackness, is part and parcel of the sometimes crass joke and the always complex fate of being American. Both Rourke and Ellison contend that Blackness helps us know who and where we are as Americans. One of Ellison's mentors, Richard Wright, stated this case in direct language: "The history of the Negro in America is the history of America written in vivid and bloody terms; it is the history of Western Man writ small. It is the history of men who tried to adjust themselves to a world whose laws, customs, and instruments of force were leveled against them. *The Negro is America's metaphor.*"[58] Along these lines, one of "Ellison's Laws" is that Blacks are canaries in the coal mine: ignore what's being done not only by us but to us, he said, and you ignore what will soon be done by and to you, to *all.*[59]

Ellison was also a student of Herman Melville's compact comic novel *The Confidence-Man: His Masquerade* (1857). It was here that Ellison found the idea of a composite American identity scored for a full novel, with the man of "confidence"—that slipperiest of terms—appearing as banker and preacher, as gambler, politician, and fancy man, as well as fast-spieling Black beggar,[60] all

facets of a single comical American figure traveling the Mississippi River. "You must have confidence!" they all declare with conviction or—to invent a word that Melville might well have approved—"*con-fiction*." Is the beggar a pathetic injured man in need or a con-man hustler playing a role? Or both? Clearly with Melville in mind, Ellison prepared an early outline of *Invisible Man* revealing that at that point, he thought of his titular character as a composite of shape shifters, a dark agent of multiple guises.[61] This idea echoes in Ellison's characters Rinehart (*Invisible Man*), one of whose first names is Bliss,[62] and (the white supremacist) Senator Sunraider (*Juneteenth*), who as a (light-skinned, cultur- ally Black) child was called Bliss and, sometimes, Reverend Bliss. Ellison obvi- ously enjoyed the irony of a word implying both religious euphoria and happy innocence (that quality which, on the American scene, has often meant turning a blind eye to acts of colossal cruelty). It is Rinehart's virtuoso confidence-man act that reveals to Invisible Man the fact of American masquerade as strategy, causing him to ask himself, "Why hadn't I discovered it sooner? How different my life might have been! How terribly different! Why hadn't I seen the possi- bilities? . . . Hadn't I grown up around gambler-politicians, bootlegger-judges and sheriffs who were burglars; yes, and Klansmen who were preachers and members of humanitarian societies?"[63]

In Ellison's essays, the comically collaged American character appears every- where, sometimes as a Black Harlemite in a tilted Confederate cap, sometimes as a racist white kid with Stevie Wonder master-blasting through his head- phones. Sometimes Ellison adds the Emersonian twist that if only we Amer- icans would become aware of these cultural mixes, both in the American self and in the American sociality, we could recognize that, for all our differences, we are fellow citizens in search of true confidence. And now I mean "confi- dence" as shared-community good humor, trust, and love—not easy to achieve in the land of masking jokers.

The Carnival King of New Orleans

The path we've followed through Henry James's and Ralph Ellison's thoughts on American humor leads us now to Louis Armstrong's most controversial comic performance. It gave tremendous impetus to his career as an international star; it also hung around his neck the moniker of "Uncle Tom," which he would try to shake the rest of his life. In late August 1949, *Time* magazine hit the news- stands with Armstrong smiling regally from the cover, his head crowned with a tilted row of golden mini-trumpets—the first time any jazz musician had so graced that magazine. People throughout the world, including jazz musicians who came of age decades after Armstrong, would have agreed that he was jazz's king (or certainly *a* jazz king): he was one of the music's originators, and maybe

its codifier. He also stood out as one of very few musicians in any category who was influential all over the globe, both as instrumentalist and singer, across musical genres. But beyond the world of music, what kind of king was Armstrong? What do we make, for example, of Satchmo's enthusiastic announcement, as part of *Time's* cover story, that in a few weeks he was about to serve as King of the Zulu Social Aid and Pleasure Club in New Orleans? "It's a thing I've dreamed of all my life, and I'll be damned if it don't look like it's about to come true—to be King of the Zulus parade. After that I'll be ready to die." (Later, he told an interviewer, "Well, I don't want the Lord don't take me literally!")[64]

For Armstrong, riding the street float as Zulu King during Mardi Gras in 1949 was a monumental personal victory, "the equivalent," one Armstrong biographer said, "of getting an honorary degree from one's alma mater."[65] But particularly for those outside New Orleans and for many Black Freedom Movement activists and intellectuals, the image of Armstrong dressed in the costumery of the occasion and, most problematic of all, wearing blackface makeup, was willfully demeaning of Black people, a slap at the faces of those working hard to replace racist Black stereotypes of minstrelsy and vaudeville with images true to lived experience. Black American celebrities in Armstrong's time, and long before, had felt pressure from African Americans to "represent the race." It was just a few months after Armstrong's tenure as Zulu King, for example, that the baseball player Jackie Robinson received the National League's Most Valuable Player (MVP) award, along with the league's crown as batting champion. At the public presentation of the MVP plaque, cameras flashed as the baseball king stood tall in his professional uniform, showing only a modest smile. Robinson was known for his understatedly dignified demeanor under the boiling pressures he'd confronted as the Black player who, in 1947, had cracked Major League Baseball's longstanding segregation code: a consummate contrast to Armstrong in the New Orleans parade.

"As Zulu King," explained Armstrong biographer Ricky Riccardi, "Armstrong would be made up in blackface, except for the area around his eyes and lips, which were painted white. . . . Besides the blackface makeup, he wore black-dyed long underwear, a grass skirt, a red velvet suit with gold sequins, gold shoes, a green velvet cape, and a red-feathered cardboard crown." Armstrong rode the lead float across Claiborne Avenue before a crowd of over two hundred thousand people who were serenaded nonstop by Armstrong recordings sounding from loudspeakers. Waving to friends and fans, the Zulu King sipped one champagne toast after another, and tossed glitter-painted coconuts, traditional Zulu Club parade souvenirs, to eager onlookers. "Armstrong was having the time of his life," writes Riccardi. At about five, as the evening sun began to sink, Zulu King Armstrong stepped off the float into the limo waiting to whisk him off to a concert—and "the souvenir-hungry crowd descended upon the tinseled float and stripped it of everything."[66]

Critics of Armstrong's appearance as King Zulu charged him with reverting to antics associated with nineteenth-century minstrel shows: grinning Sambo smiles for the white man. Minstrel shows, writes historian Robert C. Toll, "had profound and enduring impacts on show business, racial stereotypes, and African Americans in the performing arts." The genre often involved performers "wearing flashy clothes and exaggerated black makeup and speaking in heavy dialects laden with humorous malapropisms." The style later showed up in vaudeville, radio, and television, solidifying stereotypes of Blacks as lazy and happy-go-lucky: as Sambos and Uncle Toms, ever-ready to entertain white audiences with snappy dances and verbal patter, and sometimes with a long-faced, self-pitying song. Minstrelsy, Toll says, "was about race and slavery, and it was born when those issues threated to plunge America into civil war. During that period of rising tensions northern whites, with little knowledge of African Americans, packed into theaters to watch white men in blackface act out images of slavery and black people that the white public wanted to see."[67]

Here, it is important to add that well into the first third of the twentieth century, African American performers blacked up, too. For the Black Baltimorean Johnny Hudgins and Josephine Baker from St. Louis, for example, blacking up was a stage convention, a prop that did not mean self-hatred or pandering for white folks. The greasepaint was a comic front through which streamed self-mockery (for the human being is always absurd), as well as laughter at white folks (and anybody else) goofy enough to mistake these painted faces as real.

Nonetheless, Black leaders' avoidance of self-presentations that would hint even slightly of blackface minstrelsy did not begin with Jackie Robinson. This phenomenon dates back at the very least to Frederick Douglass, who by the turn of the twentieth century was both the world's most widely known Black American and the single most photographed person in the United States. As pictures of Douglass demonstrate, he was exceedingly careful about his role as a "representative of his race" who did not want to give ammunition to enemies. Building on Douglass's example, among others, from the Harlem Renaissance of the 1920s onward, Black spokespersons and artists campaigned to counter minstrelsy's blackface stereotypes with images of ordinary as well as idealized/heroic Black life. Black political cartoonists of the early to mid-twentieth century created single pictures and narrations of Black political courage and savvy, along with comic sketches of Blacks laughing at the white folks and much more often at themselves—very often at themselves facing the unfunny mugs of white racism.

One representative negative response to Armstrong as Zulu turns up in Harold Flender's novel of 1957, *Paris Blues* (for more on this book and the film version, see chapter 5). Here, a young Black American musician (played by

Sidney Poitier in the movie) who has moved to Paris to escape American racism hates the Sambo-like role inhabited by a jazz great known as Wild Man Moore, clearly based on Armstrong (Armstrong was cast to play himself on-screen). In the novel, the Poitier character loves the sound of the older performer's music but has grown to reject the man behind the horn as "the wrong kind of Negro, a white man's Negro, a handkerchief-head Negro." He "could have done so much for his people. But whatever energies were left over after blowing his horn he poured into his heavily publicized and completely meaningless madcap antics. Like the story that had appeared in *Time* a couple of months back about Wild Man Moore and his boys showing up at a Beaux Arts Ball in New York dressed as Zulus."[68]

For another type of rejection, voiced in 1949, we can look to Chicago attorney George C. Adams, one of many Blacks expressing outright disgust at Armstrong's failure to serve as a proper Black male role model: "I can't imagine a man who has risen to the heights as Louis Armstrong has, who would stoop to such foolishness and thus disgrace all Negroes. . . . When I consider the depths to which he has descended in being King of the Zulus, I am reminded of the Bible phrase, 'The dog has returned unto his vomit and the sow that was washed has returned unto her wallow.' "[69]

To comprehend Armstrong's own view of his enthronement as King Zulu of 1949, a bit more history is in order. First, it's vital to understand the Zulu Social Aid and Pleasure Club as part of a nationwide network of independent Black organizations that did much more than parade and party. Founded in 1909, the Zulus of New Orleans served the variety of community functions delineated in W. E. B. Du Bois's study, *Economic Cooperation Among American Negroes* (1907), which includes a full chapter on such clubs. Formed in response to white racial exclusionary policies and as part of longstanding traditions of Black community self-sustenance, "secret orders" like the Zulus were very numerous in the United States. "From general observation and the available figures" in the first years of the twentieth century, Du Bois writes, "it seems fairly certain that at least 4,000 Negroes belong to secret orders."[70] From 1860 to 1880, New Orleans alone had more than 226 Negro societies. And "since only the most prominent and active clubs received public notice," writes historian John Blassingame, "in all probability at least a third of them never appeared in the newspapers."[71] According to Du Bois, the function of such clubs "is partly social intercourse and partly insurance. They furnish pastime from the monotony of work, a field for ambition and intrigue, a chance for parade, and insurance against misfortune."[72] Jacqui Malone's seminal studies of Black vernacular dance in New Orleans have emphasized the Africanness of these U.S. Black secret orders; and Ned Sublette's history of that international city—aptly entitled *The World That Made New Orleans*—finds Black secret orders throughout the Black Global South, where such organizations'

self-help motives and all-fool's-day fun—along with funeral marches featuring somber and then exuberant Afro-dance beat music—typically travel hand in hand.[73] Sublette reminds us of New Orleans as a Deep Southern city that is also a Northern outpost of the Caribbean islands and of South America, where, again, Black secret societies with African elements abound in a wide variety of forms. The music historian Samuel Floyd has argued that these second-line processionals were as significant to Black cultural history (and specifically to the emergence of jazz music) as the celebrated Black ring shout; in fact, he calls the New Orleans second-line a straight-ahead version of the circular ring shout.[74] By the 1980s, the art historian Robert Farris Thompson saw Afro-accented parades like the Zulus' all over the Black Diaspora, including cities and Europe and North America: "A new art history, a new visual tradition based on beads and feathers and masks and percussion-dominated street marchers, permeates certain neighborhoods of our major cities," he writes. "A whole lot of shaking, drumming, chanting, feathering, beading, multi-lappeting, and sequinning is going on. How did it happen? *Immigration, mon.*"[75]

It is thus true that the Zulus were not solely a unit of civic-minded "Social Aid"; they were also, unabashedly, an active "Pleasure Club." Through club soirees, debutante balls, and other functions, the Zulus brought leisure-time joy to members and their circle of families and friends—and to others within their orbit. By the 1990s, the Zulus had become a fashionable part of a political network in Black and white New Orleans. But the club that Armstrong knew as a boy "was originated," as Armstrong wrote in a letter of 1952, "in the neighborhood that I was 'Reared. . . . All of the members of the Zulus are people, for generations,—most of them—brought up right there around, Perdido and Liberty—Franklin Streets."[76] These Back O'Town locals were hardworking Black laborers, service industry workers, and craftsmen whose will to party was a vital part of the group's good health and happiness. The group's party spirit took to the streets on Mardi Gras Day, the only Black self-help "secret order" to parade on that occasion. Armstrong recalled the wonder and pride he'd felt watching his stepfather, William "Willie" Armstrong, costuming (which New Orleanians call "masking") as Grand Marshal of the Oddfellows Club;[77] the boy dreamed that someday he might take his place as king of this day full of fun.

Known, of course, for Mardi Gras parades and many other events of public larks and joyousness, New Orleans was and remains a city whose impulses for imitation and parody, mimicry and mockery, are important features of the Nola party-fun story—which is vital to know if one is to understand Armstrong as 1949 Zulu King. Here, we invoke again Ellison's thesis of American slaves in the yard of the Big House, imitating and mocking the dances of the whites and their Euro-dancing masters while extending and Africanizing those dances into modern shapes and tempos—none of this circling process without Big House smiles at what whites saw as Black appreciation of whites and the enigmatic

smiles of Blacks in the yard, "who danced back their mocking replies." In such boomeranging cycles of influence that Henry Louis Gates Jr. was wise to call, from the Black perspective, "signifying," cross-cultural exchanges were ongoing and rich—and they could fling out products that non–New Orleanians could easily misunderstand. "This don't happen nowhere else but here in New Orleans!" as one local commentator put it.

To peel back more layers in Armstrong's reign as Zulu King, we need to consider that the Mardi Gras parade in New Orleans draws on a thick crazy quilt of traditions, ancient to modern: East-West-North-South, Old Worlds and New. "Carnival is an offspring of the Lupercalian, Saturnalian, and Bacchanalian festivals of Rome in pre-Christian times," says the Works Progress Administration *New Orleans City Guide* (1938). One characteristic of such processions in ancient Greece was that on "days of special license . . . you mocked and insulted freely any of those persons to whom fear or good manners kept you silent in ordinary life." The classicist Gilbert Murray calls such festival processions the seedbed for what became classical comedy. Just as tragedy purges pity and fear through dramatic presentations that induce such feelings in audiences (in Aristotle's definition of the genre), "it is easy to see," writes Murray, "that the licenses in comedy might be supposed to effect a more obvious and necessary purgation."[78] In other words, the kind of over-the-top/way-too-muchness of Mardi Gras is tightly linked with what we know as modern comic drama, with roots trailing to the no fools/no fun festivals of the ancient world.

These ancient festivals were revised over the centuries by the Catholic Church into ones marking Lent (Middle English for "springtime"), the period of fasting observed in preparation for Easter and as a time of special penitence. Thus was "Carnivale" (Latin for "the putting away of meat") born and "Mardi Gras"("Fat Tuesday")—the last day to party before the curtain of Ash Wednesday falls—inaugurating Lent's quiet weeks of contemplative self-sacrifice. Through the eighteenth and nineteenth centuries, Louisiana-style Mardi Gras became more and more deeply infused with African as well as Indian cultural traditions (on Carnival and multicultural traditions, see the discussion in chapter 1 of Ralph Ellison's "A Coupla Scalped Indians"). Some historians use 1699 as the date marking the first gestures of Mardi Gras in New Orleans. It was on Tuesday, March 3 of that year, that the French Canadian explorer and colonial administrator Pierre Le Moyne d' Iberville set up a campsite on the Native Americans' East-Bank Mississippi River hunting grounds. Iberville called a nearby stream that emptied into the Mississippi "Mardi Gras," and also christened his campsite "Pointe du Mardi Gras."[79] That evening, representatives of the Mugulasha and Quinapisa nations, Native Americans, greeted Iberville and his party with "dances of the calumet"—pipe-smoking rituals and feasts, as well as what became all-night dancing—as joyous gestures of hospitality. And so it was, says Sublette, "that the first Louisiana colonist celebrated Mardi Gras,

then during Lent, partied all day and into the night with splendidly adorned people, dancing to a beat."[80]

It's especially pertinent to Louis Armstrong's King Zulu story that by the late nineteenth century, African Americans in New Orleans were organizing what became known as "Mardi Gras Indian Tribes." "Appropriating the popular image of dangerous yet free-spirited Plains Indian warriors as displayed in Wild West shows and other forms of entertainment," says the historian Daniel H. Usner, the Afro-Indians "seemed to be disguising their own defiance and prowess in Jim Crow New Orleans behind an acceptable mask of wild Indian behavior."[81] Drawing on what they'd seen in Buffalo Bill's Wild West shows of the 1880s and 1890s—open-air performances that toured the United States and Europe, employing wild buffaloes and elks as well as romantic, sensationalized stereotypes of leatherstockinged white hunters and "wild" Plains Indians—a Black group called the "Creole Wild West Tribe" began to dress in elaborate Indian costumes every Mardi Gras.

These "Black Indians" channeled "African American song and dance into a new ceremonial pattern," writes Usner. "A deep memory of fugitive slaves seeking freedom among Indian nations since colonial times, probably reinforced by more recent familiarity with the 'Seminole Negro' experience, also influenced this association of Indianness with resistance." Usner also notes that "A Carnival Jangle," the Black writer Alice Dunbar-Nelson's fictional sketch of 1895, featured a New Orleans Mardi Gras scene with Afro-Indians performing "a perfect Indian dance" with aspects of "a sacred riot." Onlookers filled Washington Square in Faubourg Marigny "to watch these mimic Redmen, they seemed so fierce and earnest."[82] The Zulu Social Aid and Pleasure Club was not a Black Indian tribe, but who could mistake the Afro-Indians' flamboyant dance-beat parade styles and fantastically beaded and feathered "new suits" ("every year," one of their ceremonial songs says, "we make a new suit") as anything but expressions the Zulus use to symbolize their spirit?

The Zulu's Mardi Gras parade was a bold cultural collage of many colors that drew upon (and also undercut) church rites and other sacred proceedings, as well as a cavalcade of national styles (from the Indian nations along with French, Canadian, and American). The name "Zulu" may well have indicated identification with the Zulu Rebellion in South Africa, 1906. According to club historians, the direct source of the name "Zulu" was the theater. In 1909, members of the Black workingmen's social aid and pleasure club that first called itself the Tramps attended a song-and-dance performance at the Pythian Temple Theater by the Smart Set, a Black musical comedy troupe that was passing through town. Reviews of a Smart Set performance of 1902 referred to the group's singing, dancing, and "clever acrobatic work" as "the smartest colored comedy in all of America." According to Zulu club sources, the show that the Tramps saw included "There Never Was and

Never Will Be a King Like Me," a routine about the "Zulu Tribe" in which the characters wore grass skirts and dressed in blackface. Soon after the Tramps saw the skit, they met in a woodshed on Perdido Street with the Benevolent Aid Society and representatives of other Black workingmen's self-help groups, and they emerged as a new composite group called the Zulus. In 1916, the Zulu Social Aid and Pleasure Club was incorporated, with official bylaws establishing its social mission and dedication to benevolence and goodwill.

And so the name "Zulu" was based, significantly, on the kind of popular images of "Africans" that a U.S. Black traveling show, bearing traces of minstrelsy and vaudeville, might construct—a show challenging, some sources say, prevailing minstrel stereotypes with images of powerhouse "African" kings. And as with Buffalo Bill's Wild West shows, spectacle and comedy ruled the Smart Set's bill of fare. The Zulus of New Orleans sprang from many sources ultimately, including—it is important to remember—a Black traveling show's comic song-and-dance routines that included blacking up.

In their use of theatrical costumes and styles, among the major motives of the New Orleans Zulu "kings" and their courts was the will to mock the pomp and circumstance of white King Comus—and, more generally, the historical pretensions of white New Orleanians who excluded Blacks from much of the official festival fun (to say nothing of other more sweeping exclusions and cruelties, dating from slavery). Armstrong recalled that as part of one Zulu parade, one of the members named Garfield Carter (nicknamed "Papa Gar") had the nerve to dress up as a policeman known as the meanest one on the Nola force.[83] According to the research of novelist Ishmael Reed, "Whereas Rex was white, mythical, aristocratic, a Confederate pageant that once honored the daughter of Robert E. Lee, the Zulu Parade involves an ancient Afro-American survival form. Adopting the oppressors' parody of themselves and evolving, from this, an art-form with its own laws. If the whites have their King, Rex, we have our King, Zulu, a savage from the jungle like you say he is." Evidently channeling Ellison, Reed continues, "While you're laughing at us, we're laughing with you. But the joke's on you"—because of the Zulus' subversive stylings. According to the Zulu club's own archival work, at their first appearance in Mardi Gras, in 1909, their first king's symbols of lard-can crown and banana-stalk scepter "has been well documented."[84]

Marching, in deference to the state's and city's strict segregation laws, only through Black neighborhoods, "the group wore raggedy pants, and had a Jubilee-singing quartet in front of and behind King [Zulu]. 1915 heralded the first use of floats, constructed on a spring wagon, using dry goods boxes. The float was decorated with palmetto leaves and moss and carried four Dukes along with the King."[85] Then, and still in 1995, when Reed witnessed Zulu, "coconuts were the Zulus' gold doubloons," an alternative currency for an alternative kingdom, tossed out to parade followers. (In 1988, the Louisiana legislature passed SB188, dubbed the "Coconut Bill," which excluded the

hard-shell fruit from liability "for alleged injuries arising from its being distributed from the floats.")[86] From Ishmael Reed's ironical standpoint, through symbolic dramas like that of the Zulus, the symbols of white oppression are magically destroyed, with the painted smiles of King Zulu leading the parade; if such symbols are destroyed often enough, as this theory would have it, the reality eventually will disappear.[87]

Coming back to Armstrong's point of view concerning the Zulus of New Orleans, let's turn to his own accounts of his reign as King Zulu, as recorded on one of the collagelike personal scrapbooks he compiled over the years.[88] At his den at home in Queens, and in dressing rooms and hotel rooms on the road, Armstrong would pause, after hours on the bandstand night after night, to decorate the audiotape boxes that held his homemade recordings and to work on his scrapbooks.[89] The Armstrong collage most directly pertinent to our Zulu questions is a page from one of his scrapbooks topped with a cut-out newspaper headline spelling "HAIL KING ZULU." This page treats Armstrong's ascension to the Zulu throne with unequivocal pride and joy. Alongside a photograph clipped from a newspaper (beneath the words "May Your Reign Be a Merry One"), Louis affixes his Zulu Club honorary lifetime membership card and a newspaper article specifying the parade route along which King Zulu waved royal greetings from his lushly decorated truck float. In the page's left margin, Armstrong painstakingly constructed a list of the names of the Zulu kings and queens who preceded his reign, each former monarch's name neatly clipped and pasted into place.

Others could say what they wanted, but Armstrong embraced the Zulus as representatives of the Black working-class neighborhood where he was born. I do not believe that he was uneasy about having his face painted in minstrel style, as some of his defenders have claimed. He'd seen it all his life and understood it as part of the un-self-conscious frivolity associated with the club's mission of pleasure, especially at the special time of role reversal and mockery called Mardi Gras. If Aristotle was right that comic drama served the public function of setting our "humors" in order through concocted extravagances of laughter; if Ellison was right that as Americans, we need to laugh at ourselves and at our fellow citizens as a mode of social cohesion; if Reed was right that Zulu-style humor was part of overturning oppressive, racist rule—then perhaps Armstrong also was right, when asked to serve as King Zulu on Mardi Gras Day, 1949, to say—enthusiastically—YES!

Armstrong in Collage: Romare Bearden and Jean-Michel Basquiat

Louis Armstrong was a Sunday collage-making hobbyist, who produced not only scrapbooks but also other cut-and-pasted objects. As I explore in chapter 2,

alongside this art-making, he developed a magnificent "collage aesthetic" of making music—mixing opera with blues, Tin Pan Alley with hymns from church, stage-show funny biz with arialike solos that were the envy of the music world. It's pertinent to consider Armstrong's 1926 recording "King of the Zulus (at a Chit' Lin' Rag)" as one of many examples of a Satchmo audio collage.[90] In the midst of what could be a New Orleans funeral march, an obviously fake Jamaican voice pretends to intrude on the music-as-chitlin party. "Fix me one order those t'ings you call it 'chit'lins' but I call 'inner tube!'" "Hey!" mugs Armstrong. "What you mean by interrupting my solo?" It is true that Armstrong's trumpet solo at the out-chorus of "King of the Zulus" is thrilling enough to pull everything together—nearly. This makes the choice to break it up with a put-on foreign voice and a joking exchange quite telling: to be truly Armstrongian, the artistry of the performance needs to be hybrid and global. These qualities may, we should add, help us understand Satchmo's role in 1949 as King of Zulus.

But what might master Black collagists—not hobbyists now, but visual artists of the first degree—what might Romare Bearden and Jean-Michel Basquiat offer to our analysis of Armstrong as King Zulu? Both of these major twentieth-century artists dabbled in music-making,[91] both frequently used Black music as a subject. Both spoke of jazz, in particular, as a model for their artistic practice of trying to create improvised art that swung to an Afro dance beat. Bearden created works set in New Orleans in the early-to-late 1970s and into the 1980s, especially for his *Of the Blues* series and his recently rediscovered *Paris Blues* book project, that never-finished collaboration whose plan was for Bearden to use Sam Shaw's photographs (among many other materials) to build collages captioned by Albert Murray (see chapter 5).[92] In the *Paris Blues* pieces, which despite the title have several scenes set in Armstrong's New Orleans, as well as the New York and Paris that he knew, Pops was a central protagonist.[93] In fact, both Bearden and Basquiat created powerful collages using photographs of Armstrong and of Mardi Gras scenes. In the case of Basquiat, as we shall see, his painting *King Zulu* (1986) specifically zeroes in on our question of Armstrong's role as Zulu King of 1949 and the humor that it did or did not engender.[94]

Spotlight on Bearden

Bearden's New Orleans pieces accentuate that city as a wellspring of Black music, whether flowing from Black neighborhoods' public rituals of continuity or from Storyville's brothels.[95] His many paintings about Nola's Second-Line processionals celebrate the city's spirit as expressed in funeral marches that burst into exuberant dances while mourner/celebrants are "ragging home," in Mardi Gras dance/music mixes of Last-Day-Before–Ash Wednesday revelry, and in Black

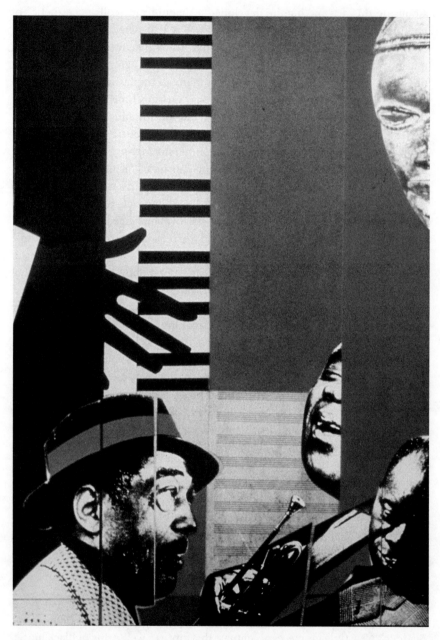

Romare Bearden, *Untitled (Paris Blues Suite)*, 1961; collage, 9 × 12 in.

Indian struts and showdowns or other expressions of Afro-Eurasian fun on parade through streets where bright, shotgun homes have gates and second-story balcony ironwork that offered a kind of objective correlative to the music.

In the 1975 collage called simply *Untitled (Paris Blues Suite)*, the presentation of African masks and masklike, scissor-cut photos of faces most commands attention. This collage's inclusion of an early Benin face in bronze associates both Duke and Louis with classic African art, with classicism in black, and perhaps also with these artists' roles as inheritors/conveyors of African continuities. As in so many Bearden paintings, the Afro-masked Benin figure stands watch over precious protected ones, in this case Duke and Louis.[96] The artist's placement of the African mask and Armstrong's contemplative face behind the familiar smiling face also helps us consider both Louis's and Duke's famous geniality as carefully prepared covers for their invisible inner lives, their layered interiority. The Afro-mask is what Ishmael Reed calls "an ancient Afro-American survival form"; for centuries, no Black person in the United States has not "worn the mask" for purposes of defense (often humorous) as well as for aggression—for survival in white America. But here, the mask is also an invocation of the diasporic Africanness of these artists' aesthetic, of their visionary work. What we do not have in Bearden's collage is anything like the Cubists, at their most naive, looking at these masks as so many shapes and lines, isolated from historical/cultural contexts. Here, instead, is the mask as a highly complicated indicator of Afro-diasporic lineages, of the authority and protection of African gods and royal leaders, of Afro-ritual purposes, past and present: *Black to the future.*

In Bearden's *Jazz with Armstrong*, part of the *Paris Blues* collage book project mentioned earlier (also listed as part of the *Jazz* series, 1981),[97] we get something akin to Basquiat's jam-packed paintings. Both artists were capable of making works seemingly determined to fill the whole frame, every inch of it—and then to run paint and other materials into and over the margins—literally off the charts. "Although I am increasingly fascinated by the possibilities of empty space on a canvas," says Bearden, "in [certain cases,] I was working for maximum multiplicity."[98] Bearden's *Jazz with Armstrong* uses this approach to pay tribute to Armstrong himself, but also to New Orleans music, sacred and secular, in which the ensemble makes room for every voice improvising at the same time—a feast of gumbo ya-ya (Louisianan for "everybody talks at once") mixed with soliloquies and mucho side-talk.

Because *Jazz with Armstrong* was conceived for a book project, the collage is laid out as a two-page spread, divided by a vertical blue line at the work's center. Each side, like the double-image spread as a whole, retains its own integrity and sense of completeness, while additional yellow and blue lines at the work's center seem to mark off yet another book page, one storyline opening another. The prevalence of rectangular structures in this work confirms Bearden's

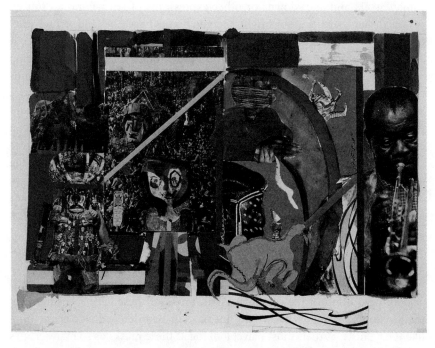

Romare Bearden, *Jazz With Armstrong*, 1981; collage on illustration board, 17 1/2 × 25 1/2 inches.

© Romare Bearden Foundation; licensed by VAGA at Artist Rights Society (ARS), New York. Courtesy of DC Moore Gallery, New York..

inheritance as a Cubist[99] and a lifelong student of certain Dutch masters: windows everywhere, again suggesting exterior and interior storylines and characters, as well as mysteries just beyond our view—in particular, at the off-white open corner above the photo of Armstrong playing his horn. This idea of public and private lives is underscored, too, by the many masked figures here—the African masks again used not for lines and structures alone, but for their multiple meanings for Nola's Black community and its Afro-diasporic extensions. Does this image of Mardi Gras owe something to the block party–style carnival celebrations Bearden had been observing on the Caribbean island of St. Martin, his wife Nanette's ancestral home, where by the late 1970s the Beardens had been spending extended stretches of time every year?

Of special note is the woman at the work's center. She regards Armstrong with a steady eye, though her face is marked and veiled, granting her, in the terms of W. E. B. Du Bois, double and clairvoyant vision. This doubleness is important to the work's images of Satchmo. The woman looks past the mad-capped gnome (whose cousin gnome rides the edge of the red line of color between her and Armstrong). She ignores, for the moment anyway, the Armstrong above her head, who, true to many traditions in the African diaspora,

balances what appears to be a marketplace fruit basket (could they be Zulu Club parade coconuts?) on his head. Her back is turned to this work's left "page" scenes of Mardi Gras–style outdoor fun and holiday high jinks quite evidently overenjoyed by the pie-eyed figure behind the veiled sister's head. Her eyes are fixed on this work's largest image of Armstrong, portraying him as quiet, contemplative artist.[100] Of course, he's part of the holiday parties and processionals, part of their myriad meanings that include those implied by the Afro-Caribbean imagery at the collage's left. Indeed, he's at the center of the fun, whether current Zulu King or Z. K., emeritus. But at the same time, he's the other Louis Armstrong, the serious-biz introspective artist of discipline from whom so much beauty freely flows.

It's quite important that like the image of Armstrong the reveler, this work's contemplative Armstrong also reflects his humor, this time of a subtler sort that gives perspective to the Mardi Gras fun. I refer now to the contemplative Armstrong's side-glancing eye full of irony—in the Jamesian sense of the eagle-eye observer upon whom nothing is lost. Here's Ellisonian irony as the disciplined will to think things through, "to systemize clear ideas," and as an antidote to deadly American arrogance. Here, in other words, is a complex King Louis indeed: a man of pieces and parts, funnyman at the head of the parade, *having*

Possibly Romare Bearden, photographs by Sam Shaw; New Orleans, 1981; photocollage and watercolor on paper, 14 × 22 inches. Gerald Peters Gallery paper, 18 × 24 inches.

the time of his life, as well as iron man of irony, Mr. Arm-Strong! Man of the kind of manifold humor that defines a nation and to save it—if it can be saved!

One important Bearden coda before we turn to Basquiat. A collage from the unfinished *Paris Blues* artbook (discussed in full in chapter 5) bears the page numbers of that project and the words "NEW ORLEANS" in caps. Hidden for decades on the shelves of collectors and gallerists, this luminous work is unknown to all but the most ardent Beardenists. Though a problem piece for those preferring single-artist provenance, to me this unsigned collage's markings as a four- or six-hand visual piano-opus (with project comrades Sam Shaw and Albert Murray on the scene as its parts were placed and glued) actually adds value. Like the Nola musika that is its subject, this is a performance ever in progress, refusing the finish line—a creation of antagonistic cooperation and ecstasy of influence. As such, it is a Bearden work with questions in sight (Would he clutter the left panel or cut off his sax player's head? Would he leave a work so heavy with photos and tape or without drawings?), along with evidence of Bearden's particular sense of Cubism-in-motion and flat-screen ways of seeing.

With this said, let's take a closer look. The Sam Shaw photographs of 1961 sampled here depict the Eureka No. 2 Brass Band of the Crescent City.[101] The ritual-strut posture of the band's grand marshal, Alcide "Slow Drag" Pavageau, wearing a bow tie and holding his hat ceremoniously in hand, identifies this as a funeral procession. As such, the scene moves from Pavageau's somber steps to the cutting-loose frivolity at the work's right edge, where trombonist Earl Humphrey and sousaphonist Wilbert Tillman blow horns under the clothes of the come-hither lady standing on the upper-right corner. All of this recalls a parallel that Bearden drew in a 1977 interview, wherein he remembered attending a funeral in Spain in 1950 whose rhythms were similar to those he'd heard in New Orleans:

> "In Málaga," he said, "there was all that mournful music, and then, after the burial, somebody began to blow on a trumpet, another kind of sound entirely, and an Englishman who was standing next to me turned and said, 'You see, now life has taken over again.' I think that's what art is—it celebrates a victory. A blues singer up at the old Lafayette, she sings about waking up one morning, there's a letter from my man, he done left me, I'm going down to the river and God knows what I'll do—but then here comes Freddy Jenkins on the trumpet, playing with a mute in, and he does a *funny kind of riff* that turns what might have been tragic into something else, into *farce*, so you don't feel like going out and committing suicide after all. Life is going to triumph somehow." [102]

Bearden-Shaw-Murray's "NEW ORLEANS" collage proclaims the same: this may be funeral time, but "Life is going to triumph somehow," and humor prevails over tragedy.

Finally, consider the central figure of "NEW ORLEANS"—Harold "Duke" Dejan—and tell me that he doesn't resemble Romare Bearden himself! Bearden self-portraits (collaborative or otherwise) are very rare; the collage *Artist in Studio with Model* may be the only explicit example. But in a few other cases, an impulse toward self-portraiture is revealed. As an artist, Bearden identified so strongly with the leader of a complex and dramatic ritual of life's continuity that, in "NEW ORLEANS," he chose (I'm guessing, unconsciously) the photo of a specific New Orleans parade musician as a way of putting himself in the picture. Nor do I think it is a stretch to say that like countless musicians, Bearden the visual artist identified closely with Armstrong: Armstrong the consummate performance artist and Armstrong as King Zulu, leader of a complex, communitywide public rite. Clearly, Bearden also appreciated Armstrong as an ironic observer of the absurd human drama, the Armstrong who aimed to deliver the blues-toned news of comedy at the edge of tragedy—the good news of life's capacity, somehow, to prevail.

Spotlight on Basquiat

In Jean-Michel Basquiat's *King Zulu*, Louis Armstrong's face floats at center canvas, with the words "KING ZULU" immediately beneath it. A commanding image against a bright blue background, the depiction shows Armstrong in the black-and-white face paint he wore as the Zulu King in 1949, as documented in a book that Basquiat drew on repeatedly, Frank Driggs and Harris Lewine's *Black Beauty, White Heat: A Pictorial History of Classic Jazz, 1920–1950*.[103] Armstrong's narrowed eyes are enclosed in large white circles, while his mouth offers a forced, toothy grin, making the face skull-like. The hair is missing— the head ends at the top of the brow—as if the face were actually a mask. Or is it King Zulu's hollow crown that's cut away? Is Armstrong a minstrel or a king? This kind of aggressively ambiguous image is emblematic of Basquiat's work—at once celebratory and derisive, comic and tragic. Here, the subject is a semiheroic figure who's also a cartoon or minstrel goof. Basquiat's aesthetic involves crossings out and stark erasures: no topper for this king, whether hair or crown; no color at all or facial features for one of the music-making figures. The painting's blue background appears unfinished, too. Is this a Bearden-like "open corner," left that way for the viewer's contemplation and completion (see chapter 2)? How do we read such impulses to doubleness and omission? What kind of Zulu King is Armstrong? Who are these people standing about in his court? As for Zulu's half-painted-on smile, is he laughing with us or at us?

Leads that help solve the problem of Basquiat's *King Zulu* turn up elsewhere in the complex sign- and signal-laden puzzle-worlds that this artist mapped so carefully, almost never without dark laughter implied. I read several of

Louis Armstrong on the cover of Frank Driggs's and Harris Lewine's *Black Beauty, White Heat: A Pictorial History of Classic Jazz, 1920–1950*, the 1982 book of jazz photographs that Jean-Michel Basquiat often sampled in his collages.

Basquiat's Deep South paintings as aggressive/defensive, snarl-comic remap-
pings of diasporic Black life: terrifying aerial views accented with signifying
close-ups. *Jim Crow*, for example, strikes me as a kind of companion piece
to *King Zulu*, both completed in 1986. The former is composed in oil stick
crayon on wood, the latter in oil on canvas; but both are cut to the same large
size (80 x 100 inches). Both feature ominous, floating Black heads (*Jim Crow's*
attached to a skeletal figure), exploding onto scenes fiercely captioned by red
block letters that serve as their works' titles. Not just here but throughout the
Basquiat canon, works detonate *"in your face,"* as bell hooks has eloquently
argued, "in keeping with the codes of that street culture he loved so much."[104]
And once Jim Crow's heads and skeletons explode onto these maps, the conti-
nents can never be the same again. The Mississippi River floods both paintings,
too. In *Jim Crow*, it moves sinisterly behind the Black head and underscores the
infamous term "Jim Crow."[105] At the time Basquiat created these works, the
word *M-i-s-s-i-s-s-i-p-p-i* synonymized the worst excesses of the violently

Jean-Michel Basquiat, *Jim Crow*, 1986; acrylic and oil pencil on wood, 80.8 × 96.1 in.

enforced Jim Crow systems of the United States, particularly in the South. That the terrors of lynching, peonage, mass incarceration, as well as the routines of forced separation according to color pervaded that state—and overflowed it— is emphasized by the many extra syllables of Basquiat's spelled-out *"Mississis-sippi,"* which flows across the full width of the canvas. The map's legend repeats the river-state's name sixteen more times, with redactions created by Black crayon implying yet more Mississippis elsewhere. The deadly scourge alluded to here by a red line running through the river and its name is not just regional or national: all the other rivers—including the Ohio and the Thames—that are listed at the left fall under its bloody color line. What are the unseen but sim-ilar arteries, names blotted out, that pump our lands with death? Mississippi everywhere!

"Everybody knows about Mississippi," said Nina Simone in her 1964 song "Mississippi Goddam." If there's any humor in Basquiat's *Jim Crow*, it's the humor of (and engendered by) Simone's song. This is humor in the category that Ellison has called "soul" humor—muffled, derisive laughter in the long blue-black shadow between the way things are and the way they're supposed to be. And it's the sort of laughter that James Baldwin associated with Harlem young-sters at midcentury—laughter "whose intent was to denigrate." "It was disen-chanted" laughter, he said, "and in this, also, lay the authority of their curses."[106]

In *Jim Crow*, it is not only the rivers that carry Black pain and death, and perhaps hard laughter. Drawn on rough wood that resembles planks of a white-washed Southern barn, the horizontal lines in this work form railway-track patterns, running, as so many real trains do, alongside a river, and often mark-ing strict divisions according to race, class, and who does the hard work in such a barn. In addition, the snarl of black lines just beneath the river at the left edge suggests an area for commercial loading and unloading at a point where rail lines converge—another ominous sign. These black lines could also represent some sort of aircraft. The point is that travel here is haunted, whether by land, sea, or sky. Looked at another way, *Jim Crow*'s horizontals could also be lines of a grim musical score—a score that might suggest you were dealing with happy-go-lucky Louis, only to reveal that behind that stage mask is the furious man of rage who was ready to go to war even, when required, against a U.S. president.

Although "Mississippi" is not spelled out in *King Zulu*, the big river floods this work, too, with the vast blueness behind the King Zulu head taking on a U.S. continental shape, implying a country full of blue moods and tragedies, as well as the endless possibilities associated with the clear sky color Basquiat has used. It also implies, of course, a country resonating with the transcendental music called the blues. In this blue-painted country, jazz men and their symbols shine like islands of gold. Nearly everybody now knows that the cliché about jazz flowing up the river from New Orleans to Chicago is false (the Mississippi does not travel to Chicago), and that jazz has several birthplaces, north and west as

Page from a scrapbook by Louis Armstrong (1952). Note that inside the photo of his own head, Armstrong has pasted a photo of his mentor, Joe "King" Oliver.

Courtesy of the Louis Armstrong House Museum.

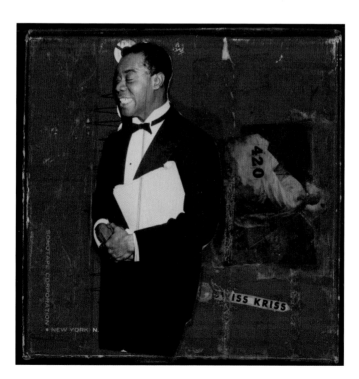

Audiotape box collaged by Louis Armstrong in 1956 or 1957; "420" is a code number for marijuana, his recreational drug of choice, and "Swiss Kriss" was his favorite laxative.

Courtesy of the Louis Armstrong House Museum.

Romare Bearden's one-eyed son of Poseidon is a Black Power figure. *The Cyclops*, ca. 1968; collage with various papers on fiberboard, 12 × 18 inches. Collection of Robert G. O'Meally.

Romare Bearden recasts Homer's killer goddess Scylla as a mother bird, guarding her babies. As in Bearden's *Cyclops*, here Odysseus is the potential menace. *Scylla and Charybdis*, 1977; collage of various papers with paint and graphite on fiberboard, 14 3/4 × 15 3/4 inches.

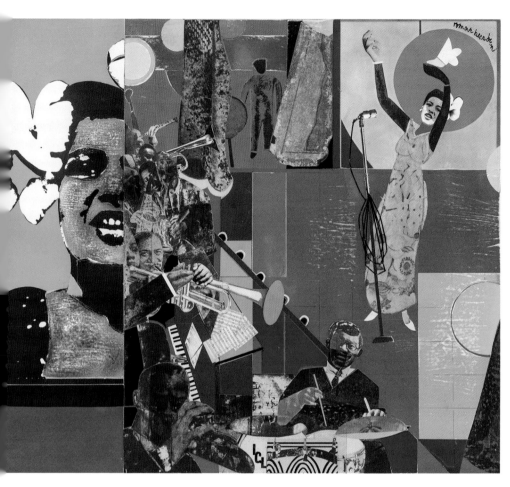

Romare Bearden created this collage for a Billie Holiday album cover. The artist said that his favorite Holiday song was "When the Moon Turns Green." Note what appears to be a self-portrait, in the top center. *Billie Holiday*, 1973; collage of various papers, acrylic, and fabric on fiberboard, 27 × 31 inches. Private Collection.

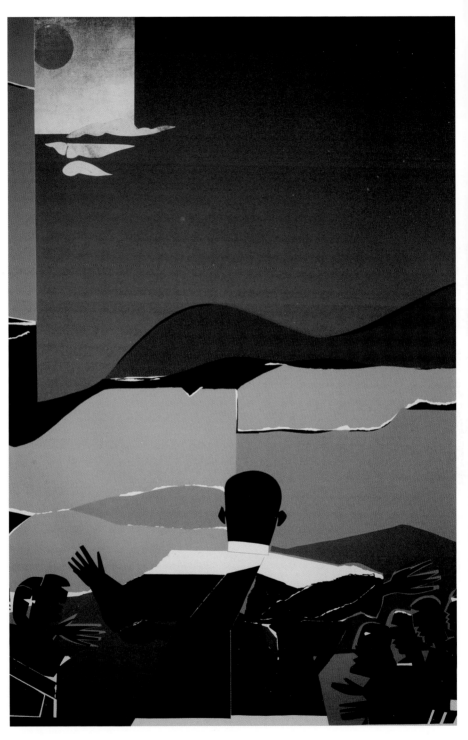

Romare Bearden's tribute to Martin Luther King. *Mountain Top*, 1968; screenprint, 30 × 19 5/8 inches. National Portrait Gallery, Smithsonian Institution, Institution. NPG.2007.170.

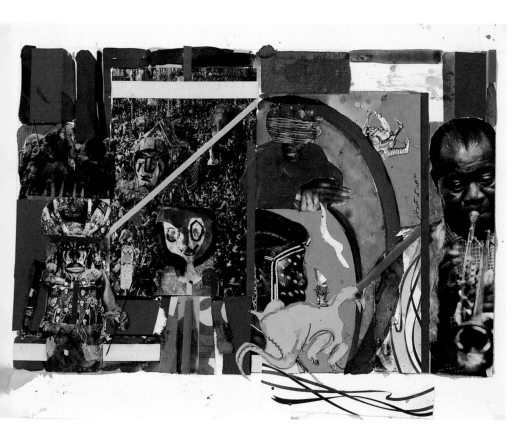

Romare Bearden, *Jazz With Armstrong*, 1981; collage on illustration board, 17 1/2 × 25 1/2 inches.

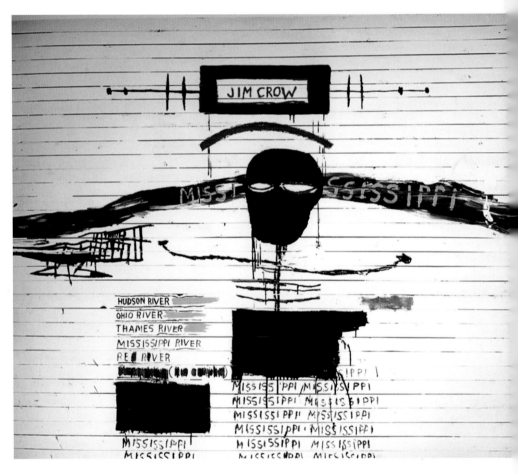

Jean-Michel Basquiat, *Jim Crow*, 1986; acrylic and oil pencil on wood, 80.8 × 96.1 in.

© Estate of Jean-Michel Basquiat. Licensed by Artestar, New York. Private collection.

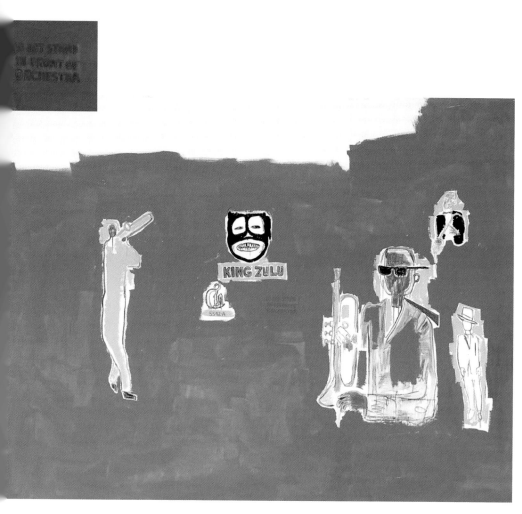

Jean-Michel Basquiat, *King Zulu*, 1986; acrylic, wax, felt tip pen on canvas; 80 × 100 inches, MACBA Musée d'Art Contemporani, Barcelona. © Estate of Jean-Basquiat. Licensed by Artestar, New York. Here Basquiat samples a small section of a photograph of Fate Marable's Band, where young Louis Armstrong played cornet in 1918. The section of the photograph Basquiat quotes reads, "Do Not Stand in Front of Orchestra."

Courtesy of the Louis Armstrong House Museum.

Romare Bearden, *Ellington with Paris Graffiti*, 1981. Collage on paper, 16 × 23 inches.

well as east and south. Still it's true that the river and other routes to and from the Big Easy were vital to the story of this music.

The dark figure stretches out its bone arms, recalling bell hook's perceptive essay on Basquiat's Black bodies as being tormented, hacked to pieces; here, the figure is also a crucifix. Without a mouth, its only feature its narrowed eyes, rimmed in red, all the figure can do is bear silent witness. All of this makes us look again at Basquiat's *King Zulu* and remember that Armstrong was by no means smiling all the time, as the Little Rock incident makes clear. Paired with the stark slashes and death-mask of *Jim Crow*, Basquiat's *King Zulu* asks: What part in this traveling blues-show history did Armstrong play? And what is the meaning of his get-up as Zulu King? Was he part of the solution to Jim Crow or part of the problem? To what degree, asks this painting, was he one in a long line of highly influential Black kings and queens (mainly sports and music figures) who, try as they might, could not entirely escape the minstrel stereotype they meant to mock, and who—with the best intentions to the contrary—nonetheless participated in their own humiliation? Armstrong's crooked smile, or deathly grin, offers as many such questions as answers.

Let us probe these questions by considering *King Zulu* as a kind of visual history course. Such a course's controlling theme is that, any way you survey it, Armstrong's example, including his image as the blacked-up Zulu King, remains at the center of jazz's geographical story and also has much to tell about American cultural history beyond the world of jazz. Each of the work's other figures and images contains worlds of meaning, too—all helping to fill out the painting's complex, Armstrong-centered American story that's about music and about more than music.

The jazz master Joe Oliver (called "King Oliver" and "Papa Joe"), along with Bix Beiderbecke, are subtly indicated in *King Zulu*. The clue to this part of the painting's puzzle is Basquiat's inclusion of the letter *G*, under which he wrote "5542-A." Basquiat drew the *G* to match the ornate serif font on the record label (Gennett) affixed to the disk containing Armstrong's first recorded solo, "Zulu's Ball" (1923), made with King Oliver. Record number 5542-A on the same label, "Sensation Rag" (1924), featured the Wolverine Orchestra with Beiderbecke playing a solo, as jazz historian Francesco Martinelli says, "that definitely shows the New Orleans riverboat influence."[107] Oliver's place at the forefront of jazz history, and as Armstrong's most significant mentor in music, is well documented. "The king of all the musicians was Joe Oliver," wrote Armstrong. He was "the finest trumpeter who ever played in New Orleans. . . . No one had the fire and the endurance Joe had. No one in jazz has created as much music as he has. Almost everything important in music today came from him. That is why they called him 'King' and he deserved the title."[108]

Bix also was a king of jazz cornet and trumpet. Those who need convincing should listen to his exquisite playing on "Davenport Blues" (1925), his own

composition, which has become one of the party-time anthems of New Orleans, Black and white. In the context of this particular painting, it's quite significant that Armstrong and Beiderbecke first met in 1920, when the Mississippi riverboat called the S.S. *Capitol* dropped anchor near Bix's hometown (Davenport, Iowa) with Armstrong on board playing cornet in Fate Marable's Orchestra. In interviews, Bix said that he fell in love with the sound of Pops's lead horn as it radiated from the dark, sky-lighted river. The two brassmen could not have played more differently; what Bix got from Pops was that a trumpeter could have a strong individual personality, and a trumpet solo could be more than fills and strong lead melody-making. It could make statements as complete and varied in mood as a rollicking New Orleans street strut, a slow dance on a riverboat cruise, or an operatic aria. Part of Basquiat's point in including Bix is that jazz is a story of race that also transcends race. Can white men jump the blues? Even in Armstrong's time, Bix and a hundred other witnesses prove that the answer should be obvious.

What tales do *King Zulu*'s other puzzle pieces tell? Fascinatingly, the half-length portrait of a male trumpeter immediately to the right of Armstrong is a composite of two more great trumpet men: one an important Satchmo mentor (like Oliver), the other a Satchmo offspring or student. The figure's torso is based on a photograph of William "Bunk" Johnson from *Black Beauty, White Heat*.[109] (Its head, as we will see, is that of another musician.) Born in New Orleans around 1879, and having played as a boy with the legendary trumpet man Buddy Bolden, Johnson was something of a trumpet king in his own right. According to Armstrong, compared with the other two founders of New Orleans trumpet playing, Bolden and Oliver, "Bunk Johnson had the most beautiful tone, the best imagination and the softest sense of phrasing"[110]—all qualities for young Armstrong to emulate and eventually to master. As "Little Louis" grew, these two men stayed in touch and, alas, Johnson, who did not record much when he was at the peak of his musical game as a young man, declined in his musical powers. When an infirm, older Bunk finally began recording in earnest, the records showed traces of his early genius and of Armstrong, now as an important influence, the student having turned teacher. "I shall never forget the look of happiness in Bunk's face," said Armstrong, "when I told him I was going to be King of the Zulu parade. . . . He said, 'Go on Dipper!' That's the nickname the early settlers of the Zulu neighborhood gave me when I was a little shaver, Dippermouth."[111]

From the neck up, Basquiat's composite jazz figure evokes the trumpeter Howard McGhee, born in Detroit in 1918, who is famously pictured with Thelonious Monk and Roy Eldridge in front of bebop music's most renowned room for experimentation, Minton's in Harlem—a photograph that is also in *Black Beauty, White Heat*.[112] Neither Detroit nor New York is a Mississippi River city; but both are river cities all the same, two of the most significant jazz cities on Earth, located on two of the world's busiest waterways. I also read the scarf

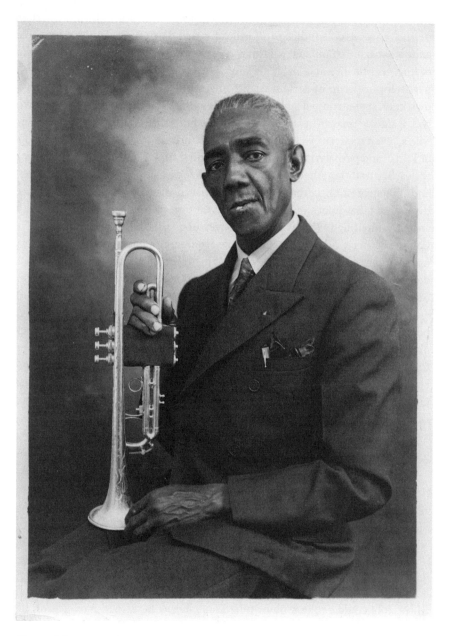

Photo of the New Orleans trumpeter Bunk Johnson (1879–1949), sampled in Jean-Michel Basquiat's *King Zulu*.

Courtesy of the Louis Armstrong House Museum.

around this figure's neck, one of Miles Davis's signature accessories of a certain period, as a possible indicator of Miles himself, born in St. Louis in 1926 and another master trumpeter who first emerged during the bebop era. In terms of lineage, McGhee and Davis certainly are Armstrongian. And despite Davis's persistent criticism of certain Armstrong onstage personae, he knew that his own cool, spare trumpet style owed much to the older musician's introspective, lyrical side. ("You can't play anything on the horn that Louis hasn't played," said Miles, "even modern.")[113] If the composite picture says that Armstrong came out of Bunk (and perhaps that Bunk began learning from Louis), both representing the earlier tradition, then whether it's McGhee or Davis on the portrait's upper end, the suggestion is that Pops's music paved the way for bebop, identified throughout Basquiat's oeuvre as the revolution in jazz with which he most ardently identified. The Mississippi River does run, by the way, through St. Louis, another world-class port city where jazz influences flowed both ways, up the river from the New Orleans of Armstrong, Oliver, and Bunk, and back downriver again from the St. Louis of Scott Joplin, Miles Davis, and many other major figures in jazz history.

The Miles possibility here is particularly intriguing: if Armstrong's stage personae included King Zulu–like high jinks, what were Miles Davis's peacock dress styles and back-to-the-audience stances if not elements of the new bebop showmanship that audiences lined up to see? Compare Miles with the flamboyant onstage jokester Dizzy, or even with the sternly bearded Modern Jazz Quartet. "For all the revolutionary ardor of his style, Dizzy Gillespie is no less a clown than Louis," writes Ralph Ellison,

> and his wide reputation rests as much upon his entertaining personality as upon his gifted musicianship. There is even a morbid entertainment value in watching the funereal posturing of the Modern Jazz Quartet, and doubtless part of the tension created in their listeners arises from the anticipation that during some unguarded moment, the grinning visage of the traditional delight-maker (inferior because performing at the audience's command, superior because he can perform effectively through the magic of his art) will emerge from behind those bearded masks.[114]

Miles, too, could evoke a blues-toned laughter as he turned his back on his listeners (but conductors always turn their backs to the audience, his defenders say) or left the stage altogether while his band played on. Where was Miles!? Well, on some level, this was all part of the Miles Davis show, which fans eventually paid high prices to see—a show, again, not without a certain wry humor.

The smaller-scale, full-length figure at the Basquiat painting's right edge, sometimes misidentified as Beiderbecke, interests me as much as the composite of Bunk and McGhee (or Miles). In fact, this is a drawing of Henry "Kid"

Rena, who played cornet in the Waif's Home band with Armstrong ("When two trumpet players were needed," one historian reports, "Rena and Armstrong were chosen.")[115] For a brief stretch in 1919, when Armstrong began playing on riverboats, Kid Rena replaced his friend Louis in Kid Ory's band. Starting in the 1910s, Rena was a high-note specialist who marched in brass bands and led his own bands until he quit music in 1947. Some New Orleans music historians say that in his prime, he could rival Armstrong in jam sessions, and Armstrong learned to control the upper register on the trumpet by studying Kid's technique. For the collage drawing of Kid Rena, Basquiat again redrew a photo from the Driggs and Lewine book. "Heavy drinking and the Depression grind depleted Rena's terrific endurance, range, and ideas," that book's picture caption read. "His only recordings (1940), though disappointing, helped initiate the New Orleans revival of the forties."[116]

That Basquiat left this figure uncolored may suggest that he is one of the many little-remembered musicians who nonetheless are part of Armstrong's story and of the history of jazz: local stars who chose not to travel, many of them women, and those who recorded too little or too late for their importance to be measured. Those, as Dan Morgenstern has written, "who don't show up in the history books but could outplay many who do."[117] Featureless and hornless here, the ghosted "Kid" stands in slant-hat rakish style; through Armstrong, and perhaps through other jazz artists known and unknown, he did make his mark on the world, but invisibly. The inclusion of his image here asserts jazz history moving from great artist to great artist, but also moving from community to community, with bands of women and men who, working with dancers and audience members, built this music not only to pay the bills but also as part of a communitywide tradition of celebration. In tribute, Basquiat wraps "Kid" in the same royal color as the more famous musicians: gold.

It's instructive to compare *King Zulu* as a map of Louis's artistic lineage with Armstrong's own scrapbook page of 1952, which also features Armstrong himself at the center and invokes the memory of King Oliver—this time with a picture of Oliver's head pasted inside Louis's own. Papa Joe was ever on Louis's mind! Like Basquiat's collage, Armstrong's portrait of his artistic family includes the head of Bix Beiderbecke, too. But then Armstrong adds other jazz musicians, all of them, aside from Oliver and Jelly Roll Morton, beyond the New Orleans/ Mississippi River story of jazz: Duke Ellington, Big Sid Catlett, Jack Teagarden, and Bunny Berrigan. From the world of Broadway and American pop culture come Florence Mills, Judy Garland, and Bing Crosby. Rhythm and blues star Ruth Brown makes the page of affiliates, too. The only real surprise here is the head of Franklin Delano Roosevelt, toward whose face Armstrong's trumpet message seems directly aimed. Here's a king saluting a president he admired.

Of all the history-lesson puzzle pieces in Basquiat's *King Zulu*, the one that's hardest to see—in fact, it's impossible to see unless you're looking directly at

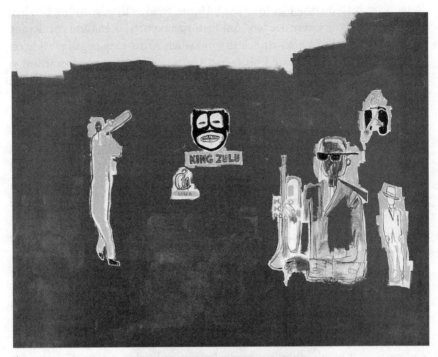

A

B

In his *King Zulu*, 1986 (acrylic, wax, felt tip pen on canvas; 80 × 100 inches. MACBA Musée d'Art Contemporani, Barcelona. © Estate of Jean-Michel Basquiat. Licensed by Artestar, New York), Basquiat quotes from this photograph of Fate Marable's Band (C). Note in particular the printed sign, in the photograph, above the pianist's (Marable's) head (D), which is sampled by Basquiat in a nearly invisible insertion (B): "Do Not Stand in Front of Orchestra."

Louisiana State Museum.

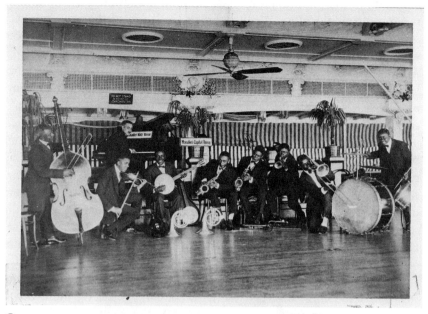

C

D

the painting (not even an excellent reproduction)—may be the only one rival-
ing Armstrong's head as the most resonantly significant image in that work.
I refer to Basquiat's inclusion of a small rectangular sign that hangs beneath
the word "ZULU." The sign hangs beneath a thin layer of blue paint, too, so you
must look again, and closely, to read the sign through the opaque veil of blue.
(As with Basquiat's crossed-out words, throughout this work, this "erasure"
makes the meaning harder to read, and yet all the more vivid and significant.)
The tiny letters read "Do Not Stand in Front of Orchestra"—a message drawn

from yet another photograph in *Black Beauty, White Heat*. The original, full photo containing this sign is quite relevant, for it depicts the very same 1919 orchestra, Fate Marable's, featuring Armstrong on cornet, that Beiderbecke would have heard on the river that day in Davenport—the very gig that freed Armstrong's cornet chair in Kid Ory's band for Kid Rena. But like the other images in *King Zulu*, the sign is not an archival relic but is rich with ongoing, productive ambiguity and touches of humor. It marks a place and time significant to jazz history, and to this painting's Armstrong (and Bix, as well as Rena) in particular. The sign reminds us that riverboat bands did not play formal concerts, with rows for seated listeners' and viewers' pleasure. Rather, these floating party-house bands played with people socializing in all manners—standing, sitting, drinking, eating, and/or dancing to the music, which in a given moment might be regarded as background music and in the next moment became the sound in the foreground, driving the fun, driving the blues away through what Henry Drewel calls its multisensorial effects.[118] These involve the sensation of moving bodies, as well as experiences of sound and sight.

So, "Do Not Stand in Front" because you'll block the sightlines of those who want to see the music makers—who want not only to hear the music but to *see* it and feel it, to move to it and get with it. "Do Not Stand in Front" because you'll block the bandsmen's experience of the audience, too, thus breaking up the call/response exchange (singer and instrumentalist swinging the dancers, who in turn are swinging the singer and instrumentalist) that is the essence of the jazz party as a ritual ground designed to bring people together. This is in keeping with Thelonious Monk's reported instruction to members of his band getting set to play: "Lift up the bandstand!"[119] To the audience, too, Brother, Sister, hear this: Don't *stand* in front of the dance-music orchestra. Put on your Mardi Gras dancing shoes, let the music catch hold of your feet some kinda way, and *dance* in front of the orchestra! Do the flirtation stomp, purify the air, dance away the blues! With your good foot in motion, assert your right to get happy—maybe with a smile as wide as King Zulu's!

Perhaps the most profound thing separating Basquiat's *King Zulu* from Bearden's is a matter of tone ("tone," that richly cross-generic term). There is something much more urgent and fierce in the tone of Basquiat's paintings, something much more directly in-your-face and oops-upside-your-head in their insistence that we confront the deadly forces surrounding us and do it *now*. Even his comic paintings snarl and scream and strike sharp notes of warning. Whatever hope is to be wrung from these Basquiats, it will involve long and steady study—both of the paintings themselves and of the dangers they warn about—and then revolutionary resolve with a broad sense of affiliation. If a way out is to be charted, Beardenian generosity of spirit and ironic good humor will not be enough. Only the direct, concerted action implied by Basquiat's fiercely slashed-line paintings can change this world, where Old Mississippi at its worst seems to surround us.

Where Bearden and Basquiat come together is just as important as where they go their separate ways. Just as I read Bearden's work as a vote for the rollicking good fun in the music and for the serious business of Armstrong's discipline as an artist—including the responsibility to think ahead and study the scene with hope balanced by a sense of irony, in intimate consultation with oneself and others—in Basquiat's warnings I read hard-won but nonetheless hopeful notes. These notes sound at the base of this chapter's thesis: in the decision to make art as a game of puzzle pieces—mystery persons, letters and numbers, Satchmo's ambiguous smile—Basquiat invites his viewers to improvise along with him, to play. And particularly when he repays those looking closely at his work, who look and look again until they see the secret words "Do Not Stand in Front of Orchestra," Basquiat joins Bearden in urging his audience to get up and dance, in the spirit of the Zulu King and his parade of second-liners, moving to the Afro-beat with smiles that are not faked, forced, or snarling, but genuine. Along with its warnings about minstrelsy, Basquiat's *Zulu King*'s smile is in the spirit of the revolutionary poet Amiri Baraka: urging the crowd that refuses to let the blues implied by minstrel paint take their dances or their smiles away. Dizzy Gillespie had been sharply critical of Armstrong's "Zulu"; but then he said: "I began to recognize that what I had considered Pops's grinning in the face of racism was his absolute refusal to let anything, even anger about racism, steal the joy from his life and erase his fantastic smile."[120] Similarly, I see *King Zulu*'s jagged smile as expressing both a sharp-edged critique and a readiness for action.

Armstrong's Smile Goes Abroad

As a finale, let's turn back to Louis Armstrong himself, this time in Africa, in 1956. Here, we witness another deeply ambiguous case of comic masquerade, now more pointedly political than anything we would see from the jazz king until he faced down Eisenhower over Little Rock the following year. (Did his trip to Africa pave the way to Little Rock?) When Armstrong arrived in Accra, Ghana, the capital of the newly independent nation that had been known as the Gold Coast, he was met by an immense, sprawling crowd that included a line of trumpeters who played while the crowd greeted him with a local pop tune transformed into a Satchmo serenade: "All for You, Louis! All for You!" It was Armstrong's first trip to Africa, and he said he felt as if he were returning home to family. One woman in the crowd who welcomed his cavalcade strongly reminded him of his beloved mother.

This Africa visit was not one of Armstrong's official U.S. State Department "goodwill" tours that followed in the 1960s; instead it was just part of Armstrong's international circuit of appearances, sponsored in this case by CBS, where producer Edward R. Murrow hoped it would be the basis of a film in

which the African American music star would resonate with the descendants of his African forebears and they with him. Still, the State Department tours of a few years later, which took Armstrong and other jazz musicians overseas, can help us interpret the Ghana appearance of 1956.

The State Department–sponsored jazz trips were by no means unproblematic, as the comprehensive study of them by historian Penny Von Eschen makes very clear.[121] In broad strokes, these tours were Cold War public relations campaigns designed to counter Russian assertions of a cultureless, racist United States with homegrown jazz that featured some of its best exponents playing in Black, white, or mixed-race bands. The tours were also designed to generate headlines that would distract from secret U.S. geopolitical and military actions considered potentially embarrassing. Take Armstrong's visit to the Republic of the Congo in 1960, part of a twenty-seven-city tour of Africa. Armstrong liked to say that, while performing in this newly independent former colony of Belgium, his band had stopped a civil war when a cease-fire was called so that both sides could hear them play. "What he did not know," writes Von Eschen,

> is that from WWII onward, US officials had had designs on mineral-rich Katanga Province in the Belgian Congo. . . . CIA director Allen Dulles had transmitted an order from President Eisenhower . . . that the recently elected prime minister, Patrice Lumumba, was to be eliminated. This explains the unusual expenditure of resources on that tour of Africa. . . . At the time of Armstrong's visit to Leopoldville at the end of October and to Katanga in November, Lumumba had been arrested and was being held and tortured by [Katanga province prime minister Moise] Tshombe's army, with American assistance. Lumumba would be assassinated in Jan. 1961 with the CIA's help, while Armstrong and his band were still playing on the continent.[122]

Von Eschen details the motives behind the Congo campaign, which were not just about the extraction of mineral wealth:

> Most fundamental to the administration's decision to assassinate Lumumba, however, was that Eisenhower, Allen Dulles, and others distrusted Lumumba's nationalist and socialist politics and did not believe that a black African was capable of independent political thought. . . . As international criticism of US economic ambitions mounted, officials with an all-too-spotty record on civil rights at home were forced to fight it out in Africa with Armstrong and his All Stars.[123]

Here, we see Eisenhower's true colors and appreciate better Armstrong's attack on the man a few years earlier: this president's racism was an international scourge. And he was unbending. Despite having been spanked by Louis over Little Rock, Eisenhower agreed to use the trumpet star in a plot to kill an African leader.

Armstrong's trip to Ghana in 1956 had its own backdrop of political drama. The film crew on hand recorded a superb, double-edged rendition by Armstrong of "(What Did I Do to Be So) Black and Blue," a protest song whose depths of meaning for Black Americans we have already sounded in this volume (see chapter 1). As Armstrong announced from the stage, this particular performance of "Black and Blue" was addressed to Ghana's new prime minister, Kwame Nkrumah, who was present for the serenade.[124] What's hidden in the television recording of Armstrong's song for Nkrumah, made after some technical mishaps with the cameras were resolved, is that Armstrong was worn out and deeply annoyed at being asked to repeat the heartfelt version of the song he'd just poured out for Nkrumah, whose eyes were glistening with tears. Those tears may have been tears of embarrassment. Also unseen, as Von Eschen has observed, is the extreme anger on Louis's part that prompted the song choice— anger at the way the crowds of local people, eager to see him, had been brutally beaten back by the newly independent nation's police force.[125] "All my life I tried to get away from this," Armstrong told an interviewer at that time. "Black people getting beat up. Knocked around. Always getting beat up. I saw the white folks do it, who maybe don't know any better. Now the colored people do it to their own folk. Worse than the Nazis."[126] Again, Armstrong was furiously giving a head of state a piece of his mind!

In considering "Black and Blue," let's remember racism back home in the United States (including prejudice of light-skinned African Americans against their darker sisters and brothers, the song's original theme). But let's also look at black-and-blue problems in Ghana. What did these everyday Ghanaians do to be so blacked and blued (so brutally bruised) by the new nation's baton-wielding cops? How was the violence involved here unlike the black-and-blue behavior of white folks in New Orleans and in Little Rock?

To shed light on these charged questions, I want to explore another key moment of Armstrong's 1956 visit to Ghana, one involving the sudden emergence onto Accra's airport tarmac of a comedian whose stage name was Ajax Bukana. In a beat-up Chaplin topper and disheveled suit with a comically spherical waistline, Bukana presented a long face painted in ways that evidently owed more to the American-style minstrel stage than to African traditions of masking. The man seemed to appear from nowhere. In fact, moments before standing with Armstrong, Bukana had jumped police lines and melted into the crowd waiting to catch a glimpse of the American star and his entourage. Then he "stood on top of a car with my painted face and big belly," he recalled. "And when Satchmo was coming down from the plane he saw me and pointed out and said he wanted to see this man! And the police brought me down to see him." Approaching Louis's party with a clownish, loping stride, Bukana saluted the trumpet king with a deep stage bow, tattered hat in hand.

Footage of the scene shows an Armstrong who could not have been more tickled. *"Look at this cat!"* exclaimed Louis. *"Personality! Chops flying everywhere!"*

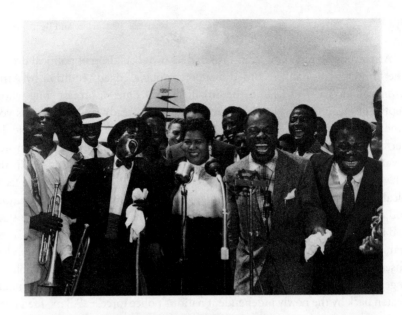

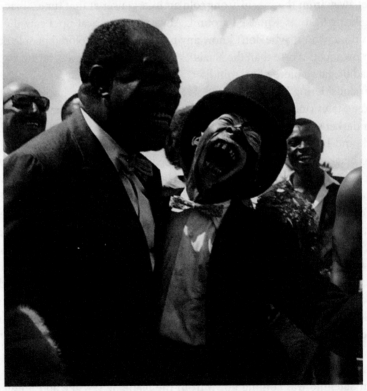

In Accra, Ghana (1956), Louis Armstrong and his All-Stars (featuring Velma Middleton, center) were met by a large crowd that included the Nigeria-born comedian James Kehinde (stage name "Ajax Bukana"), who was evidently dispatched by the Ghanaian revolutionary leader Kwame Nkrumah to add levity to Armstrong's official welcome.

"Maan," he said to Ajax, "you remind me of ole New Orleans!" Then he saluted Bukana by calling out to Ghanaian musicians and others: "Say this: *Oh Yeaaaah!*" The crowd did not miss a beat: *"OH YEAAAAH!"* Then, while the bands played—Armstrong's and the assembly of local trumpeters—Bukana cakewalked along the route arm-in-arm with Armstrong's covocalist, Velma Middleton, also parading in a joyously high-stepping manner. More than the resulting documentary *Satchmo the Great* revealed, the scene truly was reminiscent of Ole New Orleans—and of the Zulu Mardi Gras King and party-hardy court in particular—with African-diaspora cultural practices dancing full circle back in Africa.[127]

Who was this blacked-up, comical African? Born in 1920 in Lagos, Nigeria, Ajax Bukana was a Yoruba whose birth name was James Kehinde (with the second name indicating his status as a twin). The son of a policeman, Bukana had been an elementary school teacher until the late 1940s, when he began to experiment with playing percussion instruments in a jazz style. Since the turn of the twentieth century, forms of this African American music had reached urban centers all over Africa. Following an early-century wave of American (and American-style) stage shows that included ragtime and vaudeville, with their traces of minstrelsy, New Orleans jazz by the 1920s had won wide popularity in South Africa and in West Africa, where the Jazz Kings of Accra were just one of the successful bands of that city. Under the spell of this new music, in 1950 Bukana joined Nigerian bandleader Bobby Benson's traveling jazz ensemble. "Bobby Benson was playing plenty of jazz, as well as rumbas, highlifes, and quicksteps," Bukana told an interviewer. "So I started with maracas, then from maracas to congas, from congas I started to learn string bass."[128]

"Anytime we had a show," said Bukana, "we would make a concert and Bobby Benson would give me a part. He used to make some funny top hats and tails for us, and I painted my face white and had a walking stick. I used to make short comedies." Some of Bukana's impulse toward humor stemmed from long traditions of comic drama in Ghana. As early as 1918, there were "concert parties" that involved performers who "interwove jokes, singing, and dancing, and . . . fancy dress, wigs, false moustaches and the white make-up of a minstrel."[129] One entertainer who was popular at that time offered sketches "assisted by a tap dancer and a harmonium player who together provided a program of then-current popular Western dance music, such as Black American ragtime and ballroom dances like the foxtrot, quickstep and waltz." Aside from such toolkits full of cultural imports, Ghanaian comic performers "were shaped by indigenous cultural forms, notably the Anansesem storytelling tradition which featured the mischievous Ananse, the spider—a likely prototype of or major contribution to the concert-party joker." Behind certain comic performances, in other words, lay the unpredictable savior (or killer) archetypal figure of the Trickster Spider—the first cousin to the African American figure of Bre'r Rabbit. No wonder Armstrong recognized Afro-New Orleans in the African comic musician who magically appeared at Accra's airport!

Step by step, Bukana moved away from appearing in bands and began appearing as a solo comedy act. When a group of performers met Nkrumah at the airport in Kumasi, Ghana, he recalled, "I dressed myself fine and started to roll myself around and he looked at me and asked, 'Who IS that man! . . . You should send him to Accra to come and see me.' " At first, Bukana was given odd jobs around the city; then, as his friendship with Nkrumah expanded, the prime minister found the comic a source of relief from his workaday duties. In Accra, Bukana served as Nkrumah's unofficial court jester. His job was to inject notes of levity into otherwise stiff official meetings and ceremonies, national and international. In a variety of such settings, Ajax would choose a moment of dead silence to signal the release of one of his thundering sneezes. "Aahh-ahh," he'd start, to which those in the know would respond "JAX!" as the room broke down in laughter. Eventually, Nkrumah arranged for this clever man to study acting at the Moscow State Circus. "I liked it there," said Ajax. "I learned to juggle six balls and do all kinds of odds and ends."[130]

When Armstrong returned to Ghana in 1960, he arranged for Bukana's release from official state duties so he could join the band as a comic to complete its two-week State Department tour of Africa. From Ghana, Armstrong and Ajax played cities in Nigeria, Togo, and—as we have seen—the Congo. Perhaps together they performed the first worldwide hit song out of South Africa, "Skokiaan," which Armstrong had recorded in 1954.

* * *

Where does this story of complex smiles and boomeranging (right back at you) influences leave us? What do we make, finally, of Louis's Zulu King smile and getup? And what is the meaning of American humor?

No doubt Ellison was right. We need humor to survive together as a nation, so long as the laughter goes both ways. Let us laugh at one another and at ourselves; let us know that we look ridiculous to our cousins from across the way—they to us, we to ourselves. And are we not, all of us, truly ridiculous—very often as inane, empty, and vain as Christopher Newman in *The American*—and occasionally as beautiful, too? Able, at low points in our history, to rise again? Maybe the key to these puzzling images lies in the briar patch of the blues: a form that faces with an ironic smile the hard truth that life is a low-down dirty shame, that Jim Crow crucified Black people, that President Eisenhower had to be pushed to take a stand on Little Rock, and that the United States violently undermined certain newly emerging postcolonial nations. Yes, the danger zone is everywhere. But so are the things that make us smile. American humor, music, costume, collage, Mardi Gras parade—high jinks and all. We need to be good-humored, one person to the other, despite all this history, despite our deep differences. To refurbish the ideal of democracy, which, as Ellison said over and over again, is our name not just for tolerance, but for the robust sense of community that we call love.

THE WHITE TROMBONE AND THE UNRULY BLACK COSMOPOLITAN TRUMPET, OR HOW *PARIS BLUES* CAME TO BE UNFINISHED

The black actor has managed to give . . . moments—indelible moments, created, miraculously, beyond the confines of the script: hints of reality, smuggled like contraband into a maudlin tale, and with enough force, if unleashed, to shatter the tale to fragments.
—James Baldwin

What will the story be about? she said. I haven't decided yet . . . [So far we're] just chasing shadows, shooting scenes for background. Later on when we start working we'll use them, splice them in. Pictures aren't made in a straight line. We take a little bit of this and a little of that and then it's all looked at and selected and made into a whole. . . . You mean you piece it together? . . . Just like making a scrap quilt, I guess; one of those with all the colors of the rainbow in it . . .? Just about, I said. There has to be a pattern though and we only have black and white.
—Ralph Ellison

Art is a translation, and every translation is a compromise.
—Kenneth Burke

P*aris Blues* (1961), a film about American expatriate musicians pursuing jazz greatness in Paris, stars Paul Newman, with Sidney Poitier as his sidekick. Their jazz combo plays hard-swinging and slow-bluesy musical numbers to a multiple raced, national, gendered, and generational audience in a subterranean bohemian nightclub. The soundtrack, of course, was recorded by real musicians; the score, which achieves true greatness, was provided by none other than Duke Ellington and Billy Strayhorn. To dub Newman's jazz trombone performances, the film's director, Martin Ritt, specified that he wanted a player who was white.[1] The idea that the off-screen musical impersonation of the blue-eyed Newman required the services of a white trombonist (blowing, it would seem, a "white" sound) is a peculiar piece of American foolishness that offers an apt through line for this chapter. This odd specification says as much about *Paris Blues* the movie, its soundtrack, and the novel that preceded it by several years as it does about the production of midcentury American popular culture.

The notion of a "white" trombone also offers new perspective on the little-known artists' book connected with the film, initiated by Romare Bearden, Sam Shaw (the film's coproducer), and Albert Murray in the late 1970s but left unfinished nearly twenty years after Newman lifted his *Paris Blues* horn. One could call the movie unfinished, too: as such, it extends a challenge to remix its images and themes in light of archival findings and other historical considerations. In fact, I chart the history of the entire *Paris Blues* project— from concept to novel to film to collage book—as a single, unrealized effort, a many-storied, unfinished house.

The figure of the white trombonist—a free-floating ghost of white American racism—troubled the *Paris Blues* project and thwarted its best chances to achieve something radically ambitious. My aim is to contrast this bogeyman, this haunting *homme blanc*, with the more capacious and boldly transgressive realization of humanity in art that I term *unruly Black cosmopolitanism*. If this concept needs an incarnation in this tale, it would be Louis Armstrong, whose trumpet solos on the *Paris Blues* soundtrack supercharge his cameo appearances onscreen—no musical "ghosting" for him! In exploring Black artistry and politics in the *Paris Blues* project, I will return to these key questions: What, on their lower frequencies, are the "Paris blues"? What does unruly Black cosmopolitanism—whose deep blue bass line affirms life in the face of trouble—offer as a rejoinder, if not as an antidote, to the whiteness-affirming movie that is *Paris Blues*?

My account will not conform to a linear narrative but rather trace a zigzag history of fits and starts, stitches and patches. Every *Paris Blues* charted here (screenplay, novel, film, artists' book) features a white trombone or two, and in some cases a gaggle of them. Every *Paris Blues* also has magnificent moments of unruly Black cosmopolitanism, offered emphatically by the Black artists involved at each stage: Louis Armstrong, Duke Ellington, and Romare Bearden.

In contrast to unruly Black cosmopolitanism, Ritt's whites-only trombone signals, on a deep and disturbing level, the violence of American race mythology: here is whiteness meaning well (in one of the more onerous ways) but nonetheless pledging allegiance to keep Blacks "in their place": whiteness now standing post, circulating as the freelance patroller of Blacks—"paddy-rollers," slave narrators called them.

"What was I," asks Ralph Ellison's Invisible Man, protagonist of the eponymous novel, "a man or a natural resource?"[2] Here, we have the white man's primitive impression of the Black person, mind and body, whether male or female, so cut off from education, family, and memories—and from the rites and signs of personal and cultural legacy—that it has no place to be somebody. Here is the protoracist's idea: Blackness to the bone, Black folk chained to singularity of place and purpose. This specter of the white trombone— whiteness that you can detect even when you cannot see it—haunts the *Paris Blues* project.

The project's genealogy is long and complex. But first, let me share something about the trombone as instrument, which will explain why I mobilize it as a framing device for this chapter. There's much to say about this lustrous member of the brass family, arguably the one coming closest to the pleasures and powers of articulation of the human voice, singing and speaking—not to mention laughing, crying, whining, moaning, shouting, and whispering. The trombone differs from many other instruments in its capacity to slide across notes, slipping through glistening clusters of notes along the way. Similarly— along with my positioning unruly Black cosmopolitanism as the counter to white trombone fixity—I assert the truth value of the *slide* perspective. Because of the slide trombone's capacity to glide smoothly (or for that matter to rip roughly) from and through fixed positions, to pause when ready, and then to move elsewhere—the instrument is my metaphor for the refusal of fixed Black-white binaries, as well as of any other positions locked in place.[3] Ellington, who did some of his very best writing for his musically multilingual trombonists[4]— "legit" players as well as informally trained "ear cats" (those who played by ear)—also shaped the sound of *Paris Blues* in the image of the collage-and-word project of Bearden, Shaw, and Murray. In fact, Ellington is one of my star witnesses for the redeeming power of unruly Black cosmopolitanism.

The *Paris Blues* Project: Scripts, Novel, Film, Collage Book, Parts, and Pieces

For most, the *Paris Blues* project starts and ends with the 1.5-dimensional 1961 Hollywood movie revolving around two couples played by Paul Newman and Joanne Woodward and Sidney Poitier and Diahann Carroll, with cameo

appearances by Louis Armstrong. Jazz scholars have sometimes listed *Paris Blues* alongside *'Round Midnight* (1986) as one of the very few twentieth-century films to come close to representing something truthful about the culture of jazz music and the lived experiences of jazz musicians. Yet jazz scholar Dan Morgenstern's faint praise of *Paris Blues* is typical of the verdict of jazz cognoscenti: "It was far from the worst film with a jazz theme," he concludes, "if no masterpiece."[5] A few cultural studies scholars have discussed the movie alongside the novel *Paris Blues* (1957) by Harold Flender, and note that the movie casts the book's characters and storylines in telling ways.[6] In many respects—at least in terms of bald political statement, though not in terms of the implications that music itself can carry—the novel is a much more daring piece of work than the film.

For many jazz lovers, including Morgenstern, the movie's score is the thing. Presenting wholly new compositions as well as new arrangements of "Take the A Train," "Mood Indigo," and "Sophisticated Lady," along with the little-known Ellington masterwork "The Clothed Woman" and the Ellington-Strayhorn gem "Lay-By," the recorded score (available as an LP tie-in with the movie, and later in expanded form on CD) is thrilling as a concert of music on multiple levels, no matter what you think of the movie. Significantly, the project enables one of the only recorded meetings of Armstrong and Ellington;[7] the latter (with Strayhorn, who does not appear on the recordings) tailor-made the film's musical settings for Armstrong's dazzling improvised self-portraits in sound. Yet the score functions in two contrasting modes throughout the film: the composers folded their *Paris Blues* melody and gave it a variety of shapes, depending on settings and characters, and provided incidental underscoring that at times seconds and intensifies a scene's meaning. But the composers also redirected certain scenes. And when it comes to the movie's chorus of "white trombones," the Ellington-Strayhorn score, abetted by Armstrong, contradicts the movie's narrative line. Written to feature the white trombonist that Elling-ton was required to hire for this gig, the soundtrack overrules the meanings implied by this forced white presence in favor of something infinitely bigger, something better.

Along with the movie, its layered score, and the underlying novel, the saga of the *Paris Blues* project includes early storyboards by Sam Shaw and numer-ous revised scripts by various writers. These preliminary works are comple-mented by a postscript created twenty years after the movie's release, when Shaw teamed up with Romare Bearden and Albert Murray. The bond of friend-ship between Shaw and Bearden is the origin of the whole story behind *Paris Blues*, and Murray and Bearden, also close friends, were veteran collaborators.[8] In the collage-and-caption format, this trio tried to tell the *Paris Blues* tale yet again, this time free from commercial interference. Although left incomplete, their artists' book has wondrously finished pages. These compositions, most of

Sam Shaw's composite drawing and photograph of Montmartre in Paris, which evidently was part of a storyboard for the movie *Paris Blues*, where staircase promenades are a prominent motif. Photograph and drawings by Sam Shaw.

Frank Stewart's portrait of the trio of *Paris Blues* book project artists (left to right): Sam Shaw, Albert Murray, and Romare Bearden, c. 1979.

Courtesy of Frank Stewart, Black Light Productions.

them 15 x 22 inches and designed to fill an open book's double pages, along with an archive of the work in progress (notes, half-completed layouts of planned collages, and photos set aside for possible use), offer this chapter's second-best example of unruly Black cosmopolitanism—after Armstrong and the Ellington/Strayhorn score.

This was a cosmopolitanism that included people like Shaw, whose curiosity knew few bounds. In interviews, Shaw names Bearden, along with other visual artists (particularly the Cubists), as vital to his development; and then, to make more emphatic his unruliness when it comes to choosing photographic ancestors, he names the actor/dancer Charlie Chaplin as "the greatest photographer of all time," who "violated all the formal academic rules of photography in his scenes."[9] How could a photograph command the viewer's attention as Bearden's vivid collages and Chaplin's daring dance moves do?

Beginnings: Romare Bearden in Paris

The earliest stirrings of *Paris Blues* are traceable to Romare Bearden's August 1950 return to New York from his GI Bill–funded seven months in the French capital, a first tour of Europe that included casual studies at the Sorbonne as well as swings through the French Riviera to Italy and Spain. Bearden was already in his mid-thirties when he completed his military service and had his chance to discover Paris. Carrying letters of introduction from his New York gallerist Samuel Kootz and from his fellow artist Carl Holty, Bearden sought out Pablo Picasso, Georges Braque, Fernand Léger, and Constantin Brâncuşi. "Braque was very formal," Bearden recalled. "But Brâncuşi, I went to see him very often in his studio in [the artists' Montparnasse hideaway called] the Impasse Rosin." He also traveled to Juan-les-Pins to visit Picasso. "People stopped by all day to see the master," recalled Bearden. "It was like going to see the Eiffel Tower." Bearden also enjoyed the camaraderie of a number of gifted Americans, Black and white, "among them the poets Myron O'Higgins and Samuel Allen; the novelist/critics James Baldwin and Albert Murray; the painters Paul Keene, William Rivers, and Herbert Gentry; the engineer Jim Moseley; and the photographer Marvin Smith."[10]

Back home in Harlem, Bearden regaled Sam Shaw, then primarily a photographer who painted and was beginning to work in film, with stories of his Paris adventures—and most specifically, about the thrill (and sometimes the drag) of being a Black American painter in the City of Light. Artists were deeply respected—even revered—in France, Bearden reported. And what an energizing jolt for Sergeant Bearden, just released from the U.S. army, to find himself, if not really free from white racism, then no longer at the top of its list of racialized untouchables, at least for a few months. Indeed, as an American

in France and a Black American vet of World War II, he counted not only as an artist but as a rescuer of the République, an international hero.[11] Bearden's stories were so good, the idea of art given free rein so enticing, and the setting of Paris so inspiring that Shaw began to think of creating a movie around Bearden's days there.[12]

What also made Paris such a beacon for Bearden is the freedom represented by the image that the artist used over and over again in his *Paris Blues* collages years later: Picasso-inspired doves in free flight across several works in the series. Another important element of Bearden's *Paris Blues* collage series is his repeated portrayal of Ellington, Strayhorn, and Armstrong as men joyously in thought and in motion: artists on break from the slings and arrows of American racism and prejudice, as well as being inspired by working with one another. This shining sense of free movement of body and mind and the fresh air of unrestricted artistic association fill Bearden's *Paris Blues* collages. He celebrates Paris as a wonderland of street performers, sunshine circuses, lovers' lanes, rows of skyline rooftops, bridges, bookstores, and music-music-music!

Admittedly, Bearden's enchantment with Paris—both during his short stay and later, when he revisited the city in memory—left unexamined certain deeply problematic aspects of Parisian life. Would French Algerians and other colonial subjects, for example, concur with his vision of Paris as a shining, free wonderland? Some of Paris's most glaring race and class issues are absent from Bearden's *Paris Blues* series—perhaps because of the artist's determination to view Paris as a place to celebrate, not criticize, or perhaps because of the rose-colored perspective of the first-time, short-term visitor. Such matters were clearly spelled out in early drafts of the screenplay by Shaw and then, somewhat later, in the novel *Paris Blues*. In the very earliest drafts of the *Paris Blues* script, American race issues were unflinchingly probed as well.

Sam Shaw Envisions a Film About a Black Artist

After Shaw began to devise and implement plans for a film set in Paris, the *Paris Blues* project periodically stopped and stalled, took a variety of detours, found new beginnings, and gathered a big cast of characters. Although Shaw's initial vision of *Paris Blues* as a film about Romare Bearden did not come to pass, the painter remained in the evolving story behind it. The connection between the two men was due, to a significant degree, to their shared interest in the arts. Born in 1912 on Manhattan's Lower East Side, Shaw had tried his hand at sculpture and drawing before settling on photography as his life's work, and then turned to film as a set photographer and later a producer.

In the 1930s, he and Bearden had rented a studio together above the Apollo Theater and begun a lifetime of conversations about making art (a series of remarkable in-studio photo portraits by Bearden commemorate their early times together). By the late 1940s, Shaw was taking pictures for America's increasingly popular *Life* and *Look* magazines, and for France's *Paris Match*. As financial success began to come his way, Shaw recommitted to his early ambition to be an artist *first*—he promised himself that for every picture he took for the marketplace, he would take one strictly for himself. It was during this period that Shaw began his long association with the world of Hollywood film, taking stills for *Gentleman's Agreement* (1947), *Pinky* (1949), and *Panic in the Streets* (1950).

When Bearden returned from Paris in 1950, Shaw was printing his set shots for *A Streetcar Named Desire* (1951), whose star, Marlon Brando, was to play an important supporting role in the making of *Paris Blues*. It was as the on-set photographer for *The Seven Year Itch* (1955) that Shaw carefully staged the billowing-skirt photograph of Marilyn Monroe: the shot seen 'round the world.

Like *Paris Blues*, both earlier films were repeatedly revised. *The Seven Year Itch* was rewritten for film by its playwright, George Axelrod, and then re-rewritten by director Billy Wilder and others, who found themselves at sword's point with representatives of Hollywood's Motion Picture Production Code, who vetoed love scenes in the early scripts as "indecent." Axelrod and Wilder complained that the U.S. censors bowdlerized their original storylines and imposed what they called "straightjacket" censorship conditions on the film.[13]

This drama set the stage for Shaw's campaign to make Bearden's Parisian stories into a movie grappling with real issues—and more than a movie, a set of *Paris Blues* projects that could include Shaw's set photographs. Like Billy Wilder and the other *Seven Year Itch* writers, the multiple script writers of *Paris Blues* repeatedly confronted Code questions concerning the "decency" of its scenes of sexuality. And now also race, especially when race involved sex, was that film's hottest anvil of contention.

Shaw began with storyboards about Bearden.[14] As he began to make these first Bearden-in-Paris drawings, perhaps the young filmmaker was thinking of Hans Namuth's highly influential 1950 documentary of the abstract expressionist painter Jackson Pollock ecstatically at work on his paintings—an aesthetic success that seemed to contradict the conventional wisdom that an "arty" film about a painter at work could not sustain enough visual appeal for the American viewer. By 1950, the lives of certain white American artists and writers in Paris had been well documented in literature and in the French and American media. At that time, many Parisians could name at least a handful of Black American musicians either living in Paris, like Sidney Bechet, Dexter Gordon,

and Kenny Clarke, or frequently visiting there, like Dizzy Gillespie and Miles Davis. Perhaps French women or men on the street could also name a Black expat writer or two—Richard Wright or Chester Himes (James Baldwin would not emerge for the French until the late 1950s).

But what did it mean to be a Black American *painter* in Paris—and at this time when social movements in both the United States and France were gaining momentum? Let's face it: whether in France or the United States, beyond a tight circle of insiders, no one knew that Black American visual artists existed at all. Here was Shaw's chance to bring a new category of American—a new category of human being—to the attention of the world. Perhaps a new kind of movie would be possible too—something reflecting the modernist impulses demonstrated by French and American artists working across the categories of film, painting, and music. And quite aside from questions of race and nationality, could a modern film take up age-old questions of the fundamental purposes of art and of art's capacities to translate the sounds and furies of the human heart set against itself into something beautiful to see as well as hear? Could art be part of a worldwide movement toward progressive social change?

Bearden struck Shaw as the perfect protagonist for such an ambitiously multidimensional film project. Both men were left-leaning political activists. Bearden had started his career as a political cartoonist, campaigning through his drawings against racism and prejudice and the fascism of the 1930s. Both admired the early Cubists and often discussed photography versus painting as modes of flat and geometrically rhythmed modernist expression. Bearden had long used photography as part of his work process. As a painter-in-training, he'd worked at home from photos of paintings he admired, and by the 1960s, he would see that his Xeroxes of original artwork "flattened and abstracted the image," as Bearden biographer Mary Schmidt Campbell has observed, giving his repurposed photos, his photomontages, a dynamic, Cubistic aspect.[15] For Shaw's part, as much as he loved photography, he worried that compared to painting and sculpture, photography fell flat on the page and commanded a point of view that was unvaryingly fixed and finite.

By 1950, Shaw's increasingly popular commercial photography was leaving little time for his creative experiments. He reports that when time allowed, he was learning from Bearden (and others) how to add collagelike layers and abstract dimensions to his pictures. The thrill of finding that Bearden's "new mixed-media-technique creations" were translatable into photographic form helped set Shaw on a new path. Could not photography be Cubistic? Collagelike? Could moving pictures capture not only a Black artist's love of (and ambivalence toward) Paris, but some of the Cubistic/collagelike aspects of that city? Bearden's story on film could be a wondrous test case.

The Black Artist Becomes a Black Musician:
Enter Ellington and Strayhorn

According to Shaw, every prospective Hollywood partner rejected his first storyboard presentations out of hand. Each of his L.A. contacts soon made clear to him that the story of a Black painter in Paris was "too internal"—that is, it was not sellable to U.S. moviegoers, presumed (rightly, no doubt) to be unaware of Black painters, whether in Paris or anywhere else. More important, for the broad moviegoing public, the slow work of a painter could never be consistently dramatic enough to hold attention. So now, with the idea of a film about a Black painter in Paris firmly rejected, Shaw began to think of a *Paris Blues* movie with another focus.[16]

"And liking jazz so much," Shaw told an interviewer, "I thought it would be easier taking that theme and making the protagonist a *musician*."[17] For years, Shaw had played stacks of Ellington records while working in his studio darkroom above the Apollo. Shaw's younger brother, Eddie, who as a teenager in the 1930s had worked in a music publishing business that gave him routine access to many jazz musicians—the famous and the not (or not yet)—had introduced Shaw to Duke Ellington. In interviews, Shaw recalls that over the years, he and Duke often spoke of the excitement Ellington felt during his first trips to Paris in 1933 and 1939.[18] They helped make Duke aware of the international appeal of his music. Like Bearden's, Ellington's Paris—which, by the 1950s, he and Strays knew much more intimately than the former GI—was a place for Black men and women to live and breathe in more freely, where they could party without regard to race or sexual preference, and where they could dream of joining that city's tradition of creating new forms of art.

There can be no doubt that Paris played a role in Ellington's and Strayhorn's compositions. The city's magical name appears in their titles more often than any other place's, aside from Harlem. (The protagonist of one of Strayhorn's earliest masterworks, "Lush Life," suffers from world-weariness and love gone wrong and muses that "a week in Paris would ease the bite of it.") As we consider Ellington's involvement in the *Paris Blues* project, it's quite significant that while, like Strayhorn, he was a constant world traveler, particularly after the mid-1950s, his annual performance schedules invariably included swings back home to Harlem and to the numerous "Harlems," so to speak, of America.[19] When playing public dances and concerts in the Black neighborhoods of the nation, in the Savoy Ballrooms and Apollo Theaters of cities great and small, and not excluding the occasional roadhouse gig in a countryside setting, Ellington said, "that's my source." Offered an opportunity to give up such Black gigs and play only the Carnegie Halls and La Scalas of the world, Ellington said, "No, baby! You're trying to cut me off from my source!"[20]

Shaw reports convincing Ellington to undertake some sort of partnership on a *Paris Blues* film that would depict the freer Paris that Duke (and Bearden) had been telling him about. The fact that Strayhorn, who was gay, was a regular visitor to Paris, and that his lover at that time was Aaron Bridgers, an American expat in Paris, made the idea of a film that told real stories about love and art in Paris that much more appealing. "The movie was still a gleam in his [Shaw's] mind until he discussed the idea with Ellington," said one reporter at the time of the movie's release. "Duke reminisced fondly on Paris and its meaning: freedom to play and compose in a romantic atmosphere where the first consideration was artistry."[21]

Nevertheless, if Shaw invited Ellington to appear as an actor in *Paris Blues*, Ellington declined the invitation. He would not play any role on camera, but he would advise Shaw on characters and storylines, and, yes, he and Strayhorn would compose the new film's score. Perhaps Ellington regarded *Paris Blues* as an elaboration and update of the experimental musical movies he'd participated in already: *Black and Tan* (1929), by the American avant-garde director Dudley Murphy; and the superbly compact *Symphony in Black: A Rhapsody of Negro Life* (1935; 9.5 minutes), which featured young Billie Holiday's screen debut.

Like these films (and like the several "soundies" that Ellington made to promote new records), *Paris Blues* could serve as a showcase for his and Strayhorn's music. As he and Shaw discussed the project, not only would Ellington's music be integral to the movie, but music would take center stage as a spirit or character in an extended pas de deux with the city of Paris. To judge from the music that they wrote, Ellington and Strayhorn imagined such an abstract onscreen dance as being expressive of something akin to unruly Black cosmopolitanism—musical choreography by artists on the theme of feeling thoroughly at home on the road, while nonetheless scheduling regular trips back to Harlem (i.e. to Black America), the source of what was unique in their music.[22]

Unruly Black Cosmopolitanism I: Ellington

Another few words concerning unruly Black cosmopolitanism: I say "unruly" because artists like Ellington and Strayhorn have a sense of life that is disciplined but also pulls and pushes at the edges of the conventional artistic forms and genres. This unruliness wants rules but refuses to live in a world where rules don't change. Here's a testy, unsettled will to shake things up, to go for broke, to find loopholes of possibility, elbow room, running space. This is the life of the traveler, the explorer, the adventurer on the move, physically and metaphysically.

This is the fugitive who can quickly map landmarks for orientation but also *likes* to feel lost for a while, to feel the temporary vertigo of unruliness and the possibility of joyous chance encounters. She feels at home en route more than anywhere she hangs her Phrygian cap, but who, give her a minute, also is ill at ease everywhere she goes; she has recovered from juvenile homesickness and *chooses* exile.[23] Sauntering here and there, she is testing limits as she goes, questioning every twist and turn: What are the power relations and dynamics in a new space? Who has the money? How are the weakest ones treated? Who are in the jails? Who are the people enjoying privilege? Where are the people of color? Where are the women? The gays? Who, again, has the power? Here's an unruly Black cosmopolitanism that is Black without compromise or apology: a Blackness that is most Black, brothers and sisters, *most* Black. MOST Black, because so often it's presumed that the widest possible frames of reference and clearest sightlines come from the worlds of Western art and culture: that by "universal," we mean something aggressively European to which all must aspire and evolve. Correction: Not just European, but Northern Western European. Something white, or, more to the point, *white on white*.

Against this, the unruly Black cosmopolitan expresses both pride in Blackness and disdain for being pigeonholed and barred from the openness that belonging to the cosmos entails. Ellington expressed this complex attitude with wry perfection in a 1960 interview. "Do you play the music of your people?" he was asked by a French journalist, after a concert circa 1960. "My people?" Ellington replied, while striking a dissonant chord on the piano. Perhaps the maestro was deciding which of his standard answers he would offer this time. Maybe the lateness of the hour had frayed Duke's patience: "My people? Ohhh, my people!' he mused, continuing to play bluesy, discordant chords:

> What can I tell you about my people? . . . The music of my people is what? [He stops playing] What is that? That's a *strange question*, you know? I was afraid you were going to do this: Get me out here on this tape and expose me to my own ignorance, or something. Let's see, "My people?" Now which of my people? I mean I'm in several groups: I'm in the group of the piano players. I'm in the group of the listeners. I'm in the group of people who have general appreciation of music. I'm in the group of those who aspire to be dilettantes. [Smiling now.] I'm in the group of those who attempt to produce something fit for the plateau. I'm in the group of what, now? Oh yeah: those who appreciate Beaujolais! [Laughs] Well, and then of course I've had such a strong influence by the music of the people. *The* people—that's the better word: *the* people rather than my people. Because the people are my people.[24]

Ellington undoubtedly created more music in explicit celebration of Black Americans and their culture than any other composer. "Black, Brown and Beige,"

"Black Beauty," "New World A-Comin'," "Harlem," "A Drum Is a Woman," and "For My People" are just a few of his concert pieces along these lines. His people were Black people, no doubt. His ideal audience was the Black American audience, whose responses to certain musical cues he could count on. Ellington played Black music with and for Black people.

At the same time, Ellington did not want anybody to forget that his loyalty to family and homefolk did not block other powerful choices of affiliation. Duke was a committed world traveler drawn to cultivated tastes and talents wherever he found them (including, he often said, in pool halls and gamblers' dens), and to the human group as a whole—to "THE people," with its double entendre (one of his specialties) indicating both broad humanitarian and proletarian allegiances. Who created more musical compositions reflecting world travel than Ellington? Along with his many tributes to New York, New Orleans, and his hometown, Washington, D.C. (those most international of American cities), Ellington composed *The Afro-Eurasian Eclipse*, *The Far East Suite*, and *The Latin American Suite*, as well as musical tributes to Brazil, Liberia, Mexico, Senegal, Sweden, and Togo. *Paris Blues* should be regarded as part of a lifetime of creating such traveling music. "Ellington was himself a model for a new kind of avant gardism," writes John Szwed, "one who avoided the traps of early twentieth century avant gardism by opening his music up to every conceivable source of influence."[25] The Duke of Ellington represents Blackness on the move: unruly Black cosmopolitanism with an enigmatic smile to cover the wearer's anger against anyone hoisting Blackness as a fixture in some kind of a "white trombone" scenario. "Which of my people," he wanted to know. *"Those who appreciate Beaujolais!?"*

Duke Ellington's sentiments here are part and parcel of the Black freedom movement in the United States. "Put it this way," he once wrote, "jazz is a good barometer of freedom. . . . The music is so free that many people say it is the only unhampered, unhindered expression of complete freedom yet produced in this country."[26] Speaking as a member of the next generation of jazz artists, Thelonious Monk also stated the case succinctly: "Jazz is freedom. Think about that. You think about that."[27] Here's a Blackness yearning for a worldwide reach and arc—for a blue-Black diaspora akin to Jorge Luis Borges's "Congress of the World," where absolutely everyone/everything (Borges includes every plant and animal, as well as the wild air, fire, earth, and water) is a member.[28]

What I'm getting at here is that for Ellington and Strayhorn, a great deal— nothing less than the shape of their unruly Black cosmopolitanism—was riding on the score for *Paris Blues*. The movie's soundtrack was by no means a trivial side project. For them, it had precisely the same weight as the full-length concert works they had done for Carnegie Hall or La Scala—or, for that matter, for a sorority dance at a Black club in DC. After all, the projected score had the

added gravitas of soundtracking not only Blackness and Paris but also the significance of their own music in relation to European classical music—a subject, of course, very near to Duke's and Strayhorn's hearts. And for them, always, Black freedom lay at the heart of the score.

Film Treatments Confront "the Black-White Thing"

With Ellington fully committed in this way, Shaw brought new storyboards to the movie moguls. This rough screenplay in storyboards now starred a no-name young Black American musician living in Paris and striving for an audience with the Duke. Such a professional break could spell the fledgling player's graduation into membership in that great band and the big time.

One further step in the script's evolution, perhaps influenced by the many stories of Paris as told to Shaw by Bearden, Ellington, and Strayhorn, was Shaw's decision that the new main character of *Paris Blues*, this Black American musician in Paris, would fall in love with a white woman (it's not clear if she was to be American or French); and the two of them would move with ease along a Left Bank where gay and lesbian love (as well as so-called interracial love) was taken for granted, and where art mattered more than money. According to jazz historian David Hajdu, this "mixed-race" aspect of the film "contributed significantly to Ellington's agreement to take on the project."[29] "Duke thought that was an important statement to make at that time," recalled Shaw. "He liked the idea of expressing racial equality in romantic terms. That's the way he thought, himself."[30] So taken had Ellington been by this film's potentially revolutionary aspects, reports Duke's son Mercer (then a trumpet player in his father's band), "that it was one of the few times he allowed an outside project to take precedence over the band," which he left behind in New York when he and Strayhorn split for Paris to work on the film's score.[31]

Armed now with ideas for a more ambitious film than ever—a visually splendid movie where Paris was a kind of character, a movie forthrightly progressive in its politics and with music in the foreground by Duke Ellington—Shaw took a new set of storyboard drawings to one of his friends, director Otto Preminger. Shaw considered Preminger just right for *Paris Blues* because of his sense of the European scene as a stage for experimental filmmaking and complex social drama. But at first glance, "Otto hated the script," said Shaw. "He said it was a terrible script" and would not discuss it further.[32] That ended that.

In subsequent meetings with other potential Hollywood partners, Shaw could only have been half-surprised when his idea of a "mixed" romantic couple (and according to some reports, not one but *two* mixed romantic couples), even an ocean away, was unanimously rejected as out of the question. The money people had no doubt that movie houses in the South would not

screen such a film, and it could hurt their other movie projects. Presumably, that same thinking led them to thumbs-down Shaw's plan for a film starring a Black man as the central character, whether a painter or a musician. Why not make a *Paris Blues* about an American expat musician who was also a good-looking white man?

Losing one battle after another, Shaw tried to hold onto "the Black-white thing" by proposing a film about a *white* male expat musician in Paris who falls in love there with a Black woman. From what I can tell, this was the idea that Shaw took to his friend Marlon Brando, who at first approved the plan of starring in such a daring movie and of trying his hand, for the first time, as a director. At that point, Brando was not a household name yet, but he was a fast-rising star who'd already been the hero of one successful "interracial" film, *Sayonara* (1957), in which his character defies his U.S. army colleagues by marrying a Japanese woman. "He really wanted to make *Paris Blues*," recalled Shaw. "He wanted to act in it, he wanted to direct it." But Brando's business managers (led by Marlon Sr.) wouldn't let him either act in or direct "a so-called 'arty' film" that was yet another "problem" picture. Brando's company, called Pennebaker (taking his mother's family name), whose declared mission was to support films that contained "social value that would improve the world," backed *Paris Blues* financially but firmly blocked its major client from any further involvement. "Brando's business partners were not racist," said Shaw (making a claim that I'm sure would be seconded by over 99.99 percent of those white Americans who make no distinction between being "not racist" and being actively "*antiracist*," the only distinction that makes any difference). "They were very Left" in their politics, and some of them were brilliant guys, said Shaw. "But the Black-white thing did not relate to them."[33] And like the other executives, they were concerned about their markets in the American South, where they were sure no such film could fly.

"Everybody chickened out," continued Shaw. Those representing Brando told him to "turn it into a white story," not a Black story or a "mixed" story either. The next compromise, the one that stuck, was that a *white* male lead, still a jazz musician, would fall in love with a white American woman who was traveling through Paris on a tour. Questions of color could be raised by a secondary couple, a Black male expat jazz musician who falls for a Black American woman also on a tour through the City of Light. Thus would this version of the film follow the formula of the Black-white "buddy" flick, with strictly heterosexual romantic involvements true to racial patterns—nothing to offend "our southern markets." From the beginning, the Pennebaker Company had been enthusiastic about the idea of an Ellingtonian score. The idea was that Duke would fold his hit songs into a buddy movie that featured naughty Parisian romance—material for a tie-in record that, perhaps with a book of Shaw's photos, would help sell the movie.

The Novel *Paris Blues*: Origins, Originality, and Politics

Exactly when and how Harold Flender, the author of the novel *Paris Blues* and subsequently the creator of at least one script based on that novel, entered the *Paris Blues* scenario is not entirely clear. Evidently, he and Shaw had become friends in the mid-1950s, when both had been in Paris—Shaw on assignment as still photographer for the film *Trapeze* (1956),[34] and Flender a New York writer whose articles were appearing in such top literary magazines of the day as *The Saturday Review* and *The New Leader*. Flender had also written scripts for *Wide Wide World*, a documentary television series singled out by *Time* magazine as having "the highest audience rating of any daytime [television] show."[35] And he'd contributed material for *Eddie Condon's Floor Show*, the first program to feature live jazz on network television. *Paris Blues* was Flender's first novel.

With only scant paper trails to follow, my sense is that once Shaw's storyboards about a Black painter in Paris and his big ideas about jazz musicians in mixed-race/gay-straight romances were both nixed, the photographer–movie producer was not at all sure how to proceed. Printed accounts of what happened next contradict one another. Fading (and/or self-serving) memories plus ad copy prepared to promote the film obstruct the historian's will to tell the story accurately. In one interview, Shaw said he "got Flender to write the book"—meaning the novel *Paris Blues*—as a step toward creating a viable storyline for the movie he already had in mind. Shaw's biographer, Lorie Karnath, comes close to seconding this version when she writes that Harold Flender "wrote the novel in 1957 based on Sam's discussions of artistic freedom in Paris." Did Flender do the novel as a work for hire? Flender's family says that he did not work that way.[36]

Evidence suggests that before conferring with Flender, the only *Paris Blues* that Shaw had were his various hand-drawn figures mounting Paris staircases—no rounded characters, no plot. Perhaps, after all the rejections, all he had left was a sense that he wanted to make a film saying something about the excitement and angst of the Black American artist in Paris, whether painter or musician—a new kind of truth-telling screen statement where music and the city played leading roles. I'm guessing it was Flender who first put scenes and storylines to Shaw's rough sketches. One early newspaper account seems to confirm this sequence by asserting that Shaw's first *Paris Blues* inspiration was sparked when he "read a manuscript by Harold Flender . . . called 'Paris Blues' and the next day he used up all his available cash to take an option on its screen rights." "A story began to take shape after the ideas were discussed with Harold Flender," Shaw said elsewhere to a *New York Times* reporter. Flender "wrote a realistic novel called 'Paris Blues' about musicians playing and balling it up in Paris," said Shaw. "Now there was a story in existence with real characters. . . . Then the tough job of trying to convince a movie company that there was a big

audience waiting for an honest jazz film in which a Negro musician and other American expatriates figured prominently."[37]

It certainly is credible that Shaw's conversations with Flender about a Black American in Paris preceded the drafting of the novel, since—as Shaw's daughter, Meta, who was a small child in the mid-1950s, has pointed out—both her unusual first name and Bearden's equally unusual surname are assigned to background characters in Flender's book. Bearden appears briefly as a clarinet player in the lead character's band, and Meta (who recalls this as a sweet shout-out from her daddy and his friend) as a horseback rider in a Parisian circus. Both these names ultimately were dropped from the movie.[38]

In a sense, of course, this teapot drama over which and whose *Paris Blues* storylines came first is neither here nor there. Clearly, Shaw and Flender cooked up the narrative together; then it was added to (and subtracted from) by many others. What is significant here is that aspects of the Romare Bearden story are gently folded into early versions of *Paris Blues*, both novel and screenplay. And Bearden's story of Black artistic freedom persists, here and there, throughout the project's history, including the film. It also matters that in its early drafts, as novel and screenplay, *Paris Blues* was much more ambitious in its race and gender politics than in the movie as released—and this ambition persists as fleeting shadows and flashes in the movie and beyond. Furthermore, the visual splendor that Shaw always wanted also strongly persists, here and there, in the movie: Paris as a beautiful "character," dancing, as we've said, to the many-splendored music of Ellington and Strayhorn.

In Flender's novel *Paris Blues*, a Black male artist regains the leading role. Now the novelist has reimagined Shaw's storyboard Black artist character, based on Bearden, as Eddie Cook (the film's Sidney Poitier), a gifted and ambitious Black American tenor sax player living in Paris. Born in Kansas City, Eddie stays in Europe after his World War II stint in the U.S. army, first winning a following in the jazz clubs and festivals of Paris, and then throughout the jazz circuits of Western Europe. The novel's opening pages reveal that Eddie has been based in Paris for twelve years. A crisis arises when one of his serial flirtations—this time with a beautiful, sophisticated African American schoolteacher named Connie Mitchell (played in the film by Diahann Carroll) who is visiting Paris for the first time as part of a European tour—blooms into romance. Can young love convince him to move back to the United States, and thus inside the walls of Uncle Sam–style racism—into the long shadow of the white trombone and into the promises/challenges of the burgeoning Civil Rights Movement? Or will Connie find Eddie charming enough to give love a chance under Parisian skies? What does it mean to create new art here or there? What's love got to do with it? What's race got to do with it?

Such questions are made vivid by the background drama provided by Eddie's foil/buddy Benny (ultimately renamed and substantially reconceived,

in the film version, as Ram, played by Paul Newman), a white piano player and Eddie's bandmate, who gets involved with Connie's traveling roommate Lillian, a middle-aged white American (also quite reconceived in the film and played there by Joanne Woodward), also on her first trip to Paris. In other words, in Flender's novel, all of Shaw's intimations of gay or lesbian sexuality and all suggestions of Black-white love have been erased—or, as we shall see, redirected. In the novel, Benny and Lillian are a "mixed couple" insofar as he is a Jew, she a WASP, and also because she is considerably older than he.

But the novel's main question—whether to stay in Paris to make art or go home to face the challenges of the freedom struggle there—belongs again primarily to a leading Black character (Benny makes clear from the first pages that he would never consider returning to the United States). In the novel, Eddie decides that for the sake of Connie and her arguments about their responsibility to the race struggle back home, he must return to the United States with her. This broad narrative framework is kept in place in Flender's scripts based on the novel. But I read the movie's final scene as differing monumentally from the novel's, as we shall see.

In fairness to Flender, we should note that *Paris Blues* was his first novel, and his screenplay based on the book also was his first. In both documents, nearly every page falls flat when it comes to liveliness and felicity of language. At their worst, Flender's chapters and his screenplay read like notes toward essays, restrung now as forced situations and unlikely dialogue. However, at their best, both the novel and script have touches of fair writing and scenes of political and philosophical significance that reach far beyond Shaw's early storyboards, and in important instances rocket light-years beyond what Hollywood eventually approved for release. Most exciting in my rereading of the novel and film are the traces of Flender's treatment of the subject of the Black American artist in Paris as exceedingly vast and varied—and reflective of his own experience as an American Jew who loved Paris. These ideas appear only in flits and flashes in the film—and sometimes solely (and certainly most soulfully) in the music.

Consider the scene in the novel (and in an early script and in the film as well) in which Eddie and Connie joyously meander through Paris—thus following through on Sam Shaw's earliest storyboard showing his characters waltzing with that great city.[39] Up flight after flight to Montmartre they go, across bridges great and small, through the winding streets of Bastille and St-Michel, down the steps to the riverfront, moving to the rhythm of the city. In Flender's novel (but not in the film), Eddie surprises Connie with a casual reference to an obscure nineteenth-century text. "Henry James said something interesting about the thoughts you get while walking," Eddie says. "He called it the rich, ripe fruit of perambulation." Here, Eddie is alluding to James's preface to the 1907 edition of *The Princess Casamassima*.[40] In it, James declares that the inspiration to write that book, and other books as well, "proceeded quite

directly from the habit and the interest of walking the streets," specifically of "perambulating" London.

"What's the matter?" says Eddie to Connie, who looks startled. "I suppose you think the only James I should know is Harry" (he refers here to the jazz trumpeter and big band leader Harry James).[41] The obscurity of Eddie's reference (and Flender's) to the turn-of-the-century American writer's little-known sentences is quite a striking marker of the scope of Eddie's cultural life beyond the world of music per se.

Henry James's preface to *Princess Casamassima* is part of his series of works on "the art of the novel" and of his decision to present characters of rare intelligence and deep feeling—"super-subtle" observers of the scenes through which they travel. As James explains, "Their being finely aware—as Hamlet and Lear, say, are finely aware—makes absolutely the intensity of their adventure, gives the maximum of sense to what befalls them."[42] Flender creates Eddie not only as a representative Black American but also as one of James's "finely aware" artists, capable of enlisting his audience in an adventurous sense of life. Clearly, Flender's goal was not to present his readers with a Richard Wright–style victim, but something closer to a Jamesian or Ellisonian observer of scenes he traverses—a hero of the particularly musical storyline he navigates. Flender's novel testifies that there's a world of inspirational "fruit" to gather on the streets of Paris, with beautiful sights and sounds at every corner. Eddie even hears the *wah-wah* honking of Parisian car horns with a composer's ears, as "an atonal composition."[43]

There's more to Flender's reference to Henry James than the inspirational/aspirational value of traversing a great city, more than the implied presence of a gifted American character. James's many fictions and essays focus precisely on the American expat or visitor in Europe, he or she whose national "gifts" (whether the high spirits of his novella's Daisy Miller, "a child of nature and freedom," or the good-heartedness of Christopher Newman in *The American*) are measured alongside the manifestly "thin," as James says, or "blank" aspects of the American cultural landscape and its inhabitants dwelling in pitifully identical homes. In *American Scene*, James takes Americans sharply to task for their commercialism, intellectual superficiality, and ignorance of art (among other things). While Flender's Paris is by no means perfect, much of what Eddie and Connie enjoy most about their walks there is missing in the United States: the lovely views along ancient walkways and bridges, the springiness of one's footsteps, the uncomplicated displays of affection between lovers on the street, the lightness and joy in the air. Above all: the sense that life itself is a delicious thing, and art is worth creating quite aside from any money made or not made. Here, too, it's fair to ask: Where in the United States, North or South, country or city, would a Black man and woman feel so free to meander at night while flirting and having fun? Perambulating while Black?

Flender's novel also refers to Ralph Ellison's *Invisible Man* (1952) and to Billie Holiday's autobiography *Lady Sings the Blues* (1956). In scenes expressive of the dead ends of life for Blacks in violently segregated midcentury America, Flender quotes these books. These references nonetheless confirm Flender's creation of Eddie as a Black artist who is less a victim than an intellectual explorer in the mode of Invisible Man and Lady Day. (Even in her tragic songs, Holiday's voice always glowed with the capacity to persevere, to outlast the chaos she's seen.)

Several of the scenes in *Paris Blues* depicting Eddie's introspection, mounting outrage, and revelation seem to have sprung directly from Ellison's *Invisible Man* and from his own Jamesian preface–like essays, which describe his character's steady graduation in consciousness "from passion to perception to purpose."[44] But Flender's most explicit Ellison reference arises when Marie, a Black American expat who owns a jazz club in Paris, tells Eddie why she left the United States; she recounts the demise of her brother Spenser, beaten to death in a battle royal back in the family's Louisiana hometown. Eddie knows from his U.S. days what a battle royal is: "a bunch of colored kids are blindfolded and put into a ring. When the bells sounds they start punching and kicking as hard as they can. The one who stays in the longest wins the prize. It used to be a popular form of amusement at white men's clubs in the South."[45] In *Invisible Man*, the Black hero competes in just such a violent free-for-all, where the prize is a chance to participate in a mad scramble for coins that turn out to be counterfeit. That Ellison's battle royal "entertainment" for white town leaders includes a provocative dance by a "magnificent" but (to the narrator) grotesque, naked white woman turns up the heat on the drama ("The hair was yellow like that of a circus kewpie doll . . . the eyes hollow and smeared a cool blue, the color of a baboon's butt").[46]

On top of Flender's echo of this surreal scene—which is part of what finally shocks Ellison's narrator toward a sense of direction—comes Marie's deadpan account of being raped as a child. Marie's words replay the deadly, direct lingo of Billie Holiday's autobiography, where the dark night of race hatred is intensified by the rape of the genius child. "Do you know where I played as a kid?" says Marie in *Paris Blues*:

> In a cat house. . . . I used to run errands . . . and clean up around the place and once in a while to amuse the guests I'd sing a song. . . . One day when a hardware salesman asked me to go up to one of the rooms with him, I went. . . . I'd never heard of the things he wanted me to do. I told him no, but he twisted my arm in back of me so hard I thought he'd break it, and he said he'd kill me if I started to scream. I was ten years old at the time.[47]

Like Holiday, Marie is not undone by the dreadful episodes that she and her family have suffered. In Paris, she's reborn as the mistress of her own domain,

the Cove nightclub, home to *le jazz hot* (and also cool). Both in her story and in Eddie's, Flender gives us the rationale for Black expat life, even if Paris too has its pitfalls.

Problems in Paris

If Parisian streets could talk, what stories about race, gender, and freedom—according to Flender—would they tell? Both his novel and his screenplay are structured around competing excursions through the City of Light, quite different from ideas of the canonical "Grand Tour." What, according to Flender, did midcentury Americans signing up for the Grand Tour of Paris expect to see and do? What else, according to alternative tours, was there to experience?[48]

Organized for a group of American schoolteachers, the novel functions as a bildungsroman of sorts, a novel of education. In the Flender script, Connie is a brand-new teacher set to offer her first elementary school classes in the coming fall. Except for one participant, all the teachers-tourists are women, and everyone (Connie and Lillian included) bemoans the tight grip of the tour's nonstop routines.[49] (Advertised as "Paris by Day" and "Paris by Night," the tour's itineraries reflect the shrinking circumference of Paris as disclosed by the "Teachers Tours, Inc." guides, Mrs. Vogel and Mr. Luften. In a post–World War II novel, these German names mean nothing good; and the suggestion of natural adventurism in these plodding characters—"vogel" means bird, "luften," air—adds sting to the irony.) The novel's organized tours also comment on the U.S. educational systems of the era and its training of women. What was there for female Americans to learn from the Parisian way of life, from life beyond American shores? The touring "girls," as they're repeatedly called, usually in a reprimanding tone, are expected to show up en masse—no solo or independent side trips allowed. By day, the group's guidebooks are opened to the pages about Notre Dame, the Eiffel Tower, and other tourist sites, with the Louvre as a mecca of high Western culture. "In a little while," says Luften, "we're going to visit the greatest art museum in the world, the Louvre. The halls of the Louvre—halls of antiques, of painting and sculpture, of art objects and furniture—show man's cultural accomplishments from earliest history to the end of the nineteenth century."[50] By night, the imperious Luften directs the group's descent into an underground jazz den: a slumming turn down the dark stairs of the Left Bank meant (in his eyes) to confirm the Louvre's definition of true art and lessons on proper, aboveground ways of living.

It is against the grain of these official tours that readers encounter the novel's two unofficial tours—one led by Eddie, who "perambulates" Connie up and down "his Paris," "the real Paris"; and the other led by Benny, who takes Lillian to see the after-hours city he knows. These alternative mappings of the

French capital give Flender's novel and script much of their scope and energy. Eddie and Connie's flirtations open up as they stroll Paris's flower markets and riverside walks; before we know it, they are discussing what it would mean for them to remain together there, or, as she comes adamantly to prefer, to return as husband and wife to the United States. The story of Benny and Lillian, an odd (for that era), quasi-romantic, spring/autumn, Jewish/WASP couple, offers the novel's other illuminating tour—another narrative scrim through which to regard the book's official drama. The Brooklyn-born Benny's love-hate engagement with his native land resurfaces as he transports Lillian to the Paris of nude night-swimming and transgender burlesque—trips designed, as he later confesses to himself, to shock and punish her as a representative of the square white world, with its various shades of anti-Semitism, that drove him from home in the first place (although, actually, these after-dark tours gives her the thrill of her life!).

Along the way, Benny's trips through nighttime Paris uncover his love-hate feelings not only for his American motherland but indeed for his own mother—feelings that purport to account for his "courtship" of sorts of the maternal Lillian. Beyond Benny and Lillian, this loose Oedipal theme offers one of the novel's threads. Connie tells Eddie that she has heard from a psychiatrist friend that those who walk alone are searching for their mothers.

Benny's tour also makes the case that he cannot go home again because the business end of the American jazz scene is so predatory. Its "vultures" (Benny's term) feed upon the work of musicians and force them to perform whatever music makes managers and club owners the most money. (Here again, Flender may have had scenes from the Ellison and Holiday books in mind.)[51] Benny detests the slumming visits organized by "Teachers Tours, Inc.," which signal the increasing reach of profiteers into the free-flying art world that he and Eddie (like Bearden) love so much. The novel's presentation of the seedy French investor Varay, teamed with the now cynically opportunistic Marie, to bankroll the club's expansion and replace Eddie and Benny with players of more popular music hammers home this point. Varay likes the look of the new Paris clubs that feature burlesque shows instead of jazz—a shift suggesting that American-style commercialism is clawing its way into Paris.

Perhaps the most important factor introduced into the project by the novel and Flender's film script (and then dropped in the final movie) is a vital international dimension, going beyond the American-French orbit, beyond the typical American jazz artist's Paris. Here is where both Eddie's and Benny's tours of Paris—quite aside, that is, from the city's romantically glowing bridges and thrilling night swims—far exceed the film's official tours.[52] Consider the situation of the novel's character Michel Rabu, a guitarist in Eddie's band. Michel is the novel's jazz man as "Negro Frenchman," born a wealthy French citizen but suffering from exclusion both by his snobbish "Negro" family, with roots,

presumably, in the French colonies, and by France, where he was born. Michel's never-ending quest for letters of recommendation for a job teaching jazz at a Paris conservatory signals his emotional breakdown. This headlong press for official approval (suggested by Bearden's tales of letters from home to French artists or by the fool's errand scenes in Ellison's *Invisible Man*?) triggers the incident that lands Michel in jail, where he is beaten by guards before being remanded to a mental hospital.[53]

Eddie goes to the police station to rescue Michel, and his exchange with a cop there sounds notes that ring throughout the novel. " 'I've been here twelve years,' said Eddie. 'I'm more French than I am American.' 'That's what you think,' said the police official." What the official means is that the violence of the French color line applies not only to the "French Negro" but to Eddie as well: "*You may talk our language perfectly,*" says the gendarme. "*But you'll never be able to speak our language, if you know what I mean.*"[54]

A key to Michel's mental breakdown surfaces when his brother, called only Monsieur Rabu, appears at the hospital. M. Rabu is a foppish stump of a man, a caricature: "a short Negro dressed meticulously in a black suit" who "carried light gray gloves, a black fedora and a Malacca cane." More snobbish than the white French, the diminutive Black dandy hates jazz, that "strictly inferior product," which, he declares, "may mean something in the cultural desert of America but not over here."[55] He blames his brother's illness on jazz and "those people" who play it, and he wishes he would gain a professorship in the French academy (not teaching jazz, presumably, but *music*). The reader's impression of M. Rabu's own madness is confirmed by the realization that his hatred for his brother's Black leanings has left him far more embarrassed by Michel's arrest and hospitalization than concerned for his well-being and medical treatment. Like the square algebra teacher in the short story "Sonny's Blues" (1957), James Baldwin's classic study of two brothers, this short French Negro needs to learn what may be the single most profound lesson of jazz (and, Baldwin implies, of humanity itself): always closely interrogate the scenes through which one moves, and really listen. (Must the algebra teacher be his brother's keeper? No, he must be his brother's *brother*.)

With the French policeman's words to Eddie echoing in our ears, readers know that no matter how French M. Rabu may be in his language, personal culture, professional expertise, or self-image, as the son of swarthy former colonials he is always *Negro*, subject to be reminded (by gendarme force) of "his place." In the Black American author William Gardner Smith's contemporaneous novel *The Stone Face* (1963), an uneasy fraternity between Algerians and Black Americans living in Paris takes center stage. Similarly, Flender's *Paris Blues* makes the case that white French prejudice against the colonial subject, enforced by violence, is a cousin to the hydra-headed forms of white racism and violence perpetrated against Black Americans, whether in the

United States or abroad. As, by degrees, Eddie understands Michel's predicament and state of mind, he also understands the racial constraints in Paris that apply to him as well. Here, in Flender's novel, is a calculus-level version of "Paris blues" that the film, preferring the 1+1 of drugstore romance novels, does not consider.

Flender's other crucial scene on this international color-line theme, in the novel and the film script, comes when Eddie takes a cab (and then another cab) to try to rescue Michel from custody. To comprehend the exchanges between the Black American and the white French characters at street level, we must recall that the war between France and the Algerian National Liberation Front was being hotly waged at that time.

The two white French cabbies complain about the Algerian demonstrations in "their" town. When an Algerian street peddler approaches the first taxi, the driver reacts according to a pattern that Eddie recalls from back in the United States: "Beat it, you son-of-a-bitch! . . . You scum, you swine!" The seller walks away. "Some of them have their nerve," the driver tells Eddie, continuing,

> The trouble they give us in the Colonies, and then they want to be admitted into the new public housing here in Paris. And they complain about being kept out of jobs and schools, too. . . . I'm a fair man, a democratic man. France is a democratic country. We don't discriminate against Negroes, like they do in America. But these North Africans, these Algerians, with them it's a different story. They're not—.

Eddie storms out of the taxi, and when the next driver also complains about "those North Africans," he flares up. "I don't want to hear a word about the North Africans!" snaps Eddie. "Just keep quiet and do your job."[56] In the Flender movie script, Benny is with Eddie in that cab, also angry at the French driver—thus making the point that these international matters of racism and prejudice apply to him (i.e., to white American Jews) as well. Where do we (Americans) stand on the Algerian war? What responsibilities do Americans (and Blacks in particular) have to Algerians living in France? To others regarded as permanent outsiders, no matter their birth in France?

The Film *Paris Blues*: Visible Segregation and Black Musical Resistance

When Sam Shaw sent Harold Flender's novel to United Artists (UA) for consideration as the basis for a film, he was again greeted with quick, sharp refusals. Maurine Hanline, a story editor at UA, previewed the book and wrote to her boss, Milton Sperling: "I do not think it worth your time to read it," she said.

Race enters her line of critique: "This must have been written by a negro [sic]," she said, "for there is much bitterness against the United States in the writing and many dangerous scenes. It is not a pleasant prospect even if it were a good book which it certainly is not."[57]

Shaw would not give up. New scripts were produced, first by Flender and then by a series of other screenwriters. In the final version, central elements from Flender's novel and his first scripts were redacted: Marie's violent back-story of Black life in white America and the novel's references to Algeria and Algerians in Paris were cut out completely. The Black male lead was also removed and replaced by the white trombonist Ram Bowen (played by Paul Newman), who now represents the tribulations of the ambitious young American artist in Paris rather than Eddie (played by Sidney Poitier). Demoted to the role of Ram's saxophone-playing sidekick, Eddie struggles with the decision to stay abroad or return home, based on his love for Connie and responsibilities to his racial "roots" (her term). But his onscreen struggles are secondary to the heroic yearnings of Ram, the frustrated instrumentalist, to become a composer on a world-class concert stage.

According to his son Mercer, when Ellington landed in Paris and discovered all the turnarounds in the script's direction, "he was very disappointed and firm in his belief that they should have stuck to the original version."[58] Poitier also remembered the storyline shifts as a disturbing failure of nerve. He called the final movie script "a one-dimensional concoction of expatriate jazz musicians living and working in Paris. It should have been Joanne Woodward and myself, and Paul Newman and Diahann Carroll, as love interests; such unconventional pairings at that time would have made a considerable impact in the business. . . . It was rumored . . . that the original script called for exactly that kind of imaginative casting, and the United Artists Corporation and those responsible for the film felt it would be too revolutionary and backed off, leaving the creative forces no way to raise the material above the commonplace."[59]

Despite the script changes, the key Black participants in the film stayed on. According to the *New York Times*, the Diahann Carroll character had asked the Sidney Poitier character why he preferred to work in Paris. " 'Here in Paris I'm Eddie Cook, musician, period, not Eddie Cook, Negro musician.' When the Duke heard those lines, he was satisfied that the basic aims of 'Paris Blues' were still on target."[60] Perhaps Ellington and Strayhorn were also thinking that, having lived through Shaw's lost battles regarding the script, they would regroup and fight on other fronts—most notably, the music. Shaw recalls that Martin Ritt "did not dare" tell Ellington what to do. "*Nobody* told Duke what to do," Shaw said.[61] Yet there was the matter of the white trombonist, to which Ellington did agree. In addition, Ritt let Duke know that his experimental solo piano composition "The Clothed Woman" could not figure in the movie; it was too complex and not at all the recognizable Dukish "hit song" that he'd been

banking on. Duke was to star in the film's background by sticking to the "hits" for moviegoers' quick recognition and quick sales of the movie's soundtrack.

According to Shaw, Duke agreed to go along with this program but did not waver from his plan that the movie score would comprise a musical portrait of Paris and of a Black American's situation there. In the face of the movie moguls' call for "hits," Duke followed his decades-old concert strategy of answering requests for favorite songs by leading, in his soundtrack, with "Take the A Train" and "Mood Indigo," and moving, forty-five minutes in, to "Sophisticated Lady." Then, perhaps unnoticed by Ritt and company, the Ellington-Strayhorn team followed their standard concert pattern and folded a full version of the less-familiar piece "The Clothed Woman" into an important later scene. Along with "The Clothed Woman," they inserted part of a new work, "Lay-By"[62] (rollickingly featured in two scenes), as well as adding new works that Ellington composed with Strayhorn especially for the movie, some of which, as we'll see, register the composers' distress that the film was failing to follow through on its original plotline intentions.

Through their music for *Paris Blues*, Ellington-Strayhorn executed what I term a series of "James Baldwin moments"—sometimes just a few seconds in a film, sliding by. These were flickering interventions where, as Baldwin puts it, "the black actor has managed to give . . . moments—indelible moments, created, miraculously, beyond the confines of the script: hints of reality, smuggled like contraband into a maudlin tale, and with enough force, if unleashed, to shatter the tale to fragments."[63] In the case of "The Clothed Woman" and certain other works, the soundtrack composers "smuggled [in] like contraband" these forceful hints of reality as they knew it. At other times, they, in effect, collaborated with the actors to shatter the intended story line: the most powerful Baldwin moment in *Paris Blues* comes when the final scene rolls out, and both actors and musicians smuggle in contraband to contradict the maudlin tale that is this movie. Here, the music—a crescendo of jazz energy—contradicts the movie's purported message of the "white trombone" and replaces it with a strong assertion of the unruliest of unruly Black cosmopolitanism. At this point, the composers are writing music for the movie that might have been. And as we'll see, in that final scene, Sidney Poitier also switches the script and walks away from the movie as written, asserting instead unruly Black cosmopolitanism with attitude to spare.

Forbidden Storylines Stubbornly Reappear

Turning directly now to the film itself, I find that despite Hollywood's erasures and redactions, important traces of the more ambitious *Paris Blues* projects can be found onscreen. In the opening two minutes, while the credits roll and

Paul Newman coolly mimes his "white trombone" in an underground Paris jazz club, the film offers its most visible traces of Shaw's original "mixed-race" and gay-and-lesbian themes. Here, in brief, is a separate movie unto itself, a counterstatement in moving pics flickering by. The setting is Marie's Cove, and with "Take the A Train" rocking a room full of excited listeners and dancers, the cameras pan across couples Black and white, gay and lesbian and straight, young and old; friends in twos and threes moving alongside those who are traveling solo (for the moment?). All these figures promise a movie with a definite difference—an American movie about art, adult affiliations, and love.

The set designer smuggled in some contraband, too: it was Alexandre Trauner's brilliant decision to highlight (or did he install?) the on-site underground club wallpaper's "mixed-race" cakewalk dancers, performing the late-nineteenth/early-twentieth-century Black American dance that became a U.S., then a French, and finally a worldwide craze. How many viewers of this opening scene's wallpaper would recognize that Black dance as one spinning with ironies and related to the Black Mardi Gras rituals of New Orleans, whose struts were built in part as a spoof of stiff white folks' pretenses and prejudices? In that early era's competitions for best cakewalker, the winners executed this dance of derision with a mix of grace and take-no-prisoners mockery. What's more, this opening scene's music, Strayhorn's "Take the A Train," links the underground jazz scene in Paris with "Sugar Hill way up in Harlem" (as the song's lyrics say),

A still from the movie *Paris Blues*. Mirroring the movie's first club scene, this wallpaper depicts "mixed-race" dancers. The wallpaper dancers perform the cakewalk, a Black American dance, which, by the end of the 19th century, had become a world-wide hit. *Paris Blues* (1961), Directed by Martin Ritt, United Artists. Set design by Alexandre Trauner.

where similar spaces of creative freedom were to be found.[64] Here, in the film's opening crawl, are hints of unruly Black cosmopolitanism stretching from New Orleans through New York to Paris, cannily smuggled in for the careful viewer of the film.

Flashes of Shaw's original "mixed couples" plot are retained elsewhere in the film's first fly-by moments. Ram and Eddie themselves comprise a "mixed-race" jazz duo, something exceedingly rare for both U.S. bandstands and movies in the late 1950s (and beyond). As the train bearing the film's leading ladies—the close friends Connie and Lillian, another rare (for Hollywood) "mixed-race" duo—pulls into the Gare de Lyon en Paris, Ram comes on board to greet the visiting Black jazz legend known as Wild Man. Passing through one of the train cars, Ram (Paul Newman) chances upon Connie (Diahann Carroll) and is obviously romantically interested in her, and she potentially in him. When Connie says she's trying to find her white traveling compatriot Lillian (Joanne Woodward), he looks her over and flirts with her directly (and in terms of color): "Is your girlfriend as pretty as you?" "Yes," she says. "But how're you gonna find her?" Ram asks. "All these white girls look alike."

Later that night, the quartet is leaving the club where Ram and Eddie (Sidney Poitier) play, Eddie is set to step away with Connie, to Ram's dismay and

A still from the movie *Paris Blues*: Paul Newman and Diahann Carroll. *Paris Blues* (1961), Directed by Martin Ritt, United Artists.

anger. After a pause, Ram takes another look at Lillian, who was interested in him from the moment she saw him at the train station (she did not witness his flirtations with Connie), and Ram and Lillian stroll into the Paris night together. Soon enough, in other words, the two couples are lined up according to American segregation policies. However, the shadows of Shaw's early storyboards remain; the flashes of unruly Black cosmopolitanism remain in the viewer's memory.

There's another poignant reminder of the "mixed-race" film that Shaw originally had in mind, as the foursome, now coupled up according to Hollywood's strict color-line code, perambulate the city. The foursome cruise the Seine together on the sightseeing Bateau Mouches, regarded by Parisians as a sexy love boat despite its popularity among camera-strapped tourists. While Ram and Connie stand at the boat's edge to watch the city streaming its treasures before them, Lillian shares an on-deck wine-and-cheese table with Eddie. Prolonging the already highly suggestive goings-on for Hollywood movie proctors of 1961, Lillian and Eddie's talk turns serious as she tries to identify who, in their double-date configuration, is a "night person"—like Ram, who can play music and then stay up all night and longer—and who, by contrast, is a quotidian "day person." In their dialogue, the issue of "racially mixed" couples floats near the surface:

> Lillian: [Ram lives] such a crazy life.
> Eddie: Yeah, well, that's because you're one of the day people. We are the night people, and it's a whole different world.
> Lillian: You don't think they can mix?
> Eddie: Well, I don't mind them going to public places together, but I certainly wouldn't want one of 'em to marry my sister.
> Lillian: Well, now, let me see: Connie's a day person.
> Eddie: You're telling me!
> Lillian: . . . And I'm a day person.
> Eddie: Um-hm.
> Lillian: But you know something? I think you are.
> Eddie: No.
> Lillian: You're not like him.
> Eddie: Well, I'm taller than him.
> Lillian: You're steadier.
> Eddie: Don't let him fool you. He's as steady as a rock about the things that are important to him.
> Lillian: Like music?
> Eddie: Like music.
> Lillian: Oh.
> Eddie: OH!

Here, the lingo slides at the edge of the racially coded. Even where misce-
genation laws were officially overturned in the United States, through much
of the twentieth century, the phrase "some of my best friends are Black, but I
wouldn't want my sister to marry one" was a well-known signal of (supposedly)
unwitting racism. The movie's subterranean question is whether people from
different worlds can regard one another as sisters and brothers—or even as
marriage-eligible lovers. Can such pairings happen in Paris? To these veiled
hints of "interracial" love, at first glance, this film's response is *no*. But the sotto
voce signs are there (the shadows and traces), quietly but unmistakably sug-
gesting *yes!* If Lillian is right that she and Eddie are the film's true "day people,"
maybe they—like Ram and Connie at the train station and riding the deck of
the Bateau Mouches—are the soulmates who fit best together. With these mur-
murings from earlier *Paris Blues* scripts and the novel come cosmic questions:
Can the self see the Other as another self? As interactive, intertwined selves?
And back to our chapter's main queries: *What are the Paris blues? What are
the American blues? How do we, as humans, deal with blues as deep and as wide
as the sky? What is the true antidote to the blues of racism and prejudice? To the
blues of feeling cut off from others and thus from ourselves?*

Despite its slide-by scenes and embedded questions, the film's "social change"
plot does not thicken—it thins. Still, other leftovers from the project's daring
first impulses appear. As we have seen, in the novel, the club owner Marie was
a Black expat, for whom Paris was a city of refuge from virulent American race
violence; in Shaw's very first scripts, she was an older, bisexual woman with
eyes for Connie. "Everybody was shocked by me writing that," said Shaw. "The
Diahann Carroll character was to have said, 'I don't go that route.' That's it, no
big deal!"[65] But to please UA, the film's Marie became a straight, white French-
woman, and Ram's part-time lover. Yet Marie's dark eyes and hair associate her
with the old American stereotype of the lady of experience, the "dark," "Latina"
(in this case Southern European) siren who serves as a foil for the movie's blonde
Lillian—and even, ironically, for Connie, who serves as the film's Goody Two-
shoes compared with her much more risqué white friend. The film's only trace
of gay life after the opening scene comes "invisibly." Aaron Bridgers, Billy Stray-
horn's long-term lover and a superb piano player then living in Paris, appears as
part of Ram and Eddie's band. Savvy Strayhornians and others who knew the
Black gay Paris scene would not have missed this smuggled-in moment.

As already noted, the movie drops the novel's overt international color-line/
colonial questions, but hints of a wide-angle perspective are folded in, embod-
ied in the part played by the movie's guitarist, Serge Reggiano, the renowned
Italian-born French actor and singer cast as Michel, based on the novel's Michel
Rabu. In the film, Michel is most often called "The Gypsy," an offensive misnam-
ing that refers generically to the Romani population of Paris and that group's
uneasy relationship to white Frenchmen and Frenchwomen, and specifically to

the Romani guitar virtuoso who was oddly claimed by the French as proof that jazz is "French" (!), Django Reinhardt.

To keep things under wraps, the film's "Michel 'The Gypsy'" is cloaked in a bundle of stereotypes: he's a self-destructive jazz musician, a talent-doomed "genius" who's killing himself with illicit drugs. Gypsy's also a swarthy man "passing for white." Like his counterpart Michel in the novel, he's the "tragical" permanent outsider—neither Black nor white, East nor West, neither authentic French nor outright foreigner. And so, like other in-between characters that populate American fiction, the character called Gypsy is presented as having no viable choices except retreat or suicide. Since a life of fugitivity or subterranean existence does not seem acceptable for this in-between man, Gypsy must either bend to an enforced social death or kill himself—in his case through drug addiction.

It's characteristic of the movie that this man's predicament is strictly localized. If the destruction of his talent and, in the end, his body has anything to do with French treatment of the Romani people (as vaguely suggested by one scene in a Romani camp), it has no evident connection with the French Algerian war or with colonial/racial matters in France. Nor do Gypsy's Paris blues reflect problems seen by Black American expats in Paris or Blacks at home (*en Amerique*).

The novel's counterpart to "Gypsy"—the "Black Frenchman" Michel Rabu, also casts telling shadows. The novel's Rabu morphs partially into the film's Ram—in particular, in his anxious yearning for an audience with a French music professor (not, as in early script drafts, for a shot at joining Ellington's orchestra). This yearning for authentication as a "full-fledged musician" becomes a central issue (perhaps *the* central issue) of *Paris Blues* the film. What kind of musician will the American in Paris choose to be? Will Ram accept the role of the white trombone, the limited, local role circumscribed by race—or will he slide in the direction of Ellingtonian/Armstrongian jazz, the multilane superhighways of unruly Black cosmopolitanism?

Unruly Black Cosmopolitanism II: Armstrong

To probe such questions further, we must turn to the cameo star of *Paris Blues*, Louis Armstrong. Cast in the film as "Wild Man" or "Wild Man Moore," he was fulfilling a role fashioned precisely for him, inasmuch as Moore first appears in Harold Flender's novel as a character based on Armstrong himself. Later, in the Bearden-Shaw-Murray *Paris Blues* word-and-collage book project of the early 1980s, Louis shares lead-role status with Duke; the two are featured throughout the pages as monumentalized heroes, sometimes sharing center stage with Bessie Smith. Despite the weight of prior demeaning depictions of "Satchmo," drawing on traditions of minstrel and vaudeville theater (in particular, I have in mind his role in the 1932 movie called *Rhapsody in Black and Blue*), I see

Armstrong in *Paris Blue*s at sword's point against all efforts to lock him into stereotypical racial roles. In the end, in both the film (as an actor playing himself, and in the musical portraits by Strayhorn and Ellington) and in the collage book, Armstrong emerges with Duke and Strays as a powerfully dramatic embodiment of unruly Black cosmopolitanism: a living counterweight to the idea of the white trombone. If you want to read the entire chain of *Paris Blues* projects, A to Y (we have not yet seen Z), keep your eyes on Mr. Armstrong!

In a sense, Flender's moniker "Wild Man Moore" tells us all we need to know about how the writer saw Armstrong. Flender casts "Wild Man" as a foil to the buttoned-down, serious, young Black musician, Eddie; and of course the name carries racist connotations. Let us note, however, that Armstrong and Ellington may have accepted the name "Wild Man" as part of their project of sliding contraband into the film for discerning viewers. The title of "Wild Man" is not invariably a badge of dishonor: Friedrich Nietzsche's sense of the Dionysian powers of artists at highest pitch—with potencies for transformation through otherworldly invention and intervention—is sometimes translated as the power of the "Wild Man," an honorific the philosopher occasionally chose for himself. Perhaps more to the point in this context, Ellington and especially Armstrong were well aware of the Black Indians of Mardi Gras in New Orleans, for whom the ritual title of "Wild Man" has long indicated potencies not far from Nietzsche's Dionysian ideal. For the Black Indians, the Wild Man was a Mardi Gras figure serving as "medicine-man/shaman/witch-doctor . . . a being possessed, someone with more than human powers."[66] Fat Tuesday's Black Indian Wild Man was a mightily feared and fearless part of that day's early morning drama—including its sometimes scary, sometimes comical moments. Typically masking for Mardi Gras in a resplendently feathered and glittering "new suit," and with headgear sprouting animal horns, this was the tribal member whose roles and powers linked him with highly potent spirit figures all over the African diaspora.

Armstrong, who'd paraded as Mardi Gras's King Zulu ten years prior to the filming of *Paris Blues* and had known about the Black Indian "Wild Men" all his life, must have connected this title with the well-known Jelly Roll Morton composition "Wild Man Blues." Armstrong had recorded it in a classic Hot Seven session (1927), and again on his *Musical Autobiography* disc (1957)—in both instances playing solos whose rowdy, poetic flights shoot the moon. When Ellington and Strayhorn called one piece prepared for Armstrong "Wild Man Moore," they may have been thinking not only of Flender and the script but also of Mister Jelly, Nietzsche, and the Black Indians of Mardi Gras. Then again, these clever wordsmiths may have titled the piece while thinking of "Wild Man, *More!" Wild*, man. More!" or "Wild Man *Moor!"*

Did Flender or the screenplay doctors going over his novel and scripts have anything like the Nietzschean–Mardi Gras spirit figure in mind for Armstrong as Wild Man Moore? Flender's *Paris Blues*, novel and early scripts, strongly

suggest not. Instead, sadly, they offer something closer to the racial stereo-
type of the Negro as the noble savage, Uncle Tom, and/or the "genius"/idiot
savant. These versions have Eddie "worshiping" Wild Man's music but growing
to despise the public personae that the man himself was unashamed to play.
Young Eddie had been "listening to every record of [Wild Man's] he could
lay his hands on, seeing the movies he was in over and over again." But when
Eddie finally meets the famous trumpet man face to face, "it was too late,"
Eddie recalls.

> Too late because he knew by then that Wild Man Moore was the wrong kind
> of Negro, a white man's Negro, a handkerchief-head Negro. Wild Man Moore
> could have done so much for his people. But whatever energies were left over
> after blowing his horn he poured into his heavily publicized and completely
> meaningless madcap antics. Like the story that had appeared in *Time* a couple
> of months back about Wild Man Moore and his boys showing up at a Beaux
> Arts Ball in New York dressed as Zulus.[67]

The reference to Armstrong, who was crowned king of the Zulu Social Aid and
Pleasure Club in 1949—the same year he made the cover of *Time*, the first jazz
musician to do so—is explicit.

Aside from the term "Zulu," in certain contexts used as a racial slur synon-
ymous with the n-word, the key words in this passage are "too late." Flender
cast Armstrong the "Wild Man" as a cultural laggard presumed to be from a
generation of Blacks so totally dominated by the idea of their racial inferiority
that they embraced as true the "Sambo" characteristics attributed to them by
the popular media. According to this nonsense stereotype, Sambos were lazy
figures, pitiable or comical at best, who never entered modernity or recovered
from the imagined period of hating themselves and their people. Within the
trappings of this type, there was room for a gifted Black trumpet player who
played "natural"-sounding horn (he's so close to nature!), but who somehow
knows not what he does. Armstrong's role in the Zulu parade could not be, in
this view, a parody of the white pretensions of the once all-white Mardi Gras of
New Orleans and elsewhere. Nor was it, in the novel's treatment, a celebration of
local Black self-help efforts or pure fun in spite of the cruel ways of white folks.
Nor could it be a salute to Armstrong's Zulu brothers and sisters in South Africa
or a spoof of Hollywood's African stereotypes. No, this was self-hate on parade:
the madcap antics of a "white man's Negro, a handkerchief-head Negro."[68] Here
was the opposite of the dignified role taken by Sidney Poitier in *Paris Blues*.

In accordance with the stereotype, when in Flender's novel "Wild Man"
bursts into Marie's jazz club, he shows what that book knows to be Armstrong's
true colors—and sounds! "When Wild Man Moore finally made his entrance,
it was a screaming, thumping, jumping entrance, Wild Man Moore bounding

in like a kangaroo, issuing his famous high-pitched cry. He leaped among the tables, greeting the boys by slapping them on the back or pushing their heads onto the table, or hugging and kissing them."[69] This kind of characterization, repeated in Flender's script—the Black man as bounding "genius"/wild animal from the other end of the Earth—is best explained in terms of some of the most stubborn American media images of Black Americans, dating back nearly two hundred years.

Remarkably, Flender's Wild Man Moore embodies six of the seven Black stereotypes committed by white authors, as delineated in "Negro Character as Seen by White Authors" (1933), the milestone essay by Sterling A. Brown, the Black literary historian of the same generation as Armstrong. Wild Man Moore is, at various times, the Contended Slave, Wretched Freeman, Comic Negro, Brute Negro, Local Color Negro, and Exotic Primitive. "All of these stereotypes are marked either by exaggeration or omissions," writes Brown. All stress "the Negro's divergence from an Anglo-Saxon norm to the flattery of the latter; [and] could all be used . . . as justification of racial proscription. . . . All of these stereotypes are abundantly to be found in American literature, and are generally accepted as contributions to true racial understanding."[70] Flender's novel *Paris Blues* sees Eddie as an up-to-date rebuttal to the too-late sellout as represented by Wild Man Moore. "Eddie had no respect for Wild Man Moore's kind of Negro," reports the novel's omniscient narrator. "Eddie didn't want to be tolerated because he would Uncle-Tom it. He wanted to be accepted and respected—as he had been here in Paris for the past twelve years."[71] In other words, Wild Man Moore was Eddie's key testament for staying in Paris—for never again going home to the United States where, to make a living in the arts, a Black man had to play the marsupial fool, and, in so doing, turn against himself (as "Gypsy" has done) in an internal "battle royal."

But how did Armstrong react to the script? How did he see his role in this movie? According to Sam Shaw, from the beginning there was tension between Armstrong and the film's director, Martin Ritt. Shaw explained it in terms of a righteous Left Wing certainty on the director's part, which held Armstrong to be a sellout Uncle Tom whose entertainer's flair and charismatic joviality merely confirmed what he was. (Here is one of the most annoying and some-times dangerous faces of white racism.) The friction between the men was exacerbated by the fact that Armstrong's manager, Joe Glazer, always the hard-nosed wheeler-dealer, had insisted that his star be paid many times more than originally budgeted—take it or leave it. Compounding all this was the restric-tion that Armstrong was available for only a few days between his U.S. State Department tours of the Belgian Congo and Zimbabwe (then Rhodesia) and going on to a string of other dates in the United States and Europe. Rainy days in Paris made shooting nearly impossible in the time slot contracted for Arm-strong; but having no choice, the crew hurried to take advantage of moments

when it was not raining so that they would not miss altogether the chance to catch him on film.[72] He had come to seem indispensable to this jazz film's success. "Armstrong was jazz," as one of the film's reviewers said, "and jazz was Armstrong."

Whenever Louis arrived on the set, the French musicians and actors there (Black and white) burst into spontaneous applause. Here was the great man himself, flesh and blood! Between scenes, Pops would relax with extras on the set with a little shake-a-leg jitterbug dancing of his own. "The director couldn't understand. Every morning I come on the set, everybody applauded. He said, 'Why all *this?* Who do you think you are, the star of the show?' I said, 'No, that's just my cats up there.' The whole set. He was an American director," said Louis. "They don't let nothing happen in America."[73] Doubtless detecting Ritt's tone ("feeling a draft" was one Black expression of that era for feeling the airs of white prejudice), Armstrong was learning that familiar tendencies of white America had made their way to Paris! The fact that no dressing room had been set aside for him intensified the frostiness. Maybe it was on set, too, that Armstrong finally had time for a closer look at the script and its antecedent novel. What did it mean to be cast as a screeching, howling wild man, a sellout in contrast to the urbane sophisticates played by Newman and Poitier, by Carroll and Woodward? Whichever slight tipped the scales—the script, the novel, Ritt's tone, or the missing dressing room—suddenly Armstrong had enough and walked off the set to hail a cab back to his hotel. Shaw later said that only because he told Armstrong that he could have his (Shaw's) dressing room, and that he wouldn't be disturbed by Ritt, did he return.[74] But Satchmo remained on edge.

Hints of Armstrong's attitude toward all this drama are conveyed in photos taken on the set. These photographs fall into four categories:

1. Armstrong posing for the cameras with high-beam smiles (going along with the publicity program)
2. Armstrong genuinely having a ball working/playing with Ellington and the other artists, actors, and musicians
3. Armstrong studying his scripts and scores, deep in thought
4. Armstrong resting, not posing now and not looking especially jolly, again deep in thought.

Some of the greatest Armstrong photos ever taken, in my view, fall into categories 3 and 4. One in particular is a Herman Leonard photo showing Armstrong seated on the *Paris Blues* set, resting, his face in profile, looking askance at the scene. He wears the suit and tie he'll wear onscreen. Here, we meet a version of

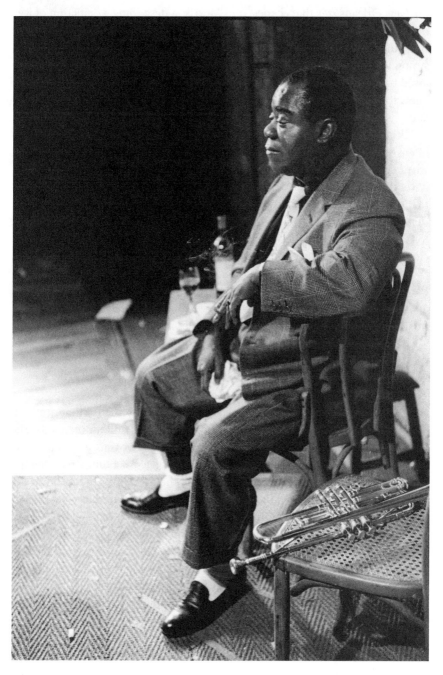

Photo of Louis Armstrong on the set of *Paris Blues*, by Herman Leonard, 1960.

the New Orleans star that echoes Toni Morrison describing a depiction of jazz musicians by Romare Bearden: the artist is resting but also in thought, in the still, quiet private space, as Morrison says, where all art begins. Of course, Armstrong was all of these: the man of glowing smiles for his fans, the man who loved to play (not just music—he was a playful man, full of fun), the man who knew the score and was studying its details, the Black man who'd had enough and was set to walk.

Ultimately, the part that Armstrong performed in *Paris Blues* was not as offensive as the Wild Man role prepared for him by Flender, or certainly, whether onscreen or on set, the Uncle Tom role evidently dreamed up by Hollywood. What happened? Maybe, as one critic said, there were so many changes to the screenplay that when it came time to shoot, there was no definite script—that many of the lines spoken onscreen were improvised in the moment. Ritt told an interviewer: "Rather than clutter it up with a lot of talking and dramatic close-ups, we thought we'd . . . [let] the actors go through the motions and let the action speak for itself."[75] Armstrong told an interviewer that he arrived in Paris knowing enough about the film's general storyline not to need a script, and (though for the most part he speaks his lines precisely as written in the final script) simply improvised his spoken lines.[76]

A Battle Royal Between Jazz and Classical

Armstrong appears just twice in *Paris Blues*, in cameo scenes that are both very important to the meanings of the movie (intended and unintended). The first time we see Armstrong, he is arriving at the Paris train station, riding in, ironically enough, on the churning musical wheels of Ellington's uptempo blues, "Battle Royal." (And the music said: Let the battle over the meanings of the movie commence!) Standing in the train window, Wild Man takes out his trumpet and salutes his cheering fans in a joyous musical repartee with them and with the welcoming Ellingtonian horns and rhythms. Ram makes his way to the Wild Man's compartment to hand him the manuscript of his new musical composition, "Paris Blues." Fifty minutes later in the film, the second Armstrong scene finds him parading New Orleans–style down the steps of Marie's Cove, where he plays the other piece that Ellington and Strayhorn wrote for him, a jam-session blues called "Wild Man Moore."

Ram and the Wild Man's encounter on the train can be read on several levels. First, Ram Bowen, the "white trombone," meets with the movie's best onscreen incarnation of unruly Black cosmopolitanism. This early scene also offers significant traces of Sam Shaw's idea that the movie's gifted young player, whom Shaw first figured as Black, would seek the approval of Duke Ellington in person. Despite all the stereotypical trappings from the novel and screenplay,

Armstrong plays himself as a star musician on the road whose wide-ranging musical experience any serious young musician would love to draw upon. "You writing music?" Wild Man says, starting to look through the manuscript pages. At this point, students of Armstrong's musicianship recall that the man was a superb sight-reader, whose in-studio first takes of music never played before were often perfect. He could discern musical magic where others saw merely flat lines and dots on paper. Armstrong wrote his share of songs, too, and arranged music for his band. Still, Wild Man tells the Armstrong truth when he looks up at Ram and says of the music he's reading: "It ain't relaxing to write it, man, only to play it." For the jazz musician, there's no fixed difference between writing and playing music. To paraphrase a jazz truism, Armstrong's compositions are *frozen improvisations*, his improvisations *liquid compositions*. Still Armstrong was not Ellington, who by 1960 was constantly writing pieces and parts of new concert-length works for sixteen instruments or more nearly every day. So Wild Man hesitates but sits down to read. "Let's see what you've got here," he says.

It's the next step in Ram's tendering the music to Wild Man Moore that's as fascinatingly problematical as the overdubbing of the "white trombone." After Ram has, in an earlier scene, shared his composition with his bandmate Eddie, whose advice Ram rejects, and asked the Wild Man for an unspecified "favor"— which the viewer presumes to mean that Wild Man himself will evaluate the score—we learn of Ram's excitement, and Eddie's, that Wild Man has passed the music along to the French music professor René Bernard (played with big cat snootiness by Andre Luguet). Of course, this change is quite important: the movie's ultimate arbiter of musical taste and of Ram's prospects for compositional mastery is neither Armstrong nor the Ellington of an early Shaw script, but rather the man from the French academy, the august Professor Bernard.

When the meeting finally arrives, late in the film, the French prof receives Ram in an office fit for a French lord. From behind his mountain of a desk, Bernard deals the young man a brush-off that is condescending and swift. Ram's music has a "genuine gift for melody," he sniffs; the manuscript of the long piece he's writing (called *Paris Blues*) shows "feeling" and "charm"—good for a commercial recording, he was sure, but nothing to be played in a concert setting. "Mr. Bowen, you are a creative musician," announces the professor. "Every time you put a horn to your mouth, you are composing. But there's a great deal of difference between that and an important piece of serious music. . . . I don't know what you are yet," continues the Frenchman, "and neither do you. . . . Paris is a great city for an artist to work and study: composition, harmony, theory, counterpoint."

So, to evolve as a musician, Ram needs to buckle down in Paris, where he can work on musical theory and structure. What the professor (and the film's script) does *not* recommend is what's most interesting here. Neither registers

the value of study on the road that was typical for Ellington, Armstrong, and other jazz musicians—mentoring by both the formally and informally trained, homework checked and balanced by trips back to Black America, sliding back, in Duke's case, to the Savoy Ballrooms and Apollo Theaters of the United States, which he called "my source." Of course, the goal of the unruly Black cosmopolitan musician-in-training would be to take lessons from both sets of teachers: "conservatory cats" (Ellington's phrase for those schooled in the history and theory of music) as well as "ear cats" (musicians who learned and work by ear, but whose technique and form can equal anyone's). Thus, Ellington never declared his lifetime of study under the master musicians Oliver "Doc" Perry and Will Marion Cook (a former student of Antonín Dvořák) to be more important than his study of Sidney Bechet, the powerhouse New Orleans reedman who refused to learn to read music lest his gift be compromised.

In contrast to the professor, Duke, Louis, and Bearden represent the both/and position of the slide trombone—not the fixed-place, white trombone one, by which I mean the single-register "essentially melodic" trombone style, unenhanced by the range of talk-shit/take-none techniques of the jazz tradition in the fullness of its unruly Black cosmopolitanism. For close watchers of the film's meanings, one of the most striking ironies of Ram's encounter with Bernard is that the music the French prof damns with faint praise is Ellington's own: the score of *Paris Blues!* Neither Bernard nor Ram (nor the movie itself) appears to understand that great music may draw on formal sources as well as informal ones—can draw on the wide, wild universe of sound, without boundaries.[77] And if you want to play authentic jazz music—jazz as personally signed, blues-based, improvised art rather than the stiff, commercial wiregrass passing for the real thing—what must be studied is the multilingual academic-nonacademic unruly Black cosmopolitan sound of Louis Armstrong and Duke Ellington, among many others. But, as we shall see, it is not in the *Paris Blues* script, but in its musical score, that Ellington and Armstrong make the film's most profound statement.

The Music of *Paris Blues*: Everyone Must Be Louis

What might *Ellington* have said to Ram, had the young would-be jazz composer come to him for advice? Doubtless, as noted, the both/and advice: Go, son, study with the conservatory boys *and* the ear cats, *both*. But let's take a step back to ponder Ellington's view of Armstrong as music maker, as the potential model for Brother Ram. "One thing I knew in advance," said Ellington, concerning his conception of the score for *Paris Blues*, "was that there was a lot of Louis in the picture. So I knew I had to write Louis to sound like Louis."[78] There is a lot to ponder in that sentence: *"I had to write Louis to sound like Louis."* This

meant that Ellington's challenge was to prepare a stage upon which his great colleague could improvise new versions of himself, a project by no means new to Ellington. Since the mid-1920s, Ellington had composed shining musical "portraits" specifically for this band to play: Josephine Baker, Florence Mills, Bill "Bojangles" Robinson, and many others. These included, ten years after *Paris Blues*, his "Portrait of Bechet" and his "Portrait of Louis Armstrong," both created for the *New Orleans Suite*.

For decades, Ellington also had been creating musical *"self*-portraits": foregrounds and backgrounds tailored to suit the musical personalities and technical strengths of particular players (some of them distinguished one-time visitors) charged with "portraying" themselves—"Self-Portrait of the Bean," for example, for Coleman Hawkins (whose nickname was "The Bean"); "Concerto for Cootie," for William "Cootie" Williams; "Portrait of Ella Fitzgerald"; "Take the Coltrane"; and many others. Because Duke and Strayhorn routinely wrote for the special strengths of each individual band member, regulars and star visitors alike, in a sense everything they wrote for that band was a self-portrait (as well as a set of ongoing, composite set of self-portraits of the composers themselves, cocomposed with their improvising band colleagues).[79] What was new in the case of the *Paris Blues* score was that it was creating a framework for a musician who was so central to the development of the very language of jazz itself—the man who *was* jazz.

In light of the challenge "to write Louis to sound like Louis," it's enlightening to learn that in rehearsal, Ellington once told his band members that, to give him what he wanted, they should all think of themselves as Armstrong. "Just do Louis," he told them. "Brass, reeds, rhythm—all. Do Louis. And I'll be Louis on the piano!"[80] Somehow, Armstrong's way of improvising solos with voicelike expressivity and arialike completeness, his genius for bending time into Afro-dance beat patterns, his charismatic presence—these and other Satchmo qualities affected every instrument in jazz, every composer, every arranger. Having told the whole band to "do Louis," now Ellington had to make way for Louis himself to do Louis, to add his own spices to the Ellington band's already rich Louisianan mix. *Here was self-portraiture to the Power of the Dipper!*

Sometimes Ellington's injunction for his whole band to "do Louis" took humorous turns and forms. In a little-known Ellington piece called "A History of Jazz in Three Minutes," Ellington had Ray Nance—one of Duke's many instrumentalists and singers directly influenced by Armstrong—come to the microphone holding his trumpet and silently mouth the lyrics of W. C. Handy's "Basin Street Blues," which Armstrong first recorded, very brilliantly, in 1928. Nance flourished his Satchmo-signature white handkerchief for the cameras and mugged with Armstrongian flair. Nance's imitation was executed with neither horn nor voice: only Ellington's comping piano and the movement of Nance's mouth identify the Handy song.[81] What's the meaning of Nance's absolute silence

in the short film? Was it that, like the words crossed out by Jean-Michel Basquiat in certain paintings to render the redactions more vividly visible, Nance's uncannily wordless, hornless performance somehow turned up its volume? Is this a version of Bearden's "open corner" (see chapter 3): an invitation for the audience's creative participation? Or was it that, despite Nance's best efforts, the hugeness and true majesty of Louis's trumpet sound could not be captured by another person, much less on recordings, audio or video; that his significance to jazz history was too expansive to capture in one segment of one short film; that like the High God of certain religious traditions, Armstrong should not be diminished by inevitably fake representations? Or was Armstrong a kind of Medusa spirit figure, who could only be seen as a reflection in a mirror (in this case, through the mirror-shield of silent comedy)? Whatever the specific calculations, these uncanny silences do evoke the man himself; they *work*.

Ellington knew that Armstrong's style had shaped the twentieth century's music across the categories, voices, and instruments; and whatever the twenty-first century's music would be, it would have something to do with the aesthetics perfected by Armstrong. What did it mean to hear Ellington and Armstrong together!? If Armstrong's was the music of the future, so was Ellington's. In the words of jazz historian John Szwed,

> Ellington became a primary influence on the development of the avant-garde in the 1960s and 1970s, and remains a central figure for what now some call our permanent avant-garde. Much of his influence in the late 1950s and 1960s was communicated to younger musicians through Charles Mingus's music; and Mingus was never shy about his debts to the Duke. This influence was evidence, however, that Ellington's work had not yet been fully assimilated by musicians, and was, in a way, too complex a message to have been absorbed so quickly.[82]

As soloists, both Armstrong and Ellington "stretched, squeezed, or shifted notes, giving the music a richness, a feeling, and a forward motion."[83] Both also "played forward"—expanded what it meant to "play in the moment" such that they synched with what was being played immediately around them (and what had been played before), while preparing what they'd add a few bars (or a few split seconds) in the future. Beyond this, in their own playing and in their composing for other players, Armstrong and Ellington made music that reflected their sense of the entire history of music (not only jazz) as it beamed guiding lights to those coming after them. At the same time, both showed what Albert Einstein, using the tools of mathematics and physics, also demonstrated: time is "elastic," and *"we are the time that we keep."*[84]

Armstrong's appearances on this *Paris Blues*—the movie's soundtrack—turn out to be brief and dignified. All the novel's references to the stereotypical Wild Man's antics and animal-likenesses are gone. All the novel's and script's side talk

by Eddie, Marie, and others about Wild Man as an embarrassing Uncle Tom have been scratched (Flender's Marie says that the word for him is the n-word). Instead, Armstrong portrays Wild Man in a way that follows Ellington's own firm rule regarding Hollywood cameos—he shows up as no one but himself. The movie's narratives directly involving him are believable. It certainly is not impossible that a fledgling jazz artist who is trying to write a concert piece would show it to Armstrong. What René Bernard tells Ram is not unlike what Ellington might have said: to graduate from talented jazz soloist—composer in the moment of improvisation—to writing long-form music for a large ensemble of players, one has to do what the musicians call " 'shedding" (or "wood-shedding"): one has to *work*.

Still it's true that between the advice of René Bernard and what Ellington or Strayhorn might have told Ram is the Grand Canyon separating the "white trombone" and unruly Black cosmopolitanism. Bernard, and the film itself, do not know that what it took for Ellington and Strayhorn to compose the music for this movie was precisely *not* to stay in Paris, or in any one city, for formal academic study of the musical lingo associated with that place alone. Not to stick to one system of musical study, as if it were the only or the "universal" one. Armstrong, Duke, and Strays were not settlers (settling down to one place or received tradition in music), they were travelers; they were not strivers for European approval, hoping that through study, they could evolve into becoming French. "Jazz is based on the sound of our native heritage," wrote Ellington in his autobiography. "It is an American idiom with African roots—a trunk of soul with limbs reaching in every direction" across the continents.[85]

Accordingly, Ellingtonian trombonists are not valve trombonists,[86] moving from one preset note to the next; they are slide trombonists, moving freely from micronote to micronote, drawing from a world of influences to create something new. What's difficult to make clear without sounding prescriptive or essentialist is that if Ram were to turn his "gift for melody" into the skills needed to create for jazz composition, he would have to study the unruly Black cosmopolitanism in the music: the trombone as freewheeling extension of the special pleasures of the African American voice. I think Ellington's advice would've been to enroll in that French academy, yes, okay; but then to travel back and forth to the Savoy Ballrooms and Apollo Theaters of the United States and study there, too. Homework: play one hundred dances on Chicago's South Side, and put that together with what you've learned in school. This is not just for non-Black players: *Even homeboys and homegirls must do this homework!*

To start on the road toward composing something with as much richness and heft as their soundtrack for *Paris Blues*, Ellington and Strayhorn might have said, you must *study the forms of jazz themselves*—precisely the kinds of up- and down-tempo blues and jam-session pieces they had prepared for Armstrong's self-portraiture. This of course means that—ironically enough—Ram needs to

learn to "do Louis!" That is, to study the liquid compositions/solo statements that Armstrong presents in pieces like "Battle Royal" and "Wild Man Moore," compressed eloquent solos reflecting the music's history and its background as the soundtrack of being Black in America.

The Actual White Trombone: Murray McEachern Revealed

Martin Ritt had observed the box-office success of *The Glenn Miller Story* (1954) and *The Benny Goodman Story* (1956). In both these films, the white trombone player was Murray McEachern, who had played in Goodman's 'bone section and ghosted those films' tremulous trombone playing. For the Glenn Miller biopic, McEachern plays trombone solos originally played by Miller himself and now mimed onscreen by James Stewart. So it's no surprise that to meet Ritt's demand for a white trombonist to cover Paul Newman's onscreen playing, Murray McEachern was the player to get. Simple as that. Nonetheless, that is not the whole story.

Hailing from Ontario, Canada, McEachern had exceptional reading skills and dexterity on strings and keyboards as well as a variety of horns, including alto sax and trombone, his main instruments. On the segregated U.S. jazz scene of the 1930s and 1940s, he worked for the outstanding "white bands" of Benny Goodman, Glen Gray, and Paul Whiteman.[87] One Whiteman colleague, Lennie Hartman, remembered the Canadian as "undoubtedly the most talented man in the band."[88] Becoming one of Southern California's first-call studio players, McEachern eventually appeared on many kinds of recordings, including the Hollywood gigs just noted.

As we weigh the choice of McEachern to ghost Ram's trombone in *Paris Blues*, it is useful to recognize Glenn Miller's own trombone style as a guide to McEachern's, for Miller evidently was his model. "I haven't got a great jazz band," Miller told an interviewer, "and I don't want one." "Instead," says jazz historians Scott DeVeaux and Gary Giddins, "the unmistakable sound of his arrangements, with their lush blend of clarinet and saxophones, aimed for the white mainstream audience, who heard his music as the embodiment of the Swing Era and of modern pop music."[89] As Miller often said, he himself was not a true jazz trombonist. Miller was a pop music arranger and solid section man who played solo trombone in a clear, singing style in the sometimes near-jazzy dance bands that he fronted.

According to music producer/journalist Leonard Feather, McEachern's trombone style recalled Tommy Dorsey's as well as Miller's. Reviewing a McEachern gig in Los Angeles a few years after the *Paris Blues* recordings, Feather noted that the Canadian trombonist had "everything Tommy Dorsey had, with a touch of warmth."[90] Would the McEachern unit return

to headline that particular venue? "No immediate replay has yet been set," reported Feather, "But his two appearances to date have shown that there is a conservative, appreciative audience for this unusual brand of jazz-inclined dinner music."[91] *Ouch!*

It's that Glenn Miller/Tommy Dorsey sound, played by McEachern, that opens the movie with a sustained note leading into "Take the A Train." In preparation for the soundtrack, Duke gave a copy of the original score to McEachern, with the clear message that these parts had been created specifically for him. "That's how I have to do it," Ellington told an interviewer. "I write for particular musical personalities."[92] In the end, Ellington liked McEachern's singing trombone sound on *Paris Blues* enough to hire him years later for a series of the orchestra's one-nighters. Clearly, for Duke, McEachern was one of the series of "legit" players he'd hired over the years. The key difference between Ellington's appreciation of a "legit" player and Martin Ritt's insistence on a white "legit" player is that Ellington knew that *any* "legit" player, Black or white, could play "legit"—including, of course, several Black trombonists in the band at the time this film was made.[93]

In the jazz lexicon, "legit" runs hot and cold. The term can refer to a dogged schoolbook imitativeness, or squareness, but also (on the upbeat side) a style of musical execution involving clean, clear readings of the notes as written. Ellington's style from the 1920s onward was a "dirty-toned" sound of half-valve and fake-finger testifying and signifying; he chose to always have a strictly "legit" player or two in his band as a counterweight. Take the valve trombone player Juan Tizol,[94] whose virtuosity was that he could pronounce notes directly at their center, broadcasting a majestically robust musical sound. Often playing lead in tandem with the trumpets, Tizol could make his big ram's horn project clarion-clear military reports or offer the most somber subtone meditations— all perfectly "correct" according to European classical canons and according to what Ellington wanted for particular passages. Tizol never felt comfortable improvising,[95] but he was an excellent reader, and Ellington left little to no room in Tizol's parts for "ad-libbing." Both knew that he would always bring musicality as he played his parts note for note, exactly as written. He was brilliantly "legit."

Ellington often referred to those who played strictly "legit" as the "conservatory cats." This was not a put-down. Off and on throughout his career, Ellington took informal lessons from the conservatory cats.[96] Ellington's writing companion, Billy Strayhorn, was not a conservatory alum per se, but when they met in 1939, Strays was devoted to the study of contemporary classical music, particularly the French impressionists. One feels the strength of Strayhorn's unruly Black cosmopolitan (his musical multilingual) presence in certain sections of the score of *Paris Blues*—notably in his complexly evocative "Bird Jungle,"

"Paris Stairs," and in certain elaborations of the *Paris Blues* theme, where "legit" styles of playing shake hands with those of the ear cats.

And so, like Tizol, as well as Miller and Dorsey, McEachern mastered a smooth, singing style that airlifted long, legato lines into the horn's highest registers and whose correctness of technique could not be questioned.

However, even without McEachern's services, Ellington already had a section full of trombone players in his band who could move in a heartbeat from "conservatory" or "legit" styles to a range of improvisatory jazz styles. Tizol had left the Ellington band in 1953. But many other Ellington 'bones, who were in the band when the soundtrack of *Paris Blues* was being taped, routinely played a variety of musical roles. All Duke needed to say was, "do Dorsey" or "do Miller" or "do Tizol."

Perhaps the very tastiest irony here is that all players in the "jazz" category, not only horn players, owe an incalculable debt to Louis Armstrong. Even the smoothest players, including Dorsey and Miller, were drawing on Pops, who, when wanted, could outsmooth the smoothest! Adding a taste of fresh-cut okra to the irony is the fact that a major source of Armstrong's style was the timbre, tone, speaking, and singing styles of African Americans—especially the relaxed in-talk voice of Black people confabbing just among themselves. Whether Duke put it this way or not, his message to McEachern was the same as his message to the rest of the band: *Do Louis!* And in so doing, the white trombone was playing Black after all.[97]

The upshot: the idea that you needed a white trombone player to ghost a white trombone player's part was nothing more than a figment of Martin Ritt's imagination, and a dangerously insidious one at that. Beneath the movie's ostensible themes of "going home versus staying abroad" and "playing jazz versus becoming a composer" is a complex duel between Ritt's conception of the "white trombonist" (somehow always superior, just wanting a little French training) and of Louis Armstrong/the Wild Man, conceived in a fixed Sambo position but in the end, like Ellington and his men, refusing to stay in place, whether on the horn or on the movie set.

Diasporic Jazz and the (Not) Leaving Paris Blues: Unfinished Endings

In Armstrong's second cameo, Wild Man Moore struts down the stairs into Marie's Cove, accompanied by his band, to make good on his promise to challenge Ram on his home turf. As Brent Hayes Edwards has observed, the viewer will be excused for misreading Armstrong's entrance into Marie's as embodying the spirit of a New Orleans "second line" parade. Along with these far-fetched New Orleans associations, Edwards argues, the movie *Paris Blues* contains

many more African diasporic traces than meet the eye. "Who," asks Edwards, "are the black and brown men who file in after Armstrong, rather blatantly faking their playing as they march to form a semi-circle in front of the bandstand?" Edwards elucidates:

> Faced with the task of drumming up a small army of actor-musicians of African descent on short notice in Paris, the producers came up with a remarkable solution: they recruited a number of Martinican and Guadeloupian men as stand-ins. Mostly they were musicians who played regularly at clubs like the Mars Club, the Blue Note, and La Cigale: Emilien Antille, Louis Marel, Maurice Longrais, Roland Legrand, Al Livrat. Part of the wave of Antillean musicians who arrived in Paris during and after the 1937 International Exposition, mostly to play beguine, although after the war many turned increasingly to jazz. Anonymous, uncredited, they take various approaches to assignment in *Paris Blues*, Livrat hamming it up behind Satchmo with a pair of dark sunglasses, some of the others snapping their fingers or miming their instruments more distractedly. Some smile with what seems a wistful inattention, going through the motions at the edges of the frame. I'd like to imagine that one can spot a slight dissonance in some of the faces, brief moments when the masks fall off, when the absurdity of the pantomime shows through[98]

With smiles that recall Ellington's saltiness when asked about "the music of his people," this company of players asserts the presence of a much Blacker, much unrulier, much more cosmopolitan element than the movie knew it was unleashing. Small wonder that when this group of "Paris musicians" (in Armstrong's words) saw Armstrong enter the studio set, they broke into sustained applause![99]

The tune they're playing is "Battle Royal," but there's no real competition onscreen. The true competition is one of imaginaries: between on the one hand, the will of Ellington, Armstrong, and yes, even Murray McEachern to create music that is multilingual, generous, and fiercely democratic; and on the other hand, the austere, divisive, and ultimately racist idea that racial differences are so pronounced that white jazz can be played only by white people.

The last scene I want to examine in this chapter is the final scene of the movie, in which the two pairs of lovers plan to meet at the Gare de Lyon. Ram Bowen is to start his journey back to America with Lillian Corning, and Eddie Cook is to say good-bye (for now) to Connie Lampson, whom he'll join soon in America to marry. The scene's climax comes when Ram shows up late, with no luggage. Before he says a word, his long face announces his decision to stay in Paris after all. Ram's choice is between going "home" with the woman he loves or staying in Paris with the music he loves, Euro-condescension, drugs (or threats of social death), and all.

A still from *Paris Blues* in which Louis Armstrong enters the club for a jam session challenge. *Paris Blues* (1961), Directed by Martin Ritt, United Artists.

Krin Gabbard argues that Ram's decision represents a repudiation of jazz in favor of the French academy. Ellington's music in the background answers the script's charge of jazz's inadequacy by broadcasting a knowledge of midcentury, modern European "classical" music as the jazz of that period, which had been indelibly influenced by Ellington and Armstrong.[100] The movie's imagery confirms the put-down of jazz—or at least what it perceives as old-fashioned or unevolved jazz. As the lovers part ways in the train station, a large billboard of Louis Armstrong/Wild Man Moore is being painted over by workmen on high ladders. In place of the announcement of his upcoming concert (now obsolete, since the performance has happened) is an ad for Larousse Books, as if the temporary interruption of Armstrong's "entertainment" has been eclipsed by the much sturdier institution of the French publisher best known for its many sizes of French dictionary, the last word (literally the written word, not the improvised statement) in culture.

But let's listen again to Ellington's music in this last scene at the station. Here is program music at its finest: as Lillian's eyes fill with tears, she turns from Ram to catch her train. Ellington's "Paris Blues" theme arises slowly, gently, without a formal beginning. It's been there all along. Lillian runs for her train in

double-time tempo to the music, while McEachern's trombone sings a mournful "Paris Blues," hers and Ram's. The trombone also serenades Eddie and Connie as they kiss and kiss again as the train begins to move. The music shifts to match the train's accelerating paces; rhythms and harmonies are quickly churning, wheels within wheels.[101]

This last scene's music evinces ever more "stacked" rhythms—2/4, 4/4, 6/8, and many more—once one realizes that not only the drums but all the instruments have a percussive function here. The notes from the recording session are unclear: are there two drummers present? Three? Four? Five (as some lists say)? The Ellington specialist Claude Carriere observes that because Hollywood money was available, Duke hired an oboist and flautists, and the drummers on this date included not only Sam Woodyard, the long-term regular with the orchestra, but also master percussionists Max Roach, Philly Joe Jones, and perhaps Jo Jones as well.[102] Others? In any case, what we hear is what we get: musical collage at its best—"something over something else" (Bearden's definition of all painting).

The harmonies match the train's mounting speed and the scene's increasing emotional intensity. What Gunther Schuller has written about "Daybreak Express," the earliest of Ellington's train masterpieces, applies to this scene's program music: "Once the train, and the orchestra, hit express speed: ca. 288 [we encounter] a variety of locomotive imitations, from the click of the tracks and chug of the engine to the wailing train whistle."[103] The contemporary composer Jason Moran hears this last scene's "locomotive onomatopoeia"[104] as an example of what young musicians of today call a "mash-up": two or more musical ideas squashed together. That's what we're hearing when the trombone continues to cry as the train pulls out, "and eventually," says Moran, "the community [of other instrumentalists] will drown out that cry." Moran also hears harmonic mash-ups: various forms of the blues contending with and against one another. By the end of the piece (which is the climax of the movie),

> the rhythm shifts and the band that has built up all this energy is now unleashed in the rhythm. They launch an unadulterated blues with shout choruses. Drums are leading the church [the whole congregation of music makers]. And the bass is *on*, only playing the tonic on each beat for two choruses. This showcases the blues as classical form. And then the bass starts walking. But what happens at the very end of the film is that we get these two pulls going against the blues. This is a tug that Duke has orchestrated: the pull of tensions in the harmonic sense, with and against the blues. This is Duke's innovation: He has made harmonic tensions into emotional sinew.[105]

What Schuller wrote about "Daybreak Express" goes double in the case of the final train-whistle choruses in *Paris Blues*: " 'Daybreak Express' was landmark

not only as a technical performance tour de force but as a stunning lesson in the capacity of the jazz medium to equal or better anything that was being done in classical program music—and in Ellington's case with an orchestra of only fourteen!"[106]

Polyrhythmical, polytonal, wheels-within-wheels, mash-ups, layers, tensions, pulls: all these concepts help us hear that last scene's music. Surely it is correct to read this music as a turbulent repudiation of the scene's intent, as announced in Ram's decision to stay in Paris to pursue classical study, suggesting the need of jazz music to "evolve" and seconded by the papering-over of Louis Armstrong's billboard picture.

And yet, to call the music in this last scene a repudiation of the movie as a whole is not quite right. As Fred Moten has observed, "a repudiation is always in some way beholden to what's repudiated," and, he continues, Ellington was above repudiating such a scene and such a movie. Moten adds:

> Maybe it's that the repudiation is almost an accidental effect of what Ellington was doing, which was just making music! A repudiation without trying, insofar as he was trying to do something else, something better. Maybe it's a quantum kind of thing: Not contrapuntal, not a counterpoint to the film but complementary with it while somehow being incommensurable with it, uncontained and undetermined by it. Because sometimes we just aren't worried about what they think or say and if all we do is preceded by and in response to what they say then we're caught. Don't you think that most of the time, because I know it could never be all the time, Duke wasn't thinking about them. . . . So maybe the repudiation is simply in the way the music is saying to the thematics of the film, "I ain't thinking about you!" or, deeper still, the musicians saying to themselves, "we ain't thinking about him" and not even really finishing that sentence because they found that what they were saying they were saying to each other and it was sounding too damn good![107]

Wow! What the movie was saying was so wrong, in Moten's view, that it did not deserve the attention required to backslap it away. The Ellingtonians were "just making music" at the usual high level that it took to please the musicians themselves, thus casually foolproofing the movie against whatever the director or the film editor or the actors or anybody else might do. Moten's right. The movie is substantially a failure, but the music stands! I'd say further that in the midst of failure, there are "indelible moments," to quote Baldwin again, that reverse this film's meaning and demolish it: these are the unruly Black cosmopolitan moments, exemplified by this last scene's churning music, that make this film worth hearing, if not worth seeing, before it's shoved aside.

Listening again to the music of that last scene makes me look again at Eddie and what Sidney Poitier brings to that part. First, two steps back: as we have

seen, the movie as released casts Connie as the film's Good Girl, a foil against which to regard Lillian's "throwing caution aside." Reversing the usual stereotype of whiteness as pure and good and Blackness as corrupt and evil, Connie is a bastion of middle-class Black respectability. Lillian runs headlong after Ram, while Connie is reticent and then only reluctantly convinced of the trueness of Eddie's love. Lillian's in Ram's bed that first night (and evidently every night of her stay in Paris). There are no bedroom scenes featuring Connie. Lillian models scanty nightclothes, bras, and other underclothes. Connie dresses beautifully, but hers is a wardrobe strictly of the chilly outdoors; we rarely see her without an overcoat pulled tight (but not too tight!) around her body. Lillian answers Ram's questions about boyfriends back home without apologizing for playmates "of all kinds." Connie teases Eddie about his love life but mentions no such history of her own.

Ram's just upset enough by the disappointing evaluation of the French academician (and just drunk enough at the farewell party) to give in to Lillian's dream of domesticity on the small-town home scene—but then the morning light sobers him up, and he decides to stay in Paris after all. I think Eddie weighs the evidence of his own tours of Paris, regarded now from the highly critical (highly American-nationalistic) perspective of homegirl Connie, who also makes the case that things are changing fast on the racial front back in the United States. So he makes the heroic choice to go "home" with her. She wants to have children—six of them (!). He'll say goodbye for now and join her shortly in Chicago.

But hold on a moment. *Is Eddie really leaving?*

After he kisses Connie goodbye and her train begins to roll away, Eddie snaps up his raincoat collar and turns back toward the streets of Paris, walking off with Ram. It's Poitier's turn and strut that marks Eddie's acceptance of this moment's creative ambiguity—the kind of indelible instant of insight and decision that Ralph Ellison calls "ambivisibility"—something carrying more meaning than any simple stay-or-go decision can bear. Eddie's turn implies the Ellingtonian decision *both to stay and to go*, to continue living a creative life on the road that includes trips home from time to time but refuses Connie's imperatives of "home" as fixed and finished—her own version, alas, of the white trombone. What Connie offers is the white-picket-fence American Dream, as opposed to a life of possibility and multiplicity and the creativity of life on the road as an improvising artist. Eddie's body language at the end is firmly aligned with the film's other hints and traces of unruly Black cosmopolitanism—all underscored one last time by the groundshaking music that Ellington and Strayhorn scored for that last scene.

Eddie's part in that last scene places him with the Afro-musicians at Marie's Cove as they mock the idea that they are all the same, interchangeable. Symbolically, he stands with Armstrong, refusing the conventional role, whether

218 The White Trombone and the Unruly Black Cosmopolitan Trumpet

in terms of race, gender, or nation. He stands with Ellington holding his glass of Beaujolais as he rises above the film's purported message of white trombone false binaries. Consider what Eddie's decision to stay in Paris might mean. I like to see Eddie turning up his collar and walking back into Paris as a spontaneous taking of the Dukeish route of learning on the fly—from ear cats like Gypsy and Ram as well as from the conservatory cats. He'll take a lesson or two at the French academy. And if they are lucky, the prof and the academy will get a lesson from the likes of him, too. Confirming all this, the end scene's dense mash-ups of rhythms and harmonies proclaim unruly Black cosmopolitanism in all colors and the obliteration of the white trombone.

What are the Paris blues? Édouard Glissant says "Amen" to the answer offered by this movie's robust soundtrack and by Eddie's endgame decision, as I read it, to stay in Paris: to choose multiplicity over singularity, music beyond category over the dream of a white trombone.[108] The Paris blues fall like rain when one is caged by forces that insist on the life of the isolato, by the idea of a kind of rigidly fixed identity that the multi-instrumentalist Roland Kirk rightly called "volunteered slavery."[109] But the blues is not only a rain-soaked state of melancholia; it is a musical form wherein one fingers the jagged edges of experience and—if the music is swinging hard enough—overcomes them "not by the consolation of philosophy but by squeezing from it a near-comic, near-tragic lyricism" and "through sheer toughness of spirit."[110]

What are the Paris blues? At their best, like the blues of Robert Johnson, Louis Armstrong, and, yes, of Billy Strayhorn and Duke Ellington (and potentially of Eddie and Ram), they are the orchestrated will to give consent to multiplicity, as Glissant puts it—to walk away from singularity. In this context, when in doubt, says Ellington, "*Do Louis!*" in all the wonder and uncertainty of his unruly Black cosmopolitanism.

CODA: *PARIS BLUES* THE COLLAGE BOOK, OR THE PROJECT REVISITED

Twenty years after the release of the film *Paris Blues*, Sam Shaw and Romare Bearden teamed up with Albert Murray to do their own version of the Black-artist-in-Paris story, this time in the form of a book of collages created by Bearden from Shaw's photographs and captioned by Murray. What had substantially failed, in their view, on the Hollywood screen, these men would recoup as a book big in size (tall and wide enough to accommodate 15″ × 22″ spread-page collages) and ambition. Brainstorming over photos and sketches, the trio went to work piecing together the image-and-word pages. Thus, they managed to create over thirty pages—some quite complete, as collages, but others no more than preliminary lines, strips of colored tape, and stick figures. Then, for reasons thus far not revealed by archival evidence, work on the artists' book ground to a full stop.

What could have happened? Murray recalled some sort of dispute between Shaw and Bearden over whose signature (or signatures) rightfully belonged on the collages themselves. According to this version, Shaw did not relish the idea that his photographs were serving as unsigned, raw material for Bearden, the collagist. Another version of the project's demise has it that Bearden began to take issue with Murray's general view of the meaning of a Black American artist's sabbatical in Paris. Bearden allegedly felt that Murray was too critical of French people and culture, too eager for the story's heroes to get back home, while he, Bearden, preferred to stay in celebratory mode, whether depicting the French or the Americans.[1]

There was also the matter of the ownership of individual pages. For many years, a dealer named Dmitri Jodidio, who'd put up money for the project in the first place, kept a tight hold on most of the most complete works. (Many more works in progress still exist in the Sam Shaw Archives.) How Jodidio acquired the collages prompted a legal dispute that was settled in favor of Jodidio, who recently sold the works to a gallery in Manhattan.[2] These tugs of war over ownership and crediting did not serve the project well.

Along with the finished and unfinished *Paris Blues* collage pages, the historian must also consider the boxes of "Paris Project" photos in the Shaw Archives, not all of which pertain directly to the movie or the period of its making. Here, among many Paris photos, one finds original prints and proofsheets sampled in Bearden's *Paris Blues* collages, some of them scissor-cut for this project, and others Magic-Markered for consideration.

With the folding of the three-man project, Murray published "Armstrong and Ellington Stomping the Blues in Paris,"[3] an essay reflecting briefly on the movie *Paris Blues* (which he dismisses as "Hollywood pulpfare") but making no mention of the truncated joint project from which this writing evidently sprang. Was some of Murray's collage-book writing redirected for the large Louis Armstrong exhibition mounted in 1994 by the Queens Museum of Art and the Smithsonian Institution, which hired Murray as its principal writer?

Our historian of the *Paris Blues* collage-book project should also take into account Bearden's semiautobiographical *Profile* series (*Part I* released in 1979, and *Part II* in 1981), for which the artist and Murray cowrote the titles and captions that accompanied every work.[4] Certainly, one or two of the *Profile* series collages could have originally been prepared for the *Paris Blues* project—notably *Rehearsal Hall*, whose setting is an Armstrong-Ellington recording session and whose rugged style of rectangular strips of color is consistent with Bearden's *Paris Blues* book aesthetic. My sense is that just as their friend Ellington might play the theme from *Paris Blues* at a Carnegie concert on one night and at a Deep South roadhouse dance party the next, Bearden, Murray, and Shaw moved pieces of the "PB" project around, repurposing them as new situations arose. One should also consider this project in light of Bearden's decision, in the mid-to-late 1970s, to spend more and more time in his wife Nanette Rohan's ancestral home of St. Martin (the French side of the island). Perhaps the *Paris Blues* page called *Lovers in the Luxembourg Gardens* reflects a sense of color and luminosity more associated with Bearden's Caribbean watercolors of this period than with any *arrondissement* in Paris.

Reviewing the various *Paris Blues* pages, along with these other smatterings of evidence (some quite fragmentary or opaque—or remixed), what may we deduce about what Bearden, Shaw, and Murray had in mind for their *Paris Blues* collage book?

As I consider this collaborative project forty-plus years later, I find that I *love* the Shaw-Bearden-Murray collage book's very incompleteness—here is art in traces and *in potentia*, dream pictures and logos in motion. These gestures toward completion, involving as they do archival and fugitive fragments along with empty file folders, missing pages, critiques of prior efforts, sheets of unresolved questions, additions, and redactions, may tell much more than most works finished and framed for publication or sale. Bearden often said that he never finished a work anyway; at a certain point, he simply "released" or "relinquished" it. Something about the very unfinishedness of the project in progress is a perfect, jazzlike instance of what I've been calling "unruly Black cosmopolitanism." Answers are ever in progress.

What is this unfinished Bearden-Shaw-Murray *Paris Blues* book all about? Who are its protagonists? Clearly, in this new *Paris Blues*, no spring-break romantic flings force choices between love and art or between escape in France versus racial responsibilities back in the States. This book seems to say: responsibilities to social justice are everywhere, all the time. And here, the focus is not on a white trombonist (or any false divides between improv and composition, academic and "ear cat" training), but rather decidedly on Duke Ellington and Louis Armstrong (and sometimes Billy Strayhorn and Bessie Smith),[5] master jazz artists unequivocally committed to their art and its never-ending development on the fly. As if to make unmistakably clear who would star in the emerging picture-and-word book, Bearden created two rather finished works, *Graffiti* (1) and *Graffiti* (2), consisting entirely of looping, autographlike letters, spelling (over and over again), "L-o-u-i-s-A-r-m-s-t-r-o-n-g" on one page, and "D-u-k-e-E-l-l-i-n-g-t-o-n" on the other. In this way, Bearden declares artistic affiliation with these men, with their story telling his story—recall that Bearden's account of his own first travels in Paris was the source of Sam Shaw's idea for the film *Paris Blues* in the first place. But now, instead of one Black artist or musician (and/or his white buddy), this *Paris Blues* book presents a layered, improvised set of overlapping word-and-image narratives of two (and then more) Black American artists of pieces and parts, collaged, on the move, and influenced by art and artists at 360 degrees, across all categories.

The Shaw-Bearden-Murray project evidently was not solely about the City of Paris, but was a tale of three cities—New Orleans, Harlem, and Paris. According to this project's sketch of jazz's geographical history, there is no Paris jazz without New Orleans and Harlem, not only as sites of origin but as places of continuing inspirational replenishment. Nor, on the other hand, could New Orleans or Harlem be what they are without these cities' vigorous and ongoing international dimensions. (In 1960 and 1980, as now, one heard Francophone speakers all over Harlem, and all over New Orleans, too.) This collage book's Armstrong and Ellington, the choice between Paris and the United States, is a

false dichotomy because, like Bearden himself (and, for that matter, like Shaw and Murray as well), Armstrong and Ellington chose both cities and many others, too. They traveled not in search of escape but as intellectual/spiritual/ artistic adventurers, as seekers determined to taste the sunshine of life as they helped make the world anew via their art.[6]

The specifically *Paris* works in this projected book presented City of Lights spaces where jazz flourished—the Cirque de Soleil, Romani encampments, and recording studios with musicians in control. Impressive in these Parisian collages are the dramatic visualizations of jazz music: the images of romance (see *Lovers in the Luxembourg Gardens*), for example, and the presentation of jazz instruments as sculpture. And then there are the circus pieces. If the music is "acrobatic enough," people will respond to it, Ellington told an interviewer; and Bearden's acrobatic collages set in Paris seem to say the same thing. For me, the *Cirque de Soleil* collage and the traveling music from that last Gare de Lyon scene in the film *Paris Blues* go together.

* * *

With this in mind, I'll give this book's last word to two collages from the Bearden-Shaw-Murray creation that have much to say about Armstrong and Ellington, specifically *en Paris: Ellington and Armstrong with Paris Graffiti* and *Being in Paris*. As we look at these works, let us ask again: What, on the lower frequencies, are the *Paris blues?* And: If there's an antidote to these blues, could unruly Black cosmopolitanism be that antidote? What, from the perspective of the new angles of this left-undone project, is unruly Black cosmopolitanism?

Ellington and Armstrong with Paris Graffiti offers answers to these questions as well as any work in the three-man *Paris Blues* book does. Like several other collages he made for this project, this single work is designed to stretch across a two-page spread, with one major rectangle per page, each tilted and overlapping to project the American sense of dynamic movement that Bearden said he found lacking in the European Cubist tradition. In this single/double collage, a light spring green predominates, with fresh new growth overflowing the borders.

The work's right page features a light-table view of Shaw's proof-sheets, rows of photos he evidently took in a Paris gallery showing Afro-modernist-inflected contemporary art. Here's one of Bearden's several statements about the process of creating the book as a whole: the journey from art observed and photographed to proofs and prints considered and then cut for collage. The page at left, giving a view through a club's or movie set's arches, with Ellington seated at the piano while Armstrong, at stage left, sits deep in private thought, is also about art's processes. Both are images of interiority. There's a golden aura around the photo of Ellington, a kind of shade or double—or perhaps

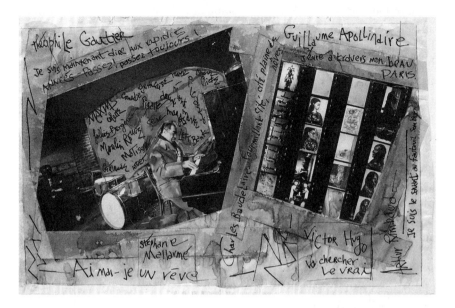

Romare Bearden, *Ellington with Paris Graffiti*, 1981. Collage on paper, 16 × 23 inches.

it's the shadow of his writing companion, Billy Strayhorn. Or is it the spirit of the figures named in script around Duke's head and then infusing the entire work—names extending the work's statement about openings: where art comes from and how it's made? Here are Duke and Louis, radically changed by one another while choosing to be changed by or adopting (the word "adopt" is from the Latin verb *adoptāre*, meaning "to choose") other artists as well.

Let's roll out the full cast of artists specifically named and/or quoted in Ellington and Armstrong with Paris Graffiti: "Guillaume Apollinaire, Eugene Atget, Charles Baudelaire, Colette, Élie Faure, Theophile Gautier, André Gide, Victor Hugo, Stephane Mallarmé, Henri Matisse, Pablo Picasso, Arthur Rimbaud, Gertrude Stein."

Clearly, Bearden conceives these artistic "ancestors," writers and painters (fascinatingly, not musicians), as representing not only the mystique of Paris, but specifically of Ellington's and Armstrong's artistic inheritances and lineages. And again, they also say something about Bearden's own way of making art, influenced by musicians, of course—specifically by Duke and Louis—but also by this cavalcade of writers and, naturally, by visual artists. Along these lines, the stylized graffito lettering here seems to signify Bearden's debt to graffito artists like the painter/collagist Jean-Michel Basquiat's "SAMO." In other words, this

work of looping letters salutes the looping of influences itself. Just as Bearden and Black music, as well as French literature, affected Basquiat, the gone-around has come around—as Basquiat tags Bearden (and the worlds of Duke and Louis) back. The colors, rhythms, and structures of one art form suggest possibilities in another. These divisions, as I've argued in chapter 1, are liquid anyway. Like the names that populate *Ellington and Armstrong with Paris Graffiti*, the influences—literary, visual, and musical—beautifully intersect as they swirl.

But where are the names of people of color in Paris? Where are James Baldwin, Richard Wright, Sidney Bechet, Henry O. Tanner, Léopold Sédar Senghor, and Aimé Césaire? Where, considering the presence of nineteenth-century French writers here, is Alexandre Dumas? Where are the many other musicians, artists, and writers of color associated with Paris who could have been shouted out (several of whom our three *Paris Blues* makers knew personally)? My best answer is that in *Graffiti*, Bearden asserts the defiant range of what Ellison calls "chosen ancestral" influences, while leaving out the too-obvious "family" connections (the Afro-Diasporan lineages) of Baldwin and other Black and Brown creative influences that Bearden, Duke, and Louis knew very well already.

Note that along with its specific citation of artists and writers, this collage stakes the American musicians' (and, again, Bearden's own) claim to iconic Parisian sites of artistic activity. Named in this collage are La Comédie française, Les Deux Magots, the Folies Bergère, the Left Bank, Maxim's, Montmartre, the Moulin rouge, la Seine, and Le Pigalle. These are not places associated with jazz solely, or even with music. Here, the point seems to be that since, in their art, Ellington and Armstrong so willfully stretch "beyond category"—to use one of Duke's favorite expressions—not only musical spaces shape who they are as artists. So, instead of clubs and concert halls, here are favorite artists' haunts of that period, places that Ellington, Armstrong, Bearden, and their other friends knew and loved, places where they'd encounter other artists from across the world and across the categories. At the same time, with its inclusion of Sam Shaw's contact sheet from an exhibition of explicitly African-influenced works, Bearden meditates on African connections in modern art, as well as the specific challenges of the contemporary Black artist to find fresh ways to draw on African inheritances without repeating the mistakes of their European predecessors. By including here rows of Shaw's pictures from the Rodin Museum in Paris, Bearden also resists too specific an Afro-centric reading of where his art comes from.

Being in Paris[7] is another of the project's luminous double-page collages where the subject is artistic sites, sources, and kinship. Marked at the work's upper-left edge and at the top right with "Page 41/42" (with a green sticky note), *Being in Paris* definitely has the air of a work in progress. The written notes and the marked-out and circled images on the work's edges and contact

sheets suggest the artist's ongoing process of improvisation by addition and subtraction, revision and redaction. Certainly, Bearden would have revisited this piece to correct the misidentification of the French music historian Hugues Panassie as Andre Hodier, the French composer/music theorist. Capping its monumental headshots of the three music men is the Paris rooftop skyline— itself a definitive signature of that city, in this instance outlining the famously independent and multiethnic neighborhood Belleville (not the Montparnasse famously associated with many of Bearden's French contemporaries). The work's three huge heads comprise a sort of skyline, too—a Mount Rushmore evidently nominating the musicians as set-in-stone founders and sustainers not of a single-state nation, but of a Transnational Realm of Music.[8]

Bearden's play with form in *Being in Paris* is highlighted by the rhythmical juxtaposition of rectangular shapes in the cityscape with those same shapes on the contact sheet—that is, a play between architectural windows and pho-tographic framing.[9] Mirroring aspects of *Ellington and Armstrong with Paris Graffiti*, each of this work's small contact photos has a windowlike aspect, sight-lines into social gatherings.[10] This is a Paris which, along with serious work and business, is a place of flirtation and fun!

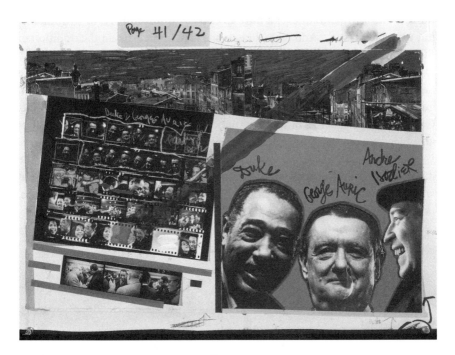

Romare Bearden, *Being in Paris*, 1981. Collage, 14 1/2 × 22 1/4 in.

As in several other *Paris Blues* collages, here are the red, white, and blue of the French and American flags, now accented in gold—and/or with a canceled Metro ticket. Indeed, bluesy "been-here-and-gone"/"sorry that I can't take you" cancellation is another motif of the series. And who are the people pictured on the contact sheets? As if to footnote the Rushmore threesome (artists as internation builders), these photos feature saxophonist Lucky Thompson and singer Nancy Holloway, both African American musicians living in the multinational Paris of that era. Although these artistic travelers are not well known beyond a specific circle of music specialists, this reinvention of the *Paris Blues* project tells their story, too. It's a collaged tale of Paris as a place to connect and share with new, Parisian artistic peers, as well as reconnect with creative folks from Ellington's proclaimed source of inspiration—from home.

Both *Ellington and Armstrong with Paris Graffiti* and *Being in Paris* emphasize ongoing processes of art making in which artists glory in their freedom to choose their own influences and ancestries. In these collages, and throughout the book in progress, Bearden, Shaw, and Murray present African American artists in Paris (and Paris-like American cities) as the unequivocal heroes of this story: ambitious artists aware of European forms and standards while also exploring American ones. These two France-centric collages turn together with book pages about New Orleans and Harlem as parallel cultural capitals that nurture the artist who does not have to choose to stay in Paris or to go home, but who can do both. And who, if he or she is to be an artist in the tradition of Ellington and Armstrong, *must* do both, and keep moving!

Without the roux from Black New Orleans and the hot sauces from the Savoy Ballrooms of Harlem, this artists' book cannot be the international gumbo-dance book—the Armstrongian/Ellingtonian book—that it wants to be. Call this the perspective of unruly (think of Bearden's layers and overlappings and bleedings of line and color beyond his pages' borders) Black (and yes, I mean to include Shaw, who was not Black, in this company, for such is the nature of Black affiliation by choice as I am defining it) cosmopolitanism (about which already, as Nina Simone once put it, " 'nuff said"). Except to say, yes, *that's* the antidote to the thinking behind the white trombone.

NOTES

Introduction

1. I borrow this phrase from Stanley Crouch, *Kansas City Lightning: The Rise and Times of Charlie Parker* (New York: HarperCollins, 2013), 19.
2. Parker first recorded "Now's the Time" in November 1945.
3. I count Native Americans here as the earliest migrants to this land.
4. See Eric Foner, *The Second Founding: How the Civil War and Reconstruction Remade the Constitution* (New York: Norton, 2019).
5. Ralph Ellison, "The Charlie Christian Story," in *The Collected Essays of Ralph Ellison*, ed. John F. Callahan (New York: Modern Library, 2003), 267. My "with and against" paraphrases Ellison's assertion that "True jazz is an art of individual assertion within and against the group."
6. Ralph Ellison, "What America Would Be Like Without Blacks," in *Collected Essays of Ralph Ellison*, 586.
7. See Ron Welburn, "Ralph Ellison's Territorial Vantage," in *Conversations with Ralph Ellison*, ed. Maryemma Graham and Amritjit Singh (Jackson: University Press of Mississippi, 1995), 309.
8. In "Brave Words for a Startling Occasion," a talk from 1953 printed in *Shadow and Act* (1964) and then in *Collected Essays of Ralph Ellison* (New York: Modern Library, 2003), 154: "The way home we seek is that condition of man's being at home in the world, which is called love, and which we term democracy."
9. Letter to Arne Ekstrom, January 14, 1987; quoted in Sally and Richard Price, *Romare Bearden: The Caribbean Dimension* (Philadelphia: University of Pennsylvania Press, 2006), 66.
10. Toni Morrison, "Abrupt Stops and an Unexpected Liquidity: The Aesthetics of Romare Bearden," in *The Romare Bearden Reader*, ed. Robert G. O'Meally (Durham, NC: Duke University Press, 2019), 178–184.

11. I'm thinking here of the wide-ranging catalogue of cultural "claims" coming "long before I thought of writing," in Ralph Ellison, "Hidden Name and Complex Fate," *Collected Essays of Ralph Ellison*, 200–202; and of Romare Bearden's two-part *Profile* series of collages, 1979 and 1981, in which he too posits some surprise influences on his artistic toolkit. See Robert G. O'Meally, "A Profile View of Bearden's Profile Series," *"Something over Something Else": Romare Bearden's Profile Series* (Atlanta and Seattle: High Museum and University of Washington Press, 2019), 37–47.

12. Morrison, "Abrupt Stops and an Unexpected Liquidity."

13. Michael Cogswell, *Louis Armstrong: The Offstage Story of Satchmo* (Portland, OR: Collector's Press, 2003), 28.

14. Obama first read *Invisible Man* when he was a student at Columbia University. He also took inspiration from Ellison for *Dreams from My Father*. See David Maraniss, *Barack Obama: The Story* (New York: Simon and Schuster, 2012), 453–454.

15. R. W. B. Lewis, "Eccentrics' Pilgrimage," *Hudson Review* 6 (1953): 44.

16. Stefano Harney and Fred Moten, *The Undercommons: Fugitive Planning & Black Study* (Brooklyn: Autonomedia, 2013).

17. Ralph Ellison, *Invisible Man* (New York: Random House, 1952), 6.

18. John Hersey and Ralph Ellison, " 'A Completion of Personality': A Talk with Ralph Ellison," in *Collected Essays of Ralph Ellison*, 801–802.

19. Ellison's part of this exchange appears as "The World and the Jug," in *Collected Essays of Ralph Ellison*, 155–188. See also Irving Howe, *A World More Attractive: A View of Modern Literature and Politics* (New York: Horizon, 1963), 98–122.

20. Ellison, *Collected Essays of Ralph Ellison*, 100.

21. Ralph Ellison, "Change the Joke and Slip the Yoke," in *Collected Essays of Ralph Ellison*, 112.

22. Albert Murray and John Callahan, eds., *Trading Twelves: The Selected Letters of Ralph Ellison and Albert Murray* (New York: Knopf, 2000), 132.

23. Ralph Ellison, *Three Days Before the Shooting* (New York: Modern Library, 2010), 328.

24. An avid science buff, especially when it came to questions of waves of sound and light, Ellison often warned of the unreliability of the touted accuracies of science data, social science data, and their metaphors. See Michal Raz-Russo, Jean-Christophe Cloutier, and John F. Callahan, eds., *Invisible Man: Gordon Parks and Ralph Ellison in Harlem* (Göttingen, Germany: Steidl/Gordon Parks Foundation/Art Institute of Chicago, 2016); and especially Jean-Christophe Cloutier, *Shadow Archives: The Lifecycles of African American Literature* (New York: Columbia University Press, 2019).

25. This excerpt from a novel in progress is presented as an appendix to Ellison, *Three Days Before the Shooting*, 1044.

26. Ellison, *Invisible Man*, 11.

27. I should draw a distinction between the true jam session—artists improvising to improve one another—and its commercially staged counterpart, which at its worst recalls the "battle royal" scene in *Invisible Man*, wherein a ring full of blindfolded Black combatants are forced to fight one another for the entertainment of the powerful.

28. Moten made this point at a 2012 Columbia University conference on the archive.

29. This is from the author's Smithsonian Institution interview with Louis Bellson, done for the video accompanying the exhibition called *Duke Ellington: Beyond Category* (1999).

30. Note that Murray titled the book of their letters *Trading Twelves*, suggesting both improvised twelve-bar-blues exchanges and "playing the dozens," itself a Black verbal game of antagonistic cooperation.

31. Heinrich Zimmer, *The King and the Corpse: Tales of the Soul's Conquest of Evil*, ed. Joseph Campbell (Princeton, NJ: Princeton University Press, 1948), 49.

32. Sumner writes of "the struggle for existence and the competition of life; antagonistic cooperation," William Graham Sumner, *Folkways: A Study of Mores, Manners, Customs and Morals* (Boston: Ginn, 1906), 16. There may also be earlier sources. Webster's dictionary lists its earliest known use in 1897, in W. J. McGee, "The Beginning of Zooculture," *American Anthropologist* 10, no. 7 (July 1897), 215–230.

33. Sumner, *Folkways: A Study of Mores, Manners, Customs and Morals*, 18 (italics mine).

34. Michel de Montaigne, "Of the Inconstancy of Our Actions," in *Montaigne's Essays and Selected Writings*, ed. Donald M. Frame (New York: Columbia University Press), 1963), 143–163.

35. Toni Morrison, "Memory, Creation, and Writing," *Thought* 59, no. 235 (December 1984): 385–390.

36. Satch Hoyt, *Afro-Sonic Mapping: Tracing Aural Histories Via Sonic Transmigrations* (Berlin: Archive, 2021), 114; Morrison, "Memory, Creation, and Writing."

37. "Seriously," said Ellison in an interview of 1976, "I did find the sort of deification of Malcolm X rather strange and uncritical: giving him credit for a certain kind of effectiveness. I don't think that he was the intellectual leader that so many people want to take him for. He was a kind of exhorter. And that was all to the good; he raised a certain kind of consciousness, but he also stressed a sort of narrowness of vision which, taken literally, got a lot of people to get into trouble; and maybe a few dead." Robert G. O'Meally and Ralph Ellison, "My Strength Comes from Louis Armstrong," in O'Meally, *Living with Music*, 280.

38. Robert B. Stepto and Michael Harper, "Study and Experience: An Interview with Ralph Ellison," in *Conversations with Ralph Ellison*, 336–331.

39. Murray and Callahan, *Trading Twelves*, 43, 217.

40. Murray and Callahan, *Trading Twelves*, 193.

41. In "An Interview with Ralph Ellison," N.A. Samstag and Ted Cohen, *Phoenix* 22 (Fall 1961), 5–6, Ellison said: "I'm more apt to be caught up by Ray Charles than Ornette Coleman—or the Modern Jazz Quartet. So much is happening in Charles, so many levels of tradition are operating, and there's such an exuberance. Listening to the radio . . . the other day, I heard him playing something that sounded like rock and roll; but I'm sure that if you started peeling those layers back you'd find something much richer and something which would bear a lot of analysis. Much of what pretends to be new in jazz seems merely pretentious."

42. See Lawrence Jackson, *Ralph Ellison: The Emergence of Genius* (Hoboken, NJ: Wiley, 2002); and Arnold Rampersad, *Ralph Ellison: A Biography* (New York: Knopf, 2007).

43. John Callahan, ed., *The Selected Letters of Ralph Ellison* (New York: Random House, 2019), 68.

44. James Baldwin said this to the author during his visit to Wesleyan University in April 1984. Although Ellison sometimes quoted Baldwin admiringly, a letter to Albert Murray (April 9, 1953) revealed an unkind side. "As for Baldwin," he wrote, concerning Baldwin's novel *Go Tell It on the Mountain*, "he doesn't know the difference between getting religion and going homo. Here he is trying to write about storefront religion with a style that one good riff from a Negro preacher's sermon would smash like a bomb." Murray and Callahan, *Trading Twelves*, 42.

45. It should be noted that in his very first published essays, Ellison did espouse a Black nationalism that was part of the U.S. leftist agenda. See his "Recent Negro Fiction," *New Masses* (August 5, 1941), 22–23; and "Stormy Weather," *New Masses* (September 24, 1940), 20.

46. Ralph Ellison, "Flamenco," in *Collected Essays of Ralph Ellison*, ed. John F. Callahan, 24.

47. "Here I can only fall back upon the teaching of that earlier Ralph Waldo," Ellison wrote, referring to Emerson, "and suggest, conscience and consciousness, more consciousness and more conscientiousness!" Ralph Ellison, "Address to the Harvard College Alumni, Class of 1949," in *Collected Essays of Ralph Ellison*, 427.

48. In this profile of Albert Murray (originally published by the *New Yorker* in 1996), Henry Louis Gates Jr. names both Murray and Ellison as making such large cultural "claims." Henry Louis Gates Jr., *Thirteen Ways of Looking at a Black Man* (New York: Random House, 1997), 33.

49. Baldwin writes of the "slimy depths to which the bulk of white Americans allowed themselves to sink: noisily, gracelessly, flatulent and foul with patriotism." James Baldwin, *The Devil Finds Work* (New York: Vintage International, 2011), 82.

1. This Music Demanded Action: Ellison, Armstrong, and the Imperatives of Jazz

1. As noted in this book's introduction, Ellison's phrase "antagonistic cooperation" evidently was coined by the Yale sociologist William Graham Sumner to describe a situation in which animals that are instinctively hostile toward one another, or may even prey on one another for food, set aside their differences and work cooperatively against a shared threat—mutual enemy animal, storm, fire, or flood. Antagonists that, in a time of emergency, *cooperate*. Sumner, *Folkways*. In Heinrich Zimmer's *The King and the Corpse* (1948), the phrase is defined in terms of the hero's enhancement of capacities through engagement with enemies. It is a keystone concept in the work of Albert Murray, notably in *The Hero and the Blues* (Columbia: University of Missouri Press, 1973).

2. Ralph Ellison, *Invisible Man* (New York: Random, 1952), 12.

3. Kenneth Burke, "Literature as Equipment for Living" (1941), in *Kenneth Burke: Perspectives by Incongruity*, ed. Stanley Edgar Hyman (Bloomington: Indiana University Press, 1964), 100–109.

4. Kenneth Burke, *Language as Symbolic Action: Essays on Life, Literature, and Method* (Berkeley: University of California Press, 1966).

5. Welburn, "Ralph Ellison's Territorial Vantage," 317.

6. Ellison, *Invisible Man*, 12; italics added. "Black and Blue" was written by Thomas "Fats" Waller and Andy Razaf.

7. James Baldwin, *Notes of a Native Son* (Boston: Beacon, 1955), 7.

8. One of Nathaniel Mackey's characters describes a jazz artist's switch from one instrument to another as a move "from grief, as it were, to grievance, from lover's lament, one might say, to slave narrative, to some extent erasing the differences between the two." Nathaniel Mackey, *Bedouin Hornbook* (Los Angeles: Sun & Moon, 1997), 148.

9. Charles L. Black, Jr., "My World with Louis Armstrong," *Yale Review* LXIX.1 (Autumn 1979), 3.

10. Black, "My World with Louis Armstrong," 2.

11. Black, "My World with Louis Armstrong," 7. In this vein, James Weldon Johnson, another lawyer from the South, called Black music the "greatest gift of the Negro." He added, "This gift is . . . the touchstone, it is the magic thing, it is that by which the Negro can bridge all chasms. No persons, however hostile, can listen to Negroes singing this wonderful music without having their hostility melted down." *The Book of American Negro Poetry*, ed. James Weldon Johnson (New York: Harcourt Brace, 1922), xix.

12. Ralph Ellison, "A Coupla Scalped Indians," *New World Writing* 9 (New York: New American Library, 1956), 225–236.

13. Ralph Ellison Collection, Library of Congress, Rare Book and Special Collections Division, Washington, DC, Box I, Folder 162; Box II, Folder 67.

14. Richard Powell, *Cutting a Figure: Fashioning Black Portraiture* (Chicago: University of Chicago Press, 2009).

15. Jean-Christophe Cloutier, *Shadow Archives: The Lifecycles of African American Literature* (New York: Columbia University Press, 2019), 174–177.

16. Ralph Ellison, conversation with the author, April 21, 1974.

17. Ralph Ellison, "Letter to Robert O'Meally" (April 17, 1989), quoted in John F. Callahan, " 'American Culture Is of a Whole': From the Letters of Ralph Ellison," *New Republic* 220, 9 (March 1, 1999), 47.

18. This idea is spelled out in Francis Fergusson's *The Idea of a Theater* (Princeton, NJ: Princeton University Press, 1949), 18.

19. Consider the figure in the blues sung by *Invisible Man*'s Peter Wheatstraw, who recalls a woman with "feet like a monkey, legs like a frog." Ellison, *Invisible Man*, 173.

20. Ellison, "A Coupla Scalped Indians," 228.

21. Ellison, *Invisible Man*, 113–114.

22. Ralph Ellison, "The Art of Romare Bearden," in *The Collected Essays of Ralph Ellison*, ed. John F. Callahan (New York: Modern Library, 2003), 690; see also Leroi Jones (Amiri Baraka), "Swing—From Verb to Noun," in *Blues People: Negro Music in White America* (New York: Morrow, 1963), 142–165.

23. The first edition of the manual was issued in 1910, a few years before Ellison's birth in 1913: Ernest Thompson Seton and Lieutenant-General Sir Robert S. S. Baden-Powell, *Boy Scouts of America: Handbook for Boys* (New York: Doubleday and Page, 1910); Baden-Powell's 1908 book, *Scouting for Boys*, later led to the official *Boy Scouts Handbook*. For an excellent account of Baden-Powell's wide-ranging racism and imperialist ideology, see Michael Rosenthal, *The Character Factory: Baden-Powell's Boy Scouts and the Imperatives of Empire* (New York: Pantheon, 1986).

24. The situation recalls Richard Slotkin's argument, in *Regeneration Through Violence: The Mythology of the American Frontier, 1600–1860* (Middletown, CT: Wesleyan University Press, 1973), that European colonists in America sought to "regenerate" themselves as new men and women through the genocide of Native Americans.

25. Consider Ellison's criticism of Hannah Arendt's "Olympian" position against Black adults' "exploitation" of Black children in confrontational freedom movement activities." Ralph Ellison and Robert Penn Warren, "Dialogue," in Robert Penn Warren, *Who Speaks for the Negro?* (New York: Random House, 1965), 344.

26. Ellison, *Invisible Man*, 441. The issue of circumcision in this story also recalls that after Ellison's father died (when he was only three), his mother, Ida Ellison, was both father and mother to him. Her insistence that her boys, Ralph and his brother Herbert, act like men meant that sometimes she was quite severe with them. But she was not a "castrator," Ellison says. "She was a circumciser." Tough Aunt Mackie is related to tough Ida Ellison, who in her mother/father role taught her sons that if they did not act like men, no good woman would want them. See David L. Carson, "Ralph Ellison Twenty Years After" (1971), reprinted in *Conversations with Ralph Ellison*, ed. Maryemma Graham and Amrijit Singh (Jackson: University of Mississippi, 1995), 196–197.

27. Underscoring the "Jewishness" of the boys' rituals (and, Ellison has frequently insisted, of American culture writ large), consider a handwritten note of Ellison's at the top of an early typed version of "Coupla Scalped": "Jesus cut the skin and was a Jew?/And you,

too." Ralph Ellison Collection, Library of Congress, Rare Book and Special Collections Division, Washington, DC, Box I, Folder 162; Box II, Folder 67. Note too that circumcision is practiced among many peoples of the world, including Muslims, as well as many pre-Columbian nations of the Americas. And if we consider the abundance of sacred traditions under the broad tent of "carnival," this story's references also reach beyond Judaism and Christianity.

28. In *Adventures of Huckleberry Finn* (New York: Charles L. Webster and Company, 1885), Huck's awareness arises through the plight of the runaway slave Jim.

29. I draw this term from Shane White and Graham White's " 'Us Likes a Mixtery': Listening to African-American Slave Music," *Slavery & Abolition* 20, no. 3 (1999), 22–48.

30. This is a story where, again and again, the sonic landscape seconds the narrative meaning.

31. Ellison, "Coupla Scalped," 236.

32. Ellison, "Coupla Scalped," 229–230. Note the oblique reference to Gertrude "Ma" Rainey's audaciously self-assertive (and overt in its adult sexuality) composition, "Hear Me Talkin' to You," which she recorded in 1928 with her Tub Jug Washboard Band.

33. The term "ambivisibility" turns up on a manuscript page of the "Battle Royal" section of an early draft of *Invisible Man*. Library of Congress, Ralph Ellison Papers, "Battle Royal" (undated), Part I, Box 1, Folder 142.

34. It's significant that Ellison said that he'd just discovered William Empson's highly influential book of literary criticism, *Seven Types of Ambiguity*, first published in 1930 (London: Chatto and Windus), and then revised (for the second time) in 1953—at a time, perhaps, when Ellison was working on this story. Ellison calls the blues "an art of ambiguity" in his essay on Jimmy Rushing in *Saturday Review*, May 17, 1958; "art of ambiguity" is in Ralph Ellison, "Remembering Jimmy," in *Collected Essays of Ralph Ellison*, 277.

35. See W. E. B. Du Bois, *The Souls of Black Folk* (Chicago: A. C. McClurg, 1903), 2.

36. See Greg Tate, "Nobody Loves a Genius Child: Jean-Michel Basquiat, Flyboy in the Buttermilk," in *Flyboy in the Buttermilk: Essays on Contemporary America* (New York: Simon and Schuster, 1992), 231–244.

37. Ralph Ellison, "An Extravagance of Laughter," *Collected Essays of Ralph Ellison*, 617–662; and "Homage to Duke Ellington on His Birthday," *Collected Essays of Ralph Ellison*, 680–687.

38. Édouard Glissant, *Poetics of Relation*, trans. Betsy Wing (Ann Arbor: University of Michigan Press, 1997); Fred Moten, *In the Break: The Aesthetics of the Black Radical Tradition* (Minneapolis: University of Minnesota Press, 2003), 162.

39. According to Aidan Levy, "For Bearden and many other artists, writers, musicians, and intellectuals . . . a day job in the Department of Welfare (renamed the Department of Social Services in 1967) was a formative part of their art and commitment to social justice. Especially during the ▨60s, a circuit of artists-cum-social-workers in New York City formed across the disciplines: Writers Alice Walker and Audre Lorde, painter Danny Simmons, and playwright Loften Mitchell are just a handful. Yet none stayed as long as Bearden." Aidan Levy, "The Quilt of Romare Bearden's Life," *The Nation* (July 13, 2018), https://www.thenation.com/article/the-quilt-of-romare-bearden-life/.

40. It is important to observe that not all blues have a twelve-bar structure. This is a common form, but alternative forms are not rarities.

41. Geneva Smitherman, *Talkin and Testifyin: The Language of Black America* (Detroit: Wayne State University Press, 1977) 128–134; John Szwed, *Crossovers: Essays on Race, Music, and American Culture* (Philadelphia: University of Pennsylvania Press, 2005), 105, 169, 179.

42. Ellison, "Coupla Scalped," 230. Ellison often spoke of improvisation in terms of Clausewitz's *On War*, which says that a good leader must have direct and indirect strategies for advancing the troops and avoiding attack. Carl von Clausewitz, *Vom Kriege* (1832), published in English as *On War* (Princeton, NJ: Princeton University Press, 2008).

43. Note here that "covey" is a noun referring to a flock of birds. Is "Mr. Covey" a one-man flock of trickster birds, a "covey" of Native American trickster-ravens? See Frederick Douglass, *Narrative of the Life of Frederick Douglass, An American Slave* (Boston: Anti-Slavery Office, 1845), 60–61. See also the reprint edition edited by Robert G. O'Meally (Barnes & Noble Classics: New York, 2005.

44. Ellison, "Coupla Scalped," 230.

45. See Christopher Winks's translation of Glissant's phrase "consent à nêtre plus un seul," in "Édouard Glissant in Conversation with Manthia Diawara," *Journal of Contemporary African Art* (Spring 2011), 5: "It's the moment when one consents not to be a single being and attempts to be many beings at the same time." Fred Moten writes that "for Glissant, consent, which is not so much an act but a nonperformative condition or ecological disposition, is another way of approaching what he calls the 'poetics of relation,' " *Black and Blur: Consent Not to Be a Single Being* (Durham, NC: Duke University Press, 2017), xv.

46. Certainly, this is one of the keys to the novel *Invisible Man*, where the protagonist takes elements from heroes and villains alike (all of whom have their good points) in the improvised creation of his identity.

47. Ellison, *Invisible Man*, 9. The full quote is: "I not only entered the music but descended, like Dante, into its depths."

48. Kenneth Burke, *Attitudes Toward History* (New York: Beacon, 1959; first published 1937), 21–33; Edward Said, *Humanism and Democratic Criticism* (New York: Columbia University Press, 2004), 57–84.

49. Ralph Ellison, "Harlem's America," *The New Leader* 49, no. 19 (September 26, 1966), 23.

50. Robert Farris Thompson said this to me in conversation on July 6, 1988. Concerning insider Afro-humor, he also used the term "culturally appropriate."

51. Dizzy Gillespie with Al Fraser, *To Be or Not to Bop* (Minneapolis: University of Minnesota Press, 1979), 296.

52. Ellison, "An Extravagance of Laughter," 630, 653.

53. Albert Murray, *The Hero and the Blues* (Columbia: University of Missouri Press, 1973), 101–102.

54. This term for the jazz party's "leadership" comes from the poet/scholar Sterling A. Brown, who used it in conversation with the author on February 19, 1973. Ellison also speaks of jazz as an "institution" requiring all three elements (dance, singing, and instrumental music) to be complete. He goes on to say that the jazz party balanced school and church in grounding the Black community's sense of where and who they were. Ellison, "Remembering Jimmy," *Collected Essays of Ralph Ellison*, 275.

55. Zora Neale Hurston, "Characteristics of Negro Expression," in *Negro: An Anthology*, ed. Nancy Cunard (New York: Cunard and Wishart, 1934), reprinted in *The Jazz Cadence of American Culture*, ed. Robert G. O'Meally (New York: Columbia University Press, 1998), 298–310.

56. Denise LaSalle, "Someone Else Is Steppin' In," published in 1982; recorded by LaSalle in 1985.

57. Bessie Smith, "In the House Blues" (1931). Columbia Records, W151594.

58. W. Jackson Bate, *Negative Capability* (Cambridge, MA: Harvard University Press, 1939).

59. Ira Gitler, "Trane on the Track," *Down Beat*, October 16, 1958, reprinted in *Coltrane on Coltrane: The Coltrane Interviews*, ed. Chris DeVito (Chicago: Chicago Review Press, 2010), 41.

60. Said, *Humanism and Democratic Criticism*, 67.
61. Virginia Woolf, "Professions for Women," in *The Death of the Moth and Other Essays* (New York: Harcourt, Brace, Jovanovich, 1942), 235–242 (Italics mine); Harold Bloom, *The Anxiety of Influence: A Theory of Poetry* (New York: Oxford University Press, 1973).
62. Said, *Humanism and Democratic Criticism*, 67–68.
63. "With and against" is a paraphrase. See Ralph Ellison, "The Charlie Christian Story," *Collected Essays of Ralph Ellison*, 267: "True jazz is an art of individual assertion within and against the group."
64. Said, *Humanism and Democratic Criticism*, 63.
65. Said, *Humanism and Democratic Criticism*, 68.
66. Said, *Humanism and Democratic Criticism*, 64.
67. Ralph Ellison, "Living with Music," *High Fidelity* (December 1955); reprinted in O'Meally, *Living with Music*, ed. Robert G. O'Meally, 6.
68. William Butler Yeats, *Amica Silentia Lunae* (London: McMillan, 1918), 27–28.
69. Stanley Dance, *The World of Duke Ellington* (New York: Scribner's, 1970), 17–18.
70. Ralph Ellison, "Remembering Richard Wright," in *Collected Essays of Ralph Ellison*, 674–675.
71. Ellison, *Invisible Man*, 11.
72. DeVito, *Coltrane on Coltrane*, 126.
73. Ellison, "Twentieth-Century Fiction and the Black Mask of Human, 95.
74. Richard Lattimore, trans., *The Odyssey of Homer* (New York: Harper and Row, 1967), book XII, lines 192–193.
75. It should be added that in 1977, Bearden created a collage called *The Siren's Song* as part of his series based on Homer's *Odyssey*. His rendering of the scene revises Homer to connect Odysseus's potentially fatal will to know not only with Christ's crucifixion but also with the lynching of a Black man. See Robert G. O'Meally, *Romare Bearden: A Black Odyssey* (New York: D. C. Moore, 2008).
76. Romare Bearden and Avis Berman, "Interview with Romare Bearden, 1980 July 31." Avis Berman research material on art and artists, 1976–1988, Archives of American Art, Smithsonian Institution. Bearden also tells a version of this story in " 'Inscription at the City of Brass': An Interview with Romare Bearden, Charles H. Rowell, *Callaloo* 36 (Summer 1988), 428–446.
77. Calvin Tomkins, Papers, Museum of Modern Art Archives, New York City.
78. Ellison, *Living with Music*, 9.
79. Ellison, *Invisible Man*, 441.
80. Ellison, *Living with Music*, 264–288.
81. Louis Armstrong, *Satchmo: My Life in New Orleans* (New York: Prentice Hall, 1955), Louis Armstrong, *Swing That Music* (London: Longmans, Green, and Co., 1936), and Louis Armstrong, *Louis Armstrong in His Own Words: Selected Writings*, ed. Thomas Brothers (New York: Oxford University Press, 1999).
82. Ralph Ellison, "Change the Joke and Slip the Yoke," in *Collected Essays of Ralph Ellison*, 109.
83. Ellison, "Harlem's America," 22.
84. Dan Morgenstern said this at a conference on the history of jazz at the Smithsonian Institution, Washington, DC, on February 9, 1997.
85. André Hodeir, *Jazz: Its Evolution and Essence* (New York: Grove, 1956), 207–208.
86. Gunther Schuller, *The Swing Era: The Development of Jazz, 1930–1945* (New York: Oxford University Press, 1989), 161–162.
87. Jacqui Malone, *Steppin' on the Blues: The Visual Rhythms of African American Dance* (Urbana: University of Illinois Press, 1996), 107.

88. This story was told to me in June 1986 by Ellington's nephew, Michael James. Its authenticity was verified in 2019 by Ellington scholar Dan Morgenstern in an email to the author, May 8, 2018.

89. Ainissa Ramirez, *The Alchemy of Us: How Humans and Matter Transformed One Another* (Cambridge, MA: MIT Press, 2020), 21–22.

90. Ramirez, *The Alchemy of Us*, 22.

91. For example, check out Davis's work on his album *Jack Johnson* (Columbia Records, 1971).

92. See Leslie Gourse, *Louis's Children: American Jazz Singers* (New York: Cooper Square, 1984).

93. I adopt this term from the key book by Ellison's literary friend Stanley Edgar Hyman, *The Armed Vision* (New York: Vintage Books, 1955).

94. Edward Said, "Reflections on Exile," in *Reflections on Exile and Other Essays* (Cambridge, MA: Harvard University Press, 2000), 185.

95. Ralph Ellison, "No Regrets," *Harper's* (July 1, 1967), pp. 4–18.

96. Ralph Ellison and Albert Murray, *Trading Twelves: The Selected Letters of Ralph Ellison and Albert Murray*, ed. John Callahan (New York: Modern Library, 2000). Of course, like jazz players, blues musicians could be antagonistic or not: but either way, they could be highly playful and highly musical.

97. Ralph Ellison, letter to Albert Murray, May 18, 1956, in Ellison and Murray, *Trading Twelves*, 132.

98. Ellison, "Remembering Richard Wright," *Collected Essays of Ralph Ellison*, 678.

99. Ellison, *Invisible Man*, 5.

100. Ellison, "A Special Message to Subscribers," in *Collected Essays of Ralph Ellison*, 356, 482.

101. Ellison, *Invisible Man*, 508 (italics mine).

102. Ellison, *Invisible Man*, 173. The lyrics come from "Boogie Woogie Blues" by Count Basie and Jimmy Rushing. Here is one of the mysteriously "enigmatic women who people the blues" that Ellison seemed to have had in mind when he created Aunt Mackey of "Coupla Scalped." Ellison, "The Art of Romare Bearden," *Collected Essays of Ralph Ellison*, 695.

103. Ellison, *Invisible Man*, 193–194.

104. Ralph Ellison, "On Bird, Bird-Watching, and Jazz" (1958), reprinted in *Collected Essays of Ralph Ellison*, 265.

105. Ralph Ellison, "Golden Age, Time Past," in *Collected Essays of Ralph Ellison*, 246.

106. Ellison, "Golden Age, Time Past," 247.

107. Albert Murray, *Train Whistle Guitar* (New York: McGraw-Hill), 153.

108. See Sophie Gibb, Robin Findlay Hendry, and Tom Lancaster, eds. *The Routledge Handbook of Emergence* (London: Routledge, 2019).

109. Ellison, *Invisible Man*, 8.

110. Ellison, *Invisible Man*, 156.

2. We Are All a Collage: Armstrong's Operatic Blues, Bearden's Black Odyssey, and Morrison's *Jazz*

1. Gerald Early, " 'And I Will Sing of Joy and Pain for You': Louis Armstrong and the Great Jazz Traditions: A Review-Essay," *Callaloo* 21 (Spring/Summer 1984): 90–100.

2. For Holiday's comment, see Terry Teachout, *Pops: A Life of Louis Armstrong* (New York: Houghton Mifflin Harcourt, 2009), 324. See also Krin Gabbard, *Hotter Than That: The Trumpet, Jazz, and American Culture* (New York: Faber and Faber, 2008), 103–104;

Brent Hayes Edwards, "Louis Armstrong and the Syntax of Scat," in *Epistrophies: Jazz and the Literary Imagination* (Cambridge, MA: Harvard University Press, 2017), 27–56.

3. "Toast of the Town—Part 1 and Part 5—Track 1," Louis Armstrong House Museum, Object 1987.3.2553.

4. "The Tears of a Clown" (1967) was written by Robinson with Hank Cosby and Stevie Wonder.

5. See Henry A. Kmen, *Music in New Orleans: The Formative Years, 1791–1841* (Baton Rouge: Louisiana State University Press, 1966), 56–166.

6. Kmen, *Music in New Orleans*, 233.

7. Dan Morgenstern, *Living with Jazz* (New York: Pantheon, 2004), 21.

8. Morgenstern, *Living with Jazz*, 20.

9. See "Miserere," *The Complete Library of Congress Recordings*, prod. Jeffrey Greenberg and Anna Lomax Wood (Rounder Records, 2005). Franco Martinelli made this assertion on a panel on "Re-Mapping Jazz" at Columbia University, October 15, 2015.

10. Ricky Riccardi, *What a Wonderful World: The Magic of Louis Armstrong's Later Years* (New York: Pantheon, 2011), 49.

11. Joshua Barrett, "Louis Armstrong and the Opera," *Musical Quarterly* 76 (1992), 216–241; and hear the interview of Armstrong by Richard Hadlock, January 17, 1962, at https://youtu.be/Zb8qqKHrpjY.

12. Kmen, *Music in New Orleans*, 233.

13. Sterling A. Brown, "Folk Literature," in *A Son's Return: Selected Essays of Sterling A. Brown*, ed. Mark A. Sanders (Boston: Northeastern University Press, 1996), 223.

14. Sterling A. Brown, "The Blues," *Phylon* 13, no. 4 (1952), 286–292; Johnny Shines, "Won't You Tell Me Mama," *Johnny Shines: 1915–1992* (Wolf, 1994).

15. Ralph Ellison, "Change the Joke and Slip the Yoke," in *The Collected Essays of Ralph Ellison: Revised and Updated*, ed. John F. Callahan (New York: Modern Library, 2003), 109.

16. The scholar Aidan Levy has recently discovered that prior to this appearance on *The Ed Sullivan Show*, Armstrong and Merrill had been performing this skit in shows in Las Vegas and elsewhere. By the time of this television performance, it was a set and polished routine. See Aidan Levy, "Satchmo Playing the Clown: Pagliacci in Vegas," presented as part of the "Louis Armstrong on Tour" panel, Louis Armstrong Continuum Symposium, Lenfest Center for the Arts, New York City, October 16, 2019.

17. Letter to Marili Mardon, September 7, 1953, Louis Armstrong House Museum, catalog number 1987.9.012.

18. How fascinating that Armstrong appears in *Ebony* magazine holding a copy of *Blues People*, a radical history of Black music in America by Amiri Baraka (then Leroi Jones). See Charles L. Sanders, "Louis Armstrong: The Reluctant Millionaire," *Ebony* 20, no. 1 (November 1964), 126–146.

19. "I really think the art of painting is the art of putting something over something else," said Romare Bearden. Calvin Tomkins, "Profiles: Putting Something over Something Else," *The New Yorker* (November 28, 1977), 53–77.

20. For Bearden, see Tomkins, "Profiles"; Sidney Bechet, *Treat It Gentle* (New York: Hill and Wang, 1960), 15; Gayl Jones, *Corregidora* (Boston: Beacon, 1975), 123.

21. Here, I am paraphrasing Joseph Conrad, *Conrad's Prefaces* (London: Dent and Sons, 1937), 52.

22. Toni Morrison, "Abrupt Stops and Unexpected Liquidity: The Aesthetics of Romare Bearden," in *The Romare Bearden Reader*, ed. Robert G. O'Meally (Durham, NC: Duke University Press, 2019), 183.

23. Toni Morrison, conversation with the author, April 9, 2010.

24. See Elizabeth Alexander, *Collage: An Approach to Reading African-American Women's Literature* (Philadelphia: University of Pennsylvania, 1992); and Elizabeth Alexander, "The Genius of Romare Bearden," in *The Romare Bearden Reader*, 185–195.

25. Morrison, "Abrupt Stops and Unexpected Liquidity," 183.

26. On the term "mixtery," see the Introduction.

27. "Do I contradict myself?" wrote Whitman. "Very well then. . . . I contradict myself,/ (I am large, I contain multitudes.)" Walt Whitman, "Song of Myself," in *Leaves of Grass* (Brooklyn, NY: 1855), 55, lines 1324–1326.

28. Michel Montaigne, "Of the Inconsistency of Our Actions," in *The Complete Essays of Montaigne*, trans. Donald M. Frame (Stanford, CA: Stanford University Press, 1958), 239, 244.

29. This recalls the work of a translator of the Hebrew Bible who pointed out that the word "Adam" as an ancient Hebrew male name that also meant "human matter." When, according to the Book of Genesis, God divided Adam to make woman, he was also making man out of the single substance (the "Adam") that preceded this division. In Hebrew, "Adam" means "man," whereas the word "adama" is translated as "soil" or "earth." See Ernest I. Jacob and Walter Jacob, abridge., ed., trans., *The First Book of the Bible: Genesis, Augmented Edition, Interpreted by Benno Jacob: His Commentary* (Jersey City, NJ: KTAV, 1974), 16–17.

30. Alexander, "The Genius of Romare Bearden," 187.

31. Alexander, "The Genius of Romare Bearden," 188–189.

32. Zora Neale Hurston, "Characteristics of Negro Expression," in *The Norton Anthology of African American Literature, Vol. 1* (3rd ed.), ed. Henry Louis Gates Jr. et al. (New York: Norton, 2014), 1050–1061.

33. Bearden's statement comes in an unpublished outtake from the documentary film *Bearden Plays Bearden*, prod. Nelson E. Breen (Third World Cinema: 1981, 2012), from the Breen Archive. Elizabeth Alexander quotes Bearden as likening his collages to "precisely what the ladies (at the quilting bee) were doing." Alexander, "The Genius of Romare Bearden," 189. Her citation: *Romare Bearden: Origins and Progressions* (Detroit: Detroit Institute of Arts, 1986), 41.

34. I put it this way with thanks to contemporary artist Kerry James Marshall, among others, who have taught us that "black is a color"; that is, both a wide range of colors and a color encompassing all others.

35. See Fred C. Moten, "The Touring Machine (Flesh Thought Inside Out")," in *Stolen Life: Consent Not to Be a Single Being* (Duke University Press, 2018), 161–182; and Fred C. Moten, "Keynote," symposium on "Producing Race: Technology and the African Diaspora," Columbia University, October 28, 2011.

36. Manthia Diawara, "Conversation with Édouard Glissant Aboard the Queen Mary II (August 2009)," in *Afro Modern: Journeys Through the Black Atlantic*, ed. Tanya Barson and Peter Gorschluter, trans. Christopher Winks (London: Tate Liverpool, 2010), p. 59). Reproduced at https://www.liverpool.ac.uk/media/livacuk/csis-2/blackatlantic/research/Diawara_text_defined.pdf.

37. For "visual notions," see Albert Murray, "The Visual Equivalent of the Blues," in *Romare Bearden: 1970–1980*, ed. Jerald L. Melberg and Milton J. Bloch (Charlotte, NC: Mint Museum of Art, 1980), 23. For "something else with it," see Murray, "The Visual Equivalent of the Blues," 17–18.

38. Robert G. O'Meally, *Romare Bearden: A Black Odyssey* (New York: DC Moore Gallery, 2008).

39. "Translated" is not quite the right term here because it implies a fixed "original," when we know that Homer inherited the scenes and characters of the *Odyssey* from myriad living sources that he too was transforming. But "transforming" is not quite the right word either.

40. Charles H. Rowell, " 'Inscription at The City of Brass': An Interview with Romare Bearden," *Callaloo* 36 (Summer 1988), 428–446, 433.

41. According to the photographer Frank Stewart, Bearden's long-term assistant, this little-known undated painting may have been created as early as the mid- to late-1960s. Full disclosure: this is in the personal collection of the author.

42. This figure may be related to Jamaican traditions in which Pitchy Patchy, a figure from early Jamaican carnival, usually wears a many-colored suit of tattered cloth and is charged with keeping the festivities orderly. (Thanks to Henry Drewell for this information.) Perhaps the outstretched arms of this Bearden Cyclops are meant to evoke Kongo gestures of authority and ecstasy, as discussed by Robert Farris Thompson in *The Four Moments of the Sun: Kongo Art in Two Worlds* (Washington, DC: National Gallery of Art, 1981); Thompson quotes K. Kia Bunseki Fu-Kiau, who said that this gesture communicates "feeling ready to fly with inherent spirit," 176–177.

43. In several talks and interviews, Bearden has explained that for him—following a variety of world cultural traditions—the snake was not so much a symbol of evil temptation as of renewal, signaled by the shedding of old skins.

44. Henry John Drewal, *Mami Wata: Arts for Water Spirits in Africa and Its Diasporas* (Los Angeles: Fowler Museum at UCLA, 2008).

45. See Elaine Pagels, *Adam, Eve, and the Serpent: Sex and Politics in Early Christianity* (New York: Vintage/Random House, 1988).

46. See Farah Griffin, "Circe in Black: Homer, Toni Morrison, Romare Bearden," in *The Romare Bearden Reader*, ed. Robert G. O'Meally, 270–280.

47. Small wonder, then, that when in work after work Bearden quotes the Benin tradition, he chooses the Queen Mother, who seems to stand for an inexhaustible wellspring of Black creative capability.

48. Thus did Murray invoke "the Empress of the Blues," Bessie Smith, and her "Empty Bed Blues" (1928).

49. Collage on fiberboard, 44 1/8 x 56 1/8 inches, High Museum of Art, Atlanta, 2014.66. Other Bearden works may also involve self-portraiture, including *The Conjur Woman and the Virgin* (1978) and *New Orleans* [n.d.; perhaps it's from the artist's *Of the Blues* series, 1974)], discussed in chapter 4. And Bearden also appears in the collage already mentioned, the Billie Holiday album cover.

50. The first citation to Homer here is from *The Odyssey*, trans. Robert Fitzgerald (New York: Doubleday, 1961), Book 12, lines 58–59; the second is from *The Odyssey*, trans. Richmond Lattimore (New York: Harper & Row, 1967), Book 12, line 52.

51. Gwendolyn Brooks, "The Chicago Defender Sends a Man to Little Rock, Fall, 1957," in *The Bean Eaters* (New York: Harper & Brothers, 1960), 34.

52. Rowell, " 'Inscription at The City of Brass': An Interview with Romare Bearden," 433.

53. Ralph Ellison, "Out of the Hospital and Under the Bar," in *Soon, One Morning: New Writing by American Negroes, 1940–1962*, ed. Herbert Hill (New York: Knopf, 1968), 243–244.

54. Ralph Ellison, "The Art of Romare Bearden," in *Collected Essays of Ralph Ellison*, ed. John F. Callahan, 688.

55. Quoted in Sally Price and Richard Price, *Romare Bearden: The Caribbean Dimension* (Philadelphia, University of Pennsylvania Press, 2006, 96.

56. Emily Greenwood, "A Tale of Two O'S: Odysseus and Oedipus in the Black Atlantic," *NWIG: New West Indian Guide* 83, no. 3–4 (2009), 281–289.
57. Lattimore, *Odyssey*, Book 12, line 85.
58. Lattimore, *Odyssey*, Book 12, line 85.
59. Lattimore, *Odyssey*, Book 12, lines 106–107.
60. Lattimore, *Odyssey*, Book 12, lines 109–110.
61. Toni Morrison, "Memory, Creation, and Writing," *Thought* 59, no. 235 (December 1984), 386.
62. Morrison, "Memory, Creation, and Writing," 386.
63. Morrison, "Memory, Creation, and Writing," 386.
64. Here, I'm indirectly quoting Ralph Ellison's character Senator Sunraider in the novel *Juneteenth*, who makes such creative remembering an article of the ongoing reinvention of the United States as "a futuristic nation." "Ours is a youthful nation," says Ellison's character; "the perfection we seek is futuristic and to be made manifest in creative action." Ralph Ellison, *Juneteenth* (New York: Random House, 1999), 19–20.
65. She often refers to visual artists, including collagists, who influenced her writing. "I may be influenced by what I read," she told Mel Watkins, "but I'm just not aware of it. What I think of influences I think of painters. In *Song [of Solomon]*, for instance, I was working on a scene where Milkman is in a small Southern town—he is anxious, feeling lost, out of place—and I literally picked a painting by Edvard Munch that I had seen in Oslo, 'Evening on Karl Johan Street' I think it was, which I felt conveyed the atmosphere I wanted." Mel Watkins, "Talk with Toni Morrison," *New York Times Book Review* (September 11, 1977), 48.
66. The opera is called *Margaret Garner*.
67. See in particular her comments on music in Thomas LeClair, " 'The Language Must Not Sweat': A Conversation with Toni Morrison," *The New Republic* (March 21, 1981), 25–29.
68. Watkins, "Talk with Toni Morrison," 48.
69. Morrison, "Abrupt Stops and Unexpected Liquidity," 181.
70. Morrison, "Abrupt Stops and Unexpected Liquidity," 182. In the original speech on which this Morrison piece is based, she completed the sentence quoted here with these words: " . . .which is never a straight line." (Archive, Robert G. O'Meally).
71. Albert Murray, *The Omni-Americans: New Perspectives on Black Experience and American Culture* (New York: Outerbridge & Dienstfrey, 1970), 121.
72. The line is from "In the House Blues," composed by Smith and recorded by her in 1931. For the purposes of this discussion, Smith is treated as both a blues and a jazz singer. While her blues reputation is obvious, it is too often forgotten that she frequently appeared with jazz instrumentalists such as Fletcher Henderson and Louis Armstrong. More important, her tone, phrasing, and impulse to improvisation all identify her as one of the founders of the jazz tradition in vocal music.
73. Toni Morrison, *Jazz* (New York: Knopf, 1992), 22–23.
74. When non-sequiturs slip out from the "cracked" Violet's mouth, a patch of truth comes to light: "crackedness" as poetic clairvoyance, sometimes foreseeing danger. From certain perspectives, Violet sees cracks in scenes she observes: "seams, ill-glued cracks and weak places beyond which is anything. Anything at all. Sometimes when Violet isn't paying attention she stumbles onto these cracks, like the time when, instead of putting her left heel forward, she stepped back and folded her legs in order to sit in the street." Morrison, *Jazz*, 22, 23–25.
75. Melanie Klein, *The Writings of Melanie Klein, Vol. 1: Love, Guilt and Reparation and Other Works: 1921–1945* (New York: Free Press, 1975), 342.

76. Morrison, *Jazz*, xix (emphasis mine).

77. Morrison, *Jazz*, epigraph from "Thunder, Perfect Mind," *The Nag Hammadi*.

78. Morrison, foreword to *Jazz*, first (unnumbered) page.

79. James Van Der Zee, Owen Dodson, and Camille Billops, *The Harlem Book of the Dead* (New York: Dobbs Ferry, 1978), 84. The book includes poetry by Owen Dodson, who'd been one of Morrison's professors at Howard University. Of this particular photograph, Dodson writes, "They lean over me and say: / 'Who deathed you who, / who, who, who, who . . . / I whisper: 'Tell you presently . . . / Shortly . . . this evening . . . / Tomorrow . . .' / Tomorrow is here / And you out there safe, I'm safe in here, Tootsie."

80. Morrison, *Jazz*, 72.

81. The term, as Griffin announces, is borrowed from Jean Toomer's collage novel *Cane* (1923), a key work of the Harlem Renaissance. See Farah Jasmine Griffin, *"Who Set You Flowin'?" The African-American Migration Narrative* (New York: Oxford University Press, 1995).

82. Booker T. Washington, *A New Negro for a New Century* (Chicago: American Publishing House, 1901).

83. Morrison, *Jazz*, 123.

84. Morrison, *Jazz*, 123.

85. Morrison, *Jazz*, 129.

86. Morrison, *Jazz*, 129.

87. Morrison, *Jazz*, 89.

88. From John F. Szwed's unpublished paper, "Robert Ryman: Musician, Painter," 5, Szwed archive.

89. Morrison, *Jazz*, 63.

90. This novel's other striking musical example of jazzlike riffing involves its several references to the "How Long Daddy Blues," an early-twentieth-century composition by Ida Cox whose bold sexual truth-telling makes Alice Manfred uncomfortable. Alice connects the recorded song, echoing throughout the neighborhood, with Harlem's 1917 march against white violence in East St. Louis, Missouri; Waco, Texas; and Memphis, Tennessee. The muffled sounds of those street marchers resound throughout this novel.

91. "Sometimes a third of the way through, I'll say, 'I know this is coming out,' " Bearden told an interviewer. "As my friend Carl Holty used to say, 'Don't close your picture too quickly; keep it open until the very last, and that gives you room to maneuver.' You reach a point when all the elements seem to focus, so that the colors and the forms will set. And at that point you can relinquish the painting." Myron Schwartzman, *Romare Bearden: His Life and Art* (New York: Abrams, 1990), 38

92. Morrison, *Jazz*, 63.

93. In light of Morrison's collage aesthetic as a novelist, it is worth noting that starting in 1912, Georges Braque and Pablo Picasso included newspaper clippings in their collages, signaling the birth of a new, modern form.

94. Morrison, *Jazz*, 74.

95. Morrison, *Jazz*, 78.

96. Violet visits Alice, who as a seamstress finds the other woman's clothes so tattered that she "wanted to slap her. Instead she said, 'Take off that dress and I'll stitch up your cuff' . . . Alice was irritated by the thread running loose from her sleeve, as well as the coat lining ripped in least three places she could see." Morrison, *Jazz*, 82.

97. Violet, who's a beautician, admires Dorcas's hair (seen in a photograph and remembered from her funeral), but she can't help pondering that the dead girl's hair needed

attention. "One thing for sure, she needed her ends cut. Hair that long gets fraggely easy. Just a quarter-inch trim would do wonders." Morrison, *Jazz*, 15.

98. Ralph Ellison, "Brave Words for a Startling Occasion," in *Collected Essays of Ralph Ellison*, ed. John F. Callahan, 154.

99. Felice's name means "happy," and "they named you right," says Joe Trace, who pronounces it "with two syllables," the teenager observes, "not one, like most people do." The two pronunciations, the single-syllable one implying, unhappily, either "fleece" (to defraud) or "fleas," give her name, like those of all the novel's main characters, a telling ambiguity. Morrison, *Jazz*, 214.

100. Note that embedded in Felice's question are titles of blues-idiom classics: "How Long" and "So What?" Note too that Violet's advice comes with a number; and recall Morrison's statement that numbers force her readers to speak out loud as they read. Violet's advice to Felice is *sound*.

101. Morrison, *Jazz*, 208.

102. For this insight, I am indebted to my colleague, the Auden scholar Edward Mendelson.

103. Morrison, *Jazz*, 112–113.

104. Édouard Glissant, *Faulkner, Mississippi* (New York: Farrar, Straus and Giroux, 1996), 28.

105. Morrison, *Jazz*, 226.

106. Morrison, "Abrupt Stops and Unexpected Liquidity," 182–183.

107. Morrison, *Jazz*, 219.

3. The "Open Corner" of Black Community and Creativity: From Romare Bearden to Duke Ellington and Toni Morrison

1. Charles H. Rowell, " 'Inscription at The City of Brass': An Interview with Romare Bearden," *Callaloo* 36 (Summer 1988), 442. See also Romare Bearden and Carl Holty, *The Painter's Mind: A Study of the Relations of Structure and Space in Painting* (New York: Garland, 1981) 113–115.

2. "Bearden Statements," Calvin Tomkins interview with Romare Bearden, February 19, 1975, Calvin Tomkins Papers, Museum of Modern Art, New York. From Tomkins's working notes for his *New Yorker* profile from 1977.

3. Romare Bearden, *Of the Blues: Kansas City 4/4*, 1974, collage of various papers with paint and ink on fiberboard, 44 × 52 in. (111.8 × 132.1 cm), Michael Rosenfeld Gallery, New York. See Romare Bearden, "Encounters with African Art," in Robert G. O'Meally, ed., *The Romare Bearden Reader* (Durham, NC: Duke University Press, 2019) 168, 170.

4. Brent Hayes Edwards, "The Political Bearden," in *The Romare Bearden Reader*, 256–269. In the watershed year of 1963, about 250,000 people participated in the March on Washington, where King made his "I Have a Dream" speech. Over 10,000 civil rights sit-ins and pray-ins also were held that year. A white supremacist terrorist threw a bomb into the 16th Street Baptist Church in Birmingham, Alabama, killing four children and injuring twenty-one other people. That was also the year that Student Non-Violent Coordinating Committee (SNCC) workers organized a mass voter registration campaign in Greenwood, Mississippi. Peter M. Bergman, *The Chronological History of the Negro in America* (New York: Harper, 1969), 578–583.

5. Valerie Smith, " 'Loopholes of Retreat': Architecture and Ideology in Harriet Jacobs's *Incidents in the Life of a Slave Girl*," in *Reading Black, Reading Feminist: A Critical Anthology*, ed. Henry Louis Gates Jr. (New York: Penguin, 1990), 212–236.

6. Langston Hughes, "To You," *Amsterdam News* (January 30, 1965), 22; republished in *The Collected Poems of Langston Hughes*, ed. Arnold Rampersad (New York: Vintage, 1995), 546.

7. Albert Murray, "Bearden Plays Bearden," in *The Romare Bearden Reader*, 236–255.

8. Quoted by John Szwed in "Robert Ryman: Musician, Painter" (2018), an unpublished paper about the jazz musician who became a visual artist.

9. Myron Schwartzman, *Romare Bearden: His Life and Art* (New York: Abrams, 1990), 288.

10. Stanley Crouch, "Notes on the Program," *The Music of Thelonious Monk*, Alice Tully Hall, August 4, 1987, 12B.

11. Amiri Baraka, *The Autobiography of Leroi Jones/Amiri Baraka* (New York: Freundlich, 1984), 176. Baraka meant the red-black-green flag of Black nationalism. I'd add that that very flag of Blackness is wide enough to cover what Jorge Luis Borges called "the congress of the world"—every body (not just human bodies) on our planet.

12. Lawrence Toppman, "Romare Bearden: Painter of Memories," *Charlotte News* (October 4, 1980), 2C. In an interview with Calvin Tomkins for his *New Yorker* profile of 1977, Bearden spoke again of destruction as part of a creative process: "You have seen these photographs I'm sure of Matisse painting a picture, how he wipes the whole thing out and keeps on and on until he gets evermore definite statements. He has the initial idea which is destroyed, built again, destroyed, built again. They go to the moon and bring back rocks which they fragmentalize so they can look at them thru an electronic microscope, to see what created it all. I think this is the modern temper." "Bearden Statements," Calvin Tomkins interview with Romare Bearden, February 19, 1975, Calvin Tomkins Papers, Museum of Modern Art, New York. From Tomkins's working notes for his *New Yorker* profile from 1977.

13. See Farah Jasmine Griffin and Salim Washington, *Clawing at the Limits of Cool: Miles Davis, John Coltrane, and the Greatest Jazz Collaboration Ever* (New York: St. Martin's Press, 2008), 218–220—particularly their discussion of Coltrane's "So What" solo on the *Live at Stockholm* album (1960).

14. Toppman, "Romare Bearden: Painter of Memories." Bearden's open-corner work suggests that the artist's story, like each painting, is unfinished, still unfolding, still reaching out for others to join the creative process.

15. Édouard Glissant celebrates the unfinished and open-ended in art: "We must not tell ourselves that the indeterminate, the uncertain, the unobvious, is a weakness. We must say to ourselves that it opens our minds to unexpected forms of complexity. The tremulous thought is . . . opposed to systematic thinking. . . . [and to] the categories of quick thinking that lead to definitive and fixed conclusions . . . We understand the world better if we tremble with it." From *One World in Relation* (Ka' Yelema Productions, 2009), a film directed by Manthia Diawara.

16. Robin D. G. Kelley, *Thelonious Monk: The Life and Times of an American Original* (New York: Free Press, 2009), 291.

17. From the author's interview with Mr. Williams, June 9, 2007.

18. Created in collaboration with Bearden's friend, the novelist Albert Murray, these captions were handwritten by Bearden on the walls in the original exhibition of 1981.

19. Romare Bearden, *Romare Bearden: Profile/Part II: The Thirties*, New York: Cordier & Ekstrom, May 6 to June 6, 1981. On this subject of Black dance as a source of inspiration and historical insight, he told an interviewer that "the greatest poem written on Charles Lindbergh's flight was done at the Savoy: the Lindy hop—the dancers throwing the girls, their skirts billowing—you realize that everything it did in that way was the essence of flight. So sometimes we tend to look in the book store or the museum for our

history, while neglecting other aspects of it." (Schwartzman, *Romare Bearden: His Life and Art*, 62).

20. The collage itself depicts Hudgins not on an empty canvas but on one he shares with a singer and full orchestra. He certainly performed before, after, and alongside other artists. The caption's further point seems to be that even without accompaniment, Hudgins's pantomime could imply a full complement of the sights and sounds of other performers.

21. It should be mentioned that the crawl space in the corner of the attic of her grand-mother's house where the enslaved woman Harriet Jacobs hid for two years as she planned her escape was a monumentally significant "open corner" of Black possibil-ity. She turned this clandestine garret into a space for "garreting," for dynamic creative agency. See Valerie Smith, *Self-Discovery and Authority in Afro-American Narrative* (Cambridge, MA: Harvard University Press, 1991); and Hortense Spillers, "Mama's Baby, Papa's Maybe: An American Grammar Book," *Diacritics* 17, no. 2 (Summer 1987), 64–81. For this insight, thanks to Elleza Kelley.

22. Ellison also attacked Moynihan for proclaiming American culture more rigidly segre-gated than Ellison believed it to be. The novelist wrote in 1970:

> We are reminded that Daniel Patrick Moynihan, who has recently aggravated our social confusion over the racial issue while allegedly attempting to clarify it, is co-author of a work which insists that the American melting pot didn't melt because our white ethnic groups have resisted all assimilative forces that appear to threaten their identities. The problem here is that few Americans know who and what they really are. That is why few of these groups—or at least few of the children of these groups—have been able to resist the movies, television, base-ball, jazz, football, drum-majoretting, rock, comic strips, radio commercials, soap operas, book clubs, slang, or any of a thousand other expressions and carri-ers of our pluralistic and easily available popular culture. It is here precisely that ethnic resistance is least effective. On this level the melting pot did indeed melt, creating such deceptive metamorphoses and blending of identities, values and lifestyles that most American whites are culturally part Negro American without even realizing it.

> Ralph Ellison, "What America Would Be Like Without Blacks," in *The Collected Essays of Ralph Ellison* (New York: Modern Library, 2011), 584.

23. No phrase or label like "realism" or "naturalism" can describe the full measure of a writer's methods or view of life. Still, it is true that Ellison and Murray found themselves writing against Baldwin's, and especially Wright's, tendency to regard the Harlems of America as more of a trap than part of what Ellison called a world "of infinite possibil-ities." Ralph Ellison, *Invisible Man* (New York: Random, 1952), 576.

24. James Baldwin, "Sonny's Blues," in *Going to Meet the Man* (New York: Random House, 1965), 140.

25. Baldwin, "Sonny's Blues," 112.

26. Ralph Ellison, *Juneteenth* (New York: Random House, 1999), 20.

27. James called the benefit of walking a great city "the round ripe fruit of perambulation." Henry James, "Preface to *Princess Casamassima*," in *The Art of the Novel: Critical Pref-aces* (Chicago: University of Chicago Press, 2011), 59. See my discussion of this passage from James in chapter 5. Toni Morrison's celebrations of outdoor spaces in New York City abound in *Tar Baby* (New York: Knopf, 1981) and *Jazz* (New York: Knopf, 1992). And note Kevin Lynch, *City Sense and City Design*, ed. Tridib Banerjee and Michael

Southworth (Cambridge, MA: MIT Press, 2002), 415. "The free use of open space may offend us, endanger us, or even threaten the seat of power," he writes. "Yet that freedom is one of our essential values . . . The pleasure of an urban space freely used is. . . . the chance of interesting encounter. . . . an opportunity for the expression of self and group, unfettered by routine constraints of workplace and family."

28. Coles gave this master class in tap for Jacqui Malone's students at the Duke Ellington School of the Arts in Washington, D.C., in the fall of 1977.

29. Ralph Ellison, "Notes for Class Day Talk, Columbia University," in *Collected Essays of Ralph Ellison*, 843.

30. The order of a great city, Jacobs says,

> is all composed of movement and change, and although it is life, not art, we may fancifully call it the art form of the city and liken it to the dance—not to a simple-minded precision dance with everyone kicking up at the same time, twirling in unison and bowing off en masse, but to an intricate ballet in which the individual dancers and ensembles all have distinctive parts which miraculously reinforce each other and compose an orderly whole. The ballet of the good city sidewalk never repeats itself from place to place, and in any one place is always replete with new improvisations.

 Jane Jacobs, *The Death and Life of Great American Cities* (New York: Knopf, 1961), 65–66.

31. Vijay Iyer, "Resistance as Music," a talk at the Center for the Study of Ethnicity and Race and the Heyman Center for the Humanities, Columbia University (April 18, 2017).

32. Ralph Ellison, "Harlem's America," *The New Leader* 49, no. 19 (September 26, 1966), 25.

33. Ellison, *Invisible Man*, 440–441.

34. Claude McKay, *Harlem: Negro Metropolis* (New York: E. P. Dutton, 1940), 22.

35. Ellison, "Harlem's America," 22.

36. Ralph Ellison, jacket blurb for Jervis Anderson's *This Was Harlem: A Cultural Portrait, 1900–1950* (New York: Farrar, Straus & Giroux, 1982).

37. Ellison, jacket blurb for *This Was Harlem*.

38. Morrison, *Tar Baby*, 221–222.

39. Jacques Derrida and Anne Dufourmontelle, *Of Hospitality: Anne Dufourmontelle Invites Jacques Derrida to Respond*, trans. Rachel Bowby (Stanford, CA: Stanford University Press, 2000).

40. See *Currencies of Hospitality*, special issue of *Public* edited by Sylvie Fortin (*Public* 61, 2021).

41. Laurence Bergreen, *Louis Armstrong: An Extravagant Life* (New York: Broadway Books, 1997), 452–453.

42. Sidney Bechet, *Treat It Gentle: An Autobiography* (New York: Hill and Wang, 1960), 8.

43. Bechet, *Treat It Gentle*, 8.

44. Harriet T. Kane, *The Bayous of Louisiana* (New York: William Morrow, 1944), 2.

45. Kane, *The Bayous of Louisiana*, 7.

46. Bechet, *Treat It Gentle*, 15.

47. Bechet, *Treat It Gentle*, 11, 31.

48. In *The Undercommons*, Fred Moten and Stefano Harney write that "the undercommons, its maroons, are always at war, always in hiding." Fred Moten and Stefano Harney, *The Undercommons: Fugitive Planning & Black Study* (Brooklyn, NY: Autonomedia, 2013), 30.

49. These words, "freedom dreams," pay homage to the work of Robin D. G. Kelley, particularly to his book *Freedom Dreams: The Black Radical Imagination* (New York: Beacon, 2002).

50. Billy Miller and Michael Anderson, "The Second Stop Is Jupiter," liner notes to Sun Ra and His Arkestra's *The Second Stop Is Jupiter* (Norton LP ED-353, 2009).

51. John Szwed, *Space Is the Place: The Lives and Times of Sun Ra* (New York: Pantheon, 1997), 192–193.

52. Whitney Balliett, *New Yorker* profile of Ruby Braff, "The Center of the Note" (July 8, 1974), reprinted in Whitney Balliett, *Barney, Bradley and Max* (New York: Oxford University Press, 1989), 168.

53. Lionel McIntyre, talk at the conference "New Orleans: Rebuilding the Musical City," at Columbia University on January 26, 2006.

54. Ellison, "What America Would Be Like Without Blacks," 121.

55. Zora Neale Hurston, "Characteristics of Negro Expression," in *Negro: Anthology* (London: Nancy Cunard Wishart & Co., 1934), 29.

56. I have in mind a passage in Ellison's *Juneteenth*, in which A. Z. Hickman, the blues trombonist–turned-preacher, speaks in prayer of his jook house days: "I in all my ignorance and desperation was taught to deal with the complications of Thy plan, yes . . . I was learning to live and to glean some sense of how Thy voice could sing through the blues and even speak through the dirty dozens if only the players were rich-spirited and resourceful enough, comical enough, vital enough and enough aware of the disciplines of life. In the zest and richness Thou were there, yes!"

57. Albert Murray, *Collected Novels and Poems*, ed. Henry Louis Gates Jr. and Paul Devlin (New York: Library of America, 2018), 410.

58. The anthropological terms here come from the oeuvre of Hurston, who was trained as an anthropologist, as well as Murray and Ellison, both novelists who explicitly based their cultural theories on the early-twentieth-century myth and ritual "Cambridge group" that included James George Frazer, Gilbert Murray, and Jane Ellen Harrison. See Arnold Rampersad, *Ralph Ellison: A Biography* (New York: Knopf, 2007), 164.

59. Willis Laurence James, *Stars in de Elements: A Study of Negro Folk Music* (Durham, NC: Duke University Press, 1995), 147.

60. On the works in this series, see Stephanie Mayer Heydt et al., *"Something over Something Else": Romare Bearden's Profile Series* (Seattle and Atlanta: University of Washington Press with High Museum of Art, 2019), 77–126.

61. A Sam Shaw photograph of Ellington, circa 1960, was evidently the source for the piano player in Bearden's collage. See this image, from the Sam Shaw Family Archive, in Heydt et al., *"Something over Something Else,"* 43.

62. On the concept of "safe space," see Farah Jasmine Griffin, *"Who Set You Flowin'?": The African-American Migration Narrative* (Oxford: Oxford University Press, 1995), 9.

63. Ralph Ellison, "The Golden Age, Time Past," in *The Collected Essays of Ralph Ellison* (New York: Modern Library, 2011), 243.

64. Ellison, "The Golden Age, Time Past," 245.

65. Romare Bearden, in outtakes from the documentary film *Bearden Plays Bearden* (dir. Nelson E. Breen, Third World Cinema, PBS, 1980). Kindly provided by Nelson E. Breen.

66. This letter, dated June 6, 1951, is reproduced in Albert Murray and John F. Callahan, eds., *Trading Twelves: The Selected Letters of Ralph Ellison and Albert Murray* (New York: Random House, 2000), 19.

67. Ralph Ellison, "A Very Stern Discipline," in *The Collected Essays of Ralph Ellison*, 737.

68. Ellison, *Invisible Man*, 471–472.

69. Ellison, "Harlem's America," 23.

70. See Jacqui Malone, *Steppin' on the Blues: The Visual Rhythms of African American Dance* (Urbana: University of Illinois, 1996), 101.

71. This phrase (actually "made poetry out of being invisible") comes from *Invisible Man* and describes Louis Armstrong's achievements. Ellison, *Invisible Man*, 8.
72. Ellison, *Juneteenth*, 320.
73. Ralph Ellison, handwritten note on an early draft of *Invisible Man*, Library of Congress, Ralph Ellison Papers, Part I, Box 1, 226.
74. Hurston, "Characteristics of Negro Expression," 41–42 (italics mine).
75. From an interview with Mr. Green included in the documentary film *No Maps on My Taps* (1979).
76. Ralph Ellison and John Hersey, " 'A Completion of Personality': A Talk with Ralph Ellison," in *The Collected Essays of Ralph Ellison*, 802.
77. Frederick Douglass, *Narrative of the Life of an American Slave* (Boston: Anti-Slavery Office, 1845), 91.
78. Virginia Liston, "You Don't Know My Mind Blues" (1923).
79. Ralph Ellison, "Remembering Jimmy," in *The Collected Essays of Ralph Ellison*, 277.
80. See "Our God Is Marching On! [Selma, Alabama Speech] (1965)," in James M. Washington, ed., *Testament of Hope: The Essential Writings and Speeches of Martin Luther King* (New York: Harper Collins, 1986), 227–230.
81. James A. Forbes Jr. related this anecdote in a faculty seminar at Columbia University on "Jazz and Spirituality" (1998).
82. This was the reverend's name for Wednesday night prayer meetings at Riverside Church, starting about 1990.
83. Edward Said, *On Late Style: Music and Literature Against the Grain* (New York: Vintage, 2007).
84. Stephen Greenblatt, *Will in the World: How Shakespeare Became Shakespeare* (New York: Norton, 2010), 323–324 (italics mine).
85. I'm thinking of problematic sections of *Othello* and *The Tempest*, where the Black characters are sometimes a step away from the Black stereotypes of the Renaissance era (not to mention our own).
86. This is an oft-repeated Mark Twainism, but its source is elusive. The closest I found is Mark Twain, "Impromptu Speech, Thirteenth Reunion, Army of the Tennessee, Haverly's Theater," given in Chicago on November 12, 1879. Twain's actual quote is, "I never was happy, never could make a good impromptu speech without several hours to prepare it." Paul Fatout, ed., *Mark Twain Speaking* (Iowa City: University of Iowa Press, 1976), 130.
87. Mark Twain, *The Autobiography of Mark Twain*, vol. 3, ed. Benjamin Griffin and Harriet Elinor Smith (Oakland, University of California Press, 2015), 250.
88. Fatout, *Mark Twain Speaking*, 191.
89. Fatout, *Mark Twain Speaking*, 325–326.
90. Fatout, *Mark Twain Speaking*, 191.
91. Fatout, *Mark Twain Speaking*, 328.
92. Buck Clayton, interview with the author for the PBS documentary film *Lady Day: The Many Faces of Billie Holiday* (Toby Byron Multiprises: 1990).
93. Edison was also the solo trumpeter of choice for Frank Sinatra and Tony Bennett, among other great singers.
94. Harry Edison, interview with the author for *Lady Day*.
95. From the interview that Holiday did for the "Sound of Jazz," a CBS television appearance on December 8, 1957.
96. "The biggest thing I do in music is listen," Ellington told an interviewer. "While I'm playing I also listen ahead to what I will be playing. It may be thirty-two or just one or

merely an eighth of a bar ahead, but if you're going to try to play good jazz, you've got to have a plan of what's going to happen . . . So you listen all the time." George T. Simon, "The Main Thing: For the Duke," *New York Herald Tribune* (July 9, 1961).

97. John Szwed, *Billie Holiday: The Musician and the Myth* (New York: Viking, 2015), 165.
98. For Morton's celebrated "Black Bottom Stomp," Morton wrote the trumpet and clarinet solos to sound improvised. John Szwed, *Jazz 101: A Complete Guide to Learning and Loving Jazz* (New York: Hyperion, 2000), 101–102.
99. Clark Terry, the author's interview (March 1998) for the documentary accompanying the Smithsonian Institution Traveling Exhibition Service's show *Beyond Category: The Musical Genius of Duke Ellington*, 1999.
100. Terry, interview for *Beyond Category*.
101. Barry Ulanov, "The Ellington Programme," in Robert G. O'Meally, ed., *The Jazz Cadence of American Culture* (New York: Columbia University Press, 1998), 166–171.
102. Terry, interview for *Beyond Category*.
103. Terry, interview for *Beyond Category*.
104. See " 'Rondolet' ('Slamar in D-Flat')—The Duke Ellington Orchestra (Live in Studio)," YouTube, https://www.youtube.com/watch?v=yUA5nXx4Nww.
105. Duke Ellington, *Music Is My Mistress* (New York: Doubleday, 1973), 97.
106. Earl Hines and Stanley Dance, *The World of Earl Hines* (New York: Da Capo, 1983), 3.
107. Louis Bellson, the author's interview for *Beyond Category*.
108. Toni Morrison, "Memory, Creation, and Writing," *Thought* 59, no. 235 (December 1984), 388–389.
109. Toni Morrison, *Jazz*, xix (italics in original).
110. Toni Morrison, "Abrupt Stops and an Unexpected Liquidity," in Robert G. O'Meally, ed., *The Romare Bearden Reader*, 182.
111. Ralph Ellison, "The World and the Jug," in *The Collected Essays of Ralph Ellison*, 186.
112. Ralph Ellison, "Twentieth-Century Fiction and the Black Mask of Humanity," in *The Collected Essays of Ralph Ellison*, 291.
113. Ellison, *Invisible Man*, 439.
114. Ellison, *Invisible Man*, 11–12.

4. Hare and Bear: The Racial Politics of Satchmo's Smile

1. For a novelist's collagelike imaginary conversation between these two artists, see John Edgar Wideman, *American Histories* (New York: Scribner's, 2018), 201–222.
2. Ralph Ellison, "It Always Breaks Out," *Partisan Review* 30 (Spring 1963), reprinted in Ralph Ellison, *Three Days Before the Shooting* (New York: Modern Library, 2011), 1046.
3. The phrase "man-and-mammy-made society" is borrowed from Ellison, who used it (and variations on it) several times in fiction and essays, particularly when the subject of American vernacular culture is raised. See Ralph Ellison, *The Collected Essays of Ralph Ellison*, ed. John F. Callahan (New York: Random House, 2003), 108, 182, 442; and Ellison, *Three Days Before the Shooting*, 69, 411, 439, 685, 694.
4. James Weldon Johnson, *Black Manhattan* (New York: Knopf, 1930), 108.
5. Ellison, "Address to the Harvard College Alumni," 429.
6. Ricky Riccardi, *What a Wonderful World: The Magic of Louis Armstrong's Later Years* (New York: Pantheon, 2011), 162–168.
7. Less known is Armstrong's response to the whip and cattle-prod attacks by police on marchers in support of Black citizens attempting to vote in Selma, Alabama, in 1963.

Passing through Copenhagen on a European tour, he told Danish reporters that he was physically sickened by the violence. "Maybe I'm not on the front line," said Armstrong, "but I support them with my donations. Maybe that's not enough. My life is music. But they would beat me on my mouth. . . . They would beat Jesus if he was black and marched." He added: "How is it that human beings treat each another in this way? Hitler is dead a long time, or is he?" "Satchmo: 'They Would Beat Jesus If He Was Black,'" *Herald Tribune*, March 11, 1965, unnumbered page with no author indicated, in a clipping file of the Louis Armstrong House Archive. Quoted by Riccardi, *What a Wonderful World*, 162.

8. Riccardi, *What a Wonderful World*, 162. Also see Robert G. O'Meally, "Checking Our Balances: Louis Armstrong, Ralph Ellison, and Betty Boop," in *Uptown Conversation: The New Jazz Studies*, ed. Robert G. O'Meally, Brent Hayes Edwards, and Farah Jasmine Griffin (New York: Columbia University Press, 2004), 278–296.

9. David Margolick, "The Day Louis Armstrong Made Noise," *New York Times*, September 23, 2007, https://www.nytimes.com/2007/09/23/opinion/23margolick.html.

10. Riccardi, *What a Wonderful World*, 165.

11. See David A. Nichols, *A Matter of Justice: Eisenhower and the Beginning of the Civil Rights Revolution* (New York: Simon and Schuster, 2008). Penny Von Eschen reports that Eisenhower's foreign policy decisions were sometimes driven by the fact that he "did not believe that a black African was capable of independent political thought." Penny Von Eschen, *Satchmo Blows up the World* (Cambridge, MA: Harvard University Press, 2004), 66.

12. Eisenhower was pressed not only by Armstrong but by many other critics of his stance on Little Rock. Still, Armstrong's immense popularity and worldwide renown made him a particularly effective spokesman.

13. Carmichael wrote and first recorded the song in 1929.

14. "Louis Armstrong, Rockin' Chair," Gold Standard Series (RCA Victor, EPA-5000 H2PH-3556), 1957. See the performance at the 1958 Newport Jazz Festival in *Jazz on a Summer's Day* (Bert Stern and Aram Avakian, 1959), or on December 30, 1957, in New York (https://www.youtube.com/watch?v=eOxx1-LIAWA).

15. For the 1930 recording of "Rockin' Chair," see *The Indispensable Bix Beiderbecke 1924–1930* (RCA, 1983).

16. Richard Meryman, *Louis Armstrong: A Self-Portrait* (New York: Eakins Press, 1971), 27. It also could be misinterpreted that Armstrong placed a picture of Teagarden on the ceiling of his home in Queens, New York. Some might ask, "What's that white man doing on your ceiling, Brother?!" The answer is that Tea was a much-admired, close friend.

17. "As Emerson insisted, the development of consciousness, consciousness, *consciousness*. And with consciousness, a more refined conscientiousness, and most of all, that tolerance which takes the form of humor, for when Americans can no longer laugh at each other, they have to fight one another." Ralph Ellison, "Address to the Harvard Alumni, Class of 1949," in *The Collected Essays of Ralph Ellison*, 429.

18. Henry James writes specifically of the challenges confronting Nathaniel Hawthorne on the culturally "blank" terrain of that novelist's native New England: Henry James, *Hawthorne* (New York: Harper Brothers, 1880); reprinted in Henry James, *Henry James Literary Criticism: Essays on Literature, American Writers, English Writers* (New York: Library of America, 1984), 1:351–352.

19. James, *Hawthorne*, 352.

20. Henry James, *The American* (Auckland: The Floating Press, 2011, original 1877), 5.

21. James, *The American*, 48.

22. Henry James, Preface to "The Lesson of the Master" (1907), reprinted in Henry James, *Henry James, Literary Criticism: French Writers, Other European Writers, Prefaces to the New York Edition* (New York: Library of America), 2:1229.

23. It would be a stretch to compare Newman's humor, or Armstrong's, to that of Frederick Douglass, whose platform speeches could evoke a dry laughter, but whose irony was typically barbed by humor several degrees more fiercely unsparing than theirs. And yet Douglass was so self-aware and aware of America's faults. The humors of Douglass and Armstrong were distant cousins but nonetheless *related*.

24. Second and third readings of *Invisible Man* can lead to LOL hilarity. Take, for example, the scene in chapter 25 where Harlemites observe Ras and the rioters. Ralph Ellison, *Invisible Man* (New York: Random House, 1952), 424–425.

25. Ellison refers to James on "the American joke" in "Society, Morality, and the Novel" (1957) and "Going to the Territory" (1980), republished in *The Collected Essays of Ralph Ellison*, 722. He also refers to the passage by James in "The World and the Jug" (1964), republished in *The Collected Essays of Ralph Ellison*, 167.

26. Ralph Ellison, "Going to the Territory," in *The Collected Essays of Ralph Ellison*, 607. Ellison jabs at James for missing the poetry and wisdom of American vernacular speech in general, which James scorns as "the bastard vernacular," dipping to "unutterable depths." See Henry James, Preface to "Daisy Miller" (1907), reprinted in *Henry James, Literary Criticism: French Writers, Other European Writers*, 1280; and Ralph Ellison, *Selected Letters of Ralph Ellison*, ed. John Callahan (New York: Random House, 2019), p. 825.

27. Ellison, "Society, Morality, and the Novel," 722.

28. Ralph Ellison, "Homage to Duke Ellington on His Birthday," *Washington Star*, April 27, 1969, reprinted in Ralph Ellison, *Living with Music*, ed. Robert G. O'Meally (New York: Modern Library, 2001), 84. See also Ralph Ellison, "Alain Locke Symposium" (1974), reprinted in Ralph Ellison, "Alain Locke," in *The Collected Essays of Ralph Ellison*, 449. "When Americans, all Americans, began to dance on the popular stage or wherever, one place they could look and be sure that they were Americans was back there in those slave yards, and later the Negro dance halls and juke joints where that original American choreography had found its direction."

29. Henry Louis Gates Jr., *The Signifying Monkey: A Theory of Afro-American Literary Criticism* (New York: Oxford University Press, 1988); Robert Farris Thompson, "African Art and Motion" (1974), reprinted in *Jazz Cadence of American Culture*, ed. Robert G. O'Meally (New York: Columbia University Press, 1998), 311–371.

30. Quoted in Lawrence Levine, *Black Culture and Black Consciousness* (New York: Oxford University Press, 1977), 17.

31. Jean and Marshall Stearns, *Jazz Dance: The Story of American Vernacular Dance* (New York: McMillan, 1968), 22.

32. Maurice Peress, *Dvořák to Duke Ellington: A Conductor Explores America's Music and Its African American Roots* (New York: Oxford University Press, 2004).

33. One problem with discerning the humor in the blues as conceived by the Black communities and artists who invented the form is that according to the racist white American stereotype, Blacks were nothing but funny (or pathetic or dangerous) anyhow. "By popular logic what was Negro was conceived to be funny," writes the scholar/poet Sterling A. Brown. "Bessie Smith, the great blues singer, was first labelled as a 'comedienne,' for instance—and music in the Negro idiom was tricked out to stir laughter. Comic devices were urged by the entrepreneurs." Sterling A. Brown, "Stray Notes on Jazz" (1946),

reprinted in *Sterling A. Brown: A Son's Return*, ed. Mark A. Sanders (Boston: Northeastern University Press, 1996), 266–267.

34. Nathaniel Mackey, "Sound and the Sentiment," in *Discrepant Engagement: Dissonance, Cross-Culturality, and Experimental Writing* (Cambridge: Cambridge University Press, 1994), 252–253.

35. Barry Ulanov, *Duke Ellington* (New York: Creative Age, 1946), 276.

36. This exchange is recorded in the documentary *A Duke Named Ellington*, directed by Terry Carter (*American Masters*, Season 3, Episode 2, Eagle Rock Entertainment, 1988).

37. Ellison, "Homage to Duke Ellington on His Birthday," 85.

38. James, Preface to "The Lesson of the Master," 1230.

39. James, Preface to "The Lesson of the Master," 1230.

40. Ellison, "Address to the Harvard College Alumni," 425.

41. Ralph Ellison, "What America Would Be Like Without Blacks," *Time* (April 6, 1970); reprinted in *The Collected Essays of Ralph Ellison*, 586. In this essay, Ellison also says that the American nation "could not survive being deprived of their [the Blacks'] presence because, by the irony implicit in the dynamics of American democracy, they symbolize both its most stringent testing and the possibility of its greatest human freedom." *The Collected Essays of Ralph Ellison*, 587–588.

42. Ellison, "Address to the Harvard College Alumni," 429.

43. Michael Holroyd, *Bernard Shaw: The One-Volume Definitive Edition* (New York: Random House, 1998), 767.

44. Ellison, *Selected Letters*, 426–428, 710–718.

45. Ellison, *Selected Letters*, 486.

46. Sterling A. Brown, "The Blues as Folk-Poetry" (1930), reprinted in *Jazz Cadence of American Culture*, 540–551.

47. Ralph Ellison, "American Humor, An Address of Ralph Ellison" (1970), unpublished, included as an appendix to Elwyn Breaux's dissertation *Comic Elements in Selected Prose Works by James Baldwin, Ralph Ellison, and Langston Hughes* (Stillwater: Oklahoma State University, 1971), 148. Of course, Ellison knew very well that slavery and the Jim Crow system murdered and maimed, scarred and battered many thousands of Africans, something that is by no means a matter to be laughed away.

48. One source of the image of the undiscardable item may have been "Abu Kasem's Slippers," in Heinrich Zimmer, *The King and the Corpse: Tales of the Soul's Conquest of Evil* (Princeton, NJ: Princeton University Press, 1948; reprinted in 1971), 9–25. More, shortly, on Herman Melville as another source of this image.

49. For this concept, developed by Ellison's contemporary Kenneth Burke, see chapter 1.

50. Ellison, "It Always Breaks Out," 1055.

51. Ellison, "It Always Breaks Out" (italics in the original), 1055.

52. For Burke on comedy, see Kenneth Burke, *Attitudes Toward History* (New York: New Republic, 1937), 39–44.

53. See Ralph Ellison, "Introduction," *Invisible Man* (thirtieth anniversary edition, New York: Random House, 1982), 2.

54. Ralph Ellison, "Flying Home" (1944), reprinted in Ralph Ellison, *Flying Home and Other Stories* (New York: Random House, 1996), 147–173.

55. Ellison, "Society, Morality, and the Novel," 722.

56. Ellison, "Alain Locke Symposium," 449.

57. Ellison, "What America Would Be Like Without Blacks," 585.

58. Richard Wright, *Black Power* (1954), reprinted in *Black Power: Three Books from Exile* (New York: Harper Collins, 2008; italics added).

59. On the centrality of Blacks in America's culture and democracy, in Ellison's view, see his essay "What America Would Be Like Without Blacks."

60. In letters, Ellison tells friends that *Invisible Man's* toy bank in the shape of the head of a Negro that rolls his eyes when fed coins is based on "Guinea," Melville's Black beggar in *The Confidence-Man*, who catches tossed coins (some of them buttons) in his open mouth that's "at once target and purse." Ellison, *Selected Letters*, 358, 481. Herman Melville, *The Confidence-Man* (1857), reprinted in Herman Melville, *Pierre, Israel Potter, The Piazza Tales, The Confidence-Man, Uncollected Prose, Billy Budd* (New York: Library of America, 1984), 850.

61. Ralph Ellison, "Working Notes for Invisible Man," in *The Collected Essays of Ralph Ellison*, 342–350.

62. In a letter to Stanley Edgar Hyman, Ellison says that the "P." in Rinehart's name stands for "Proteus." "Change the Joke and Slip the Yoke" (1958), reprinted in *The Collected Essays of Ralph Ellison*, 110.

63. Ellison, *Invisible Man*, 509–510.

64. The Armstrong cover appeared in *Time* 53, no. 8 (February 21, 1949).

65. Gary Giddins, *Satchmo* (New York; Anchor, 1988), 168.

66. Riccardi, *What a Wonderful World*, 35.

67. Robert C. Toll, "Minstrels, Minstrelsy," *Encyclopedia of African-American Culture and History*, Volume 4, ed. Jack Salzman, David Lionel Smith, and Cornel West (New York: Simon and Schuster, 1996), 1811; see also Robert C. Toll, *Blacking Up: The Minstrel Show in Nineteenth-Century America* (New York: Oxford University Press, 1974).

68. Harold Flender, *Paris Blues* (New York: Ballantine, 1957), 2.

69. Riccardi, *What a Wonderful World*, 35.

70. W. E. B. Du Bois, ed., *Economic Cooperation Among American Negroes* (Atlanta: Atlanta University Press, 1907), 96; thanks to Jacqui Malone's *Steppin' on the Blues: The Visible Rhythms of African American Dance* (Urbana: University of Illinois Press, 1996) for steering me to Du Bois.

71. John Blassingame, *Black New Orleans 1860–1880* (Chicago: University of Chicago Press, 1973), 147.

72. Du Bois, *Economic Cooperation*, 96.

73. Malone, *Steppin' on the Blues*, 9–22. Sublette, *The World That Made New Orleans*, 112–115.

74. Samuel A. Floyd, Jr., *The Power of Black Music* (New York: Oxford University Press, 1995), 83.

75. Robert Farris Thompson, "Recapturing Heaven's Glamour: Afro-American Festivalizing Arts," in *Caribbean Festival Arts: Each and Every Bit of Difference*, ed. John W. Nunley and Judith Bettelheim (Seattle: University of Washington Press, 1988), 17.

76. Louis Armstrong, "Letter to Jane Holder, February 9, 1952," in *Louis Armstrong in His Own Words*, ed. Thomas Brothers (New York: Oxford University Press, 1999), 151.

77. Shane Lief and John McCusker, *Jockomo: The Native Roots of Mardi Gras Indians* (Jackson: University Press of Mississippi, 2019), 88–89. Lief and McCusker report that according to Louis Armstrong, one year Willie Armstrong dressed for Mardi Gras in a white bodysuit and a monkey mask.

78. Gilbert Murray, *A History of Ancient Greek Literature* (New York: D. Appleton and Company, 1900), 211. Murray observes that fragments of Aristotle's writings on comedy suggest this "easy to see" definition of comic drama as purgation through nearly unbearable excesses of onstage frivolity.

79. Ned Sublette, *The World That Made New Orleans: From Spanish Silver to Congo Square* (Chicago: Chicago Review Press, 2008), 37.

80. Sublette, *The World That Made New Orleans*, 38.
81. Daniel H. Usner Jr., *American Indians in Early New Orleans: From Calumet to Raquette* (Baton Rouge: Louisiana State University Press, 2018), 117–118; see also Lief and McCusker, *Jockomo*.
82. Usner, *American Indians in Early New Orleans*, 118.
83. Louis Armstrong, *Satchmo: My Life in New Orleans* (New York: Prentice Hall, 1954), 127–128.
84. Ishmael Reed, *Shrovetide in Old New Orleans* (New York: Doubleday), 1978), 29.
85. "History of the Zulu Social Aid and Pleasure Club," researched by Clarence A. Becknell, Thomas Price, and Don Short (http://www.kreweofzulu.com/history).
86. "History of the Zulu Social Aid and Pleasure Club."
87. The language here comes from *19 Necromancers from Now: An Anthology of Original American Writings for the 1970s*, ed. Ishmael Reed (New York: Anchor, 1970), specifically the epigraph by Charles Marowitz.
88. One of Armstrong's favorite pastimes, he told a friend in the early 1950s, was "using a lot of scotch tape . . . to pick out different things during what I read and piece them together and making a little story of my own." Quoted in Marc Miller, *Louis Armstrong: A Cultural Legacy* (Seattle: University of Washington Press, 1994), 212. The original letter is from Armstrong to Mrs. Marili Mardon (September 27, 1953), Louis Armstrong Archives, Queens College, City University of New York.
89. He moved to New York briefly in 1924 and then to stay in 1943.
90. Armstrong rerecorded "King of the Zulus" for his *Musical Autobiography* (Decca, 1957); reissued on *Louis Armstrong: New and Revised Musical Autobiography, vol. 1* (Storyville Records, 2001), this time as more of a feature for trumpet. In his spoken introduction for this performance, Armstrong said: "Here's a song that we did that was all about one of the big events of the year in my hometown, the Zulu parade in Mardi Gras week. We dedicated this tune to the man that was elected king of the parade that year [1926, Joseph L. Smith]. But it wasn't until 1949, twenty-three years after I made this record, that they elected Satchmo to be the king of the Zulus. That West Indian accent you will hear near the beginning is our trombonist, Trummy Young." In his article on the difficulty of articulating lived experience in language, Michael Collins writes about this later version of the song: "Maybe only Armstrong who turned the chronic hunger of his childhood into an epic 'chitterling rag' . . . can sufficiently seed history with the imaginal to turn the flight of meaning into something that blesses. . . . [T]he song celebrating the King makes jouissance out of Armstrong's memories of a childhood and a neighborhood wracked by want and death but blessed by what guitarist Danny Barker called the "aurora borealis" of music." Michael Collins, "Signifying in New Orleans: Notes on a Journey into the Imaginal," *Callaloo* 32, no. 2 (Spring 2009), 9–10.
91. In the early 1950s, Bearden experimented with writing song lyrics. One of his cocompositions, "Sea Breeze," was recorded by several jazz artists, including Dizzy Gillespie, Tito Puentes, and Branford Marsalis. (See the Branford Marsalis CD *Romare Bearden Revealed*, Marsalis Music, 2016). Before settling on visual art as his profession, Basquiat played clarinet and percussion in Lower East Side bands, collected jazz records, and often spoke of jazz in particular as an inspiration. See Evan Haga, "Basquiat and Jazz: A Guide," *TIDAL* (July 2, 2019), https://tidal.com/magazine/article/basquiat-and-jazz-a-guide/1-55590.
92. The collages from the *Paris Blues* project are currently at the DC Moore Gallery, New York, after many years in a private collection where they were out of the public eye.
93. Armstrong may also appear in Bearden's collage *Show Time*, from the *Of the Blues* series (1974). The handkerchief and trumpet held by the singer on the work's left, as well as his smiling, masklike face, suggest this.

94. It's important to regard this particular *King Zulu* piece alongside Basquiat's other works bearing this same title. One that is deeply ambiguous shows the image of Armstrong as King Zulu, side-captioned with the word "SCHWARZ" (which means "black" in several European languages, and also in certain contexts the equivalent of the American n-word) repeated five times. Beneath these words appear "NERO" ("black" in Italian, and also the name of the notorious Roman emperor) and then "BLACK," which can serve as a racial slur as well as a term of praise and pride. These ambivalent terms pose questions, not answers, about Basquiat's take on Armstrong.

95. Bearden's *Storyville* paintings and collages of 1973–1974 are in the celebratory category as well. Bearden associates them with fantastically beautiful women and with the Black music made in such places. One bordello scene in the *Profile* series, *Railroad Shack Sporting House*, depicts a woman that the artist recalls as his childhood girlfriend Liza's mother. On this work's back wall is what appears to be the portrait of a high school girl—perhaps the sex worker, perhaps her daughter—a reminder of the layeredness of this woman's life. Bearden's Storyvilles quote the odalisques of Jean Auguste Ingres and Henri Matisse, as well as the Storyville photographs of Ernest Bellocq.

96. Quite often, Bearden's protected ones are African-masked young women watched over by African-masked female elders, guard-mothers. Consider, for example, his collages *Susannah in Harlem* (1980) and *Prelude to Farewell* (1981)—both in his *Profile* series, part 2.

97. Sharon F. Patton, *Romare Bearden: Narrations* (Purchase, NY: Newberger Museum of Art, 2002).

98. Romare Bearden, "Rectangular Structure in My Montage Paintings" (1969), reprinted in *The Romare Bearden Reader*, ed. Robert G. O'Meally (Durham, NC: Duke University Press, 2019), 125. See also my discussion of Bearden's use of the "open corner" in chapter 3.

99. This despite Bearden's critique of the early European Cubists as insufficiently aware and respectful of the cultural/historical settings from which African art's drums and masks drew meaning, among his other critiques.

100. Toni Morrison spoke of a Bearden watercolor depicting "a row of Preservation Hall–type musicians, standing before a riverboat, all in white, with their traditional sashes of color. For the first time in a representation of black jazz musicians, I saw stillness—not the active, frenetic, unencumbered physical movement normally seen in reproductions or renderings of musicians, but the quiet at the center. It was, in a word, sacred, contemplative. A glance into an otherwise obscured aspect of their art." Toni Morrison, "Abrupt Stops and Unexpected Liquidity," *The Romare Bearden Reader*, 183–184.

101. Shaw took these pictures in the summer of 1961 in connection with his production of the film *Walk on the Wild Side* (1962). Along with the musicians already named, this photo presents the saxophonist Manuel Paul over the central figure's right shoulder. Behind Paul is the trumpeter Kid "Sheik" Colar (with his face partially obscured). Ernest Poree is the distant sax behind the middle shot of Wilbert Tillman (to the left of "NEW ORLEANS"). Manuel Paul is the top-left sax, and Albert Warner is the trombonist at the lower left.

102. "Putting Something over Something Else," a *New Yorker* profile by Calvin Tomkins (1977), reprinted in *Something over Something Else: Romare Bearden's Profile Series* (Seattle: University of Washington, 2019), 147 (italics mine).

103. Frank Driggs and Harris Lewine, *Black Beauty, White Heat: A Pictorial History of Classic Jazz, 1920–1950* (New York: William Morrow, 1982), 46.

104. bell hooks, "Altars of Sacrifice, Re-membering Basquiat," in *Outlaw Culture: Resisting Representations* (London: Routledge, 1994), 29.

105. Originally, "Jim Crow" was a dance/song in a white performer's blackface minstrel routine, copied from a Black man. It became the moniker for the racial segregation laws enacted in the United States between 1876 and 1965.

106. James Baldwin, "Sonny's Blues," in *Going to Meet the Man* (New York: Dial, 1965), 104.

107. Francesco Martinelli, "Jazz-thetics: King Zulu l'Enigma Jazz di Basquiat," in *Musica Jazz* (February 2010), 41–42.

108. Armstrong, *Satchmo*, 230–231.

109. My examination of this painting owes a great deal to Martinelli, "Jazz-thetics." Special thanks also to Daniel Soutif, curator and scholar of both musical and visual art.

110. Armstrong, *Satchmo*, 240–241.

111. Armstrong, *Satchmo*, 1924.

112. Driggs and Lewine, *Black Beauty, White Heat*, 318.

113. Quoted in Dan Morgenstern, *Living With Jazz* (New York: Pantheon, 2009), 17.

114. Ralph Ellison, "On Bird, Bird-Watching, and Jazz" (1962), in Ellison, *Living with Music*, ed. Robert G. O'Meally, 70. In this context of clownish jazz artists, note that the brilliant pianist/composer Fats Waller routinely served his fantastically layered and alluring forms of art behind a face mask of "rollicking buffoonery." (See Brown, "Stray Notes," 272.)

115. Karl Koenig, *Under the Influence: Four Great Hornsmen of New Orleans Early Jazz* (1994), https://basinstreet.com/, 9.

116. Driggs and Lewine, *Black Beauty, White Heat*, 23.

117. Morgenstern, *Living with Jazz*, 10.

118. Henry John Drewel, "Sensiotics, or the Study of the Senses in Material Culture and History in Africa and Beyond," in *The Oxford Handbook of History and Material Culture*, ed., Ivan Gaskell and Sarah Anne Carter (New York: Oxford University Press, 2020), 275–294.

119. From Steve Lacy's list of "Thelonious Monk's 25 Tips for Musicians" (1960), https://www.openculture.com/2017/12/thelonious-monks-25-tips-for-musicians-1960.html. It should be noted that the preeminent Monk scholar Robin D. G. Kelley has cast serious doubt on the authenticity of this quote from Lacy. See Robin D. G. Kelley, *Thelonious Monk: The Life and Times of an American Original* (New York: Free Press, 2009), 525.

120. Dizzy Gillespie with Al Fraser, *To Be or Not to Bop* (New York: Doubleday, 1979), 296.

121. Von Eschen, *Satchmo Blows up the World*.

122. Von Eschen, *Satchmo Blows up the World*, 68.

123. Von Eschen, *Satchmo Blows up the World*, 66–67.

124. Armstrongians cannot help recalling his response, in a London theater where King Edward was in attendance, to the injunction that performers never directly address the king. Midconcert, Armstrong shouted up to the royal box, "This is for you, Rex." And then he played "I'll Be Glad When You're Dead, You Rascal You!" *Satchmo the Great* (Columbia LP-42259), with Armstrong and Murrow (1957).

125. Von Eschen, *Satchmo Blows up the World*, 62–63. See the video at https://www.youtube.com/watch?v=V2XrVX-pUJQ.

126. Robert Raymond, *Black Star in the Wind* (London: MacGibbon and Kee, 1960), 19.

127. *Satchmo the Great*.

128. John Collins, *West African Pop Roots* (Philadelphia: Temple University Press, 1992), 177. There's a long tradition of American jazz drummers, and then of jazz drummers everywhere, doing comedy. Certainly this was true of virtuoso drummers such as Baby Dodds, who recorded with Armstrong units off and on from 1923 to 1947, and Sonny Greer, a master percussionist in early and later Ellington bands, who played skins, cymbals, bells, and whistles. As Dodds says in an important interview, the true jazz drummer was responsible not just for fun and jokes but also for maintaining a light

and joyous spirit on the bandstand. Often with witty remarks heard by the band but not (usually) by the audience, or with jokes embedded in the drumming style itself, Dodds could remind colleagues what the music was all about: to remove a jazz room's "evil spirits," as he called them, and to make players and listeners alike feel joyously welcomed by the music. See Chip Stern's transcript of the Dodds interview with Bill Russell at http://www.chipstern.com/chip_tribal_baby.htm.
129. Kwabena N. Bame, *Come to Laugh: African Traditional Theatre in Ghana* (New York: Lilian Barber, 1985), 8.
130. See Collins, *West African Pop Roots*, 177–181; Bob Neiland, "Ajax Grows Grassroots Appeal," *Times Colonist* (November 19, 1973), 21.

5. The White Trombone and the Unruly Black Cosmopolitan Trumpet, or How *Paris Blues* Came to Be Unfinished

1. According to Sam Shaw, the movie's producer, the only time that Ritt "had the temerity" to interfere with Duke Ellington's decisions for the soundtrack was on this point. Ritt did not want to use any of Ellington's regular trombonists, not even the exceptional Lawrence Brown. Ritt insisted on a player with the "sweet" West Coast sound associated mainly with white players, so he hired Murray McEachern, a (white) Canadian alumnus of the Benny Goodman Orchestra who was active on the Los Angeles studio scene. McEachern also "ghosted" for Jimmy Stewart playing Glenn Miller in *The Glenn Miller Story* (1954). Audiotape of interview of Sam Shaw by David Hajdu at a meeting of the Duke Ellington Society, April 21, 1994, from the archive of the Duke Ellington Society.
2. Ralph Ellison, *Invisible Man* (New York: Random House, 1952), 103.
3. On this view of binaries, see Yves Citton, *Contre-Courant Politiques* (Paris: Fayard, 2018), 9–17.
4. Kurt Dietrich, *Duke's 'Bones: Ellington's Great Trombonists* (Rottenburg, Germany: Advance Music, 1995), 195–204.
5. Dan Morgenstern, liner notes to *Louis Armstrong & Duke Ellington: The Great Summit/Complete Sessions/Deluxe Edition* (Roulette Jazz 724352454822, 2000).
6. See Brent Hayes Edwards, "Rendez-vous in Rhythm," *Connect* 1 (Fall 2000): 182–190, and Krin Gabbard, "*Paris Blues*: Ellington, Armstrong, and Saying It with Music," in *Uptown Conversation: The New Jazz Studies*, ed. Robert G. O'Meally, Brent Hayes Edwards, and Farah Jasmine Griffin (New York: Columbia University Press, 2004), 297–311.
7. According to Morgenstern, the exceptions are a 1946 all-star session "that allowed for minimal interaction" between the two stars, and a 1959 Timex television broadcast ("no taping then," says Morgenstern) of a cut-short version of "Perdido" that featured Duke's band with "Satch riding over the ensemble"; see Morgenstern, *Louis Armstrong & Duke Ellington*. For a full set of Ellington and Armstrong working together, this Roulette Jazz reissue, containing outtakes and studio talk, is indispensable.
8. See Romare Bearden, "Rectangular Structure in My Montage Paintings," in *The Romare Bearden Reader*, ed. Robert G. O'Meally (Durham, NC: Duke University Press, 2019), 121–132.
9. Herbert Mitgang, "Sam Shaw Sings the 'Paris Blues,' " *New York Times*, November 5, 1961, X7.
10. See, respectively: Myron Schwartzman, *Romare Bearden: His Life and Art* (New York: Abrams, 1990), 167; and *The Art of Romare Bearden*, ed. Ruth Fine (Washington, DC: National Gallery of Art, 2003), 220.

11. Michel Fabre makes the point that many French people were mystified and horrified by white American racism, and that Black servicemen were particularly valued for their cultured manners and their grace under the pressure of mistreatment by their white colleagues. See Michel Fabre, *From Harlem to Paris: Black American Writers in France, 1840–1980* (Urbana: University of Illinois Press, 1991), and Tyler Stovall, *Paris Noir: African Americans in the City of Light* (Boston: Houghton Mifflin, 1996).

12. Shaw, from the audiotape of the Duke Ellington Society meeting.

13. *Billy Wilder: Interviews*, ed. Robert Horton (Jackson: University of Mississippi Press, 2002), 124.

14. Conversation with Lorie Karnath, February 2018; see also her book, *Sam Shaw: A Personal Point of View* (Stuttgart: Hatje Cantz, 2010).

15. Mary Schmidt Campbell, *American Odyssey: The Life and Work of Romare Bearden* (New York: Oxford University Press, 2018), 147–148.

16. Shaw, from the audiotape of the Duke Ellington Society meeting.

17. Shaw, from the audiotape of the Duke Ellington Society meeting.

18. Shaw, from the audiotape of the Duke Ellington Society meeting.

19. Ellington scholars have recorded his itineraries in meticulous detail. See W. E. Timner, *The Recorded Music of Duke Ellington and His Sidemen* (New York: Scarecrow Press, 2002); Ken Vail, *Duke's Diary: The Life of Duke Ellington, Parts One and Two* (New York, 2002); Klaus Stratemann, *Duke Ellington: Day by Day and Film by Film* (Copenhagen: JazzMedia, 1992).

20. This story was told to me in June 1986 by Ellington's nephew, Michael James.

21. Mitgang, "Sam Shaw Sings the 'Paris Blues,'" X7.

22. Ellington also provided the score for a little-known sci-fi film called *Change of Mind* (1969), in which a white man's brain is transplanted into the body of a Black man.

23. See Edward Said's discussion of such productive unease in *Reflections on Exile and Other Essays* (Cambridge, MA: Harvard University Press, 2003), 185; see also Richard Wright's "I Choose Exile," draft, corrected typescript (c. 1950), Box 6, folder 110, Richard Wright Papers, Beinecke Rare Book and Manuscript Library, Yale University.

24. Terry Carter, dir., *A Duke Named Ellington*, documentary film (The Council for Positive Images, 1988).

25. John Szwed, "The Antiquity of the Avant Garde: A Meditation on a Comment by Duke Ellington," in *People Get Ready: The Future of Jazz Is Now! (Improvisation, Community, and Social Practice)*, ed. Ajay Heble and Rob Wallace (Durham, NC: Duke University Press, 2013), 56–57.

26. Both statements are as quoted in Adam Bradley, *Ralph Ellison in Progress: The Making and Unmaking of One Writer's Great American Novel* (New Haven, CT: Yale University Press, 2010), 45.

27. Quoted in Bradley, *Ralph Ellison in Progress*, 45.

28. For "Congress of the World," see Jorge Luis Borges, "The Congress," in *The Book of Sand* (New York: Dutton, 1977), 27–50. This unruly Black cosmopolitanism is not unique to Ellington and Strayhorn. It extends to the will on the part of so many of the artists in this project to create new works that exult in crossing the usual borders of disciplinary affiliation and lineage.

29. David Hajdu, *Lush Life: A Biography of Billy Strayhorn* (New York: Farrar, Straus and Giroux, 1996), Kindle location 3633.

30. Shaw, from the audiotape of the Duke Ellington Society meeting.

31. Mercer Ellington with Stanley Dance, *Duke Ellington in Person: An Intimate Memoir* (Boston: Houghton Mifflin, 1978), 183.

32. Shaw, from the audiotape of the Duke Ellington Society meeting.

33. Shaw, from the audiotape of the Duke Ellington Society meeting. How early script ideas of gay and lesbian romance fell away is not clear, but presumably, they also were rejected out of hand.

34. Filmed entirely in Paris, with key scenes shot at the Cirque d'Hiver, *Trapeze* yielded Shaw's outstanding portraits of Burt Lancaster, Tony Curtis, and Gina Lollobrigida, as well as ones of circus performers—including circus shots of Lancaster, who was a former acrobat. Some of these pictures by Shaw would figure in his (and Bearden's) *Paris Blues* collage book—with the aesthetic of upward free flight that we see in Bearden's maps of the city, also included in the book.

35. "Birth of a Baby," *Time* magazine, March 5, 1956, 73.

36. Sam Shaw, unpublished interview in the David Hajdu archive; Lorie Karnath, *Sam Shaw*, 170; and conversations and email exchanges with Flender's daughter, Nicole, November 2016 to October 2018.

37. Mitgang, "Sam Shaw Sings the 'Paris Blues,'" X7.

38. Author's telephone conversation with Meta Shaw Stevens, July 19, 2018. For a taste of clarinetist Jess Bearden, see Harold Flender, *Paris Blues* (New York: Ballantine, 1957), 118, 124, 126–127; for Meta, see 145–46.

39. Given how unsafe it was for Blacks to walk the city streets of then-even-more-segregated America, or—sometimes worse yet—its country roads, whether in the North or the South, particularly at night, Eddie's speech on inspirational street-stepping through nighttime Paris is another marker of his aspiration toward true unruly Black cosmopolitanism—which I see as the film's subterranean theme.

40. Actually Eddie is slightly misquoting James, who describes walking London's streets as "the ripe round fruit of perambulation." Preface to *The Princess Casamassima* (1907), reprinted in *Henry James: Literary Criticism, Vol. 2: French Writers, Other European Writers, Prefaces to the New York Edition*, ed. Leon Edel and Mark Wilson (New York: Library of America, 1984), 1086.

41. James's popularity crested in the late 1940s, but his band was still well known while Flender was writing.

42. James, preface to *Princess Casamassima*, 1088. For James's "super-subtle fry," see Henry James, "Preface to 'The Lesson of the Master'" (1907), in *The Art of the Novel: Critical Prefaces by Henry James*, ed. Richard Blackmur (New York: Scribner's Sons, 1934), 221, reprinted in *Henry James Literary Criticism* (New York: Library of America, 1984), 1229.

43. Flender, *Paris Blues*, 37.

44. These steps in consciousness and in writing are spelled out by Ellison as derived from literary critic Kenneth Burke in Ralph Ellison, *Shadow and Act* (New York: Random House, 1964), 176–177. See Kenneth Burke, *A Grammar of Motives* (New York: Prentice Hall, 1954), 264ff.; and Francis Fergusson, *The Idea of a Theater* (Princeton, NJ: Princeton University Press, 1949), 18.

45. Flender, *Paris Blues*, 132.

46. The full passage includes this phrase: "the face [was] heavily powdered and rouged, as though to form an abstract mask." Ellison, *Invisible Man*, 16. Ellison seems to have in mind Pablo Picasso's *Les Demoiselles d'Avignon* (1907).

47. Flender, *Paris Blues*, 131. In her autobiography *Lady Sings the Blues* (New York: Doubleday, 1956, 15–16), Holiday says: "Mr. Dick crawled up on me. . . . I started to kick and scream like crazy. When I did, the woman of the house came in and tried to hold my head and arms down on the bed so he could get at me. I gave both of them a hard

time, kicking and scratching and screaming. . . . It's the worst thing that can happen to a woman. And here it was happening to me when I was ten."

48. Two guidebooks are mentioned in the novel. Connie refers to *Fielding's Travel Guide to Europe*, by Temple Fielding (New York: William Sloane Associates, first published in 1948), whose chapter on France (1956–57 edition) opens with this sentence: "For thirteen centuries the French have offered the world a puzzling, provocative personality, as multiple and unpredictable as a psychiatric patient" (277). The Paris monuments and cuisine are exquisite, Fielding observes. "But the whole nation is absurdly expensive, unclean (streets and people), and substantially anti-American. The gay old tourist Eden of Hemingway, Fitzgerald, and Elliot Paul simply doesn't exist any longer" (278). She also references *Asinof's Guide to Dining on the Continent*, which has led her to the American breakfast spot in Paris called the Pam-Pam Bar, where she first meets Eddie. Called by Connie "a very good book" with "a lot of wit in it," *Asinof's* appears to be a made-up title, a joke. See Flender, *Paris Blues*, 22.

49. The lone male teacher observes the many couples making out on Paris streets, and he wishes he could meet some Frenchwomen! The number one French freedom is romantic/sexual. Flender, *Paris Blues*, 103–105, 170.

50. Flender, *Paris Blues*, 33.

51. Ellison's *Invisible Man* does not feature jazz clubs or jazz musicians, but there are many deeply compromised scenes in which Black characters perform for white audiences: Invisible Man in the battle royal, Trueblood in his meeting with Norton, Tod's dancing dolls. These may be contrasted with scenes where Blacks perform for their own communities, such as the singer Peter Wheatstraw and the unnamed horn player at Tod's funeral. The treachery of playing music on the commercially driven American scene is a recurring subject in the section "Sound in the Mainstream" in Ellison's *Shadow and Act*, 187–258. See in particular the essays on Charlie Parker (221–232) and Charlie Christian 233–240).

52. They may also exceed the reach of the collage book that Bearden and Shaw worked on with their friend, the novelist Albert Murray. See the discussion of this art project's limitations later in this chapter.

53. The "fool's errand" of gathering recommendation letters and Michel's racist treatment in a mental hospital both recall the "factory hospital" incident in *Invisible Man* (176–190).

54. Flender, *Paris Blues*, 81, italics added.

55. Flender, *Paris Blues*, 80.

56. Flender, *Paris Blues*, 76–77.

57. Maurine Hanline, letter to Milton Sperling, March 31, 1958; archive, Warner Brothers Studios (Burbank).

58. Ellington and Dance, *Duke Ellington in Person*, 83.

59. Sidney Poitier, *This Life* (New York: Knopf, 1980), 239.

60. Mitgang, "Sam Shaw Sings the 'Paris Blues,' " X7.

61. Shaw, from the audiotape of the Duke Ellington Society meeting.

62. "Lay-By" evidently was written for "Suite Thursday," Ellington and Strayhorn's 1960 composition based on the John Steinbeck novel *Sweet Thursday*.

63. James Baldwin, *The Devil Finds Work* (1976), reprinted in *James Baldwin: Collected Essays*, ed. Toni Morrison (New York: Library of America, 1998), 554. Baldwin continues: "The moments given us by black performers exist so far beneath, or beyond, the American apprehensions that it is difficult to describe them. . . . Black spectators supply the sub-text—the unspoken—out of their own lives, and the pride and anguish in [the Black actor's] face can strike deep. I do not know what happens in the breasts of the

multitudes who think of themselves as white: but, clearly, they hold this anguish far outside themselves," 555.

64. On this idea of free Black spaces, see Farah Jasmine Griffin, *"Who Set You Flowin'?" The African American Migration Narrative* (New York: Oxford University Press, 1995).

65. Shaw, interviews in the David Hajdu archive, 3.

66. Samuel Kinser, *Carnival, American Style: Mardi Gras at New Orleans and Mobile* (Chicago: University of Chicago, 1990), 205; see also Roger D. Abrams, with Nick Spitzer, John F. Szwed, and Robert Farris Thompson, *Blues for New Orleans: Mardi Gras and America's Creole Soul* (Philadelphia: University of Pennsylvania, 2006).

67. Flender, *Paris Blues*, 2.

68. It should be noted that many Black jazz musicians of the midcentury period considered Armstrong an embarrassing Uncle Tom. Some holding this view—Miles Davis and Dizzy Gillespie, for example—later recanted. Davis said, "You can't play anything on the horn that Louis hasn't played . . . even modern." Quoted in Dan Morgenstern, *Living with Jazz* (New York: Pantheon, 2004), 17. See more comments on Armstrong by fellow musicians in the special Armstrong edition of *Down Beat* magazine (July 9, 1970).

69. Flender, *Paris Blues*, 118.

70. Sterling A. Brown, "Negro Character as Seen by White Authors" (1933), reprinted in *Sterling A. Brown: A Son's Return*, ed. Mark A. Sanders (Boston, Northeastern University Press, 1996), 150–151.

71. Flender, *Paris Blues*, 3.

72. Thomas Wood, "Story of Cool Cats on a Paris Prowl," *New York Herald Tribune*, January 8, 1961, D12.

73. Louis Armstrong, "Dan's Den," radio interview by Dan Serpico at Storyville Cape Cod, in Harwich, Massachusetts, 1961. Louis Armstrong House and Museum Collection, object ID 1987.3.673.

74. Shaw, interviews in the David Hajdu archive, 3.

75. Aaron Goudsouzian, *Sidney Poitier: Man, Actor, Legend* (Chapel Hill: University of North Carolina, 2004), 191.

76. Armstrong, "Dan's Den" radio interview.

77. Fred Moten and Stefano Harney, *The Undercommons: Fugitive Planning and Black Study* (New York: Minor Compositions, 2013).

78. Stratemann, *Duke Ellington Day by Day and Film by Film*, 432.

79. In this context, it is fascinating to consider "Caravan" as a self-portrait of Juan Tizol, who wrote the piece's opening strain. In this self-portrait, the contrast between the "legit" Tizol and the "unruly Black cosmopolitan" Charles "Cootie" Williams—and, of course, Ellington—could not be more evident. It is also worth noting that Williams is one of the many Ellington trumpeters whose style is quite directly based on Louis Armstrong's.

80. This story was told to me in June 1986 by Ellington's nephew Michael James. Its authenticity was verified on May 7, 2019 by Ellington scholar Dan Morgenstern.

81. Stanley Dance records that after an Ellington concert that included the standard Armstrong tribute along with a version of "Tiger Rag," also associated with Armstrong (and the history of the music), Duke joked about Pops and "Southern music." "Ah yes," he said, "we're becoming adult at last—catching up with the Bunks and Boldens, so to speak." Dance's liner notes, *Duke Ellington Eastbourne Performance* (RCA, 1973, 1975), RCA APL 1–1023.

82. John Szwed, "The Antiquity of the Avant Garde," 56–57.

83. Ainissa Ramirez, *The Alchemy of Us: How Humans and Matter Transformed One Another* (Cambridge, MA: MIT Press, 2020), 20.

84. Ainissa Ramirez, paper for an online conference on Louis Armstrong at Columbia University, "The Armstrong Continuum," April 10, 2021.

85. Duke Ellington, *Music Is My Mistress* (New York: Doubleday, 1973), 436.

86. Juan Tizol was the exception to this pattern. He was a master of the valve trombone.

87. These bands were indeed almost invariably all white.

88. Dick Raichelson, "Dr. Ian Crosbie's Sidemen Correspondence, related by Dick Raichelson: Paul Whiteman's Orchestra, Part 3," *IAJRC Journal* (September 2012): 25.

89. Gary Giddins and Scott DeVeaux, *Jazz* (New York: Norton, 2009), 197.

90. The point here is that while every one of the groundbreaking leaders in jazz has been a strong melodist—none more so than Armstrong, Ellington, Strayhorn, and their primary associates—because of their many other strengths in terms of rhythm, texture, and harmonies beyond the scope of conventional melodies and tonalities, they could never be called musicians of "an essentially melodic style." Such a label implies the musical limitedness that I am associating with "legit" playing of the weakest kind—the kind of essentially melodic monolingualism that Ritt evidently had in mind when he called for a white trombone.

91. Leonard Feather, "Murray McEachern Performs at Donte's," *Los Angeles Times*, July 17, 1968, G13.

92. Richard O. Boyer, "The Hot Bach" (1944), reprinted in *The Duke Ellington Reader*, ed. Mark Tucker (New York: Oxford University Press, 1993), 231.

93. A corollary to Ellington's unraced view of instrumental style is that at times, white members of the band were called on to play in styles associated with Black instrumentalists. The white trombonist Art Baron told me that when he approached the microphone to solo for Black dancers in Chicago, Ellington reminded him, "Go on the South Side. *South Side, baby!*" (author's interview with Baron, January 15, 1999).

94. Ellington praised Tizol's commitment to the *valve* trombone. For other trombonists, this was a secondary instrument; not so for Tizol, whose mastery of that horn, Ellington felt, exceeded that of its occasional players.

95. Boyer, "The Hot Bach," 231.

96. Albert Murray, "Armstrong and Ellington Stomping the Blues in Paris" (1996), reprinted in *Albert Murray: Collected Essays and Memoirs*, ed. Paul Devlin and Henry Louis Gates Jr. (New York: Library of America, 2016), 604.

97. Consider the words of the outstanding African American trumpet player Roy Eldridge: "Of course, lots of people can play like Louis but they can't get that sound—that's what puts Louis in first place—it's that sound! I remember when I first came to New York, Lips Page heard me and said "Man, how come you play like an ofay trumpet player?"—I was kinda playing like Red Nichols in those days. So Lips took me along to hear Louis and that was the first time I caught that sound; I still dig it." Sinclair Traill, "In My Opinion - Roy Eldridge," *Jazz Journal*, June 1960, https://jazzjournal.co.uk/2020/06/26/jj-06-60-in-my-opinion-roy-eldridge/.

98. Edwards, "Rendez-vous in Rhythm," 184.

99. Through the professionalism and kindness of Anne Legrand and Jean-Pierre Meunier, I have filled out the list of participants in this scene to include Slan D'Albonne (a saxophonist), Émilien Antille (a beguine player called "M. Saxophone," born in Guadeloupe), Marie Clotilde "Toto" Bissainthe (a singer born in Haiti), Aaron Bridgers (a pianist), Jack "Jacques" Butler (a trumpeter born in Washington, D.C., and a regular at La Cigale), Billy Byers (a trombonist), Anatole "Barrel" Coppet (an alto saxophonist and clarinetist born in Martinique), Germain Couvin (a trumpeter), Antoine Duteil (a musician from Guadeloupe who played drums, sax, and piano), Moustache Galepides

(a drummer), Edmar Gob (a tenor saxophonist born in Guadeloupe), Guy Lafitte (a tenor saxophonist), Roger Laguerre (a trumpeter), Roland Legrand (a trumpeter), Maurice Longrais (a trumpeter), Sylvie Mamie (a bassist), "Ti Marcel" Louis-Joseph (a saxophonist), Al Lirvat (a trombonist) Louis-Joseph Marel (a tenor saxophone), Pierre Rassin (a trombonist), and Joseph Reinhardt and Jean Vees (both guitarists).

100. Gabbard, "*Paris Blues*: Ellington, Armstrong, and Saying It with Music," 297–311.

101. Author's conversation with composer Dwight Andrews, September 28, 2019.

102. Author's conversation with Ellington scholar/pianist Claude Carrière, April 9, 2019.

103. Gunther Schuller, *The Swing Era: The Development of Jazz, 1930–1945* (New York: Oxford University Press, 1989), 62.

104. This superb phrase (used in an email to the author, July 18, 2019) is borrowed from Albert Murray, "An All-Purpose, All-American, Literary Intellectual," interview by Charles H. Rowell (1997), reprinted in *Albert Murray: Collected Essays and Memoirs*, 860.

105. Jason Moran, email to the author, July 18, 2019.

106. Schuller, *The Swing Era*, 72.

107. Fred C. Moten, email to the author, July 18, 2019.

108. See *Édouard Glissant: One World in Relation*, dir. Manthia Diawara (Third World Newsreel, 2010).

109. See Roland Kirk's album *Volunteered Slavery* (Atlantic, 1969), especially its lead track.

110. Ralph Ellison, "Richard Wright's Blues" (1945), reprinted in *Shadow and Act*, 78, 94.

Coda: *Paris Blues* the Collage Book, or the Project Revisited

1. Author's conversation with Albert Murray about the Shaw/Bearden dispute, June 9, 1985; author's conversation with Dmitri Jodidio about the Bearden/Murray conflict, September 5, 2015. Jodidio says that he has documents outlining Bearden's plan for the book, which, according to him, Murray disliked. However, such documents have not yet surfaced.

2. The collages are owned by the DC Moore Gallery in New York City.

3. Albert Murray, "Armstrong and Ellington Stomping the Blues in Paris," *The Blue Devils of Nada: A Contemporary American Approach to Aesthetic Statement* (New York: Pantheon, 1996), 97–113.

4. Paul Devlin, "Two American Modernists, Second-Person Singular," in *"Something over Something Else": Romare Bearden's Profile Series* (Atlanta: High Museum of Art, 2019), 63–73.

5. In certain collages, evidently part of this series, Bessie Smith is also a protagonist.

6. For the record, Ellington's actual hometown and first training ground was Washington, D.C., and Harlem was one of his *adopted* hometowns.

7. Actually, there are several pages in this series called *Being in Paris*, of which the one described in this text is one.

8. Bearden's editing of the Rushmore monument may reflect the longstanding protest by the Oglala Sioux Nation that Rushmore stands on stolen sacred land and the huge white heads are a vulgar affront to the Oglalas.

9. I owe this observation to Brent Hayes Edwards.

10. It's interesting to consider this collage alongside Bearden's masterwork *The Block* (1971), displayed in the Metropolitan Museum of Art in New York, with its views of complex lives also revealed through windows, this time along Harlem sidewalks.

INDEX